## DATE DUE

| | | | |
|---|---|---|---|
| OC 2 1 '00 | | | |
| AP 26 '10 | | | |
| | | | |
| | | | |
| | | | |
| | | | |
| | | | |
| | | | |
| | | | |
| | | | |
| | | | |
| | | | |
| | | | |
| | | | |
| | | | |
| | | | |
| | | | |

DEMCO 38-296

# Photography and Its Critics

## Cambridge Perspectives on Photography

*Series Editor:*
Barbara L. Michaels

*Advisory Board:*

Andy Grundberg, Director, *The Friends of Photography, San Francisco*
Naomi Rosenblum
Maren Stange, *The Cooper-Union, New York*
Sarah F. Stevenson, *Scottish National Portrait Gallery, Edinburgh*
Roger Taylor, *National Museum of Photography, Film, and Television, Bradford*
Glenn Willumson, *Palmer Art Museum, The Pennsylvania State University*
Naomi Rosenblum, author, *A World History of Photography*

Cambridge Perspectives on Photography raises and addresses broad questions about photographic history. Books in this series will link photography with cultural history, the sciences, economics, literature, art history, politics, and anthropology, among other subjects. Typically, studies will examine how photography has acted as a catalyst on other fields, and how photography itself has been influenced by other art forms and intellectual disciplines.

# PHOTOGRAPHY AND ITS CRITICS

## A CULTURAL HISTORY, 1839–1900

MARY WARNER MARIEN

*Syracuse University*

CAMBRIDGE
UNIVERSITY PRESS

.ESS SYNDICATE OF THE UNIVERSITY OF CAMBRIDGE
Trumpington Street, Cambridge CB2 1RP, United Kingdom

CAMBRIDGE UNIVERSITY PRESS
The Edinburgh Building, Cambridge CB2 2RU, United Kingdom
40 West 20th Street, New York, NY 10011–4211, USA
10 Stamford Road, Oakleigh, Melbourne 3166, Australia

© Cambridge University Press 1997

First published 1997

Printed in the United States of America

Typeset in Cheltenham Book

*Library of Congress Cataloging-in-Publication Data*

Marien, Mary Warner.
    Photography and its critics : a cultural history, 1839–1900 / Mary
Warner Marien.
        p.   cm. – (Cambridge perspectives on photography)
    Includes bibliographical references and index.
    ISBN 0-521-55043-2 (hc)
    1. Photographic criticism – United States – History – 19th century.
    2. Photographic criticism – Europe – History – 19th century.
    3. Photography – Philosophy – History – 19th century.   I. Title.
    II. Series.
    TR187.M37   1997
    770—dc20                                                        96-31557
                                                                         CIP

*A catalog record for this book is available from
the British Library*

ISBN 0 521 55043 2 hardback

# CONTENTS

# ILLUSTRATIONS

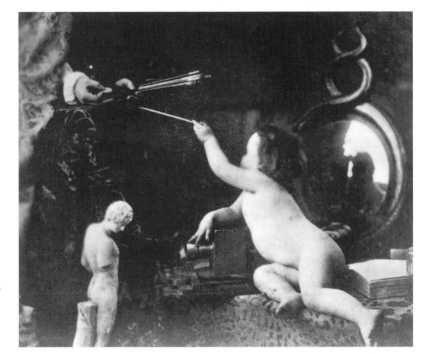

FIGURE 1

Oscar Rejlander, *Infant Photography Giving the Painter an Additional Brush,* 1856. Collection of the J. Paul Getty Museum, Malibu, California.

# PHOTOGRAPHY *IS* THE MODERN WORLD

I have to say that the history of photography was thrust upon me. Several years ago, I was asked to teach what had been my hobby. For me, the notion of presenting the photographic record in a detached and programmatic way augured loss. My reluctance was that of an autodidact sensing ignorance's withdrawing warmth.

Indeed, the organization of a photographic history course did entail forfeiting my predilections. But even greater sacrifices loomed. Leaving art history for photographic history felt like quitting the humanities at the very moment that the field was quickening with theoretical vitality and was enlarging its purview with materials from everyday life. The expanding orbit, interdisciplinary interest, and methodological variety of the contemporary humanities seemed discouragingly distant from camera work. Which proved, if proof were needed, that I didn't know much about what was happening in photographic studies.

During the 1980s, photography was becoming the decade's vogue art. College photography courses became more common, and photographs gained in the art market and in the museums. But it was society's photographic condition, not photography per se, that emerged as a central intellectual concern. Seeing and knowing, nature and culture, reality and illusion – the big terms of Western thought – were being rearticulated with reference to the experience of mass media, especially visual media.

Put another way, it looked as though photography, which had been trying perennially to free itself from being an index of the obvious, had finally become socially symbolic. In the last quarter of the twentieth century, photography has come to stand for not simply the mass media but the experience of mediated reality. The photographic condition signaled a deterioration of the human condition: Edenic natural perception had been eroded by photographic, that is, mediated, perception. The impact of mass media on individuals and on society has become nearly synonymous with postmodernity. The sense of termi-

nal rupture with the past has brought apocalyptic joy and nostalgia. In his seminal 1981 essay "Last Exit: Painting," the artist and critic Thomas Lawson argued that

> To an unprecedented degree the perception of the "natural" is mediated these days. We know real life as it is represented on film or tape. We are all implicated in an unfolding spectacle of fulfillment, rendered passive by inordinate display and multiplicity of choice, made numb with variety; a spectacle that provides the illusion of contentment while slowly creating a debilitating sense of alienation. The camera, in all its manifestations, is our god, dispensing what we mistakenly take to be truth. The photograph *is* the modern world.[1]

"The Work of Art in the Age of Mechanical Reproduction," written decades earlier by the German cultural critic Walter Benjamin, was revived in the 1980s and designated the touchstone of urgent contemporary ideas. The essay proclaimed a new era of human history, inaugurated by mass media, and a culture of uninhibited representation that ultimately vanquished older formulations of originality.

Despite inconsistencies, a nexus of concepts and attitudes coalesced into the notion of the photographic condition, whose visible signs were the photograph, the still photographer, and the camera. Throughout the 1980s, photography became so detached from its particularity that a painting or sculpture making visual reference to photography would be understood to be about television or advertising. In other words, photography seemed loosed from any particular practice or genealogy, and it emerged as a complex concept.

As photography became an idea, photographic history became, for me, the history of *the idea* of photography. Photographic history thrust itself upon me again not in the familiar fondness for specific images, but as a component of humanistic study. I realized that the idea of photography had not developed recently, but had been a potent axis of Western cultural thought – even before the invention of the medium! By viewing the history of photography as the history of the idea of photography, I was able to discern repeated tendencies in the writing of the medium's history.

As the intricate, unstated assumptions of writings on photographic history became the focus of my study, my old perplexities became instructive. I had long wondered about the defensiveness of photographic texts, which I superficially interpreted to be a defense of the medium itself. Rereading early histories of photography as histories of the idea of photography, I realized that photography had been involved in a contest of meaning. The defensiveness permeating its history was not merely a justification of the medium as art or information, but an effort to govern and direct the social meanings of photography.

I began to examine the schemata of nineteenth- and early-twentieth-century texts for patterns of meaning, signifying strategies, implied absences, contradictions, elisions, conflations, and just plain crot-chets. I would like to say that the debates in contemporary cultural history guided my exploration of photographic history, but just the opposite

is true. When I observed that the historical definitions of the medium were inconsistent, I returned to the recent debates in French historiography that took up the issue of conceptual meldings. I would like to say that dawn broke over my work while I was rereading Michel Foucault, but that would not be accurate either. Foucault's attention to the symbiotic discourse of power and knowledge prompted my study of cross-currents such as the association between nineteenth-century literacy movements and photography, but it has been to the theoretical and historical writings of Roger Chartier that I return again and again.[2]

The present study retraces some of the steps that convinced me to situate photographic history in the humanities. It aims to demonstrate the variety of meanings that were part of photographic discourse from its disclosure in 1839 to the beginning of the twentieth century. It presents photography as an idea, shaped by social concerns and inherited concepts, and as a burgeoning visual practice. When photography is viewed as a multifaceted social idea, vested in the practice of but not limited to image making, the oft-made distinction between photographic document and photographic art can be transcended. In our time, the art of art photography, so much a part of nineteenth-century dispute, has been recognized by museums and universities. But the intellectual history of photography, including art photography, has been less well served. Photographic studies require what the historian Erwin Panofsky called an iconology, an inquiry into "*cultural symptoms* or '*symbols*' in general," so as to gain "insight into the manner in which, under varying historical conditions, *essential tendencies of the human mind* were expressed by specific *themes* and *concepts.*"[3] One of the key tasks of photographic studies is to analyze the notion of photography itself, at a level of generalization indicating its connections to cultural concepts and historical settings. Photography may be an art, but photographic history is not art history. It is a comprehensive field of inquiry encompassing many disciplines.

Even if one accepts that photography was unprecedented, it does not follow that the medium penetrated society without reference to existing ideas and mental habits. The first section of this book details how early understanding of photography was fashioned through prior notions of nature, originality, and imitation, some of which evoked the continuing authority of Greek concepts in Western culture. Whereas photography's first definitions were drawn in relation to its origins, the emergent photographic discourse was imbued with a spectrum of ideas about the role of images in society. The creation of the concept of photography was not a process simply of borrowing, but of effecting new meanings through earlier ones. As Nathaniel Hawthorne wrote in *The House of the Seven Gables,* a novel that used photography as a symbol of modernity, the discourse of photography grew from the past, "gradually renewing . . . by patchwork."[4]

Though extensive, photographic discourse has not been consistent. Perhaps the outstanding characteristic of early notions of photography was the durability of the contradictions they accommodated. As photography's prehistory was articulated, the idea of

photography proved to be impressively elastic. The medium could be seen as both old and modern, as natural and cultural, as invented and discovered, as art, as magic, and as science.

The notion of photography, conjoined to practice, developed as a symbol of social change for audiences ranging from American farmers to Parisian art critics. Apocryphal stories about photography's origins, which arose in the 1840s and the 1850s, invested the daguerreotype and the photographer with magical powers. Mythic tales about mysterious inventors of photography emerged and were quickly subsumed into early histories of photography available in books and journals for lay readers. At the same time, the art and photographic literature read by cognoscenti, amateurs, and practitioners uncritically absorbed and proclaimed as accurate utterances by the painters J. M. W. Turner and Paul Delaroche about the lethal effect photography would have on painting. These parallel stories and their social significance are highlighted. The vigor of legend in photography underscores the extent to which photography as an idea embodied anxieties about cultural transformations for people of differing rank and experience. The prominent arguments for and against photography must be seen in the larger frame of societal change.

Often isolated from social analysis, the art world's debate about photography's aesthetics can be read as a surrogate for several larger issues. Photography's art potential became a topic that engaged judgments about the repercussions of industrialization, urbanization, and class relations. Practices like landscape, amateur, and High Art photography enunciated understandings of personal expression, social betterment, and morality in modern society.

The ways in which the promise of a democratized image permeated cultural notions of photography are discernible in the public dialogue about verbal and visual literacy that took place in the latter half of the nineteenth century. The pedagogic value of art, especially of art broadcast through photographic reproduction, became part of the rhetoric of modernization. The idea of a museum without walls, dependent on photographic facsimile, matured at the same time as two other new cultural spaces, the public museum and the department store. As concepts and institutions, the gallery and the department store suggested an abundant economic and social access to culture and commodities that did not exist. In the rhetoric of verbal and visual literacy, as well as that of the museum and department store, freedom stemmed from individual choice among a vast array of items, be they cultural or commercial. Crime and poverty too were construed as choices, that is, as the results of personal will, rather than as faults in the social system.

In the waning years of the nineteenth century, art photography proclaimed its freedom from commercial photographic practice. That putative autonomy has been a commonplace of photographic history – a declaration of independence that eventually led to the establishment of photography departments in museums and galleries. Certainly the art theory written at the end of the nineteenth century seldom touched on the ordinary experience of photography. Nevertheless,

photography's attempts to create aesthetic sovereignty transpired in the context of larger social debates about the role of science and its relation to cultural achievement.

The alignment of photography and notions of modernity inform this text. With the passing of time, photography continued to connote the modern, but the notion of modernity changed. That transition is conspicuous in the writings of the photographer and theorist Peter Henry Emerson. The variety of issues that Emerson addressed in his books and articles on photography, written in the late 1880s and early 1890s, differed greatly from those articulated a half-century earlier. Emerson found it necessary to calibrate photography's relation to the weighty accumulation of scientific knowledge, as well as to specific theories, such as evolution. His jerry-built balance between the claims of culture and the claims of science on photography reveals the way in which the idea of photography remained a vital social reference at century's end. Once a mirror of the external world, photography was reestablished as modernism's shadow. It outlined the elegiac premonition that modernism was faltering as well as the perception that the future would be increasingly dependent on science and technology rather than on fundamental political change.

In the current study, the interactions between diverse photographic practices and the evolving cultural notion of photography are examined. Photography was simultaneously a transformational technology and a convenient metaphor for beneficial *and* harmful change on the planes of personal and societal experience. As both an idea and a social fact, photography unceasingly redrew the apparent line between nature and culture. Compounding issues as disparate as public morality, the effects of industrialization, and the value of cultural accomplishment, photographic discourse provided a new way to explain transitions and to articulate anxiety about personal change as well as societal directions.

It has been my good fortune to work with many gracious people and organizations during the writing of this book. Among those at Syracuse University, Professor David Tatham must be noted as the person who managed to convince me to teach what had been my hobby. Without Professor Frank Macomber, the book would not compute. Randall Bond and his staff in the Art Library have been steadily resourceful and encouraging.

I am grateful to Professor W. Warren Wagar of Binghamton University for his support and readily given historical knowledge. Dr. Barbara L. Michaels, editor of the Cambridge Perspectives on Photography series, simultaneously gladdened my heart and made me do my best. Both Beatrice Rehl, Editor, Fine Arts and Media Studies, and Camilla Palmer, Production Editor, perseveringly helped to transform the manuscript into its final form. I can also recommend the benefits of Dr. Michael Marien's twenty-four-hour editorial service.

For their ideas and aid with illustrations, I am especially grateful to the following: J. Roy Dodge, Jean Horblit, Debbie Jackson at the Met-

ropolitan Museum of Art in New York, Julian Cox at the J. Paul Getty Museum, Malibu, California, Lori Pauli at the National Gallery of Canada, Ottawa, and, especially, Sandra Stelts at the Pennsylvania State University Library, who affirmed my belief in the kindness of strangers. Dr. Jeffrey Horrell, art librarian at Harvard's Fogg Museum, and Amy Rule at the Center for Creative Photography in Tucson provided needed assistance with image resources and information.

Early versions of the first chapter and the fourth chapter were granted Logan Awards from the Photographic Resource Center at Boston University. A Fellowship from the New York Foundation for the Arts furthered my research.

For his continual intellectual inspiration, generosity, and joie de vivre, this book is affectionately dedicated to Professor William Fleming, teacher, mentor, and friend.

## A NOTE ABOUT THE ILLUSTRATIONS

Some of the images reproduced in this book refer to specific photographs discussed in the text. For the most part, though, they typify the dimensions of nineteenth-century popular and artistic photographic practice.

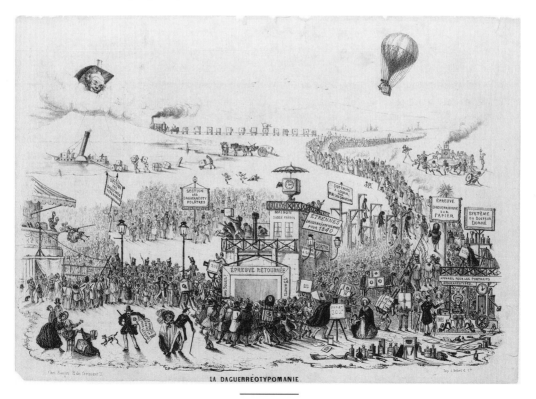

LA DAGUERRÉOTYPOMANIE.

FIGURE 2

Théodore Maurisset, *La Daguerreotypomanie,* lithograph, 1840. National Gallery of Canada, Ottawa, Canada.

# THE ORIGINS OF PHOTOGRAPHIC DISCOURSE

## AND THEN CAME DAGUERRE

In 1939, one hundred years after photography had been disclosed to the world, the thicket of received ideas about the medium's invention was so dense that even such an astute observer as Paul Valéry could not extricate his thoughts from the tangle. For years the French poet and critic had been recording his unique perceptions of science, history, and contemporary culture. His commentary-filled notebooks gradually acquired the reputation of an informal national archive. Yet when Valéry addressed the French Academy on January 7, 1939, in observance of photography's centenary, he merely reworked mytho-poetic conventions: "And then came Daguerre," Valéry intoned. "With him, the photographic vision was born and it spread by singular leaps and bounds throughout the world. A marked revision occurred in all standards of visual knowledge."[1] *Sans ornement,* this was what people had been saying for decades: Photography was unprecedented – powerfully, mysteriously, unprecedented.

For Valéry, and many others, photography had not evolved gradually in the manner of other nineteenth-century inventions. Instead, the medium had erupted into the social world like Athena emerging fully formed and impatiently precocious from the head of Zeus. Photography had no apparent childhood, no period of adolescent experimentation, and no interval of incremental progression in the public eye. Even after one hundred years of thought and experience, 1839 remained an annus mirabilis. The arrival of photography resisted rendering in ordinary terms. The medium's enigmatic origins aroused the kind of agreeable frisson nobody much cares to extinguish with plain facts.

Those who witnessed the advent of photography in 1839 discussed its debut in the language of exceptions. Long before it could effect sig-

nificant social change, photography was confidently described as a transformational technology. In 1839 and the decade that followed, anticipation of photography's having social consequences drew credence not from shifts already attributable to the medium in its first years, but from the apparent suddenness of the medium's appearance. Before anyone had seen much of it, photography was said to be a wonder, a freak of nature, a new art, a threshold science, and a dynamic instrument of democracy.

As might be expected at such an event, Paul Valéry's centenary lecture accentuated the marvelous aspects of photography. Had he elected to, Valéry could have related other equally credible chronicles. He might have drawn on the durable genealogy that supposed photography to be the inevitable outcome of a set of experiments and technological devices. His talk might not then have been as exhilarating, but the absorption of photography into the saga of progress would have been equally familiar to his audience.

One hundred years after its 1839 disclosure to the world, photography's origins had not one story but many conflicting stories. The medium was thought to be old and new, natural and artificial, the result of brilliant individual effort and the outcome of gradual societal development. Today, these contradictions continue to pack its history or, one should say, its histories. Although the story of photography grew considerably more elaborate with time and circumstance, its basic lineaments were legible in 1839. Fundamental to past and present renderings of the medium has been photography's distinctive relationship to nature.

---

## Spontaneous Reproduction: Nature and the Natural as Explanation in Photography

---

Before the book, the codex; before the automobile, the carriage. Before photography?

Photography has no single, clear, antecedent in part because the medium's many applications do not easily submit to a unitary definition. In photographic morphology there is no preparatory Ur-form. If photography is defined principally as a means of making multiple copies, then its precursors can be sought among print media such as woodcut and engraving. But if photography is defined as a means of copying observable reality exactly, then its antecedents are likely to be located in a wide range of visual – and even verbal – encodings of optical experience. When replication and exactitude are compounded in the definition, pursuit of photography's precursors can lead to the realm of magic and illusion.

Photography's basic conceptual difficulty might have been troublesome in writing its prehistory and history. Instead, the several definitions of photography allowed writers to choose among and combine emphases. Within a decade of photography's disclosure in 1839, the circumstances of its invention and substance were expressed by a collection of inconsistent ideas.

Photography's multiple definitions also facilitated the grafting of old meanings onto the new medium. A central source of photographic interpretation was the complex of ideas about nature and originality that had been rehearsed in eighteenth-century thought. Writers such as Alexander Pope distinguished between natural genius and genius that was achieved through learning.[2] They ranked natural agency above human agency and held that the product of effortless inspiration was more authentic and more valuable than a product derived from work. Relatedly, genius and the works of genius were legitimized not simply by inspiration, but by that aspect of originality that emphasized the importance of being first.

William Henry Fox Talbot, Louis Jacques Mandé Daguerre, and Joseph Nicéphore Niépce – the recognized pioneers of photography – shied away from explaining photography as an invention wrought by human hands. Each insisted that photography originated in nature and was disclosed by nature. According to Talbot, an English scientist, photography depicts its images "by optical and chemical means alone." The image is "impressed by Nature's hand."[3] As Daguerre put it: "The DAGUERREOTYPE is not an instrument which serves to draw nature; but a chemical and physical process which gives her the power to reproduce herself."[4] And Niépce, the least-known photographic forebear, defined his accomplishment as "spontaneous reproduction, by the action of light."[5] An agreement drawn up by Niépce and Daguerre referred to Niépce's attempts "to fix the images which nature offers, without the assistance of a draughtsman. . . ."[6]

Photography's inventors of course were aware of the medium's verisimilitude and reliable visual reproduction. Yet they stressed the apparent spontaneity of the medium. Photography was autography, a natural phenomenon discovered and revealed by experimenters, not a process invented by humans.[7] In other words, beginning with the earliest verbal accounts of the medium, photography was described in different terms than the machines, instruments, and processes of the Industrial Revolution. For example, however radical the changes wrought by the railroad, the story of its invention has remained mundane.

By situating photography in natural history rather than in human history, photography's pioneers distanced the medium from technological history as commonly understood. They challenged simple notions of technical genesis with the proposition of natural genesis. As a revelation, photography seemed to be qualitatively removed from the history of print media such as woodcut.

The idea that photography originates in nature periodically re-

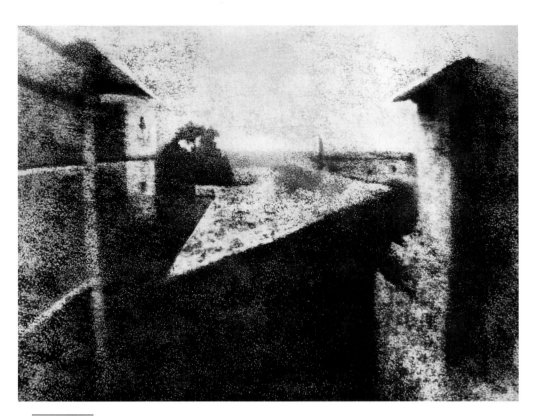

FIGURE 3

sanctioned the medium's worth. In a letter to the American painter Washington Allston, Samuel F. B. Morse wrote, "Nature . . . has taken the pencil into her own hands."[8] William Henry Fox Talbot (unwittingly, one supposes) would later adapt this phrase for the title of his book *The Pencil of Nature* (1844–46). Ralph Waldo Emerson accentuated the affinity between a natural, that is, an egalitarian, society and the natural art created by photography. "'Tis certain that the Daguerreotype is the true Republican style of painting." He added, "The artist stands aside and lets you paint yourself."[9]

The ongoing denotation of photography as a natural phenomenon is evident in the persistent, interchangeable use of the words "discovery" and "invention" to describe photography's beginnings. For example, Talbot, despite having experimented with photography over a long period of time, referred to his work as a "discovery" and as an "invention." Contemporary newspaper accounts also used both terms.[10] In the mid-twentieth century, the critic Clement Greenberg still found it appropriate to use both terms as well. "Photography is the most transparent of the art mediums *devised or discovered* by man," Greenberg wrote.[11] The penchant for using the two words interchangeably was also apparent during the 1989 sesquicentennial of photography.[12]

Phrasing the new medium as a component of nature allowed photography to be imbricated in a much older cultural disposition. From ancient times, there persisted what might be called the idea of pho-

tography before the fact of photography. The idea of photography was the yearning in Western culture for a means of representation free from omission, distortion, style, murky subjectivity, or outside interference. The idea of photography betokened the wish for a universal language conceived by nature and therefore appropriate to genuine human progress as well as to scientific pursuits.

The idea of photography enunciated an intimate connection between seeing and knowing that has its roots in Plato's *Republic* (Book VI). But in the eighteenth century, sight and insight were part of an ongoing dialogue about humans in a state of nature. In 1758 Jean-Jacques Rousseau proposed that a communal festival be held out-of-doors, in the bosom of nature, where false appearances could be shed, allowing the hearts of all present to beat as one.[13] In his essay titled "Nature," published in 1836, just prior to the public disclosure of photography, Emerson articulated the belief that innocent sight could lead to transcendence:

> Standing on the bare ground – my head bathed by the blithe air, and uplifted into infinite space, – all mean egoism vanishes. I become a transparent eyeball; I am nothing; I see all; the currents of the Universal Being circulate through me; I am part or particle of God.[14]

In this proposition, passive sight yields greater knowledge than active reason can uncover. Sight is both site and symbol of unmediated perception.[15]

For some nineteenth-century commentators, the possibility that natural vision was chaste vision promised personal redemption. Seeing implied an impeccable and direct truthfulness not achievable through verbal texts. For all its beneficial effects, reading could not hold a candle to pure seeing. "While we are confined to books," Henry David Thoreau wrote, "we are in danger of forgetting the language which all things and events speak without metaphor, which alone is copious and standard." "No method or discipline can supersede the necessity of being forever on the alert," he continued. "What is a course of history or philosophy, or poetry . . . compared with the discipline of looking always at what is to be seen?" True sight yields insight. "Will you be a reader, a student merely," Thoreau taunted, "or a seer?"[16]

Interpretations of the photographic medium fused with prior, recuperative senses of seeing. One can observe Edgar Allen Poe, in his article "The Daguerreotype" (1840), merging the idea of photography with photographic practice. Poe argued that "all language must fall short of conveying any just idea of the truth . . . but the closest scrutiny of the photogenic drawing discloses only a more absolute truth, a more perfect identity of aspect with the thing represented."[17]

Photography as natural vision easily transmuted into photography as neutral vision. The camera image was thought to be an analogue of the picture on the human retina. As such, the medium was understood as material confirmation of the Enlightenment proposition that the im-

age on the human retina is independent of the subject's thoughts and feelings. The photograph was externalized, ideal human vision. It confirmed the possibility of direct perception of knowledge and authenticated the Cartesian model of an intellect that routinely scrutinizes retinal images for information.[18]

Even before a camera image was successfully fixed, the concept of such a picture was explained in terms of perfecting an artificial retina. In 1816 Niépce casually referred to the camera he was building as an artificial retina.[19] François Arago, the French politician-statesman who championed the new medium, spoke of photography's potential to be a kind of objective retina (*rétine physique*) that would make possible the study of the properties of light, "independent of our senses."[20] He predicted the usefulness to science of an artificial eye (*une sorte d'oeil artificiel*).[21] An early report on the new medium, written by Jules Pelletan and published in January 1839, described Daguerre's achievement as an artificial retina. Soon after, J. B. Biot, the distinguished scientist who lent his political and scientific support to Daguerre, also used the phrase.[22]

The conception of photography as an artificial retina ignored critical differences between camera vision and human vision. In early analogies between photography and human sight, the artificial retina was understood to be monocular and static, not binocular and active like human vision. Nevertheless, the similarities between camera vision and human vision were pushed to the point that the two types of vision became synonymous. The creation of an artificial retina was perceived as a credible scientific goal. Concurrently, the analogy between human sight and infallible perception expressed a wish for permanence, stability, and control and implicitly challenged arbitrariness, fragmentation, and disorder. The photograph as an exterior, artificial retina seemed to reflect the desire to immobilize and intellectualize discrete images rather than render the flux of optical reality. In other words, as the first photographs were made, the emergent photographic discourse shaped the meaning of photography as a symbol of order. In this regard, it is important to note that despite early photography's technical flaws, for example, the fragility of the daguerreotype and the instability of the calotype, photography was frequently called faultless. The medium's lengthy and messy procedures were acknowledged, yet discounted. The idea of the artificial retina's neutral vision made real photographs look better.

The photograph gave palpable physical evidence of an objective space in which the intellect could freely function and augured a radical change in the condition of knowledge. Photography suggested that the world would become more immediate and more legible to more people than in the past. This expansion of knowledge was not simply the result of more people having easier access to more images. At its most utopian, the photograph surpassed the need for interpretation because the measure of its success was the appearance of the world to ordinary people. Nascent in the concept of photography as a neu-

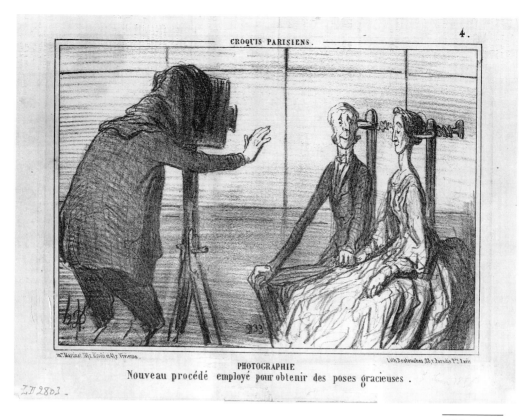

PHOTOGRAPHIE
Nouveau procédé employé pour obtenir des poses gracieuses.

FIGURE 4

Honoré Daumier, *Nouveau procédé employé pour obtenir des poses gracieuses,* lithograph, c. 1856. National Gallery of Canada, Ottawa, Canada.

tral, artificial retina was the revolutionary idea that pre-photographic domains of power and expertise could and should wither.

## Neutral Vision in the Modern Era

Just as the idea of photography as natural vision persisted into the modern era, so too did the notion of photography as neutral vision. However much we know about the psychobiology of human vision, we experience seeing directly. Nothing appears to come between us and the world. Many of the words and concepts that we use ("I see"; "I'll have a look"; "that was short-sighted") equate sight with knowledge. Imbedded in both language and experience is the sense that seeing is believing. The experience of sight is perpetually symbolic.

The nineteenth-century belief that photography offers humans an innocent, dispassionate way of seeing sustained the post–World War I modernist experiments of Alexander Rodchenko, Man Ray, and László Moholy-Nagy.[23] The intrinsic distinctiveness of the camera's glass eye (the phrase is Clement Greenberg's) is that it is ingenuous, possessed of a transparency that can "sense contemporary reality naively and express it directly." In a 1946 review of the photographer Edward Weston's work, Greenberg characterized photography as "clean of past and tradition."[24]

Greenberg maintained that art photography that was unwilling to take account of the mechanical nature of the camera was bad art.

More than a decade earlier Lewis Mumford had expressed a similar judgment. Mumford disparaged Pictorialist photographs, the gauzy views popular at the turn of the century and for the next several decades. Pictorialism struck him as a "relapse from clean mechanical processes . . . [that] worked ruin in photography for a full generation."[25] According to Mumford, montage – the splicing together of unrelated images employed in dadaism and surrealism – was "not photography at all but a kind of painting."[26] Mumford insisted that predilection for pure form in photography, the trait of so much modernist work, enervated the medium and evinced a "segregated esthetic sensibility."[27]

Similarly, in the 1960s the modern French critic André Bazin observed that in contrast to painting the originality of the photographic medium rested on its "essentially objective character."[28] Bazin's sense of photographic originality echoes with the two meanings of originality that had evolved in photography's first decade. Like photography's earliest commentators, Bazin applied this dual sense of originality. His concept of photography begins in nature: "Photography affects us like a phenomenon in nature, like a flower or a snowflake whose vegetable or earthly origins are an inseparable part of their beauty." The medium is without precedent. The advent of photography was the "first time an image of the world is formed automatically, without the creative intervention of man." Bazin did not totally discount the personality of the photographer, but he emphasized the way in which the medium brought about a rupture with the past. "All the arts are based on the presence of man, only photography derives an advantage from his absence," he observed.[29]

Working from entirely different perspectives, some contemporary critics have, perhaps unintentionally, ratified photographic transparency by insisting that photographic meaning is constructed entirely outside and beyond the camera.[30] In his frequently cited passage, John Tagg has asserted that photography has no special identity and that "its history has no unity. It is a flickering across a field of institutional spaces."[31] The idea of photographic transparency, which is central to its originality, has been embedded in some very disparate arguments. Transparency has been used to differentiate photography from media such as etching and engraving, where craft techniques are more apparent. The notion of photographic transparency has also contributed to the argument that the history of photography is one with its subject – that it is no more than the history of what it pictures.

## Natural Magic

Photography's veiled beginnings, the legend of photography's genesis in nature, the relatively spontaneous appearance of the photographic image, and the uniqueness of the photographic copy combine to suggest that something exceptional took place with the advent of photography. The proclivity of early viewers to associate photography with magic may date from Daguerre's ill-fated attempt to market

shares in his invention directly to the public. Parisians, shown photography's marvelously exact replications of street scenes and familiar with the dramatic illusions produced by Daguerre on the stage of his Diorama, concluded that Daguerre's camera images were the result of either enchantment, trickery, or a sly combination of the two.[32] The highly illusionistic quality of the daguerreotype put audiences in mind of magic. Even for commentators who had not actually seen a daguerreotype, the medium seemed "more like some marvel of a fairy tale or delusion of necromancy than a practical reality."[33] Subsequent writers frequently stressed the magical appearance of the image on the negative, a transformation made more mysterious by the fact that so few viewers actually witnessed the process.

Occasionally, even scientific minds explained photography with reference to the unconventional and supernatural. Recounting his first reaction upon viewing daguerreotypes, the renowned British scientist John Herschel declared that "it is hardly saying too much to call them miraculous."[34] And as intent as François Arago was to render a convincing and conventional technological account of photography's invention, he too ranged beyond the prosaic in his argument. In the version of photographic prehistory that he gave to the Chamber of Deputies and the French Academy of Science, Arago enlisted the speculative fiction of John Wilkins and Edmond Rostand. Arago proposed that however farfetched they might seem, fictional moon voyages, artificial wings, and machines powered by the sun were reliable heralds of coming events, framed in the language of the time in which they were written. For Arago and for many later authors, science fiction played a crucial formative role in technological development: in its dreams began wondrous machines.[35]

Photography's supposed origins in nature and its association with nature guided conjecture about possible anticipations of the medium. The early Parisian photographers Mayer and Pierson expanded Arago's notion of the technological imagination in their 1862 account of the discovery of photography. In a brief excerpt from *Giphantie,* a French utopian tale by Tiphaigne de la Roche published in 1760, by Mayer and Pierson uncovered what they believed was a prediction of the invention of photography.[36] Ever since, despite an occasional objection, *Giphantie* has been part of photographic lore.[37]

In *Giphantie* a voyager travels to an island where elemental spirits dwell. To make their art, these creatures smear a mysterious viscous material on canvas. The canvas, thus prepared, will retain a mirror image of any scene to which it is exposed.[38] The *Giphantie* canvases have been routinely cited as proof that the human imagination outruns the social and material means of production and that that which can be imagined is an accurate glimpse into the future. Whether magically or through the collective will or spirit of a people, photography had emerged. Like the artificial retina, this brand of naive futurism embodied a wish for predictability and unity in history. In photographic history, *Giphantie* has had a specific utility.

The persistence of the *Giphantie* excerpt may be explained by the

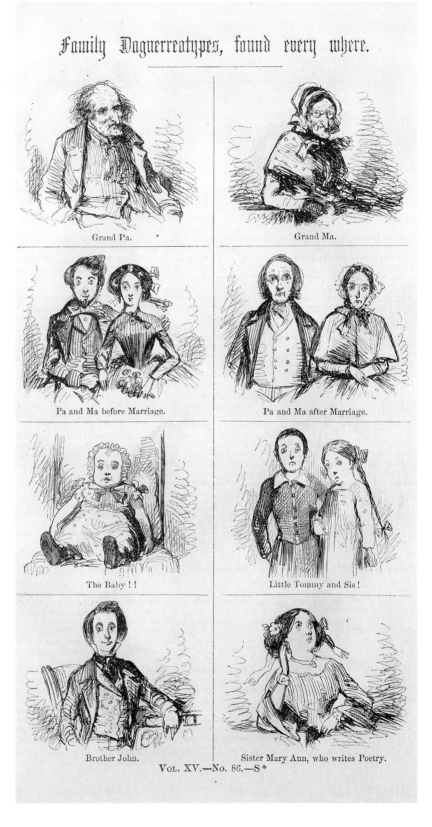

Family Daguerreotypes, found every where.

Grand Pa.

Grand Ma.

Pa and Ma before Marriage.

Pa and Ma after Marriage.

The Baby ! !

Little Tommy and Sis !

Brother John.

Sister Mary Ann, who writes Poetry.

VOL. XV.—No. 86.—S *

Cousin Frank, who adores Mary Ann.

Aunt Sally, who attends all the Charity Fairs.

Uncle Ben, who lives in Illinoy!

Uncle Josh, who has been to Congress, and is *ric*

"Lucy Lilac" and "Carrie Cowslip" (our Cousins, who write for the Magazines).

Our Uncle, Colonel Popkins.    (Taken while on Duty.)

Cousin Fred, who sent this Picture from California to his Mother.

Cousin Tom, the New York Volunteer who receive that Gold Snuff-box.    (Picture rather vague.)

FIGURE 6

Unknown Artist, *Family Daguerreotypes, found every where. Harper's New Monthly Magazine* 15 (July 1857): 286. Courtesy of the Syracuse University Library.

way the story links photographic discourse to a major motif in Western thought. *Giphantie* updates the age-old human ambition to make images real and to make realistic images. For example, the *Giphantie* tale links photographic discourse with the enduring tales about the ancient Greek painters Zeuxis and Apelles, who painted images said to be so lifelike that they seemed more the products of legerdemain than of craft. It also connects the understanding of photography with Western culture's durable stories about magic mirrors, like Faust's vision of the enchantress in the mirror.

Human ingenuity is paramount in the science fiction of Wilkins and Rostand, cited by Arago.[39] But *Giphantie* relies solely on supernatural afflatus. The story's paintings are the products of elemental spirits who secretly conspire with witches and alchemists through the ages. They are the creators and users of the viscous materials. Photography's magical qualities have been repeatedly underscored through the continuous acceptance of the *Giphantie* story as a forecast.

During its first decades, photography was sutured to the tradition in Western art of images that fool the eye and of images created for or during divination: Zeuxis's grapes or Apelles's portraits. The autographic photograph gave an eerie presence to an absent subject. The early and continuing association of photography with magic fortified the idea of the medium's natural genesis: As magic, photography did not have to be explained developmentally. Even commentators who knew exactly how photography worked wrote about it as a wonder.

In "Some Account of the Art of Photogenic Drawing" (1839), William Henry Fox Talbot mused:

> the phaenomenon [*sic*] which I have now briefly mentioned appears to me to partake of the character of the *marvellous,* almost as much as any fact which physical investigation has yet brought to our knowledge. The most transitory of things, a shadow, the proverbial emblem of all that is fleeting and momentary, may be fettered by the spells of our *natural magic,* and may be fixed for ever in the position which it seems only destined for a single instant to occupy.[40]

Similarly, Edgar Allen Poe, who understood the photochemistry of the daguerreotype, did not let his scientific knowledge mute the wonder he felt at the photograph's "miraculous beauty."[41] In informal writing, photographs were spoken of in the vocabulary of magic. In a letter to her friend, Miss Mitford, Elizabeth Barrett Browning exclaimed:

> do you know anything about that wonderful invention of the day, called the Daguerreotype? – that is, have you seen any portraits produced by means of it? Think of a man sitting down in the sun and leaving his facsimile in all its full completion of outline and shadow, steadfast upon a plate, at the end of a minute and a half! The Mesmeric disembodiment of spirits strikes one as a degree less marvellous. . . . It is not merely the likeness which is precious . . . but the association, and the sense of nearness involved in the thing . . . the fact that the *very shadow of the person* lying there fixed for ever! It

is the very sanctification of portraits I think – and it is not at all monstrous of me to say . . . that I would rather have such a memorial of one I dearly loved, than the noblest Artist's work ever produced.[42]

As the traditional vocabulary of magic suffused photographic discourse, the public perception of photographs as powerful fetishes increased. Thus in several short stories written during the daguerreotype era, photographs and photographers have the power either to hypnotize or to be surrogates for their sitters.[43] Yet, ironically, as the language of magic infiltrated photographic discourse, the documentary, or evidentiary, capacity of photographs became stronger as well.

The association of photography with magic was in place when Nathaniel Hawthorne published his novel *The House of the Seven Gables* (1851). One of the book's major themes is the perennial interplay of the past and the present – a dialectic impervious to scientific or technological improvement. For Hawthorne, human advancement was not technological; nor was it merely the tearing down of "the moss-grown and rotten Past."[44] Instead, the future grew from the past, "gradually renewing . . . by patchwork."[45] In the novel, painting and photography – the old image making and the new – stand for the patchwork progress that Hawthorne viewed as fundamental.

A major figure in Hawthorne's novel is the daguerreotypist, Mr. Holgrave. His spectrum of personal traits is similar to the characteristics that connect photography with nature. Holgrave springs from a family with the legendary talent to conjure animate figures in a looking glass. His daguerreotype portraits are more than copies. They extend human sight and reveal what ordinary vision cannot bring into focus: the moral character of individuals. In accord with his natural gifts, Holgrave is untutored and uncivilized.[46] He possesses an intense loathing for the grip of the dead hand of the past on the present. He is a man of the future, regardless of his hereditary link to the victim of the Pyncheon family's past injustice. In the end, progress depends on his uniting in marriage with the character who symbolizes the past renewing itself, Phoebe Pyncheon.

*The House of the Seven Gables* is not primarily about photography. Still, its symbols, narrative, and major metaphor of darkness and light (photography's graphic property) show the extent to which photography and magic were affiliated and the degree to which that affiliation could be familiarly deployed in literature. In slightly more than a decade, photography had become a symbol with a complicated meaning involving the idea of the double, or the intermixing of truth and deception. Where before mirrors might have been used, now, photography was the commonly understood symbol of the uncanny.[47]

## Modern Magic

The association of photography and magic was not just a nineteenth-century crotchet. In his enduring essay "The Work of Art in the Age of

Mechanical Reproduction" (1936), Walter Benjamin critiqued the impact of mass reproduction in terms of magic, photography, and originality. Benjamin argued that the cult value of a work of art, that is, its magic and ritual value, was altered under conditions of reproducibility. An object's authenticity, what Benjamin called its aura, emanated from its singularity, which was diminished when multiple copies or images of it could be made available. For Benjamin, the invention of photography created a crisis in originality: If all prints were more or less equal, which print could be considered the original? Because of reproducibility, the object was freed from its cultic identity and made available for other uses – artistic, political, or both.

Benjamin's thinking was at home in the early twentieth century, when many people were predicting that mass media like radio and mass printing techniques would devalue original works of art.[48] Benjamin did not foresee that other factors, such as class emulation and wider access to free public education, would produce even larger audiences for original artworks and thereby increase their cultic value. Benjamin stressed the magic that accrued to single, original objects and ignored those elements of photographic discourse that described the photograph as a special kind of copy. The aura or authenticity of the subject matter in some mass-produced photographs is not necessarily reduced by replication.[49] Photographs of John F. Kennedy or Martin Luther King, for example, have a fetishistic quality close to the cultic value of an individual work of art.

The enduring effect of the marvelous in photographs may borrow the language of magic as an explanation, but, in practice, photography is fundamentally different from magic. Magic achieves its effects through the audience's ignorance of its means. When the audience is let in on the trick, the magic evaporates. In photography, especially in the early nineteenth century, photographic processes were simple and widely available for study; audiences knew, in a general way, how photographs were made. Yet the photographic results, resting on an intricate language of explanation and on the audience's willingness to believe, remained magical.

The association of magic and photography fostered a view of the photographer as a magician or shaman, that is, as one who works outside the bounds of everyday life and morality. These qualities rubbed off on the medium as well. Nineteenth-century literature often alluded to the connection between photography and magic. In his 1846 novella *The Daguerreotype Miniature: or, Life in the Empire City,* Augustine Joseph Hickey Duganne spares no adjectives in portraying how "the mystic art" of photography can thwart villainy and make straight the path of true love.[50] In the anonymously penned short story "My Lost Love" (1862), a Svengali-like daguerreotypist lures a young man away from his wholesome village life. "I knew that I was helpless against the phantom which was leading me forth," the prodigal recalls.[51]

Less melodramatically, the connection between photography and

magic has been rearticulated in the modern era's affection for so-called primitive photography, that is, for the images that were made in photography's first decade. Writing on early French photography, the artist and critic Minor White made extensive use of a cluster of ideas about magic and inspiration. White chose to refer to the photographs as primitive not because he judged them to be technically inferior to later work, but because the photographers worked like inspirational geniuses, that is, they worked "unconsciously": "French primitive photographers, as well as men of other nations, unconsciously worked with and showed the major characteristics of unique photography: scrambled time, communication without syntax, exactly repeatable images, mutual inward mirror of the photographer and the world, the possibility of direct manifestation of the moment of revelation."[52]

In White's description, nineteenth-century photographers "worked with the photograph, innocently or naively ... entranced" by it, though they "knew little or nothing of the medium." White knew of the extensive technical literature on photography that sprang up soon after the medium's disclosure. But he shunned the prosaic and favored a mystical theory for early photographs, one in which the photographer transcended the mundane medium. The photographs made by early photographers were composed intuitively. They were what White called mythic: concomitantly of the moment and beyond time.[53]

Whether Minor White actually believed in the photograph as a site of magic is not at issue. What is important to note is the adaptability of photographic discourse. White updated and expanded the concept of photographic originality through his insistence that a photograph is revealed rather than made. To White, the camera image posed nature against culture. It disestablished and demoted the importance of the ordinary world and ephemeral politics. White rejuvenated the notion of intuitive photography, a concept as old as photography itself, and helped legitimize pure art photography in the post–World War II era.[54]

## Inventing Photography's Inventors

Like many inventions, photography retroactively invented its inventors. The terms of natural genesis were speedily adapted to shape the public identity of the medium's pioneers. The proponents of Daguerre's photography – aided by Daguerre's keen sense of self-promotion – cast the inventor and his invention as originals. By inserting the leitmotif of the exceptional individual into the values of an increasingly commercial society, they succeeded in portraying Daguerre as an untutored, inspired genius. Daguerre was thought to be an original in the sense of his being first – the first person to produce and fix, relatively quickly, a detailed photochemically induced image. He was also considered an original in that his insights had arrived un-

beckoned. No one suggested the more pedestrian hypothesis – that Daguerre was able to invent photography precisely because his lack of education allowed him to try experiments that better-trained scientists scorned.[55]

The invention of Daguerre as the original genius of photography proved to be more a matter of enhancing elements of his biography than of fabricating a public image for him. Daguerre's achievement overshadowed that of Joseph Nicéphore Niépce. The clarity and detail of the daguerreotype were far greater than those of Niépce's photography. And even rudimentary daguerreotypes took much less exposure time than Niépce's photography. In addition, Niépce had died six years before Daguerre's process was made public. Niépce had been a secretive person, and his written records do not support an unimpeachable claim to his having been the first person to fix a photochemically induced image. Also, Niépce's right to be called the inventor of photography was compromised by his son and heir's participation, after Niépce's death, in Daguerre's self-promoting effort to be identified as the principal inventor.

Moreover, in French society at the time, as so richly chronicled by Honoré de Balzac, notions of natural genesis could be articulated in a way that favored Daguerre's claim. French society in the 1830s was like an ice-clogged river in March. Winter and spring were visible in the same view. Winter – the hold of class-based, agrarian interests – remained strong but was beginning to yield to the forces of commerce, industrialization, and bourgeois egalitarianism. Although liberty most often meant that citizens were free to use their wiles to make their fortunes, it also meant that a more meritocratic elite based on intelligence, ability, and, in no small measure, cunning, could rise to power. For example, persons of humble birth could now hold important positions in the government.

Spring favored intellectual consideration of the decency of the common individual mixed with the idea of Romantic individualism. We have come to think of Romanticism as the equivalent of Romantic art theory, which situates the artist in an antiestablishment outpost at the social margins. But a similar psychological profile and social position were requisite for the social hero. Napoleon, who had been dead for nearly a decade by 1830, entered French legend as the epitome of the self-made man – the lonely fulfiller of his own destiny. Daguerre's age was the epoch of the entrepreneur, the virtuoso, the arriviste.

Daguerre's life could be used to characterize him as a natural talent and a class hero. Born in 1789 to a petit-bourgeois family in Cormeilles, Daguerre had little formal education. He worked his way up from an architect's apprentice to be a Paris set designer and scene painter. With his partner, Charles Bouton, he created convincing stage illusions at the Diorama. Whatever talents Daguerre displayed appear to have been inborn, not learned.

Daguerre's presence in Paris undoubtedly kept his case before the

public. He used promotional skills honed on publicizing the Diorama to get and keep ranking scientists interested in his photography. It is likely that he initiated rumors of foreign government interest in the daguerreotype to accelerate the French government's granting him a pension.[56] In the pamphlet required of him upon receiving the pension, Daguerre described the history of and process governing his photography. He also took the opportunity to promote the Diorama and himself as well as the daguerreotype. The first cover for this booklet does not show the daguerreotype but does have an illustration of the Pantheon, the temple to French luminaries such as Voltaire, Rousseau, and Mirabeau. Over the main portal of the building is the legend, clearly visible on the pamphlet's cover, "Aus grands hommes la patrie reconnaisante." The public greeted Daguerre's bids for fame with grudging admiration. What today we see as unembarrassed advantage seeking by Daguerre was not just a quirk of his personality, but a necessary part of getting ahead in Paris of the 1830s.

By contrast, Joseph Nicéphore Niépce was socially disabled by his prerevolutionary connections. Born in 1765 to a family of Royalists, Niépce could recall the ancien régime and its benefits. His family's wealth provided him with a fine education and fostered within him expectations that were out of tune with the times. Furthermore, unlike Daguerre, Niépce treasured the seclusion of rural life.

Niépce had plenty of inventor's drive, but he was an awkward entrepreneur, unwilling and unable to push his inventions with much success. The meekness – or was it aristocratic hauteur? – of Niépce could not compete with the aspiration – or was it opportunism? – of Daguerre.

The various reports on photography made to the Chamber of Deputies, the Chamber of Peers, and the French Academy of Science, as well as the broadsheet that Daguerre prepared in order to sell shares in the invention publicly, distanced Daguerre's achievement from that of Niépce, who was credited with making lesser discoveries around the same time. In his broadsheet, Daguerre does credit Niépce with having discovered one principle that led to photography's invention. But, overall, Niépce's rights are made out to be sentimentally moral – proceeding from his early agreement with Daguerre – rather than genuinely historical.[57] In his discussion before the French Academy of Science, Arago asserted that the daguerreotype was "*entierement neuf.*"[58] Similarly, in his report to the Chamber of Deputies, he described Daguerre's work as that of genius, threatened by the efforts of petty geniuses – presumably epigones who claimed to have invented photography.[59]

Arago does not appear to have wanted to rob Niépce of fame or Niépce's heir of wealth, but he does seem to have realized the practical wisdom of having a single inventor for photography. He was undoubtedly familiar with the continual challenges of prior formulation within the scientific community – Priestley and Lavoisier contesting the discovery of oxygen, for example. The well-respected, very much

alive William Henry Fox Talbot was more of a threat to Arago's plan than the deceased Niépce, however. In his brief to the Chamber of Deputies, Arago carefully undermined Talbot's claim to priority by observing that, "in case of controversy," Daguerre's initial labors could be dated from 1826.[60] Talbot had recently admitted to having begun his experiments in 1834.

Between January and August 1839, while his application for a government stipend was being evaluated, Daguerre's reputation as an original genius subtly coalesced. Despite Arago's report that the daguerreotype was the logical extension of prior experiments with the camera obscura, the bill to pension Daguerre that was considered by the Chamber of Deputies introduced the notion of natural genesis. It cited the daguerreotype as an unexpected invention. Daguerre's diligence was generally admitted; the particulars of the bill to pension him note that he worked long and hard.[61] Still, the bill did not specify the source of his knowledge or the details of his efforts. It was as if such information were not needed.

Neither Daguerre nor his proponents ever amplified their accounts of the stages of the daguerreotype's development, which must have included painstaking trial-and-error work. In Daguerre's broadsheet, he credits Niépce with vast knowledge and intensive research but is vague about his own background and work. The absence of information about the development of the daguerreotype helped envelop the inventor and his invention in mystery.[62] There was, however, no widespread call in the press for more information about the formative period of the daguerreotype. That sort of inquiry seems to have been deemed unnecessary, foreclosed by the accumulating discourse on originality.

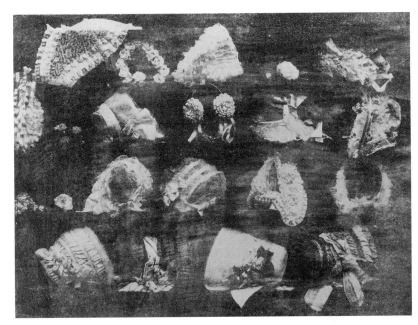

FIGURE 7

William Henry Fox Talbot, *Bonnets in a Milliner's Shop Window,* c. 1846. Anonymous loan in honor of David Becker. Courtesy of The Fogg Art Museum, Harvard University Art Museums, Cambridge, Massachusetts.

On August 18, 1839, the journalist H. Gaucheraud, writing in the *Gazette de France,* referred to the daguerreotype as a prodigy.[63] Daguerre and his invention were as one and were equally inexplicable in ordinary terms. The metonymic substitution of Daguerre for the daguerreotype and vice versa persists into the present era. In 1979, writing on American photography and the frontier tradition John Szarkowski, the influential director of the Photography Department at the Museum of Modern Art in New York, referred to "the medium's own eccentric and original genius."[64]

To fill the gaps in Daguerre's story, tales of fortuitous accidents, unidentified strangers, and miraculous ocular events evolved around Daguerre's work. It is impossible to sort out which of the mysterious narratives of Daguerre's invention, like the preternatural camera obscura vision that Daguerre is said to have experienced, were initiated by Daguerre and which stories evolved independent of him.[65] But it must be noted that supernatural tales did not develop around the contributions of photography's other pioneers, such as Niépce and Talbot.

Five years after the disclosure of photography to the world, Talbot published the introductory installment of his phototext *The Pencil of Nature.* In the book's historical overview, he pronounced photography a "process entirely new."[66] Somewhat more subtly than Daguerre, and certainly with more panache, Talbot encouraged his readers to identify him with the principal quality of the invention, originality. A distinguished classical scholar, Talbot chose to embellish the title page of *The Pencil of Nature* with a quotation from Virgil's *Georgics* (3. 292-3): "Juvat ire jugis qua nulla priorum castaliam molli deritur orbia clivo"[67] [Joyous it is to cross the mountain ridges where there are no

FIGURE 8

William Henry Fox Talbot, *The Haystack,* 1839. Courtesy of Columbia University in the City of New York, from the Collection of the Chandler Chemical Museum.

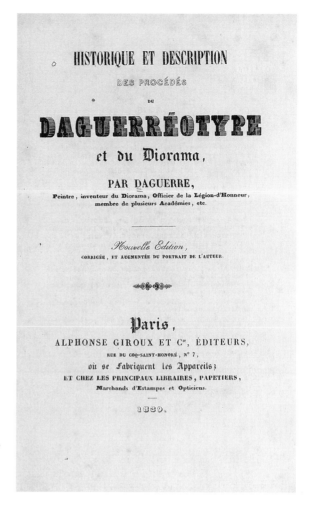

HISTORIQUE ET DESCRIPTION

DES PROCÉDÉS

DU

DAGUERRÉOTYPE

et du Diorama,

PAR DAGUERRE,

Peintre, inventeur du Diorama, Officier de la Légion-d'Honneur,
membre de plusieurs Académies, etc.

Nouvelle Édition,
CORRIGÉE, ET AUGMENTÉE DU PORTRAIT DE L'AUTEUR.

Paris,

ALPHONSE GIROUX ET Cᵉ, ÉDITEURS,
RUE DU COQ-SAINT-HONORÉ, Nᵒ 7,
où se fabriquent les Appareils;
ET CHEZ LES PRINCIPAUX LIBRAIRES, PAPETIERS,
Marchands d'Estampes et Opticiens.

1839.

FIGURE 9

*Title Page of
Daguerre's Manual,
Nouvelle Edition,
1839.* Courtesy of
The Fogg Art Muse-
um, Harvard Univer-
sity Art Museums,
Cambridge, Massa-
chusetts.

wheel ruts of earlier comers, and to follow then the gentle slope of
Castalia]. As Carl Woodring has pointed out, road making was a promi-
nent emblem of Romantic originality.[68]

Whether he knew it or not, Talbot had adopted the tack of photog-
raphy's other inventors, each of whom, though using different strate-
gies, eschewed any debt to his forerunners. Niépce's notes and letters
do not reflect on developments in the arts and in the sciences that
might have aided his work. When Daguerre republished Arago's re-
ports to the French Chamber of Deputies and to the Academy of Sci-
ence in his *Historique,* he underscored Arago's point that there had
been a fundamental discontinuity between Daguerre's experiments
and those conducted by Niépce. Arago's emphasis on the develop-
ment of the camera obscura displaced a bit of the glory from Daguerre
to a historical process yet positioned Daguerre at that point in the de-
velopment of photography at which the idea came to material fruition.

During the decade following public disclosure of photography, the
uniqueness of the medium – and of its inventors – became a favorite
theme, which was reinflected in all manner of settings. Writing to Da-

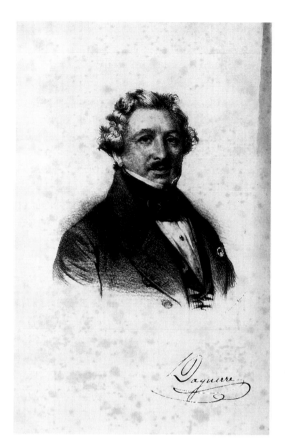

FIGURE 10

*Portrait of Daguerre
from Daguerre's
Manual, Nouvelle
Edition,* 1839. Cour-
tesy of The Fogg Art
Museum, Harvard
University Art Mu-
seums, Cambridge,
Massachusetts.

guerre in May 1839 to inform him of his election as an Honorary Mem-
ber of the American National Academy of Design, Samuel F. B. Morse
assured the Frenchman that he, not Talbot, would be known through-
out America as the sole inventor of photography.[69]

## THE MACHINE
## FOR MAKING PICTURES

One might think that the proclivity of Niépce, Daguerre, and Talbot to
explain photography as the eruption of a natural phenomenon into
the predictability of everyday life would have thwarted efforts to con-
figure photography's history in conventional, linear, technological
terms. Further, there was no evidence of the existence, before the end
of the eighteenth century, of a specific apparatus that, however
humbly, recorded and preserved nature's image through photochem-
ical means. Nevertheless, linear technological histories of photogra-
phy survived despite photography's pioneers' touting of either the
medium's magic or its natural origins. When politically expedient, the

technological argument could coexist with notions of natural genesis. For instance, some of the first writings on photography identified the camera obscura as the immediate, direct predecessor of the photographic camera.

Literally the "darkroom," the camera obscura had been used since the Renaissance in the West and since the Han dynasty in the East. In the darkroom, an observer viewed an image of nature projected on a far wall through a tiny hole sometimes equipped with a lens. The observer studied the view or manually recorded the image by tracing the outlines of its projected shapes. The recording had to be done manually. No chemicals were used. Nothing was automatic.

Artists, particularly seventeenth-century Dutch artists, used the camera obscura, but its projected images were unsatisfactory in some ways. The camera obscura's lens tended to bow straight lines. Its projected colors and tonal changes were extremely condensed, making the subtle declensions of shade and shadow difficult to observe and to copy. The camera obscura's tendency to remove surface glare appealed to seventeenth-century Dutch painters, but it did not accord with the nascent optical realism favored by many European painters in the late eighteenth and early nineteenth centuries. Also, in the hands of amateurs, camera obscura tracings tended to be stiff and mechanical. A camera obscura drawing had neither the technical pizzazz of a close rendering nor the fluid line of an artist's spontaneous reaction to light and movement in nature. However helpful they might be to artists and observers, the camera obscura's images were "traditionally stigmatised as mechanical and inartistic."[70]

And the camera obscura lacked imagination. It could not be used to create a religious, historical, or mythological scene or to make a

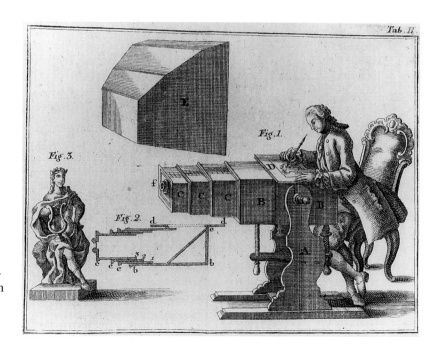

portrait. It could not be employed in dim light. It was primarily employed as an aid to the artist in taking views from nature that were, until the seventeenth century, backdrops to the action of a painting, not the main subject matter.

Over time, the camera obscura became the *camera portabilis,* a smaller device that was more convenient for outings. The camera obscura's greatest vogue came in the middle years of the eighteenth century. In Western art, the camera obscura was no more than an auxiliary tool for the artist and the amateur draughtsman. It was by no means universal. It changed size, but it did not greatly improve in function or fidelity from the Renaissance to the invention of photography. No camera obscura could record anything, either automatically or chemically. With the pantograph, the camera lucida, the *velo,* the *vetro,* and a host of drawing machines, the camera obscura was intended to assist manual recording.[71] Unlike print media, it could not produce multiple images.

Photography's inventors modified the camera obscura to house the photochemical process known as photography. However dissimilar the camera obscura's original function, or however far removed it was from the natural genesis explanations given by most of photography's pioneers, this new instrumental use cast the camera obscura as the technological precedent of the photographic camera. Eventually, the camera obscura connected photography to past experiments in optics, mechanical drawing, and photochemistry in ways that other devices did not. At crucial points in their work, photographic pioneers such as Niépce and Talbot used the solar microscope, a small lensed device that projected the image of small objects. But neither the solar microscope nor lenses in general directly involved the manual tracing of an image or could easily become a metaphor for the replacement of human labor by machines.

The initial positioning of the camera obscura in photography's lineage was more a matter of politics than of technology.[72] Although he utilized the discourse of natural genesis, Arago also argued that the camera obscura was the direct precursor of photography. Possibly he wished to insure that the invention of photography would be seen as a French accomplishment. In the bill to reward Daguerre, Arago explained photography as "the process to fix objects reflected in a camera obscura." His explanation significantly altered Daguerre's conception as Daguerre had expressed it in his earlier broadsheet. Daguerre wrote of "images of nature received in the camera obscura" and of procedures involving "the aid of an ordinary camera obscura."[73] The language of the bill, unlike the language of the inventor, simplified photography by taking the instrumental use of the camera obscura and synoptically suggesting that capturing images with the camera obscura was an end in itself.[74]

In his July 3, 1839, report to the Chamber of Deputies, Arago proposed to examine whether Daguerre's process could rightly be called an invention.[75] His emphasis and choice of words responded to the

legal stipulations and the presumptions about the development of devices that surrounded the awarding of government stipends to inventors. Concurrently, he developed a counterweight to the notion of photography as a revelation or discovery of a natural process. Arago's proof began abruptly, with a history of the invention of the camera obscura. If he in fact knew that many early treatises describing the use of the camera obscura throve "in the context of natural magic, [and] as a means of exploiting natural phenomena to astonish and entertain the spectator, rather than as a direct crib for painters," Arago did not mention it.[76] He elaborated on the idea that those who used the instrument "greatly regretted" that camera obscura images could "not be preserved *of their own accord.*" Out of this disappointment he concocted what he called a dream: "the dream" of fixing the camera obscura image. To substantiate the dream, Arago cited prephotographic sources for it – not in science, but, as has been noted, in fantasy fiction. The dream, Arago argued, can be followed "from its very germ" through its fulfillment in alchemy and chemistry.[77] It was an orderly, "cooperative" dream that did not recognize that the primary historical function of the camera obscura was not to produce final pictures.[78]

The aim of Arago's argument becomes clearer when his history of the dream is used to explain the early image-making trials by the English scientist Thomas Wedgwood. Arago ambiguously attributed to Wedgwood "the first elements of the new art." But having installed the camera obscura as the parent of photography, Arago underscored that Wedgwood had not been able to fix the images of the camera obscura but had achieved his best results using the solar microscope. Furthermore, Wedgwood had been unable to fix those images either. In elevating the importance of the camera obscura, Arago displaced Wedgwood's work from the paradigm of the linear, progressive discovery of photography that he had earlier laid out. The removal of Wedgwood made photography's prehistory less complicated for Arago's purposes. It gave preference to France, and to French citizens (Niépce and, eventually, Daguerre) for the invention of photography.[79]

Arago's argument, weak in itself, was strengthened by a climate of opinion holding that the inevitable outcome of the Industrial Revolution was the production of machines that could reduce or eliminate human labor. Everyday, mechanical devices were improved or speeded up by the application of new energy sources. From this perspective, it was possible to see photography not only as another product of the Industrial Revolution, but also as itself subject to the rush of change. Reacting to the initial disclosures of photography, *The Literary Gazette* for Saturday, February 2, 1839, betrays an appreciation of endless transition: "No human hand has hitherto traced such lines as these drawings displayed; and what man may hereafter do, now that Dame Nature has become his drawing mistress, it is impossible to predict."[80] Edgar Allen Poe, writing on the daguerreotype in 1840, remarked that "it is a theorem almost demonstrated, that the conse-

quences of any new scientific invention will, at the present day exceed, by very much, the wildest expectations of the most imaginative."[81]

On this view, the camera obscura was a machine. Like other machines, it improved upon human labor and was itself liable to additional technological improvement. As the critic Jonathan Crary has concluded, before photography, "the camera obscura, with its monocular aperture, became . . . a more perfect incarnation of a single point than the awkward binocular body of the human subject . . . [and], in a sense, was a metaphor for the most rational possibilities of a perceiver within the increasingly dynamic disorder of the world."[82] The camera obscura was the logical integer on the way to the photographic camera. It was the prototype of a machine that could combine optics and photochemistry to do the work of the hand and eye.

From the first accounts in 1839 of photography and its formation to those written in the modern period, one can read that "men . . . strove . . . to capture the images in the camera obscura."[83] Yet thoughtful reading of the works of Niépce, Daguerre, and Talbot reveals that none of these men had this outcome precisely in mind when he began his work.[84] Niépce may have modified the camera obscura's design, but his immediate goal was to find a means to retain, or fix, the camera obscura's image chemically and thereby pursue his ultimate aim, which was to create cheap multiple images. Daguerre's immediate goal was likely to refine the quality of Diorama illusions. And though Talbot publicly recollected an early attempt to capture the camera obscura's "fairy pictures," hoping that they would "imprint themselves durably and remain fixed upon the paper," he began his endeavor in what we now call photography with chemistry experiments.[85] Like other pioneers in photography, Talbot employed the camera obscura, but his primary emphasis, and theirs, was on the photochemistry of photography. The closest one comes to detecting the singular intention to improve the camera obscura is in a letter that Talbot wrote to John Herschel, dated January 25, 1839. In the letter, Talbot reemphasized the automatism of photographic reproduction, that is, the effortless way in which the photographic image seemed to appear. But he also described his work as "a new Art of Design which I discovered about five years ago, *viz.* the possibility of fixing upon paper the image formed by a Camera Obscura; or rather, I should say, causing it to fix itself."[86]

Photography's inventors occasionally wrote about fixing the camera obscura image as verbal shorthand for a larger enterprise.[87] But they did not fully equate their efforts with such a project in the way that Arago did. Untroubled by his concurrent appeal to natural genesis, Arago invoked a parallel scheme for the technological development of photography. In it, the process of invention is regular and progressive – each experiment succeeding in an orderly way from the achievements of the past. None of photography's pioneers, however, reported making headway in that manner.

Whereas Arago's immediate aim in regularizing the progression of photographic machines might have been to ensure that photography would be acclaimed a French invention, his composition of photographic prehistory as a technological history had a wider-ranging effect by situating the germ of the invention in human history, rather than in nature. In various forms and circumstances, technological genesis emerged as the major alternative explanation for the invention of photography. As this argument matured, it became increasingly antagonistic to notions of natural genesis, spontaneity, and inspiration as the sources of photography.

## THOMAS WEDGWOOD AND THE PREHISTORY OF PHOTOGRAPHY: DEFINING THE MISSING LINK

Formulating the prehistory of photography as a steady, linear development presented complications. The camera obscura provided a shaky foundation on which to build a technological history. Importantly, Thomas Wedgwood's experiments with photochemistry, which he reported in 1802, did not fit the pattern of progressive empirical achievement.

Thomas Wedgwood grew up in the late eighteenth century in regular contact with "a kind of scientific general staff for the Industrial Revolution."[88] His father, Josiah, was typical of his age in his belief, in the years immediately before the French Revolution, in the perfectibility of human society. Like many early industrialists, Josiah Wedgwood saw himself as living in a renaissance. Although not formally a member, the elder Wedgwood participated in the meetings of the Lunar Society, a distinguished group of scholars, scientists, and inventors that included Dr. Erasmus Darwin, James Watt, and Joseph Priestley. Through its correspondence, the society kept abreast of scientific discoveries in Europe and America and, most importantly, sought practical applications for new scientific findings. Thomas shared his father's scientific interests and also attended meetings of the society.

Thomas Wedgwood's particular interest was chemistry, what young people of his day called "new chemistry," or "French chemistry" – the chemistry of Lavoisier – which required empirical demonstration through seemingly endless experiments. The drudgery of the laboratory was relieved by the knowledge that one was working in the forefront of chemical science. Every element in the wide world was a potential subject for investigation. The new chemists believed that they were making the world afresh through analysis, and they charged themselves not only to observe and record what happened in their experiments but to posit why it happened. Every generation of scien-

tists has its vogue science, whose vanguard asks questions that go beyond the simple materialist one of which commercial product is most immediately needed in the marketplace. In 1820 the vanguard science would be geology, whose findings stretched the world's age and led to evolutionary theory. But when Thomas Wedgwood was doing his work, at the end of the eighteenth century, the vogue science was chemistry.

Wedgwood talked with the young scientist Humphry Davy, then an apothecary's apprentice, about his work with photochemical responses. Davy was a polymath of a sort more common before the age of scientific specialization. Davy, who wrote poetry, conducted chemical experiments, and even took fishing seriously, must have seemed to the perpetually ailing Wedgwood to have boundless energy. Much of what we know of Wedgwood's work in photography we know through Davy. For example, Wedgwood made several attempts to fix the image produced when an object's shadow is cast on photosensitive paper or leather. Davy's measured report on these experiments is fresh and modern: "Nothing but a method of preventing the unshaded part of the delineation from being coloured by exposure to the day is wanting, to render the process as useful as it is elegant."[89]

Even those who are convinced that the invention of photography proceeded linearly have found the work of Thomas Wedgwood a problem. For instance, several historians have wondered why Davy did not read the work of the Swiss chemist Carl Wilhelm Scheele more carefully.[90] Scheele's work, available in English and known to Davy, who cited Scheele in a footnote to his article on Wedgwood, recorded that ammonia dissolved chloride of silver. Chloride of silver, still actively sensitive to light in the unexposed areas of the Wedgwood–Davy image, thus could have been washed out by ammonia, thereby making the print more permanent.

Scholarly frustration with Wedgwood and Davy is summed up by the photographic historians Helmut and Alison Gernsheim: "One cannot absolve so eminent a chemist as Davy from blame for his failure to find a fixing agent."[91] From this point of view, Davy's enterprise should have rested on all the chemistry that had preceded it. Of course, Davy was notoriously given to grand schemes and imagined experiments. Still, it seems imprudent to chastise him for willfully absenting himself from the uninterrupted pattern of technological development.

In fact, there was something "wrong" – or different – in Davy's procedures. Davy was a new chemist in the manner of Lavoisier. The new chemistry, which was less scholastic than the old chemistry, stressed laboratory observation and replicability over deductive reasoning. Scheele practiced the old chemistry and, in particular, supported the theory of phlogiston (phlogiston was thought to be a material lost in burning). Some historians generously assume that "phlogiston" was just another word for "oxygen." But phlogiston was actually an exponent for a large body of theory that was specifically refuted by the new

chemistry. Lavoisier, relying on Priestley's newly discovered gas, oxygen, formulated a theory of combustion that effectively ignited the phlogiston notion. By 1800 the theoretical model for physical behavior based on phlogiston had evaporated, and it is not difficult to understand why Davy did not consider a close reading of Scheele. For Davy, Scheele's work must have appeared vastly out-of-date.

The inability of Wedgwood and Davy to fix their images has reverberated through photographic history. These early experiments were phylogenetically barren. They did not produce successors. The Wedgwood–Davy experiments implicitly called into question the advent of photography as a result of cumulative technological achievement.

William Henry Fox Talbot felt it necessary to explicitly deny that his experiments relied on the work of Wedgwood and Davy. In his booklet "Some Account of the Art of Photogenic Drawing" (1839), Talbot made it clear that he had begun his experiments with photochemically induced images in 1834 and that he had managed to fix the image *before* searching the literature to see if others had made similar attempts. With engaging self-mockery, Talbot announced that had he located the journal article by "so distinguished an experimenter as Sir Humphry Davy" before he had succeeded in fixing a shadow, he might not have persevered in his endeavor.[92] Taken at his word, Talbot did not build on the work of prior experimenters; he worked out the problems of stabilizing the image on his own. In effect, Talbot refused to place his invention on the line of development of a larger field. As Wedgwood and Davy had ignored Scheele, so he would ignore the two Englishmen. Still, his refusal recognized that he had to situate his work in some relation to the standard paradigm of development.

The technological approach and its problems haunt the writing of photographic history.[93] It is simple enough to show that inventions do not necessarily beget inventions and that many inventions and theories do not yield progressive and practical results. Still, in writing scientific history, it is difficult to avoid inadvertently creating a narrative that makes the story conform to implicit notions of linear history.[94]

Many writers of photographic histories in the nineteenth and twentieth centuries built them around formulaic linear narratives that implied a regularity and order in the unfolding of history. For example, an 1843 article on photography published in the *Edinburgh Review* gave a longish synopsis of the work of Wedgwood and then admitted that Talbot was not directly influenced by this work. The article strained to impose an order that its own sense of the facts could not support.[95]

By the 1860s, symptoms of such strain had vanished from accounts of photography. Both the camera obscura and Wedgwood's work had by then been assigned the places in the story of photography's invention that they continue to occupy today. In *La photographie considérée comme art et comme industrie* (1862), Mayer and Pierson interpreted the development of the camera obscura and the experiments of Wedgwood and Davy as installments in the dream

(borrowed from Arago?) to create photography, a dream that they trace back to the alchemists of the Middle Ages.[96] On this view, invention is continuous, driven by desire for material fruition. Mayer and Pierson left vague the causal connections between instantiations of the dream, and they substituted a stack of chronological events made to seem serially generative.

In the latter half of the nineteenth century, the story of photography's technical prehistory was well established. Writers needed to do little but arrange its touchstones in a chronological sequence. They did not have to spell out causal connections. Louis Figuier, in his *La photographie* (1869), and Marcus A. Root, in *The Camera and the Pencil* (1864), include the camera obscura and the experiments of Wedgwood and Davy but do not relate them developmentally.[97] In her version of the story, published in 1857, Lady Elizabeth Eastlake creatively misreads Davy's article on the Wedgwood experiments. She inserts the camera obscura into their experiments, even though Wedgwood had clearly found that the camera obscura images were too faint to be useful and had moved on to using the solar microscope and producing shadowgraphs.[98] Eastlake's account bears witness to the strength of the technological paradigm to which it tacitly appeals.

Though technological genesis eventually became ascendant, it did not mute the case for natural genesis and all that photography's association with nature implied. Photography continued to be seen as Nature recording nature, as sun painting, and as a profound rupture with the image making and record keeping of the past. Natural genesis and technological genesis, seemingly incompatible ideas, are found mingled in the many nineteenth-century treatises on photography, and they survive as well in twentieth-century thought on the origins of photography.

Through repetition, and with time, technical genesis and natural genesis interpenetrated and became synchronous. The illogic or mutual antagonism of these explanations for the discovery of photography sank below the surface of perception and analysis. As a result, the ductility of photographic discourse increased. Just as the language of genius has never resolved the contrary notions of madness and superior intelligence, but has used elements of each to interpret specific historical circumstances, the language of photography naturalized incongruous ideas.

Many of the concepts that describe photography cluster around natural genesis and technological genesis. Nature/culture, nature/human, nature/technology, nature/science, truth/deception, present/past, present/absent, time/timelessness all relate to the origins of photography. Like natural genesis and technological genesis, these ideas can be studied as either pairs or opposites. But when invested in the language and practice of photography, they do not necessarily function in either reciprocal or antagonistic pairs. Often these ideas overlap. For example, both natural genesis and technical genesis promote the objectivity of photography. Both anchor objectivity in au-

tomatism, even to the point of making objectivity contingent on automatism. Importantly, there were no systematic analyses in the nineteenth century of the inconsistencies and contradictions presented by technological genesis and natural genesis.

In its first decades, photography became an omnibus idea. Like modernism, to which it is related, the idea of photography carried within it a large, loose collection of allusions and values. Moreover, because the notions of natural genesis and technological genesis did not exist in a vacuum, but were incarnated in the messiness and opportunism of particular historical circumstances, contrary ideas about photography commingled, were reinflected, realigned, collapsed, or augmented with relative impunity.

## The Politics of Knowledge: The Disclosure of Photography

Photography's material record is slim at the point that it excites much interest, the years of its development. This is often the case with beginnings. In photographic studies, the absence of information has given exaggerated importance to the year of photography's disclosure. That year – 1839 – the year in which the French government pensioned Daguerre and gave photography to the world, has become an intellectual barrier, a line of demarcation. What happened before 1839 is prehistory; what happened after is early history. The day the daguerreotype process was made public has become a kind of birthday.[99]

The fixity of 1839 helps to sustain the model of technological genesis. It urges a historiographic model of incremental development: *a* before *b, b* before *c;* or, Joseph Nicéphore Niépce before Louis Jacques Mandé Daguerre, before William Henry Fox Talbot.

Yet no historian has been able to configure a convincing prehistory of photography in which each careful and deliberate concept or experiment led to another, which, in turn, yielded a plateau of shared understanding upon which the next generation of researchers could again build. The concept of "development-by-accumulation,"[100] as it has been called, blunts understanding of the politics of choice (and the choice of politics) that promoted Daguerre as the premier inventor of photography. Its simple rendering of causality has been as effective as the notion of magic in excluding the social production of photography.

Certainly Niépce was no straight-line inventor. By the time he formed a partnership with Daguerre, Niépce had created at least two kinds of photography.[101] The history of these developments is sketchy and, because of Niépce's caution in his correspondence, like-

FIGURE 12

Unknown Photogra-
pher, *Daguerreotype
of a Painting of
Seibred Dodge,* n.d.
Courtesy of the
J. Roy Dodge Collec-
tion, Syracuse,
New York.

ly to remain so. Ironically, Niépce abandoned his first photographic
process, which employed the photosensitivity of silver, the basis of
the modern technique, and turned to a second process that was much
closer to engraving and etching. For a number of reasons, Niépce
agreed to divulge the particulars of this second photographic process
to Daguerre.

We have only unsubstantiated anecdotes to support the claim that
Daguerre had developed his own sort of photography by 1829, the
year of the agreement in which Niépce revealed his methods to Da-
guerre. Daguerre's success with photography may have taken at least
five years from the agreement date, which argues strongly against the
inspirational and accidental model of invention that eventually sur-
rounded Daguerre's photographic discovery. The first daguerreotype
cannot be firmly dated before 1837.

Unlike Niépce's photography, the daguerreotype was based on a la-
tent image. The successful deployment of photography in society is
so dependent on the latent image that it has been argued that its dis-
covery, rather than the daguerreotype itself, should mark the birth-
day of photography.[102] In Daguerre's process, a photographic plate
sensitized with a surface layer of silver iodide was exposed in a cam-
era obscura. The image, which was not visible at the time of the ex-
posure, was developed out by using mercury fumes. Daguerre's tech-
nique was fast, and it produced a highly detailed image. As noted
earlier, Daguerre attempted to sell stock options in his new photog-
raphy to the general public. When that venture failed, he turned to the

French government for support. Government efforts on his behalf, though late in coming, ensured that Daguerre would be singled out as the sole inventor of photography.

Government support of science and invention is a feature of nineteenth-century French intellectual life that differs greatly from English and American practice in the same period. Where an English citizen or an American would likely have to pursue private capital to fund a scientific venture, a French citizen could approach the government. The system in France was as old as the French Academy of Science, incorporated in 1666. Although the academy had been disbanded briefly during the Revolution, its postrevolutionary form reflected the centralized and hierarchical character of the ancien régime. To obtain a government grant, an inventor would solicit the sponsorship of an academician, who would then instigate a committee of academicians to judge the worthiness of the invention and, if it so merited, recommend the invention to an appropriate department of government. Although postrevolutionary practice and politics had changed the system somewhat, the academy generally followed the procedure begun with its incorporation.[103] As Helmut Gernsheim and Anne McCauley have pointed out, pensions such as that ultimately awarded Daguerre were commonly given to government and military officials upon their retirements, not to inventors.[104] Nevertheless, government support of scientific projects was unexceptional.

The French Revolution and its aftermath helped dispel some of the preciosity of science. Scientists were still mostly well-to-do individuals, but science had new priorities. Under Napoleon, science became the buttress of national greatness, the prime evidence of French intellectual superiority. Science, not literature, became the fulcrum of a new public education effort, a tribute to Condorcet, the French philosopher and mathematician, who ranked scientific studies above belles lettres. With the growth of industrialization in France, practical applications of scientific theory were prized and rewarded in a system that gave preference to commerce and industry.

Daguerre took advantage of government policy when his efforts to sell stock came to naught. He won the attention of François Arago, academician, secretary of the French Academy of Science, director of the Paris Observatory, and, since 1830, decidedly liberal deputy in the French lower house. Arago aligned himself with the forces who saw in the early tenure of Louis-Philippe possibilities for social progress through government intervention. Arago advocated public education. He encouraged new inventions, carrying forward the revolutionary belief that technical achievement would increase national well-being. During his government service, Arago sponsored bills for the development of railroads and the telegraph, and he urged the government to support a museum at Cluny, the monastery complex nearly destroyed during the Revolution.

Arago worked on the scientific forefront. His studies included research on the properties of light. In 1838, the year in which Daguerre

contacted him, Arago sponsored government support for a device to measure light. Thus Arago's initial interest in Daguerre's invention might have been prompted by photography's photometric potential, not by its image reproduction per se. In any event, Daguerre showed Arago the daguerreotype process, and Arago even made some photographs himself. Arago immediately began a campaign to pension both Daguerre and Niépce's heir, Isidore, and to give photography to the world as a gift from the French nation. Yet in his initial public statement to the French Academy of Science, Arago so minimized the contributions of Niépce (called by Arago a collaborator in only one sentence of the presentation) that the newspapers did not pick up Niépce's name in their reports.

Arago's motives for emphasizing a single inventor of photography were practical and nationalistic.[105] Fortunately for the memory of Niépce, an English acquaintance, learning of the newspapers' omission, reintroduced Niépce's contribution to the public.[106] Unfortunately for Arago, the specter of multiple claimants to the origination of photography then arose.

Arago put pressure on the minister of the interior to approve Daguerre's pension by recommending expeditious action. He made his plea as an academician, but reminded the minister that he was also a deputy and could also speak on behalf of Daguerre from the floor of the Chamber of Deputies. Still, during 1839, nearly a dozen individuals came forward to assert their own simultaneous or prior invention of photography.[107] One such individual, Hippolyte Bayard, a minor official in the Ministry of Finance, claimed to have been experimenting with a direct positive process since 1837. Arago effectively nullified his claim. Abroad, William Henry Fox Talbot announced that he was the first inventor. For Talbot the issue was not (or at least not immediately) one of financial advantage, but was one of recognition in the scientific community.

Arago could persuade the authorities to reject the claims of Bayard, a timid clerk, but he had little recourse against the statements of Talbot. The effort to pension Daguerre had been dragging on since January, like a long election campaign that was losing its luster. At the same time, public interest in the new process of image making grew, increasing the risk that another inventor might appear, muddying Daguerre's clear claim and nullifying the invention as a purely French achievement. Sensing this possibility, perhaps, Arago cleverly manipulated the politics of photography's disclosure by appealing to French Anglophobia.

In Arago's report to the Chamber of Deputies (July 3, 1839), one reads the reflections of a prescient scientist – and an accomplished Machiavellian. A report to the Chamber of Peers (July 30, 1839) was prepared by Arago's old friend and scientific colleague, Joseph Louis Gay-Lussac. Arago and Gay-Lussac articulated the potential importance of photography to photometry and, especially, of photography's applications to astronomy. They assured their audiences that

FIGURE 13

Hippolyte Bayard,
*Self-portrait with
Plaster Casts,* 1850.
National Gallery of
Canada, Ottawa,
Canada.

photography would assist the natural sciences in the organization
and transmission of knowledge and in the making of various sorts of
scientific calculations. Topography, meteorology, physiology, and
even medicine would be aided by the new invention.

Arago and Gay-Lussac went beyond offering simple scientific argu-
ments for the stipending of Daguerre. They sought to secure the in-
vention of photography as a French achievement. Chagrined national
pride and international politics spurred their efforts. Years after the
French occupation of Egypt (c. 1798–1801), the French recollection of
that brief, militarily unsuccessful, experience became as rhapsodic as
did the memory of Napoleon. Scientists regarded the Egyptian cam-
paign as a model of government collaboration with science in the
name of progress. More than one hundred and fifty scientists and
scholars had worked in Egypt. The subsequent decades were filled
with publication of their work, which, in turn, served as a sort of in-
tellectual and cultural victory over the English.

The monumental *Description de l'Egypte* (1809–1828) provided the
backdrop for the sensational decoding of the Rosetta Stone, which led
to the modern understanding of hieroglyphics. The stone, which had

been found by a Frenchman, passed into English hands with the defeat of France in Egypt. An Englishman gave the stone an initial, spare, and faulty interpretation. Although controversial, Jean François Champollion's extensive translation of the stone was a source of French national pride and a vindication of the French occupation. In enlisting the French adventure in Egypt as an argument for the acceptance of the daguerreotype, Arago was issuing a covert warning about another threatening English scientific coup – Talbot's photography – which the French had to make haste to forestall.

Additional nationalism, and Anglophobia, warmed Arago's subsequent arguments. Following the Revolution, medieval architecture in France had become a source and symbol of national pride. The French created their own Gothic Revival style, extending it to embrace all the architecture of the Middle Ages. The Revolution's suppression of religious orders hastened the decay of churches and abbeys throughout France. Early in the century, learned societies attempted to raise money for restoration of these structures, but not until the late 1820s did public sympathy and government funding support their pleas. Not until well into the reign of Louis-Philippe could a new generation demand and receive significant subvention for the restoration and maintenance of the architecture of the Middle Ages.

In 1837 France's Historic Monuments Commission was created, made up primarily of archeologists. The commission's task was to assess the state of medieval architecture in France and to focus restoration funds. This vast project, rivaling English and German efforts to preserve their pasts, called for a seemingly objective method for documenting the state of the monuments. This "great national enterprise,"[108] Arago insisted, must have available to it the new medium of photography. To deprive France of the benefits of the invention would be a loss of great magnitude, as great, Arago argued, as the alleged loss of visual records in Egypt. Photography, then, was no ordinary invention destined to serve only immediate commercial interests. On the contrary, photography would serve high ideals, such as love of country and duty to history. Arago's speech to the Chamber of Deputies has the urgency and rationale of an American politician's address to Congress in the months following the successful launching of Sputnik.

Gay-Lussac, too, invoked Anglophobia. In his pronouncement "that the éclat of one nation, with respect to others, never shines more than by the improvement it makes in civilisation,"[109] the English are the "others." Arago took a similar course, warning that if the Chamber of Deputies did not vote to pension Daguerre, if it "misjudg[ed] the importance of the daguerreotype and the place which it will occupy in the world's estimation, every doubt would have vanished at the sight of the eagerness with which foreign nations pointed to an erroneous date, to a doubtful fact, and sought the most flimsy pretext in order to raise questions of priority and try to take credit for the brilliant ornament which photography will always be in the crown of discover-

FIGURE 14

Unknown Photogra-
pher, *Medical Man
with Skeleton,*
daguerreotype,
heightened with
color, 1855. National
Gallery of Canada,
Ottawa, Canada.

ies."[110] The erroneous date? 1835. The doubtful fact? The invention of
the first photography by William Henry Fox Talbot. The foreign na-
tion? England.

## THE *LONGUE DURÉE*

Especially because their components could be intermixed, models of
natural genesis and technological genesis sufficed to explain the ad-
vent of photography. But in the latter nineteenth century, as the par-
adigm of evolution gained increasing acceptance and application, evo-
lution was enlisted to explain the emergence of "a new art in the
middle of an old civilization."[111] It seemed appropriate to have the his-
tory of the pencil of nature written by another stylus of nature, evo-
lution. Evolutionary investigations of photography's invention were
conducted on a wide scale, ignoring the efforts of individual inven-
tors. Because photography had been articulated as a qualitative leap
beyond hand-generated images, the search for photographic an-
tecedents generally did not probe far into the realm of visual com-
munication. A typical exordium for a discussion of photography's evo-
lution was light.

The photographer John Werge titled his 1890 book *The Evolution of*

*Photography.* Werge's opening remarks recalled the "dark ages," when humankind became acquainted with photochemical reactions.[112] Josef Maria Eder, a photographic historian, opened his sweeping history of the medium, published in 1900, with accounts of Plato's and Aristotle's understanding of light. A year later, in *Flame, Electricity and the Camera* (1901), George Iles tracked the origin of centuries of visual representation to cave painting. Iles believed that "there was no essential advance in imitative art down to the first decade of the nineteenth century," when the "careless or unfaithful" eye and hand were surpassed by photography. Photography let light "limn its own impressions." The medium was no quiet incremental advance in visual representation, but a quantum jump in the condition of knowledge. The medium freed the erring eye and bungling hand from their inherent limitations.[113] By 1930, photohistorians such as Erich Stenger were writing in requisite generalities about ancient observations of the bleaching effects of sunlight as if photography were a primordial possibility.[114]

By installing light as photography's principal predecessor, these tracts on the prehistory of photography effectively divorced visual communication from print communication. In Iles's book, for instance, the invention of printing is traced back ultimately to speech and functionally to the origins of symbolic representation in the alphabet. Iles pursues the question of the camera's antecedents – or lack of them – separately.[115]

Many progressive Victorians also sanctioned broad historical explanations for inventions, explanations that subsumed individual actions in a general, long-term, progressive unfolding. The creative individual or inventor was simply the right person in the right place – in the nineteenth-century phrase, "the proximate initiator of change." For example, in this perspective, James Watt was merely the incipient inventor of the steam engine, which was actualized by knowledge accumulated through centuries of observation. Watt was able to envision the steam engine because the requisite physical materials, technology, economic need, and social capacity for use converged in the late eighteenth century. In short, the time was ripe.

In the nineteenth century, the *longue durée,* or long time period, integral to this explanation for causality was favored by such diverse intellectuals as Henry Thomas Buckle, Herbert Spencer, and, of course, Karl Marx. Varieties of this view, frequently religious in origin, informed everyday opinion. According to the anonymous author of an article in an 1854 issue of the *North American Review,* "All is life and growth in the universe, – forces seeking form." Evolutionism further substantiated the role of the predictive dream. It became more common to believe that "by some inscrutable means all needed books, pictures, and inventions find authors for themselves."[116]

In the twentieth century, evolutionism, which was increasingly deployed to portray the advent of photography, incorporated meanings from other elements of photographic discourse. For example, in his

sweeping 1934 tract *Technics and Civilization,* Lewis Mumford propounded a notion of cultural readiness to explain invention. On the one hand, he cautioned readers against narrowing their sights to technological development, which marginalized the importance of "ideological and social preparation."[117] On the other hand, Mumford valued the way in which machines, implicitly including the camera, enhanced the accuracy of human perception – even if that improvement taxed "experience as a whole."[118] Though he may have been poised to discuss the elements of cultural readiness that led to photography, Mumford succumbed to the metaphor of the camera as a machine whose inherent aim was factual verification and veristic reproduction.[119] Mumford thought the camera was a better eye, recalling the centrality of neutral vision to photographic originality.[120]

The task of analyzing photography's readiness to be born was taken up again in 1964 by the art historian Heinrich Schwarz. Schwarz set the stage by describing the development of Western art from the fourteenth century to the late nineteenth century as a vast interplay of science and art. He concentrated on the prehistory of photography, what he called "the days before photography was invented yet already present."[121] Like Mumford, Schwarz embraced a comprehensive theory of cultural attainment that deemphasized the accomplishments of particular individuals.

The "inner preparedness" of photography consisted of the cumulative thought, art, and science of the time.[122] This inner preparedness grew from the increased acceptance by artists and their audiences that art consisted of faithfully rendering objects in nature. Artistic interest was transferred from the established codes of realism to science and to devices, like the camera obscura, deemed capable of aiding an objective account of optical reality.[123]

Schwarz's thesis accounted for the sudden arrival of photography. The "full-fledged technique" emerged "after long and almost continuous development."[124] That development was public, if scattered. It was progressive, if not specifically technological. The gradual cumulative ascendancy of casually composed, illusionist painting, paired with improvements in the various machines for aiding close rendering, catalyzed the invention of photography.

The issue of photography's broader causality has persisted. It was the theme of a controversial exhibition at New York's Museum of Modern Art in 1981. The show's curator, Peter Galassi, theorized that the scientific and technological bases for photography had awaited not only the formation of a middle class, vested with both the interest and the expendable income to buy plural images, but also the accumulation of a critical mass of illusionist paintings. Galassi believed that "an embryonic spirit of realism," itself the product of the increasingly material culture of industrialism, had instigated the need for photography as incontrovertibly as had the social upheavals and scientific achievements of the late eighteenth and early nineteenth centuries.[125]

Like Schwarz, Galassi attempted to relate the invention of photography to the history of painting. Still, their undertakings were significantly different in breadth. Schwarz's thesis proposed an active reciprocity of science and art since the Renaissance, which produced "inner preparedness." Galassi attended to a highly selective (and little known) assemblage of paintings, which he grouped as an avant-garde. To Galassi, the optical illusionism of these paintings fomented the invention of photography. He took formal resemblances between some paintings done prior to the disclosure of photography and some actual early photographs to be evidence of an evocation or potentiation of photography before photography.[126] Although Galassi referenced the dynamics of evolutionism, with its disregard for individual action, he fixed on a brief moment of time and overlooked the model's appeal to broad, transformational forces.

An effort more analogous to the Victorian understanding of the *longue durée* and its implications for photography was that advanced by the philosopher Susan Sontag in a series of essays that resulted in her book *On Photography* (1977). Sontag initiated a second coming for photography, and she moved the date in the discussion of photography's inception from 1839 to the early decades of photographic practice and to what she saw as a gathering consensus of the medium's credibility. Simply put, in Sontag's view, photography was not born in 1839, but evolved its meanings through continual use and contextualization in societal concerns. Sontag depicted the nineteenth century as "the new age of unbelief [which] strengthened the allegiance to images."[127] During this new age, a profound, long-term, cultural process of secularization moved the center of belief from the unseen to the seen, from the general to the particular, and from the hierarchical to the natural, nature being the more democratic subject of art. This movement required an agent or instrument that one could believe in as a neutral recorder: the camera.

In Sontag's writing, the invention of photography is a desperate socially symbolic palliative for an awful truth. In its puny way, photographic authority is a sign for the loss or absence of transhistorical meaning. What one knows about the photograph is merely that its subject was once before the lens. Being trivially true, the photograph cannot be false. With Sontag, the matter of photographic evolution, which began in light, entered an entropic darkness.

## THE COPY, THE FACSIMILE, THE SIMULACRA

For many people in the nineteenth century, the photograph alloyed a mirror's fine detail with a window's view to the wide world. The re-

sultant image was doubly authentic. It could not be said to be a copy in the same way that a wood engraving of a scene from nature was a copy. The photograph suggested infallible representation because of its parallels to sight.

Lost to us is the sensation of wonder that those in photography's first decade felt when viewing photographs. The exactitude of the daguerrean image, which people studied under a magnifying glass, was a source of awe. The notion that the medium comprised a new kind of copy was abetted by the startling appearance of the photograph, a sensation that would go flat by the end of the century. But in the nineteenth century, when measuring devices of all kinds were inexact and yielded only approximate results, photography was appreciated as having an uninflected, literal relationship to that which it gauged. As the contemporary critic Allan Sekula handily observed of this response, "The daguerreotype achieved the status of the Aeolian harp."[128]

The idea of photography augmented the authenticity of the photographic copy, as it did other aspects of photography.[129] Photographic originality, with all of its attendant associations, suggested that the photographic image was an unprecedented kind of reproduction. As such, photography was potentially capable of legitimately dismissing traditional iconography and formulaic composition. In the legislation proposing to reward Daguerre for his invention, the new sense of the copy is expressed by the word "facsimile."[130] Describing daguerreotypes in 1840, during a speech to the National Academy of Design, Samuel F. B. Morse also used the word. He mused that daguerreotype images *"cannot be called copies of nature, but portions of nature herself."*[131] Throughout the nineteenth century, the term "facsimile" was threaded throughout both professional and general discussions of photography. Whether one regarded photography as a boon to public education or a catastrophe for public taste, one described it as a replica of original experience.

With the advent of photography, the copy committed by the human hand was open to new charges of representing a misapprehension, bias, or an error. The actuality of the faultless copy, yielded by nature, was a component of Daguerre's science. Daguerre held that there existed a special, if subtle, physical relationship between the photograph and the object pictured. In his writing, he recounted that his experiments had taught him "that light cannot fall on any peculiar body without leaving traces of decomposition on the surface of that body . . . these same bodies may be recomposed."[132] Surely, the association of photography with magic owed much to the belief that the photograph had the potential to recompose the objects it imaged.

Oddly enough, twentieth-century language theory has categorized the photograph in a way that Daguerre might recognize. Drawing on the semiotic investigations of C. S. Peirce and Roland Barthes, the contemporary critic Rosalind Krauss pronounced "photography . . . an imprint or transfer of the real." In her analogy, the photograph "is a

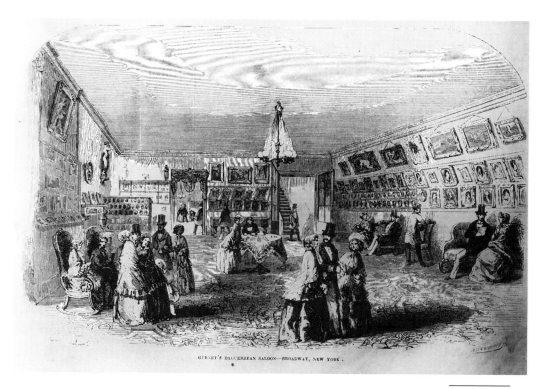

GURNEY'S DAGUERREAN SALOON—BROADWAY, NEW YORK.

FIGURE 15

Woodcut illustration of Gurney's Daguerrean Saloon – Broadway, New York, *Illustrated News* (November 12, 1853). Courtesy of the American Antiquarian Society, Worcester, Massachusetts.

photochemically processed trace causally connected to that thing in the world to which it refers in a way parallel to that of fingerprints or footprints or the rings of water that cold glasses leave on tables . . . photographs are indexes."[133] Although their appreciations of the photographic process were similar, Daguerre and Krauss were not writing in the same context. Daguerre was groping for a way to explain the fine detail of the daguerreotype, whereas Krauss was employing the special status of photography to explicate surrealism's philosophical assumptions.

The language-theory distinction between arbitrary verbal signs and the photograph's explicit indexical character was not a disparaging one. But in the 1970s and the 1980s, the unique truth value assigned to the photographic copy or facsimile was reversed. The view that photographs replicated an authentic moment of human experience became suspect. The notion of the simulacra, proposed by critics such as Jean Baudrillard, introduced the idea that neither the photograph nor mass media such as film and television was the trace of a prior-existing reality. In the late twentieth century, reality was superseded by the hyperreal, an unanchored welter of images not of the things pictured, but of representations: "Simulation is no longer that of a territory, a referential being or a substance. It is the generation by models of a real without origin or reality: a hyperreal."[134] The concept of the simulacra undermined the pillars of photographic originality: the connection of sight and insight and the concept of neutral vision.

This influential postmodern position turned on a crucial difference between the experience of photography in its early decades and the

experience of photography in the era of mass media, that is, from the late nineteenth century to the present. Simulation assumes the condition of mass media, with the media's unceasing reproduction of images that do not describe external reality so much as they refer to other pictures. In the early years of photography, however, the multiple was not understood as synonymous with the copy. The copy referred to the making of a single likeness, not numerous reproductions.

## MULTIPLES

Had photography produced only single, nonreproducible pictures, as the daguerreotype actually did, its social impact would have been markedly diminished. Sensing the implications of this limit, Daguerre's broadsheet forecast that his photography might become a charming toy, something to amuse the ladies.[135]

The discourse in photography's early years was so focused on the medium's originality that it tended to exclude discussion of photography's capacity to produce multiple copies. Curiously, François Arago's apprehension about Talbot's photography does not seem to have encompassed the potential of Talbot's photography to make multiple images. Of course, Arago may not have picked up on the somewhat enigmatic suggestion that Talbot's photography had the capacity to produce multiple prints from what would later be called the negative. But in his various statements about the future of photography, Arago seems to have envisioned series of photographs made fresh each time.

Similarly, Talbot's repeated explanation that photography is the natural production of images was not accompanied by an equally emphatic claim for photography's reproducibility. Indeed, Talbot's formulation neglected the distinct advantage of his own photography, especially the reproductive range of the improved process that he called calotype.

From the first, with efforts such as M. P. Lerebours's *Excursions Daguerriennes* (1840–1843), a series of etchings based on daguerreotypes, practical methods for producing multiple photographic images were sought. However diligent these attempts were, they did not open early photographic discourse to a serious, sustained discussion of multiples. The closest that one comes to a sustained treatment of the idea is a perfunctory genuflection toward photography's broad educational virtues. Even though Niépce invented his photography during a search for an autographic lithography, even though Arago's arguments for photography implicitly assumed the production of multiple images, and even though the nineteenth century saw millions of duplicate photographs made, the concept of mass reproducibility

was not continuously appended to reflections on photography's antecedents until the middle of the twentieth century.[136]

## Modern Multiples

In the twentieth century, the historian Heinrich Schwarz was among the first to create a dual definition of photography. He saw photography as both a means to make a faithful replica and a method to make many copies. Schwarz's pairing of these ideas was tentative and uneven. He centered his essays on the high-art tradition of Western visual art, allowing the double meaning of photography to slip into the more familiar designation of optical illusionism. It is as if Schwarz suspected that the history of multiples would stretch his narrative beyond intelligibility.

In his doctoral dissertation (1921) and early curatorial work, Schwarz concentrated on the history of the graphic arts. This route led him to the history of photography. William Ivins, curator of prints at the Metropolitan Museum of Art in New York from 1916 to 1946, came to the study of photography in a similar way. In *Prints and Visual Communication* (1953), Ivins formulated a prehistory for photography that largely relocated photography and printmaking outside the high-art tradition.

Ivins was impatient with the arid connoisseurship that elevated all prints to high art. He maintained that "the principal function of the printed picture in western Europe and America has been obscured by the persistent habit of regarding prints as of interest and value only in so far as they can be regarded as works of art."[137] Ivins concluded that "the importance of being able exactly to repeat visual statements is undoubtedly greater for science, technology and general information than it is for art."[138]

Ivins undertook to shift the lineage of photography not simply from painting to printmaking, but from high art to popular art. He set photography as the end point of printmaking's pursuit of exact repeatability and credibility and thought of photography as the most successful kind of print communication. By embedding photography in the progressive development of the non-art print, Ivins automatically placed greater emphasis on the societal preconditions for photography's invention. Like Mumford and Schwarz, Ivins believed in cultural readiness. Photography was catalyzed by the late-eighteenth-century's need for a new pictorial syntax, not a new art.

The vast range of uses eventually found for photography hinted that photography might be multiply determined, proceeding from a variety of very different functional forebears, not just from painting. Still, discussions of cultural and social readiness have seldom gone beyond noting that photography was somehow coaxed into being by the needs of an industrializing society. Even Ivins did not extend his purview to include the history of engineering and technical drawing.[139] Social historians tend to agree that conditions during the years

surrounding the French Revolution fostered the invention of photography, but these scholars differ in their understanding of the direct effects of the Revolution on the future consumers of photography.[140] Clearly the Revolution accelerated a fundamental change in art patronage and promoted the increased demand for images that had begun several decades earlier. History painting, which includes depictions of religious and mythological subjects as well as of historical scenes, had been to the taste of major prerevolutionary patrons: the rich, the royal, and the religious. The new bourgeoisie of the postrevolutionary period preferred portraiture, landscape, and still life – the very genres that were soon to be within the technical range of photography. The pastel palette and confident, sensuous brushstroke of the prerevolutionary period gave way to somber gray tones and a smooth canvas – for critics like Galassi, this was photography before photography.

The newly rich middle classes who gathered in the salons and art galleries after the Revolution created an international set of upwardly mobile art appreciators. They did not frequently buy art objects, but they did demand art reproductions and their demands increased the work of printmakers before and after the development of photography. Painters could count on an income from their paintings in reproduction and sought competent etchers and engravers to replicate their work. Etchers, for their part, argued that they were not mere copyists, but were interpreters and educators.

The spread of trade throughout the world created a significant core of individuals who had visited foreign lands and who also wanted more, and more exact, views than a hired watercolorist could produce. Science and industry became reliant on visual documentation. Often it was the draughtsman, not the painter, who quaked at the announcement of photography.[141]

In the years preceding the invention of photography and in the short interval during which photographic portraits were not technically possible, the increased middle-class taste for pictures of themselves was partially supplied by what the social historian Gisele Freund has called the "ideological predecessor" of photography.[142] The physionotrace modified shadow tracing, or silhouette making, a process that both Eastern and Western cultures have associated with the origins of painting.[143] It combined silhouette making with engraving to produce multiple images. Although its procedures are mechanical and chemical, not photochemical, the physionotrace is a functional forebear of photography in that it served the needs of the middle class in the same way that photography would soon come to serve. Like the photograph, it challenged the unique art object. The physionotrace was mechanized, and it could be produced by persons of lesser talent and experience than possessed by miniature painters. The proliferation of physionotrace images augured the industrialization of the portrait that the photograph would accomplish.

Roland Barthes once asked, "By what essential feature . . . [is photography] to be distinguished from the community of images?"[144] Had he queried the Museum of Modern Art's John Szarkowski, Barthes would have gotten a reply resonant with the soft consensus of many scholars and the general public. Szarkowski spoke for this group when he characterized the course of nineteenth-century photography as attractively anarchic, like a colorful stain on the tabula rasa of the period's intellectual history. Szarkowski described "the monstrous and largely shapeless output [that] constituted an enormous, unstructured experiment, out of which came suggestions that more sophisticated photographers later made coherent and shapely." He said that "it is difficult to think of a medium that has been used with such extemporaneous, undisciplined, centrifugal, mindless energy as photography . . . this experiment was . . . free to proceed in its purest laissez-faire form in the United States."[145] Szarkowski reinscribed the self-legitimizing language of photographic transparency, spontaneity, genius, and originality. By suggesting that nineteenth-century photography had no customs, he reiterated the self-reflexivity that became a common public and scholarly mental habit in the nineteenth century. Without a past, photography appeared free to be a universal language: a visual Esperanto.

But the concepts that have shaped the understanding of photography have been neither shapeless nor anarchic. Instead, they have been flexible, porous, and actively responsive to circumstance. Whereas the photographic discourse that has evolved to describe the medium's prehistory and early decades has been enlarged and emended, it has never been annulled or replaced by an alternative paradigm.

The lack of any sure definition of the medium proved to be not a hindrance but a benefit. Photography could be simultaneously old and new, modern and antimodern, natural and cultural, invented and discovered, societal and individual, art and science, art and craft, magic and science, of time and outside of time. The public experience of photographs in family life, commerce, government, war, education, science, and art became comprehensible through an open, malleable system of ideas established to explain the medium's prehistory and early years.

Still, being able to find a precedent for one or another kind of photography did not end heated disagreements in the nineteenth century about what was authentic photographic practice and what was not. Increasingly, photography came to be seen as a defining technology, that is, as "one that develops links, metaphorically or otherwise, with a culture's science, philosophy, or literature; it is always available to

serve as a metaphor, example, model, or symbol." Like the loom and the clock before it, and the computer to come, photography collected and focused "seemingly disparate ideas . . . into one bright, sometimes piercing ray."[146] By midcentury photography had matured as an imaging technique and as an open, socially symbolic vessel.

# Photography and the Modern in Nineteenth-Century Thought

As photographic practice proliferated, it became increasingly entangled in what the Victorian sage Thomas Carlyle characterized as "the doom of the Old." "The Old has passed away," Carlyle wrote, "but, alas, the New appears not in its stead; . . . Time is still in pangs of travail with the New."[1] Photography proved to be a versatile symbol of modernization's gains, sacrifices, and contradictions. On the one hand, photography seemed to emanate from a new democratic order – it made more things visible to more people and threatened to disestablish elite systems of knowledge. On the other hand, photography retained preindustrial notions of magic and Romantic concepts of intuition. Photography appeared to be one more integer in technological progress as well as one more bit of evidence pointing toward cultural decline. Concurrently, photography symbolized progressive and regressive change *and* a stillpoint within change – one of the many involuted contradictions that suffused photographic discourse. As an imaging method and as a social symbol, photography gave assurance that the world was knowable. But the features of photographic information and its impact on society and individuals were debated more and more. Neutral vision did not stay neutral for very long.

## Photographic History as Modernist Myth

In the 1850s and 1860s, elements of anecdotal photographic history entered into popular stories whose function was not simply to structure a coherent past for the medium, but to soothe in speculative symbolic form larger social perplexities. Photography emerged as a protagonist in durable mythic narratives of the modern experience.

Myth makes use of what is at hand.[2] Events and attitudes are woven together into a smooth story that explains why things are the way they are, or why things happen the way they do. Myth is authorless social fiction, fueled by encrypted imaginary resolutions to societal problems and events. There is no "once upon a time" in myth – no artifice that sets the story at arm's length. Myth seeks to be continuous with real life. In fact, it intensifies real life to the point that actual occurrences, circumstances, and personalities can be read metaphorically. To that end, myth masks how its disparate elements are woven together. The effect is an almost magic unity – an unchanging truth derived from apparently random facts and opinions.

Early photographic discourse was preoccupied with suppositions about the originality of photography. This fixation abetted the growth of origin stories. The creation, or origin, story, a central type of myth, engrossed nineteenth-century writers, who dealt with the dearth of facts about photography's arrival by condensing and codifying legends explaining the invention of photography. These tales were subject to extensive narrative manipulation, an act made easier by the obscurity of and lack of data about the invention of photography.

Despite their prominence in nineteenth-century writing on photography, these stories have been discounted in contemporary photographic history. It is not so much that they have been proven false, but that most writers today interpret the role of photographic history as the organization of corroborated facts and the impact of those facts.

One prominent origin story concerns Professor Jacques Charles, the French academician and inventor of the hydrogen gas balloon. The basic tale is this: While experimenting with the light sensitivity of salts, Charles produced impermanent silhouette images on paper as well as some poorly defined contact prints of engravings.[3] In his report to the Chamber of Deputies on Daguerre's invention, Arago acknowledged Charles's photographs but argued that Charles's historical importance had died with him because Charles had neither recorded his work nor informally divulged the secret of his photographic methods. For political purposes, Arago favored Thomas Wedgwood as the first person to bring together the components of a photographic image. As one example of this version's influence,[4] in January 1843 *The Edinburgh Review* reproduced Arago's account of Charles almost verbatim.[5]

The Charles story lay fallow until the early 1850s. By 1853, however, the year in which Francis Wey published his short history of photography, Professor Charles seems to have become an eminent figure in photography's prehistory.[6] Wey, an engraver and later the editor of *La Lumière,* the publication of the French Heliographic Society, deemed it appropriate to illustrate his article with a depiction of Charles, completing a triumvirate of photography's chief precursors: Charles; J.-B. Porta, a perfecter of the camera obscura; and Humphry Davy, Thomas Wedgwood's renowned scientific associate. Wey considered Charles to be a great visionary, the first person to have

N° 36. — 1856.  Prix du numéro : 45 centimes.  6 Septembre.

JOURNAL POUR RIRE,

# JOURNAL AMUSANT

JOURNAL ILLUSTRÉ,

Journal d'images, journal comique, critique, satirique, etc.,

RÉDIGÉ PAR

CH. PHILIPON, fondateur de la maison Aubert et C^ie. du Charivari, de la Caricature politique,
du Musée Philipon, des Modes Parisiennes, etc.

ON S'ABONNE
CHEZ LE SUCCESSEUR
d'AUBERT et C^ie,
RUE SANSON, 20.

PRIX :
3 mois . . . . . 5 fr.
6 mois . . . . . 10
12 mois . . . . . 17

ETRANGER :
selon les droits de poste.

ON S'ABONNE
CHEZ LE SUCCESSEUR
d'AUBERT et C^ie,
RUE SANSON, 20.

Les lettres non affranchies
sont refusées.

L'administration ne tire
aucune traite et ne fait
aucun crédit.

Toute demande non accompagnée d'un bon sur la Poste ou d'un bon à vue sur Paris est considérée comme nulle et non avenue. Les messageries nationales et les messageries générales font les abonnements sans frais pour le souscripteur. On souscrit aussi chez tous les libraires de France. — A Lyon, au magasin de papiers peints, rue Centrale, 27. — Delisy, Davies et Co., 1, Norfolk-Street, Strand; et 1, Finch Lane Cornhill, London. — A Saint-Pétersbourg, chez Dufour, libraire de la Cour impériale. — A Leipzig, chez Goetse et Miorieach et chez Durr et C^ie. — Prusse, Allemagne et Russie, on s'abonne chez MM. les directeurs des postes de Cologne et de Sarrebruck. — Bruxelles, Office de Publicité, rue Montagne de la Cour, 19.

## A BAS LA PHOTHOGRAPHIE⁽¹⁾ !!!

### TEXTE ET DESSINS PAR MARCELIN.

In conspectu meo stetit sol.
(Un photographe.)
La photographie est un cas pendable.
(Une jolie femme.)

I.

COMMENT SE FAISAIT LE PORTRAIT D'UNE JOLIE FEMME AUTREFOIS.

..... Le doux portrait de ma bergère.

Au musée de Versailles, dans une galerie des étages supérieurs, on voit un tableau datant de la dernière moitié du dix-huitième siècle, représentant une réunion de personnages célèbres du temps, chez le prince de Conti, au Temple.

Dans un grand salon à panneaux de boiseries sculptées, aux fenêtres hautes donnant sur un jardin, se presse une foule nombreuse. Ici Mozart enfant prélude sur le clavecin; le prince de Latour-Taxis et madame de Guébriant l'écoutent accoudés au dossier de son fauteuil. Là Jélyotte, le chanteur à bonnes fortunes, accorde une guitare, assis au milieu d'un groupe de musiciens aux énormes basses. Plus loin, abritées par un paravent formant un petit salon dans le grand, la maréchale de Luxembourg et la princesse de Chimay déjeunent en compagnie d'un abbé.

Enfin dans un coin du tableau, près d'une fenêtre drapée d'un de ces grands rideaux de velours à torsades d'or qui servent de fonds aux portraits de Rigaud, un peintre, qui ne peut être que Latour, fait le portrait de madame d'Egmont. A demi couchée sur un sofa, la

(1) Quand elle n'est pas faite par notre ami Nadar, rue Saint-Lazare, 113.

FIGURE 16

Marcelin, *A Bas La Photographie!!!, Journal Amusant,* no. 36 (1856): cover page. Courtesy of Sandra Stelts, Pennsylvania State University Library.

glimpsed the possibility of photography. He judged Charles's early efforts to be both prophetic and fertile. For Wey the invention of photography was channeled through Charles.

Nine years later, the French photographers Mayer and Pierson dilate Charles's biography and his prominence in photographic history. They describe Charles as an eccentric who is given to wearing strange costumes, delights in being an entertainer, and seeks opportunities to amuse audiences with clever science tricks. The professor has become a magician.

Mid-nineteenth-century histories of photography expanded the historical significance of Charles's simple photographic silhouettes. The silhouettes' violet color indicated to Mayer and Pierson that Charles had employed iodine somewhere in his secret photographic process. For Mayer and Pierson the implications of Charles's using iodine were considerable. It meant that not only was Charles the individual who foresaw the concept of photography, but he was also the person who potentially understood the role of iodine in creating a surface so light sensitive that it could retain what would come to be called the latent image.[7]

Several years later, another French historian, Louis Figuier, added a salient narrative element of his own to the Charles story. In *La photographie* (c. 1868), Figuier has Daguerre attending a lecture by Charles, during which the professor demonstrates his silhouette technique. The lecture becomes an epiphany for Daguerre. He exits exclaiming, "I will go one better! I will fix the fugitive images [of the camera obscura]."[8]

The presence of mystery and traces of the occult relate the Charles story to another, more romantic tale – that of The Stranger – current at the same time. The Stranger's story begins in the Paris shop of the optical instrument–maker Charles Chevalier in January 1826. Three visitors are said to come in rapid succession to Chevalier for assistance. The first is Daguerre, who, in this story, prematurely claims to have successfully captured camera obscura images. The second visitor is a cousin of Niépce, who comes to the shop to buy optical equipment for Niépce's experiments. The third visitor to Chevalier's shop is the individual known as The Stranger.

The Stranger comes to Chevalier's shop to purchase a camera obscura. Because he is poor, he is not able to buy the best instrument. In the course of the transaction, The Stranger tells Chevalier of his attempts to fix the images of the camera obscura, and he shows the optician some photographs. As he departs, The Stranger leaves an unidentified brown liquid with Chevalier. The mysterious fluid is supposed to produce photographs. Unfortunately, The Stranger does not leave instructions with Chevalier, who cannot figure out how to employ the substance. Nor can Daguerre, to whom Chevalier gives the bottle, use the chemical to create pictures. Of course, The Stranger could have demonstrated the liquid's use or presented the process at a later date. But, as listeners to the tale probably anticipate, he instead leaves Chevalier's shop hurriedly and never returns.[9]

Given the number of persons who stepped forward in 1839 to claim the invention of photography, there may have been some basis for Chevalier's story.[10] But the way in which the story developed during the nineteenth century did not rely on there having been a stranger. Indeed, it was easier for The Stranger's story to ripen in the absence of a real person.

For writers such as Wey, the story of The Stranger filled a gap in the saga of photography's invention. Wey's philosophy of history did not allow for a single inventor of photography. Wey compared transformational inventions to epidemics: Both infect many people at once. By Wey's lights, there had to have been many more Daguerres. Oddly, Wey showed no interest in evaluating the claims of prior invention of photography put forth in 1839. Instead, he invented a possible additional inventor by "splitting" Daguerre in two – a daytime Daguerre and a nighttime Daguerre. Wey reasoned that because Daguerre was an insomniac, his sleepless nights afforded him the extra time it would take to make an invention as stupendous as photography. Having formulated this hypothesis, Wey could not fully convince himself of it. His story calls for another inventor. Enter: The Stranger.

By 1853, it appears that there was enough information about The Stranger to allow Wey to describe him. Wey's account is more elaborate than earlier ones. In it, Wey accentuates the poverty indicated by the ragged appearance of The Stranger, who wears tight clothes and a threadbare hat and has neither shirt collar nor cuffs.[11] Wey also de-

FIGURE 17

Unknown Artist, [Image of The Stranger], from Francis Wey, *"Comment le soleil est devenu peintre: histoire du daguerréotype et de la photographie,"* *Museé des Familles,* (June 1853). Widener Library, Harvard University, Cambridge, Massachusetts.

scribes the photographs that The Stranger shows to Chevalier. One image is of a skyline, the other of the dome of the Invalides. Figuier, who tells much the same tale, concocts a description of The Stranger in which he appears to be more a Byronic figure than simply down on his luck.

When Mayer and Pierson take up the story, they give an even fuller narrative, not of the creation of photography, but of The Stranger. Their Stranger is intelligent and dreamy, with pale skin as befits someone with a weak disposition. The Stranger's unsettling appearance leads the authors to conjecture about why The Stranger never returned to Chevalier's shop. Did The Stranger, shivering with cold and hunger, end his days with a plunge into the Seine? Did he languish in a charity hospital? Was he buried in a common grave with other paupers? Did he die in an asylum? Disinherited by fate, did he bury himself in some lowly job? For a man of genius, they conclude, disappointment is sadder than it is for the rest of us.[12]

## PHOTOGRAPHY AND
## TECHNOLOGICAL CHANGE

The known records do not support the existence of The Stranger or indicate if Professor Charles ever dabbled in photography. As a consequence, modern historians have let these stories recede from the archivally based history of photography into the realm of fiction and popular culture. Yet photography's origin stories incorporate a central social construction of photography that was routinely reiterated in nineteenth-century thought.

These tales were told by advocates or practitioners of photography who prepared histories of photography for a general audience. Science writers in a dynamic era of popular science, they cultivated a patient linearity in their texts that did not condescend, but did imply that in due time everything would be thoroughly explained. The nineteenth-century writers who included these stories in their histories were neither researchers nor authors who, like Lady Eastlake, wrote for an audience of their worldly, literate peers. Instead, they were writing within a set of socially shared perceptions of human creativity and image making. They explained the invention of photography within these conventions. These authors do not appear to have made up their stories; they took apocryphal tales and reiterated them in a way that brokered between the photographic community and the public. This is an ideal context for mythmaking, because myth attempts to harmonize, explain away, or otherwise subvert the sense of difference and the discomfort that comes with change.

Myth quells the disruptiveness of transition by making change re-

FIGURE 18

Photographer Unknown, *Track-laying on the east side of the Stampede Pass switchback, Northern Pacific Railroad,* 1887. Courtesy Eastern Washington State Historical Society.

semble the past, in effect, by taking the change out of change. Myth frequently sets its explanations in harsh and unforgiving historical terrain. Giving assurance that new events are familiar and predictable is more consequential for myth than making the events pleasant. The story of The Stranger and the tale of Professor Charles both became popular about the same time, in the 1850s and 1860s, when photographs, especially stereographs, a kind of three-dimensional photography, had been seen and used by many people. By the 1860s enough people were familiar with photography to raise questions not only about its social impact but also about its value as a potent symbol for the myriad changes perceived to issue from industrialization and democratization. Indeed, photography was so new, its technological progress so rapid, and its potential so incalculable that it was a felicitous symbol of the ambiguously valued transition to modernity.

In the stories about them, Professor Charles and The Stranger begin as scientists and end up as men of mystery. Over time, their tales become filled with intimations of magic, illusionism, and alchemy. They make discoveries that cannot be explained or duplicated. The photographic images that result from their work vanish without a trace – as do they themselves, more or less. Charles dies without divulging his secrets; The Stranger never returns to Chevalier's shop. Charles and The Stranger are quirky and antisocial. Their knowledge comes from intuition, not hard work. Thus both figures incline toward the profile of the natural or inspired genius as it is drawn in Romantic art theory and early photographic discourse.

The invention of photography is not a simple historical event in these stories. Technological change, symbolized by the photograph,

53

is inverted and absorbed into a world in which change is motivated by a mysterious, nonscientific agency. Historical time and scientific accomplishment are made to seem irrelevant and superficial. By presenting the invention of photography in the age-old terms of magic, these stories declare that there is no change in change. What appears to be transformation is just insignificant surface mutability. These stories attempt to prove that behind or beneath change, the old, still world of magic and metaphysical wonder continued to hum along. Further, by suggesting that invention is a mysteriously acquired gift, these stories imply that invention is not a deliberate human act, but an unpredictable eruption of the eternal and enigmatic natural world into the world of culture. At the same time that science promised to lay bare the bones of the universe, mythic tales about the invention of photography disputed that expectation.

Yet myths about photography, like many myths, are implicitly self-contradictory. They acknowledge the real and the symbolic power of photography in the very attempt to invalidate it. Like other myths about the invention of photography that gained popularity at the time – the story about Daguerre's nap-time vision of a camera obscura image or the anecdote in which a spoon left in Daguerre's cabinet is provocatively darkened overnight by the fumes of mercury that had been accidentally spilled – they seem almost frantic in their attempts to restore an esoteric element to technological invention.

Photography's origin stories exploited notions of photographic originality. They diverted the discourse on photography, established by writers such as Talbot, to a popular level in order to pitch mystery, magic, and alchemy against banal technological accounts of photography's advent. The stories evince the extent to which the general public conceived of the medium as an internally conflicted symbol of the modern. By the 1850s, the photograph exemplified the possibility of a new, direct experience while it expressed the apprehension that direct experience would be altered or lost to mediation. In an important sense, these stories plead the importance of Edenic, natural perception, which, like The Stranger, has become impoverished. Paradoxically, these appeals for natural perception were frequently made in books and magazines addressed to the nineteenth-century's newly literate readers. Thus mass-mediated words and pictures communicated the hopes for *and* fear of the effects of mass-mediated words and pictures.

Although The Stranger, a figure of romantic or artistic genius, haunts one of photographic prehistory's principal origin stories, the narrative did not expand to include the topic of the new medium's relation to the established visual arts, where genius continued to be a topic. But painting is the subject of two other concurrent mythic narratives that purported to render the reactions of famous artists to photography. The first story describes the English painter J. M. W. Turner as being disconcerted by his first view of a daguerreotype.

**ARTFUL!**

*Dodge of Little Sperks, showing how Parties below the Middle Height, by the use of Miniature Background Furniture, may gain a more Imposing Stature in the Carte de Visite.*

FIGURE 19

Unknown Artist, *Artful, Punch* 42 (January 18, 1862). Courtesy of Syracuse University Library.

"This is the end of Art," Turner purportedly remarked, "I am glad I have had my day."[13] In the second tale, the French artist and antiquarian Paul Delaroche, who enjoyed an international reputation for his precise architectural interiors and costume designs, echoes Turner in the remarks he allegedly made in response to photography. An assortment of nineteenth-century texts presume to report Delaroche's exact words upon first viewing a daguerreotype: "From today painting is dead." Historians in the nineteenth and early twentieth centuries have reiterated and expanded upon Delaroche's remark, but more recent historians, unable to verify the legendary quotes of either man, have dismissed the remarks as rumors.[14]

These anecdotes fly in the face of what we know to have been the attitude of both Turner and Delaroche toward photography. Nothing in Turner's involvement with the medium gives credence to his alleged negative reaction to the daguerreotype. Indeed, Turner evinced a strong curiosity about photography and its chemical processes. In the late 1840s, he made the acquaintance of J. E. Mayall, an American daguerreotypist working in London. The photographer recorded his interaction with Turner in a letter sent to one of Turner's earliest biographers. Mayall, one of the first photographers to compose inspirational *tableaux vivants,* caught Turner's attention with an image entitled "This Mortal must put on Immortality." Turner requested that he be allowed to develop a figure study along the lines of a *tableau.* Importantly, Mayall recorded that Turner was intrigued not so much with the making of a scene, but with the light effects that the photographer was able to create. "He came again and again, always with some new notion of light," Mayall wrote.[15] The photographer's ac-

count of Turner's interest resounds with self-flattery. Mayall stressed that the painter found in the setups and the daguerrean chemical processes some exempla of his intense involvement with theories of light and color and their allegorical treatment on canvas. Although the opportunity was ripe for Mayall to include or to allude to Turner's end-of-art pronouncement, he does not do so. There are no intimations of impending catastrophe for painting in the story.

Similarly, we know that Delaroche's response to photography was a positive one. Underscoring the distance between fact and legend, Beaumont Newhall observed that Delaroche continued to paint after his pronouncement of the death of art.[16] Moreover, Delaroche wrote in support of the bill requiring the French government to give money to the inventors of photography. In this Note to the legislature, Delaroche declared that among its other benefits, the daguerreotype was a quick and precise method to render preliminary sketches and studies. In other words, Delaroche thought photography to be an aid, not the apocalyptic successor, to art.

Few painters other than miniaturists saw in early photography a technique that would supplant or fundamentally alter painting. The editorial response of *The Athenaeum* (1847), which cooled claims made by Mayall that the daguerreotype was capable of illustrating history, was typical. The journal found this proposition to be too ambitious. "At best, he [Mayall] can only hope to get a mere naturalist's rendering," wrote the reviewer. "Ideality is unattainable, – and imagination supplanted by the presence of fact."[17] Because the photograph was understood as nature delineating nature, it was found wanting in indispensable qualities such as human imagination. "Nature is only become the handmaid to Art, not her mistress," wrote one observer. "Painters need not despair; their labours will be as much in request as ever, but in a higher field: the finer qualities of taste and invention will be called into action more powerfully; and the mechanical process will be only abridged and rendered more perfect."[18]

Even photography's exultant friends, who sang the medium as "Art's youngest and fairest child . . . heir to a new heaven and a new earth,"[19] did not see the child as a rival or subverter of painting. Alophe (the pseudonym for the Parisian photographer Adolphe Menut) concluded his otherwise enraptured study *The Past, the Present, and the Future of Photography* (1861) with the thought that photography, however much it was a wonder of the nineteenth century along with the telegraph and steam power, would not transform painting because it could not encompass the ideal.[20]

In general, critical reactions to photographs and photography balanced enthusiasm with caution. After all, as an aid to the artist, photography presented no more of a threat to painting than prosaic close rendering did. Occasionally, there were world-weary reactions like that of one commentator writing in 1842 who was not "able to discover any practical use in all the Daguerreotype inventions, except in

their having got the inventor a handsome pension from Louis Philippe."[21] But calamitous predictions such as those attributed to Turner and Delaroche were rare.

Taken verbatim the exclamations of Turner and Delaroche are distinctly dissimilar to the documented reactions of these individuals to photography and, on the face of it, are untrue. Yet the continual reiteration of these anecdotes suggests that they satisfied questions larger than those raised by photography's early history. On a mythic level, these succinct stories about Turner and Delaroche spoke to cultural uncertainty in the same way that the tales of Professor Charles and The Stranger did. By articulating the clash between traditional art media and photography, the prophetic statements of Turner and Delaroche expressed the collision between traditional patterns of authority and the arts and the emergent modern commercial world. As Walter Benjamin discerned, the controversy over art and photography remained more legible in its symbolic form than in its literal dimensions: "The nineteenth-century dispute as to the artistic value of painting versus photography today seems devious and confused. This does not diminish its importance, however; if anything it underlines it."[22] The conflict between photography and painting was frequently reiterated in public discourse, where the long-term democratic social logic of the photograph appeared to be at odds with the traditional role of art as social-class indicator. The dispute was real enough for its participants, yet it also betokened conflict within an enlarging middle-class society that simultaneously prized meritocratic achievement and cultural one-upmanship.

## PROGRESS IN SCIENCE / PROGRESS IN ART

The association of photography with progress was formed within photography's first decade. In 1843, an unnamed commentator for the *Edinburgh Review* effused that photography "is indeed as great a step in the fine arts, as the steam-engine was in the mechanical arts . . . and . . . it will take the highest rank among the inventions of the present age." Yet the reviewer urged his readers to make a distinction between the linear, cumulative development of science and technology and what constitutes genuine advancement in art. Progress in art, according to the reviewer, is not endlessly incremental: "It would be hazardous to assert that Apelles and Zeuxis were surpassed by Reynolds and Lawrence, and still more so that Praxiteles and Phidias must have yielded the palm to Canova and Chantrey." Nor does photography, by implication, constitute a threat to art: "Any art . . . which should su-

Unknown photographer, *New Westminster, British Columbia. View of Holy Trinity Church,* c. 1861. Courtesy of Special Collections and University Archives, The University of British Columbia, Vancouver.

persede that of the painter, and deprive of employment any of its distinguished cultivators, would scarcely be hailed as a boon conferred upon society."[23]

A corresponding friction is apparent in the English critic John Ruskin's shifting evaluation of photography. At first, Ruskin was enamored of photography. In a letter from Venice to his father, dated October 7, 1845, Ruskin declared that "Daguerreotypes taken by this vivid sunlight are glorious things. It is very nearly the same thing as carrying off the palace itself." From Padua on the 15th, he wrote: "Among all the mechanical poison that this terrible 19th century has poured upon men, it has given us at any rate one antidote – the Daguerreotype. It's the most blessed invention; that's what it is."[24] Less than a year later (August 12, 1846), having worked with both photography and drawing, Ruskin evolved the more complex view that persisted in his subsequent writing. Although acknowledging the daguerreotype as "the most marvellous invention of the century," useful for historic preservation and all sorts of record keeping, Ruskin had come to doubt its benefits to art: "As regards art, I wish it had never been discovered, it will make the eye too fastidious to accept mere handling."[25]

For Ruskin, the verisimilitude and automatism of photography had become objectionable. Illustrating his lecture on the art of England (1883), he equated the sentimental realism of Benjamin Vautier, a Swiss painter of the Düsseldorf school, with "our modern system of scientific illustration aided by photography."[26] Ruskin took Vautier,

FIGURE 21

Unknown photographer, *New Westminster, British Columbia. View toward Holy Trinity Church,* c. 1862–1864. Courtesy of Special Collections and University Archives, The University of British Columbia, Vancouver.

who enjoyed some reputation for his genre scenes, as an example of a copyist, not an artist. "A photograph is *not* a work of art, though it requires certain delicate manipulations of paper and acid and subtle calculations of time, in order to bring out a good result," Ruskin pronounced. A work of art, in contrast, "expresses the personality, the activity, and living perception of a good and great human soul."[27] Ruskin, the expressive naturalist, was by no means a strict proponent of realistic representation. He emphasized that superior art is suffused by the particularities of a human intelligence and spirit. Ruskin insisted that creating the effect of optical reality on the canvas constituted a sort of visual illiteracy.[28] "Photographs," Ruskin wrote, "supersede no single quality nor use of fine art, and have so much in common with Nature, they even share her temper of parsimony, and will themselves give you nothing valuable that you do not work for. They supersede no good art, for the definition of art is 'human labor regulated by human design.'"[29]

Photography's automatism threatened to make the public weary of the work required in art making and to instigate a chic indifference to painstakingly acquired human skill. Ruskin concluded that the photograph was the product of a machine and therefore was on a collision course with culture. "Next," Ruskin scolded, "you will have steam organs and singers, and turn on your cathedral service." "You *have*

FIGURE 22

Unknown Photogra-
pher, *J. C. Stoddard
and His Steam
Calliope,* c. 1855.
National Gallery of
Canada, Ottawa,
Canada.

very nearly succeeded in turning on painting," he accused. "The pho-
tograph is entirely mechanical."[30] Ruskin's disciples were similarly
disposed toward photography. *The New Path,* the journal of the Soci-
ety for the Advancement of Truth in Art, a New York group, echoed
Ruskin's thoughts. "Photography can never supersede Fine Art," an
unsigned article advised, "no matter what greater perfection of de-
velopment it may reach, it will still remain just as imperative as ever
that the artist should labor faithfully and patiently to record facts of
natural aspects."[31]

For Ruskin, the threatened substitution of the photograph for hand-
made images promoted the naive yet dangerous notion that progress
in the arts and in society could be achieved through industrialization.
He warned that good taste, which he considered a moral quality,[32]
would decline as people became impatient with the traditional arts:

> almost the whole system and hope of modern life are founded on
> the notion that you may substitute mechanism for skill, photogra-
> phy for picture, cast-iron for sculpture. That is your main nineteenth-
> century faith, or infidelity. You think you can get everything by
> grinding – music, literature, and painting. . . . Even to have the bar-
> ley-meal out of it, you must have the barley first; and that comes by
> growth.[33]

Ruskin was not alone in scorning the social tendency that mani-
fested itself as enlightened intolerance of both imaginative art and
theoretical science. John Henry Newman, the English theologian and
scholar, assailed the meanness of this attitude in his 1852 lectures
"The Idea of a University." Newman found himself defending "the real
worth . . . of . . . 'a Liberal Education,'" against "the supposition that it
does not teach us definitely how to advance our manufactures, or to

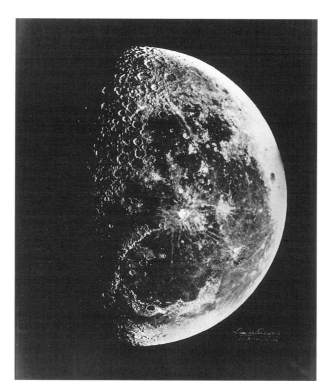

FIGURE 23

Lewis M. Ruther-
ford, *Moon,* n.d.
Courtesy of Colum-
bia University in the
City of New York,
from the Collection
of the Chandler
Chemical Museum.

improve our lands, or to better our civil economy."[34] Similarly,
Thomas Henry Huxley, the biologist, upheld the study of scientific the-
ory and reminded his listeners "that the improvement of manufactur-
ing processes is only one of the conditions which contributes to the
prosperity of industry."[35] Against the presumption of the practical
person's discomfort with high culture, Ruskin's heated words make a
certain sense. From his point of view, if the public assumed that pho-
tography did more or less what painting did, only more accurately and
quickly, then the survival of the Western cultural heritage and that
heritage's role in effectuating social cohesion were at stake.

## Photography and Progress

It may be that Ruskin exaggerated the dangers of photography, but in
the context of mid-nineteenth-century enthusiasm for the social ben-
efits of the Industrial Revolution, his reactions are more proportion-
al. One recurring argument for photography was underpinned by the
notion of the broad coordination of material and spiritual progress, in
which individual casualties were less visible than were the ample
tides of elevating change. An anonymous reviewer in an 1868 issue of
*The Philadelphia Photographer* defended chromolithography and pho-

tography by suggesting that "if artists can live only by copying either their own works or the works of others, they ought to give place to this new and wonderful invention, as the seamstress gave place to the sewing machine, as the old copyist made way for Hoe's lightning presses."[36]

"The march of civilisation is in unison with the advance of science," wrote Robert Hunt, a scientist, photographer, and critic.[37] His essay, expounding upon the interconnected progress of science and society, served as an introduction to the scientific displays at the influential industrial show, the Crystal Palace Exhibition of 1851, in the *Art-Journal*'s special issue. Hunt maintained that the benefits of science extend beyond the material. As science reveals the order underlying the apparent chaos of the physical world and literally puts that order to work in society, it simultaneously discloses the fundamental interdependence between the material and spiritual worlds. Expose the material and the spiritual is revealed. Scientific discovery, good in itself, creates "psychological phenomena, – which shall result in the production of order and spread of peace." Assemble the accomplishments of science and technology worldwide together and make international bonds: "The gathering of nations in the Industrial Palace of Hyde Park cannot but be for the good." Scientific discovery fosters "communion": "Bring people together – let them know one another, – they develope [*sic*] the latent good which is in every human breast."[38] Similarly, an article on the exhibition in *The Athenaeum* concluded,

> Events like the Hyde Park Exhibition bring home to the senses, the reason, and imagination a conviction that the true interests of humanity are common interests, – the real cause of progress and civilisation is not selfish and isolated, but general and all-embracing. . . . How vast the progress of ideas! Many amongst us, not yet old, can remember a time when it was taught in our schools and on our hearths as a creed that Frenchmen were our born enemies; and already we can contemplate with a calm historical curiosity, coldly criticize as works of Art, the canvas glowing with the triumphs of their military prowess. . . . The sense of enmity is past.[39]

Behind such global altruism, of course, lay a plainer political and economic agenda. As one observer remarked, "In no age except the present – in no country perhaps save England – could the industry and the industrials, the conceiving mind and the executive hand, of the world have been brought together under the same conditions."[40] Still, the utility and the aesthetic aspirations of the photographic samples in the exhibition's scientific section affirmed the notion of progress.

In the middle of the nineteenth century, the medium's proponents regularly argued that photography was one of the great modern inventions, along with the steam engine and the telegraph.[41] Like these, photography was seen as historically comprehensive, the inevitable

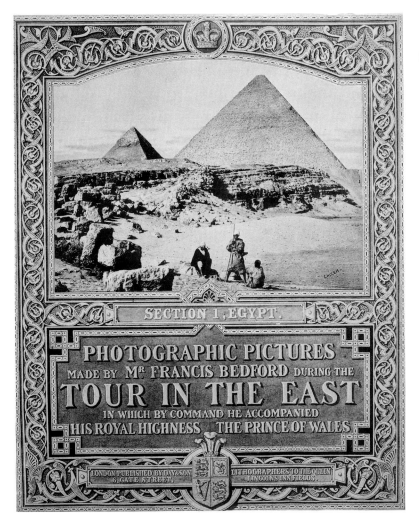

FIGURE 24

Francis Bedford,
*Section 1, Egypt,*
1862. National
Gallery of Canada,
Ottawa, Canada.

successor of previous visioning techniques. By bringing together functions that had been disparate, photography was progressive in the same way as the factory system. The factory condensed the various elements in the production of goods, substituting steam power and the machine for human labor wherever possible. Photography appeared to be similarly advanced because it too consolidated previously separate activities, such as record keeping, drawing, and printmaking. Through the agency of a machine, photography accelerated the speed of these activities. Albeit theatrically, the Turner and Delaroche statements speak to this characteristic of photography. People did not necessarily have to believe that the camera would replace painting to hold that photography was of the future. To embrace photography often was to argue that the medium was materially and socially progressive. For example, the photographer and critic Marcus Aurelius Root proclaimed that "what this art [photography] is doing, and is still more largely to do hereafter [is to increase] the knowledge and happiness of the masses."[42]

The French poet and critic Charles Baudelaire composed the best-known rejoinder to these optimistic assumptions. For all their differences, Baudelaire agreed with Ruskin that the notion of progress was a "gloomy beacon" for art and for society.[43] With the anonymous writer for the *Edinburgh Review,* Baudelaire differentiated between progress in "the material and the spiritual" and progress in the realm of the imagination.[44] Because Ruskin and Baudelaire insisted that accomplishments of art are not cumulative, but fluctuate in direct relationship to the values of the society that produced them, both writers feared the degrading effects of materialism.

Baudelaire believed that photography was a main support of mass culture's reduction of art to naturalistic presentation. His writing is nowhere more aggressive than when he accuses "the idolatrous mob" of demanding of photography "an industry that could give . . . results identical to nature."[45] Mocking the middle-class point of view, Baudelaire continues: "And now the faithful says to himself: 'Since Photography gives us every guarantee of exactitude that we could desire . . . , then Photography and Art are the same thing.'"[46]

Baudelaire allows photography a role in society as a record-keeping device, "secretary and clerk of whoever needs absolute factual exactitude in his profession."[47] It is "the ill-applied developments of photography, like all other purely material developments of progress, [that] have contributed much to the impoverishment of French artistic genius."[48] Baudelaire and Ruskin understood photography as a

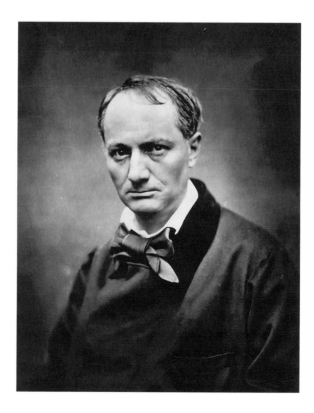

FIGURE 25

Etienne Carjat,
*Charles Baudelaire,*
c. 1862. The Metropolitan Museum of
Art, Rogers Fund,
1970.

multivalent metaphor. To champion photography was not simply to stand for realistic representation, but to embrace positivism.[49]

Photography's danger rested in its potential psychosocial effect: "Each day art further diminishes its self-respect by bowing down before external reality; each day the painter becomes more and more given to painting not what he dreams but what he sees."[50] To Baudelaire, photographs of *tableaux vivants,* like those that came to Turner's attention in Mayall's studio, vulgarize the pursuit of history painting: "Some democratic writer ought to have seen here a cheap method of disseminating a loathing for history and for painting among the people, thus committing a double sacrilege and insulting at one and the same time the divine art of painting and the noble art of the actor."[51]

Ruskin and Baudelaire focused on photography's part in the rise of a mass culture, suggesting that photography debased high art and good taste. Declinist arguments of this sort were well advanced before the invention of photography. The French political leader and writer Chateaubriand saw only degeneration around him: "Everything appears used up: art, literature, morals, passions: all are deteriorating."[52] In 1839, the year of photography's official disclosure, the literary critic C. A. Sainte-Beuve decried the advent of industrial literature, lowbrow pablum served up to satisfy, rather than to raise, the tastes of the middle class. *Littérature industrielle* included popular journals and novels as well as theatrical productions. Sainte-Beuve called the predilection for such fare democratic: pandering, egotistical, and seamy.[53] One year later, in 1840, Sir Francis Palgrave devoted a major aside in his article "The Fine Arts in Florence" to a denunciation of mechanically produced art:

> Steam-engine and furnace, the steel plate, the roller, the press, the Daguerreotype, the Voltaic battery, and the lens, are the antagonist principles of art; and so long as they are permitted to rule, so long must art be prevented from ever taking root again in the affections of mankind. It may continue to afford enjoyment to those who are severed in spirit from the multitude: but the masses will be quite easy without it.[54]

The novelist Gustave Flaubert was one of the major declinist voices after photography's invention. He recoiled from what he called "a whorish century," filled with "fake materials, fake luxury, fake pride."[55] Industrialism, he charged, had developed ugliness to gigantic proportions. In Flaubert's sense, photography was fake painting. Late in the century, James McNeill Whistler, the American painter who lived in London and Paris, echoed Flaubert when he decried the rising of "a new class, who discovered the cheap, and foresaw fortune in the facture of the sham."[56]

Photography's inception in nature did not relieve it of being a negative symbol for the effects of the Industrial Revolution. Because photography could be read as a fusion of nature and technology, it became an emblem of nature transformed and removed from direct

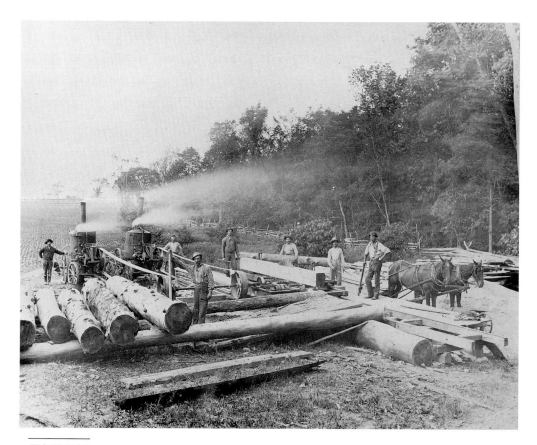

FIGURE 26

Unknown Photographer, *Morton's Sawmill, LaFayette, New York,* 1886. Courtesy of the J. Roy Dodge Collection, Syracuse, New York.

experience. At the same time, photography's natural origins and its artless automatism, qualities hailed during the medium's initial years, were rearticulated in a larger cultural discourse, where they symbolized the social effects of industrialization and urbanization and the perceived threat posed by mass culture to the individual and to individual creativity.

## PHOTOGRAPHY, FOR AND AGAINST

Photography's prominence in discussions of modernization's effects on mass taste mandated that the medium's supporters react to the charges against it. In other words, photography's proponents responded to criticisms rather than initiate a dialogue. Summing up the societal significance of photography for *Musée des Familles* (1853), a midcentury publication typical of the European and American journals devoted to the education of the new middle class, Francis Wey agreed that photography's stringent truth to optical reality could nullify the individual's apprehension of beauty. Wey proposed giving preference to paper photography, "which allows more initiative and sets

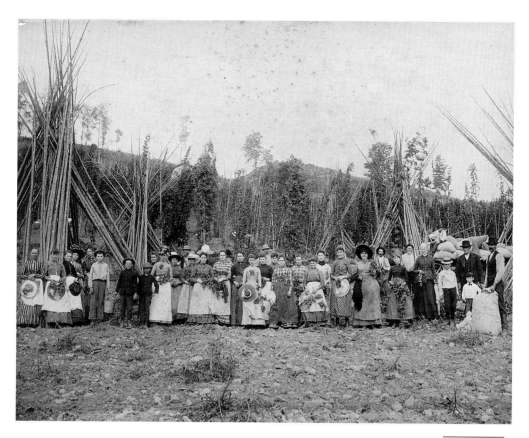

FIGURE 27

Wade Lawrence,
*Lyman Bush's Hop
Yard, LaFayette, New
York,* 1887. Courtesy
of the J. Roy Dodge
Collection, Syra-
cuse, New York.

to work more talent on the part of the practitioner than the da-
guerreotype."[57] The latter imaging method, he asserted, was too re-
alistic, too impressed by the appearance of the physical work, to
spark the spirit. Art, he argued, consists not in strict delineation of the
real, but in metaphysical interpretation. The discerning intelligence
and unique personality of the artist create an image that inculcates
the essence of the scene or sitter. In the future, Wey speculated, the
human intellect might achieve artful photographs of artifacts, but he
was certain that there would never be photographs of nature or of
people than could rightfully be called art. A mechanism, Wey con-
cluded, can depict the works of human beings, but not the works of
God.[58] Photography's friends frequently admitted the medium's in-
herent restraints.[59] In part, their caution sprang from the experience
of photographic practice. Also, their measured admiration for pho-
tography rested on the religious notion that human inventions cannot
rival those of the deity and must not seek to do so.

Antoine Claudet, an early daguerreotypist, expressed photogra-
phy's limitations in relation to the fine arts. Admitting that a sensitive
photograph can capture the poetry of nature, Claudet nonetheless
contended that "poetic art possesses a power that photography does
not; one creates, the other copies."[60] Philippe Burty, a frequent re-
viewer and critic for the cautious *Gazette des Beaux Arts,* warned that
"photography carries with it indelible traces of its mechanical ac-

tion."[61] Similarly, the American painter Rembrandt Peale regretted the chilly impartiality of the daguerreotype. "We do not see with the eyes only," Peale admonished, "but with the *soul.*"[62] Eugene Delacroix, who occasionally used photography as an aide-mémoire for his paintings, and who was a founding member of the French Heliographic Society, was comparably disposed. He made a crucial differentiation between the perception that occurs in the union of the eye and mind and that which occurs because of the lens and film. The camera, which Delacroix often called "the machine," reproduces images that are so exact that they are untrue to human perception. The mind filters and emphasizes, whereas the machine does not. The full use of the sensibilities to seek out the essence of the person or the object portrayed, to engage the world and other persons with one's own distinctive spirit, must be the goal of painters. For Delacroix, the intractable verisimilitude of photography forbade a dialogue of soul speaking to soul, the central activity of art.[63]

Even the ardent art photographer Gustave Le Gray found it essential to promote photography not for itself, but for its utility to artists and its capacity to perfect public taste. In the preface of the 1852 edition of his *Photographie: traité nouveau théorique et pratique des procédés et manipulations sur papier . . . et sur verre,* Le Gray suggested that the influence of photography on painting would be immense and positive because at the same time that photography clarifies the difficulties of art, for the painter, it refines public taste by accustoming the public to see the fullness of nature.[64] Correspondingly, Robert Hunt warranted photography because its replication of nature brought about "an improvement in public taste," and Francis Wey asserted that the new medium would not only raise public taste but would also eliminate illustration in other graphic arts.[65] Neither Le Gray nor Hunt nor Wey believed that verisimilitude produced good painting. The photographic effect that they did laud was not visual, but social – the long-term cultural elevation of mass society.

English advocates of photography also cautioned about its poten-

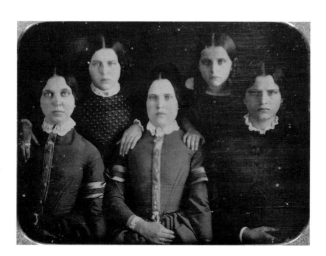

FIGURE 28

Unknown Photographer, *The Park Sisters,* 1849. Courtesy of the J. Roy Dodge Collection, Syracuse, New York.

tial threat to the intellect and to moral sense. As Hunt natured-
ly observed: "Few men could paint as the sun paints; it is not to be de-
sired that they would so, since the expenditure of time in producing
all this wonderful detail would swallow up too much of a man's life,
and it would, we fear, as a final result, produce marvellous mecha-
nism, to the sacrifice of mind."[66] Moreover, Hunt ventured that

> the result of taking a photographic study as a guide in the produc-
> tion of a work of Art, is that however perfect the finished picture
> may be, it will want the evidence of MIND. No picture was ever paint-
> ed – no matter how great the mechanical dexterity may have been
> by which it was produced – *which could live as a work of Art,* unless
> it bore the impress of thought.[67]

The debate about photography's impact on art and place among the
arts echoed in 1853, the first year of *The Journal of the Photographic
Society.* An abstract of a paper by John Leighton conveyed the idea
that photography was too literal to compete with works of art. Like
many of his colleagues, Leighton reasoned that "sun pictures" could
elevate public taste indirectly, "by rendering us more familiar with na-
ture's infinite beauty, and educate the eye by presenting her transient
forms and effects in all their variety, imprinted by her own hand with-
out fear or favour, causing true art to be better appreciated and more
widely understood."[68] In his 1863 essay "On Photography as a Fine
Art," delivered to the annual meeting of the British Photographic So-
ciety, W. D. Clark remarked that the high feelings surrounding the is-
sue of photography's art status prevented photographers from clear-
ly assessing the standing of their medium. Addressing photography's
claim to be the equal of painting, Clark wrote that the medium,
"looked upon as an intellectual pursuit, is far inferior to that noble art
[of painting]."[69]

Photographic verisimilitude, conceded to be a problem by many of
the medium's friends, became a bludgeon in the hands of photogra-

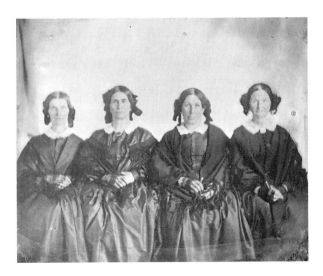

FIGURE 29

Unknown Photogra-
pher, *The Daughters
of Seth Baker,* n.d.
Courtesy of the
J. Roy Dodge Collec-
tion, Syracuse,
New York.

phy's enemies. Henri Delaborde, curator of prints for the Bibliothèque Imperiale, declared that contemporary art was decadent because it reduced the talent of the artist to that of a mere copyist. Naturalism, he observed, distracted the public taste from the good – that is, the morally good – and substituted truth to optical reality for truth to moral principle. To Delaborde, photography was an ally of the forces of decline.[70] In a series of articles devoted to the Exposition of 1850 (Paris), published throughout the winter of 1851 in the *Journal des Débats,* the critic Etienne-Jean Delécluze cited the drift toward naturalism as pernicious to high art. He saw photography, which he viewed as a science, changing the tastes of artists and patrons. By its example, photography prescribed a dogged and enervated imitation of the real.[71]

Declinist arguments embraced the idealism of generally accepted art theory, a stiff and simplified version of the art principles of the English painter Sir Joshua Reynolds. Reynolds's posthumous influence was substantial, as evidenced by John Ruskin's need to tackle his teachings in the third volume of *Modern Painters,* which appeared in 1856.[72] Certainly, Reynolds survived in the minds of the rebellious painters of the Pre-Raphaelite Brotherhood, for whom Sir Joshua was the silly Sir Sloshua, so called because the academician urged young painters to learn to correct the imperfect and blemished particularities of nature, to abstract the perfect form from the imperfect incidentals of optical perception.

A clever dialogue appearing in the English *Art Journal* for 1858 underscored the extent to which photography's social consequences were calibrated by the rules and assumptions of academic art. Its introductory summary quotes Reynolds on imitation in art, a position the dialogue writer does not find diminished by the fact that Reynolds died nearly fifty years before the official disclosure of photography. The *Art Journal* article asserts that "the *body* of photography is incompetent to maintain its existence in antagonism with the *soul* of Art: that no mechanical process can long supersede the living agency of man's mind."[73] From Reynolds's thoughts, the dialogue writer may readily have fetched the remarks of his protagonist, the Artist, who in the manner of Baudelaire scorns democratic taste. In conversation with a no-nonsense Philistine, Mr. Dogberry, the Artist announces: "I do not speak to the million, but to the educated and intelligent thousand, more specially to a select portion of it."[74] The dialogue, which unfolds into something of a monologue by the self-absorbed Artist, concludes with an extensive quotation from an article in the *Quarterly Review* of 1857, which we now know to be the work of Lady Elizabeth Eastlake.

Lady Eastlake, who wrote a substantial body of art criticism, also employed Sir Joshua Reynolds's concepts to explain the relationship of photography to art. In her brief history of the medium, she argued that photography progressed from small, generalized, and somewhat vague views and portraits, like those of David Octavius Hill, to large

views and portraits that are thick with detail. In Lady Eastlake's opinion the earlier products of photography were more artful because they were less specific.[75] She suggested that as photography progressed mechanically and chemically, it regressed artistically.[76] The debasement of art photography was a direct response to the decline of public taste. Eastlake judged photography to be "made for the present age, in which the desire for art resides in a small minority, but the craving or rather necessity for cheap, prompt, and correct facts [resides] in the public at large."[77] What photography "does best is beneath the doing of a real artist,"[78] Eastlake concluded.

Ironically, Eastlake thought photography's only acceptable role in relation to art was as the means by which the public might realize what art is not: "If, therefore, the time should ever come when art is sought, as it ought to be, mainly for its own sake, our artists, and patrons will be of a far more elevated order than now: and if anything can bring about so desirable a climax, it will be the introduction of Photography."[79] With William Newton, a painter and photographer whom she admired, Eastlake helped to promote an intentionally anachronistic photography, one in which "pictures [were] taken slightly out of focus, that is with slightly uncertain and undefined forms,"[80] by employing an out-dated technology.

A comparable opinion was voiced two years later in *The Athenaeum*. Reviewing the Sixth Annual Exhibition of the London Photographic Society in January 1859, the journal found much to like, yet declared "the obstinate fact that while the sun-machine has eyes keen as an angel's, a hand swift, sure and fluent, it has no soul, no heart and no intellect . . . it can but copy, – create it never can . . . to shape out an ideal purity, nobleness or bravery, that it will do – *never*. It is at best an angel copier; a god-like machine of which light and sunshine is the animating Promethean fire. Put it higher, and you degrade Art to the worshipper of a machine."[81]

From time to time, the arguments that built against photographic verisimilitude embraced ideas associated with the art for art's sake movement, itself partly a reaction to industrialization, urbanization, and the emergence of mass culture.[82] Articulated by critics such as Théophile Gautier,[83] the movement proclaimed that the adherence to fact in art was a crime against beauty and a capitulation to stultifying bourgeois utilitarianism. As photography increased its technical capacity to render optical reality, this otherworldly aestheticism surged.

Photography was easily allied with the naturalist school of art, which critics before and after the advent of photography associated with the machine and with mechanistic thinking. An unsigned *Art-Journal* review of the London Photographic Society Exhibition for 1857 opined:

> With the Photographic Exhibition it is not necessary to speak of individual works as we would of the production of painters. The

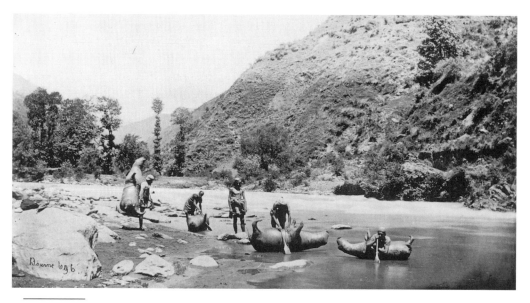

FIGURE 30

cases are not parallel: the painter employs, or should employ, eye and hand, governed by a presiding mind; the photographer uses a machine, and requires a little judgment.[84]

During photography's first quarter century, with some important exceptions, individual photographs were lumped together and discussed as photography. In other words, the abstract idea of photography, with its many connotations, figured strongly in exhibition reviews, and reviews extolling individual photographs might nonetheless disparage the medium. Critics praised and dismissed photography at the level of generalization.

Like scientific and technical illustration, photography confronted art at a basic level.[85] Francis Frith, an English photographer, tellingly remarked that "some [artists] who hailed it [photography] as a beautiful thing, and who even made a partial and timid use of it, have harboured it as they would a tame snake; giving it a good switching now and then, lest it should grow rampant and bite."[86] Photography was both the child and the agent of the new scientific perception and, as such, a surrogate defendant in the debate about the relationship of humans to nature. To idealists, be they artists, clerics, or critics, photography was reductive, presenting a false picture of a demystified and totally material nature. Even though individual photographs might celebrate ancient copses and misty mountains, photography threatened that the trees were trees and the mountains only geological phenomena. The passion and duration of the nineteenth-century debate about photography as an art were not just reflections of an incidental, amusing Luddism. Photography was a technology that provoked a rethinking of humankind's relationship to nature.[87] Its instantaneous imaging challenged how people thought about the world. Photography abrogated idealistic philosophies and their attendant

notions of transcendent realities. It proclaimed the truth of the senses and of the palpable world. After 1839 photography became an important proxy for the effects of science, technology, and popular democracy. Although the antagonism was played out in aesthetic terms, it was never far from a larger societal resonance.

Oddly enough, what critics saw as photography's truth to optical reality helped to identify appropriate uses for the medium. "Vile photography," as Monsieur de Saint-Santin called it in mock disgust, did a fine job in reproducing art, so much so that engraving and lithography must be doomed.[88] "Photography has spoiled us," Saint-Santin wrote. "We want more than a facsimile, we want the thing itself."[89] Because engraving and lithography produce less exact art reproductions, Saint-Santin predicted their imminent demise, "There is nothing left to do but dress them for the funeral."[90] Philippe Burty consistently commended photographic art reproductions, despite his having some uneasiness over the occasionally salacious carte de visite. Like Saint-Santin, Burty suggested that photography would deal the final blow to art reproductions rendered by engraving or lithography.[91] It is important to note that neither Burty nor Saint-Santin blamed photography for the sad state of printmaking. Instead, each suggested that printmaking was in decline because, like photography, it had been trivialized through slavish imitation and because it responded only to the base promptings of the marketplace.[92]

Photography's friends regularly argued that the medium produces images that are preferable to those made by inferior artists. In France, Francis Wey made this assertion, claiming that photographic portraits were preferable to those produced by mediocre talents.[93] In England, one writer suggested that "if photography destroys vulgar miniature painting that will be no loss to Art, no more than if chromolithography should destroy the mere painters of plums and grapes."[94] Another proposed that "photography will, we hope, in time entirely destroy all necessity of men wasting their time in painting still-life."[95] In *The Athenaeum,* where high art values were often proclaimed against the mechanical interloper, one booster of photography mixed his metaphor in praise of the medium's potential: "If photography turns the sticking-plaster portrait cutters and such into photographists, all the better for both arts. Art will be weeded, and the crop grow all the stronger for the healthier plants having more light, air, and elbow room"[96]

## DEMOCRATIC ART

In 1839, Samuel F. B. Morse, who helped to popularize the daguerreotype in America, wrote to Washington Allston that "art is to be won-

derfully enriched by this discovery." "How narrow and foolish," he continued, "the idea which some express that it will be the ruin of art, or rather artists, for everyone will be his own painter." Morse contended that the daguerreotype would improve art and taste by making nature the measure of artistic representation.[97] As noted in Chapter 1, Emerson concluded that photography was the true "Republican" art because it allowed one to do one's own portrait.[98] The emphasis on democratic opportunity found in Emerson's opinion reverberated in nineteenth-century defenses of photography, especially in the United States, where class lines were less established than in Europe.

To many, photography's capacity for art education outweighed the danger it might pose in lowering public taste. The British photographer William Lake Price extolled photography as enabling "the diffusion of knowledge and the creation of a feeling for Art."[99] Charles Blanc, founding editor of the *Gazette des Beaux Arts,* saw the photographic reproduction of art works as a means to "decentralize" knowledge of great art.[100] Between 1853 and 1858 Blanc worked on an album of photographically reproduced works by Rembrandt, which eventually totaled one hundred photographs. "The best use that one can make of photography and the most noble use, is assuredly to employ it in the reproduction of the enduring masterworks of art,"[101] Blanc asserted. Henri Delaborde, who had written that naturalism would distract the public taste from moral good, grudgingly allowed that there were educational benefits to be had from photo-

FIGURE 31

Unknown Photographer, *The Ogle Brothers,* n.d. Courtesy of the J. Roy Dodge Collection, Syracuse, New York.

graphic reproduction of works of architecture and architectural sculpture.[102] Delaborde's admission is impressive because he touted the superiority of printmaking over photography for the reproduction of paintings and prints. The printmaker, Delaborde argued, gave needed interpretation to works of art. Through interpretation, the artist maintained the role of teacher and improver of culture. Moreover, *la réalité brute,* unrefined reality – raw nature, or exact reproduction of a painting – impressed Delaborde as mechanical, as lacking in human sentiment, taste, and thought.[103] Like Delaborde, Lady Eastlake eased her doubts about photography with the thought that the medium could be "the purveyor of . . . [factual] knowledge to the world."[104]

## THE ORDINARY PHOTOGRAPH

Photography did not mature as the democratic art imagined by Morse or Emerson. Instead of resulting in every person's being a painter, photographic practice professionalized and commercialized. In the mid-nineteenth century, photographic studios and traveling "operators," as photographers were called, served the majority of clients. Amateur photographers, whose sometimes painterly use of the medium did emulate elements of art practice, were too few to be seriously influential. Even High Art Photography, the attempt to construct a morally persuasive photography, did not have the social influence of the common photograph. Ordinary uses for the common photograph were quietly revolutionary. The quotidian function and experience of photography shaped photographic discourse as surely as did attempts at art photography and their accompanying theory.

The practice of postmortem photography readily demonstrates how non-art uses of the medium steered conventional ideas about photography. Postmortem photography had precedents in painting and drew on the elaborate mourning rituals of the Victorian era. Especially in the 1840s and 1850s, when relatively few people had been photographed, postmortem photography was a reasonable response to life's most unreasonable situation. The deathbed photograph gave a family a chance to hold fast the appearance of a loved one in a form deemed more reliable than human memory. As Jay Ruby observed in his study of funeral photography, "Prior to 1880 [postmortem photographs] concentrated on the facial features of the deceased."[105] Advertisements for postmortem photographs and remarks by their viewers emphasized the way in which these photographs permanently registered likenesses.

The concept of likeness was widespread in photographic portraiture.[106] It referred not only to physical resemblance but also to the

idea that the photograph and the person pictured shared personal qualities. Through its extensive reiteration, the concept bolstered the initial associations of photography with magic, the double, and totems. Though portrait photography in the mid-nineteenth century was reminiscent of portrait painting and portrait miniature painting, its sheer ubiquity made it unlike any preexisting medium. Letters and diaries of the time, as well as references in fiction, testify to the intense study of portrait photographs. The sitter's presence seemed to be almost palpable to the viewer. No medium fully presaged the common photograph's ability to externalize memory or to produce mass-mediated images conceived of as genuinely akin to actual experience. About this, the literary historian Terry Castle has gone so far as to suggest that the medium fulfilled "a deep preference for the phantoms of the mind." She declared photography to be "the first great breakthrough – a way of possessing material objects in a strangely decorporealized yet also supernaturally vivid form."[107]

Oliver Wendell Holmes, the American doctor, writer, and amateur photographer, articulated the changing relation of photography and memory in a series of *Atlantic Monthly* essays. For Holmes, photography was the fulfillment of ancient human longing and speculation, "It has fixed the most fleeting of our illusions . . . ," and become "the *mirror with a memory*,"[108] which surpasses human memory: "Our own eyes lose the images pictured on them. Parents sometimes forget the faces of their own children in a separation of a year or two. But the un-

FIGURE 32

Unknown Photographer, *Woman with Dead Infant*, n.d. Courtesy of the J. Roy Dodge Collection, Syracuse, New York.

fading artificial retina . . . retains their impress. . . . How these shadows last, and how their originals fade away."[109]

An exuberant technocrat, Holmes saw photography as a progressive step beyond the "murderous doings" of "those wandering Thugs of Art,"[110] the itinerant painters who traveled through the country producing platitudinous images: "No picture produces an impression on the imagination to compare with a photographic transcript of the home of our childhood. . . . The very point which the artist omits in his effort to produce general effect may be exactly the one that individualized the place most strongly to our memory."[111]

Alert to the common responses to photographs, Holmes verbalized the experience of human memory and contrasted it with the memory-like appearance of the photograph. Remembered events and places are often recalled in still mental images. Stirred by one or another association, memory images are nonetheless general, that is, they do not teem with detail in the way that photographs do. To Holmes the pungent specificity of the photograph was an improvement in memory, promising to enlarge human experience. Rather than auguring a dystopian capitulation to mechanization, the photographic externalization of memory promised to reveal moments of time and aspects of appearance undiscerned by normal human perception and attention.

Holmes thought individual photographs capable of totalizing scenes, moments, and objects. For him, depersonalized memory was the kind of neutral vision forecast at photography's advent. With others of his time, such as the geologist Edward Hitchcock, Holmes proposed that previously invisible aspects of age and family resemblance would become components in a new scientific documentation. Moreover, depersonalized memory offered a new and better kind of communication. "A new form of friendship" has been made possible Holmes wrote, "A photographic intimacy between two persons who never saw each other's faces."[112]

Holmes's enthusiasm recalls Jean-Jacques Rousseau's aspiration for human communion, but it is a desire emboldened with a passion for the efficacy of information. In Holmes's "conceivable, if not possible future," "*Form is henceforth divorced from matter.*" Through the magic of photography, form slips from its supporting shape, leaving the original intact: "Every conceivable object of Nature and Art will soon scale off its surface for us. Men will hunt all curious beautiful, grand objects, as they hunt the cattle in South America, for their *skins,* and leave the carcasses as of little worth."[113] Holmes saw an information revolution latent in photography, "Matter in large masses must always be fixed and dear; form is cheap and transportable."[114] He contended that photographic representations would superannuate their subjects. "There is only one Coliseum or Pantheon," he wrote, "but how many millions of potential negatives have they shed, – representatives of billions of pictures." He foresaw an age that would demand:

FIGURE 33

Unknown Photographer, *Arc du Carrousel, Paris* (stereograph), n.d. Collection of the Author.

"Give us a few negatives of a thing worth seeing, taken from different points of view, and that is all we want of it. Pull it down or burn it up, if you please."[115] In effect, Holmes dissolved the distinction between memory and history.

Holmes's notion of a past forcefully discarded by technological change erupted again in the Italian futurist movement before World War I and, later, in the technocracy movement of the 1930s. It remains, even in jaded late-twentieth-century thought, a powerfully attractive vision of the world streamlined and transformed by technology. Its persuasiveness has been reckoned in the promise of television, cable television, genetic engineering, space colonization, and Computopia. Since the Industrial Revolution, the aesthetic dandy has been matched by a technological man about town, who is associated with the future through some device or science.

Holmes expressed his thoughts about photography in relation to stereographic photographs, whose illusion of depth and three-dimensionality granted photography an even greater verisimilitude. Countless stereographs were produced in the late 1850s and 1860s. In abundance, stereos were rivaled by cartes de visite, or card photographs. These inexpensive, 4- by 2½-inch mounted photographs resembled calling cards and were produced by the millions. As had been true for the daguerreotype and the variety of paper photographs, the personal portrait was the most popular kind of carte photograph. The camera that was used to execute cartes allowed the sitter to have several poses on one photographic plate. As the vogue expanded, other

FIGURE 34

A. A. E. Disdéri,
*Princess Gabrielli,*
n.d. Gernsheim
Collection, Harry
Ransom Humanities
Research Center,
Austin, Texas.

kinds of images, such as popular paintings and lithographs, were photographed and offered in carte form.

Cards or cartes not only increased the number of personal portraits available to the public, they also greatly increased public access to views and to celebrities. Before cartes, daguerreotypists had displayed portraits of prominent citizens and entertainers, and illustrated newspapers showed engravings of famous persons and important incidents. But the wedding of photographic verisimilitude to the production volume of the carte de visite helped to shape the modern demand for visual mass media. With stereo photography, the carte potentially verified everything from natural disasters to the playthings of royal children. Framed in the language of democracy by critics like Holmes, this vast capacity seemed like a political entitlement. However voyeuristic, the right to look – and the necessity to make the world visible – were aspects of the mid-nineteenth-century understanding of modernity.[116] Allied with the interdependent concepts of natural and neutral vision that suffused photographic discourse, looking became a perquisite of modern life.

The sheer number of images available to the public through cartes and stereos necessitated, as it does for elements of contemporary mass media, that the images be physically and symbolically disposable. Produced cheaply and in anticipation of public taste, many images were destroyed even before they left the stockroom. The format of the carte photograph aided in its disposal. Unlike daguerreotype

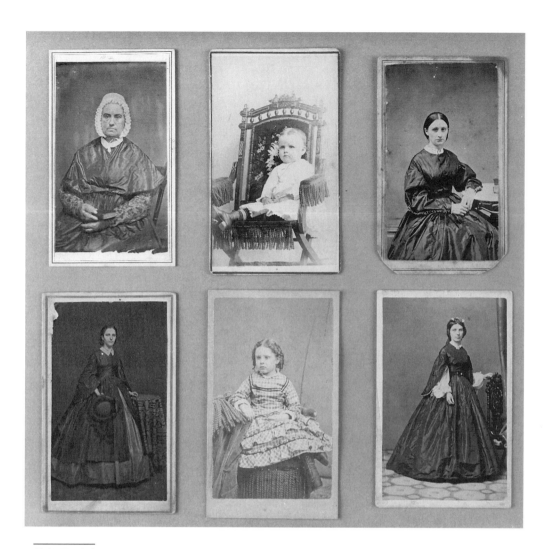

FIGURE 35

portraits and the best portraits of paper photography, cartes usually showed a full figure standing in the midst of accessories. The viewer was to judge the sitter, as Holmes had foreseen, by the array of items, not by the face, which was often difficult to make out in detail. Carte photography was not character photography. It encouraged the sitter to display a public face and discouraged spontaneous poses and gestures. Because cartes often show sitters in conventional stances with studio furniture and backdrops, nuances of gestures and expression were often diluted.

The card photograph was a medium of choice for the upwardly mobile and the parvenu, who quickly learned to manipulate its apparent verisimilitude. Politicians also appreciated the benefits of a media image divorced from troublesome peculiarities of appearance. Cartes accommodated the established nineteenth-century practice of invoking a language of shorthand symbols or stereotypes. Just as Victorian

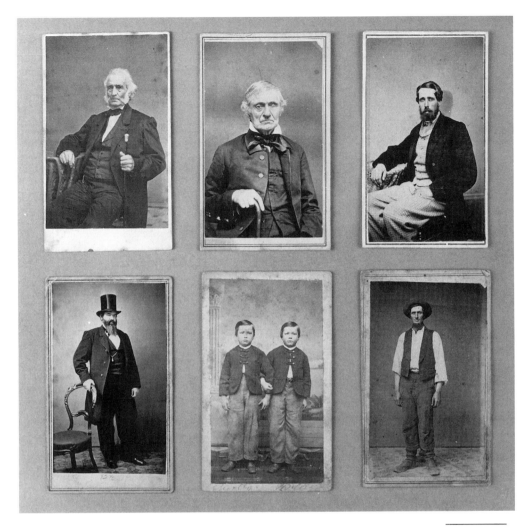

novelists hinted at the moral makeup of their characters through physiognomic traits, the carte compressed information into stereotypes. In the popular mind, physiognomy became synonymous with anthropological investigation, which, in turn, assisted the classification of human cultures by race, gender, and physically observable attributes.[117] At the same time, the carte photograph increased the fetishistic qualities of the photograph. Even though it was often of inferior quality, in popular parlance the photograph remained a unique trace of the sitter. Commodification did not dampen this sentiment. To have an image of Queen Victoria or President Lincoln was to evoke the sitter's presence, to be, in some small way, part of her or his world. The modern attitude that amalgamates owning images with controlling images developed in the middle years of the nineteenth century, increasing the understanding of photographs as tokens of people, places, and things.

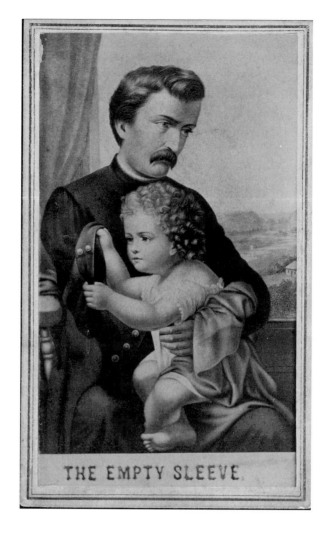

FIGURE 37

Unknown Artist,
*Carte de visite
of a Lithograph of
"The Empty Sleeve,"*
c. 1865–1880. Cour-
tesy of the J. Roy
Dodge Collection,
Syracuse, New York.

## CONCLUSION

Roland Barthes found it paradoxical that "the same century invented History and Photography." The photograph, Barthes thought, "is a certain but fugitive testimony," chafing the "pure intellectual discourse [of History]," "which abolishes mythic Time."[118] But Photography partook in History. The photograph held time in a frame. In the midst of modernization, photography suspended time, making each installment hypothetically knowable. The intense visibility of the photograph implied that the present was more measurable and the future more controllable than the past had been. Photographs lent a tempting continuity to the discontinuities of change. They marked the progress of change and cushioned the jolts. On an individual level, photographs eased the sorrow of urban anomie and the homesickness of travelers and immigrants. Even the commercialization of pho-

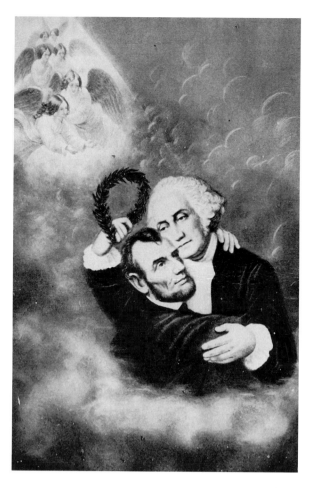

FIGURE 38

Unknown Artist,
*Carte de visite
of a Lithograph of
George Washington
Welcoming Abraham
Lincoln into Heaven,*
c. 1865–1880. Cour-
tesy of the J. Roy
Dodge Collection,
Syracuse, New York.

tography worked to assure the impression of stability and pre-
dictability. In the face of "revolutions, contestations, assassinations,
explosions, in short . . . of everything which denies ripening,"[119] the
ubiquity of stereographs and cartes de visite gave assurance that
everyone wanted the same thing. Make no mistake, the thing wanted
could be corrupting on a personal and societal level. But the same-
ness lent a grim hope that modernization was not anarchic self-
interest. It had pattern. In an important sense, the common use of the
common photograph vouched for the continuity of the personal as
well as the public past with a rapidly emerging future.

# ART, PHOTOGRAPHY, AND SOCIETY

## INTRODUCTION

The social dialogue about photography and modernism was amplified by a concurrent discussion of photography's stature among the arts. The debate about photography, art, and society was earnestly felt and genuine in its arguments. At the same time, the exchange about photography's place and influence on art was a surrogate for larger social topics, such as social mobility, democratization, the consequences of industrialization, and the relation of capitalist societies to their pasts.

Unqualified commendation for photography's relation to art was scarce in the mid-nineteenth century. Purple prose like that written by an exhibition reviewer for an 1857 issue of the English *Journal of the Photographic Society* is rare:

> Photography is an enormous stride forward in the region of art. The old world was well nigh exhausted with its wearisome mothers and children called Madonnas; its everlasting dead bodies called Entombments, its wearisome nudities called Nymphs and Venuses; its endless porters called Marses and Vulcans; its dead Christianity, and its deader Paganism. Here was a world with the soil fainting and exhausted; worn by man, into barrenness, overcrowded, over-housed, over-taxed, over-known. Then all at once breaks a small light in the far West, and a new world slowly widens to our sight – new sky, new earth, new flowers, and a very heaven compared with the old earth. Here is room for man and beast for centuries to come, fresh pastures, virgin earth, untouched forest; here is land never trodden but by the angels on the day of Creation. This new land is Photography, Art's youngest and fairest child; no rival of the old family, no struggler for worn-out birthrights, but heir to a new heaven and a new earth, found by itself, and to be left to its own children.
>
> For photography there are new secrets to conquer, new difficul-

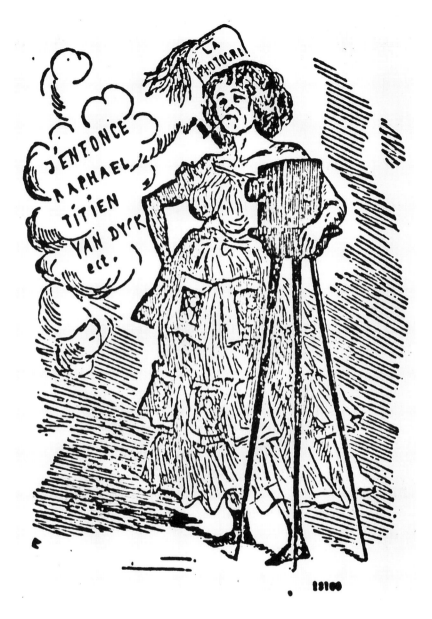

FIGURE 39

Marcelin, *"J'enfonce
Raphael, Titien, Van
Dyck, ect,"* Journal
Amusant, No. 36
(1856). Courtesy of
Sandra Stelts, Penn-
sylvania State Uni-
versity Library.

ties to overcome, new Madonnas to invent, new ideals to imagine.
There will be perhaps photograph [*sic*] Raphaels, photograph [*sic*]
Titians, founders of new empires, and not subverters of the old.[1]

More an argument-by-assertion than anything else, this passage
nonetheless identifies photography as the successor to art. Swamped
in its effusions is an idea, reiterated by writers and photographers,
that photography is a unique medium with its own strictures and
strengths. Reviewing their early years of photographic practice, the
Parisian photographers Mayer and Pierson wrote that the medium
was endowed with singular capacities, ones that did not duplicate the
vocabulary or potential of painting.[2] The authors shrewdly observed
that photography was too often understood as synonymous with its

subject matter, condemned for what it delineated, not for what it was inherently.[3] Similarly, an early treatise by the photographer Philip H. Delamotte declared that photography's "processes and manipulations require a nicety and delicacy unknown in any other art whatever."[4] A. A. E. Disdéri, the instigator of carte de visite photography, was comparably impressed with what he deemed the unprecedented language of photography.[5] Lady Eastlake, although convinced that photography would never become a full-fledged art, recognized the medium's uniqueness, calling photography "neither letter, message, or picture," but a "new form of communication."[6] Analogously, when the critic Phillip Hamberton denounced photography as no peer of painting, he still acknowledged the socially beneficial aspects of the medium. Hamberton crisply proclaimed that "photography and painting are for ever independent of each other. . . . each has its own path."[7]

Intellectual efforts to partition photography and art miscarried, punctuating the perception of photography as a threat to art. Rather than a way of insulating the new medium from association with the fine arts, the critical recognition of photographic realism was an issue in itself. In addition, verisimilitude came to betoken the controversy about realism that was already aligned with middle-class taste and commercial culture.[8] After all, Baudelaire's severe rebuke to photography was not grounded in an objection to the medium's record keeping per se, but in the presumption that naturalistic representation would blunt human imagination. Baudelaire sensed what would become a continuing criticism of realism: that it dumbed down the Western tradition, compelling artists to depict only familiar appearances and commonly held ideas. With John Ruskin, Baudelaire complained that photography was fact, agent, and symbol of a mass society that would inhibit the subtleties and individual insights of art. One response to the critique of photography as a morally flaccid medium was High Art Photography.

## HIGH ART PHOTOGRAPHY

In his 1861 article "On Art Photography," the American photographer C. Jabez Hughes arranged photographic practice in a tripartite system. The most utilized aspect of photography, which Hughes called mechanical or literal, relied on the notion of photographic automatism. It included "all kinds of pictures which aim at simple representation of objects to which the camera is pointed." Hughes endorsed the reality effect of mechanical photography. "Everything . . . is to be depicted exactly as it is, and . . . all the parts are to be equally sharp and perfect," he wrote, carefully adding that he meant no derision by calling such pictures mechanical.[9] Hughes's middle category, art pho-

tography, described "all pictures when the artist, not content with taking things as they may naturally occur, determines to infuse his mind into them by arranging, modifying, or otherwise disposing them."[10] The last type that Hughes listed is what he called High Art Photography, a class of "pictures which aim at higher purposes than the majority of art-photographs, and whose aim is not merely to amuse, but to instruct, purify, and ennoble."[11] In this formulation, the middle group, art photography, mediates between the imitative and the moral.

The first and last components of Hughes's paradigm, mechanical photography and High Art Photography, allude to outside standards against which one can measure their success: respectively, the appearance of the world and conventional rectitude. But art photography as defined by Hughes has no apparent outside standard other than personal inclination. It recognizes the photographic practice of leisured, amateur photographers as well as the commercial efforts of artist-photographers such as Gustave Le Gray.[12] Art photography prospered insofar as it was seen to proceed from a special sensibility called imagination, genius, or taste.

High Art Photography diluted the importance of imagination and individual expression. In a sense, High Art Photography was a response to critics who saw photography as primarily imitative by relinquishing a major claim on the imagination. Instead, High Art Photography ventured to find its place among the many social betterment schemes of midcentury. If High Art Photography could not claim to evince superior human creativity, it could at least try to improve society, one viewer at a time.

As noted in Chapter 2, the daguerreotype said to have caught Turner's eye in Mayall's shop window was a High Art photograph, the kind of photograph that Mayall had been making since the early days of photography. For example, in 1843 Mayall produced interpretive views of the Lord's Prayer. In one picture, a weary pilgrim receives his daily bread from the hands of a child. Mayall also composed illustrative views based on history or taken from poetry.

Though seldom understood in this way, High Art Photography was a kind of *gesamtkunstwerk*. Like opera, it orchestrated separate media. High Art photographs blended theater, printmaking, and painting with photography. Actors or other players were posed singly or in a *tableau vivant*. Interestingly, specific paintings were only occasionally replicated in High Art Photography. For the most part, these images rendered original conceptions, illustrating religious or moral precepts often in the manner of maudlin genre painting and popular Victorian prints. By partaking in the established didactic function of the fine arts, High Art photographers attempted to skirt objections to the medium's inartistic verisimilitude.

The nineteenth century's most publicized High Art photograph, Oscar Rejlander's "Two Ways of Life" (1857), is composed in a clear, intellectual pattern that Rejlander, who worked as a copyist in Rome,

appears to have derived from Raphael's *School of Athens.* In the photograph, a bearded Sage introduces a Disobedient Youth and a Good Youth to life in the city. On the viewer's left, scantily draped Sirens, Idlers, and other tempters and layabouts quickly get the wayward youth's attention. On the right, the Good Youth looks as though he is less engrossed by the respectable representatives of Religion, Industry, and Married Life than by the sinners. The photograph's narrative development is more successful when considered in its original scale, 31 by 16 inches. In reproduction, its size contracted to that of a postcard, "Two Ways of Life" seems to be little more than a simplistic homily.

The "Two Ways of Life" brings into focus the dilemma of High Art Photography and photography in general. Critics rebuked High Art Photography on the basis of both its factuality *and* its lack of factuality. The picture could not escape being seen as an objective imprint of what transpired before the camera. The nude figures in the photograph gave offense. These models, recruited from Madame Wharton's "Pose Plastique Troupe," were recognized as real persons caught in a state of undress and lewdly disporting themselves.

In addition, the photographic techniques used in "Two Ways of Life" was not, in the usual sense, photographic. "Two Ways of Life" was a combination print worked up from many negatives, rather than an image produced by only one exposure. Combination printing disturbed what was understood to be the automatic character of the medium, and, despite Le Gray's use of the technique, it was openly discouraged in French photographic circles.[13] The reactions to "Two Ways of Life" disclose the quandary in which photography found itself. On the one hand, practitioners of the medium were urged to stick to images of observable reality. On the other hand, the literalness of photography's delineation of observable reality denied the medium credit for originality and prevented it from being considered a fine art.

Exhibition reviews reveal the contradictory attitudes toward High Art Photography. *The Athenaeum,* for example, praised Rejlander, noting that he had "left mere photography far behind." "Life," as the journal's reviewer called "Two Ways of Life," was "in many points masterly – worthy to be painted as a fresco." Yet the imitative quality of the photograph disturbed the writer, "The beings of photography are *all* of clay, and the sun brings out their imperfections."[14] A later *Art Journal* reviewer wrote approvingly of the quality of Rejlander's effort, yet concluded: "We do not, however, desire to see many advances in this direction. Works of high Art are not to be executed by a mechanical contrivance. The hand of man, guided by the heaven-born mind, can alone achieve greatness in this direction."[15]

It is important to note that the basic elements of this critical response had coalesced before Rejlander produced "Two Ways of Life." Criticism that had emerged in response to prior High Art photographs by Rejlander and others was readily available to greet the picture when it was exhibited in 1857. Commenting on works submitted by

FIGURE 40

O. G. Rejlander, *Two Ways of Life,* c. 1854. The Royal Photographic Society, Bath, England.

Rejlander and William Lake Price to an 1856 exhibition at the London Photographic Society, Robert Hunt summed up the contrary public response to *tableaux vivants* and to High Art Photography: "They are wonderfully clever, but after all they are but the images of actors posed for the occasion; they all want life, expression, passion. Passion they have none, and yet these pictures tell a pleasing tale."[16] However much critics concurred with the reform aspirations of High Art Photography, they typically shared Hunt's opinion that the wrong thing was unintentionally being taught by the effort. "We doubt the propriety of attempting to rival the historical painter," Hunt wrote:

> We believe, indeed that such pictures as those will have a tendency to lower the appreciation of Art in the eyes of the public, and unfit them for receiving the full impression intended by, or of seeing the beauties of, the artist's production. We do not mean to disparage the works of Mr. Price or of Mr. Rejlander, they are excellent of their kind, but our love of High Art leads us to desire not to see too many of this class of subjects.[17]

Despite the ardor of its rhetoric, High Art Photography did not nullify the understanding of photography as a special kind of copy, a facsimile of the real world. The effort to balance or to override photographic verisimilitude with appeals to morality backfired, fortifying the indictment against the medium as an inartistic, mindless mirror. High Art Photography inadvertently underscored the ongoing critique of photography as a limited medium, ill-suited to serious thought and human creativity. During much of the nineteenth century, imagination and moral excellence were understood as values existing on the same exalted plane. The absence of one implied the absence of the other. Photography's presumed inability to produce imaginative works or didactic works implied that even its non-art purposes were somewhat shady.[18]

In general terms, High Art Photography was symbolic terrain upon which mid-nineteenth-century progressives and conservatives contested. To some critics, the promise of moral uplift through the visualization of ennobling scenes and sentiments was not a social advancement, but a parody of cultural attainment. In "The Salon of 1859," Baudelaire saved his most stinging charges for High Art Photography:

> Strange abominations took form. By bringing together a group of male and female clowns, got up like butchers and laundry-maids at a carnival, and by begging these *heroes* to be so kind as to hold their chance grimaces for the time necessary for the performance, the operator flattered himself that he was reproducing tragic or elegant scenes from ancient history.[19]

Baudelaire read photography as a nasty product of bourgeois society, one that narrowed taste and depreciated the fine arts by substituting a venal, mass-produced popular culture. Rather than improving the moral capacity of the masses, as proponents of progress argued, High Art Photography, in Baudelaire's opinion, stimulated a hatred for painting.[20] High Art Photography increased the disparity between progress in the sense of economic betterment and progress in the sense of cultural advance. In mid-nineteenth-century thought, photography was a potent symbol for the inconsistency between modernization and civilization.

There is a lesson to be gleaned about the direction of photographic meaning from photography's High Art period. High Art photographers could not guide the public and the elite to an understanding of their experiment in moral suasion. Even art photographers were unable to steer the general interpretation of their work. Widespread as it was, photography lacked a credible community of public advocates. In the medium's first decades, photographers created many more pictures than they did theoretical terms that could be used in appreciating their work. Nor could the medium's friends dictate the vocabulary of photography's acceptance and appreciation in society. In the nineteenth century, photography did not intrigue artists, writers, and critics to the same extent that experimental efforts such as impressionism and naturalism in painting and literature did. Consequently, few critics brokered between the public and photographers to create a wider understanding of and an informed debate on the new medium.[21] Photographic criticism relied on hand-me-down terms from the other arts, like "imitation" and "imagination" – terms that did not fit very well and that hobbled assessment of the medium. Photography's advocates did not methodically either adapt old terms or invent new ones with which to appraise the medium. Photographic criticism was repeatedly reactive and apologetic.

High Art Photography was principally an English phenomenon, but even in England it represented only a small proportion of the photographs created and reviewed in the mid-nineteenth century. In some ways, the category has been more important to the modern era than it was to the earlier century. With time, and with the invention of a Vic-

torian quaintness that had little to do with life as it was lived in the period,[22] High Art Photography gained prominence. It became the exemplar of second-rate photographic practice against which late-nineteenth- and early-twentieth-century art photography could be self-approvingly measured.[23]

## GENIUS AND THE SCIENCE OF SACRIFICE

High Art Photography was a response to criticism of photography's subject matter. Another style of mid-nineteenth-century photography, the blurred image, reproached ordinary photography's clear-eyed appearance. For some critics and photographers, diminished distinctness and detail in the photographic print implied the absence of mechanical contrivance and the presence of human intervention and imagination. As the critic Henri de la Blanchère succinctly stated: "The less machine, the more art."[24]

In an influential paper on the indistinct photographic image, read at the founding meeting of the Photographic Society of London in 1853, William Newton advocated an art photography that deliberately worked against what he called the glut of detail produced by "chemical Photography." He suggested what would become a much-debated technique of rendering the subject a little out of focus.[25]

This so-called theory of sacrifice also runs through much mid-century French photographic criticism. The idea pertained to photographic techniques that muted the sharpness of a print, or accentuated patterns of light and dark, in order to render a painterly appearance. In general, the theory stressed the extent to which a good photograph resulted from the photographer's active, knowledgeable choice of equipment, his point of view, the time of day, or his use of chiaroscuro.[26] The French photographer Charles Nègre noted that he deliberately sacrificed detail to achieve what he deemed to be a picturesque photograph. His contemporary Gustave Le Gray similarly equated photographic beauty with the principle of sacrifice.[27]

The theory and practice of would-be art photography during the mid-nineteenth century repudiated the charge that photography had to "submit to the iron law of 'things as they are.'"[28] This was a reply to other objections as well. Frequently, these responses were expounded with reference to landscape images. Even those critics who denigrated photography as an idle copyist, sometimes admitted that in "landscape subjects[,] the photographer has to a limited extent the power of giving *expression* by developing his plate to a certain point, and bringing out some parts more than others, as well as by skilful printing."[29] Le Gray centered his arguments for artistic photography on landscape, and Newton based his principles on landscape depic-

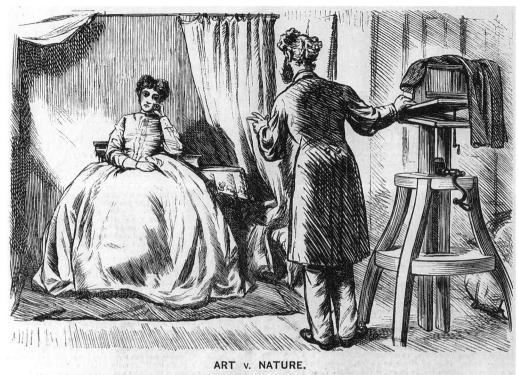

**ART v. NATURE.**

*Sitter.* "OH, I THINK THIS POSITION WILL DO, IT'S NATURAL AND EASY."
*Photographer.* "AH, THAT MAY DO IN ORDINARY LIFE, MA'AM; BUT IN PHOTOGRAPHY IT'S OUT OF THE QUESTION ENTIRELY!"

FIGURE 41

Unknown Artist, *Art v. Nature, Punch* 48 (March 4, 1865): 88. Courtesy of Syracuse University Library.

tion. This permitted Newton to assert that manipulation of the lens and the negative imitated the "broad and general effects" of nature.[30] These effects, he later argued, followed precepts established by Sir Joshua Reynolds.[31] A paper offered by R. W. Buss to the Photographic Society, "On the Use of Photography to Artists," argued that Newton's notion of "breadth of effect . . . simply employ[ed] . . . the camera to do what is recorded as the practice of Sir Joshua Reynolds."[32]

Arguing from art principles and from the experience of optical reality, Newton prescribed imitating the "atmospheric veil" of nature. "In the [photographic] illustrations which are sent forth to a world to be placed in similar positions as pictures and engravings," he wrote, "their appearance ought not to be so *chemically,* as *artistically* beautiful."[33] Nevertheless, Newton objected to the notion of an intrinsic photographic aesthetic that had to be accommodated and to the ancillary idea that the photographer has a responsibility to render an unchanged image of that which is before the camera. "The Camera," he charged, "is by no means calculated to *teach* the *principles* of art."[34]

One way in which photographic critics tried to enhance public perception of the medium was to argue for the creative intelligence of the photographer. In his writing, the critic Ernest Lacan spoke of:

> the artist photographer, who, having devoted his life to studying one of the arts such as painting, architecture, engraving etc., perceived photography as being a new means by which to convey his

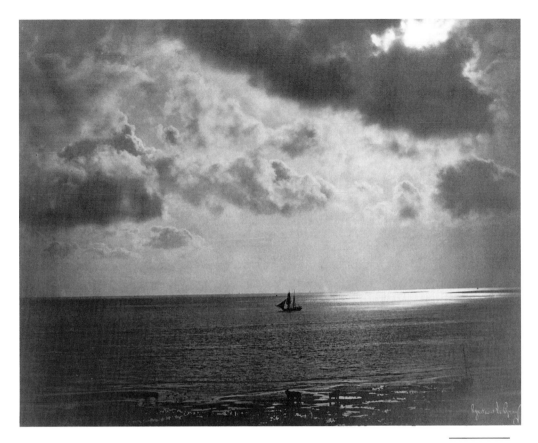

FIGURE 42

Gustave Le Gray,
*Brig on the Water,*
1856–1859,
Sir Thomas Phillips
Collection. The
Harrison D. Horblit
Collection of Early
Photography. The
Houghton Library,
Harvard University,
Cambridge, Massa-
chusetts.

impressions, to imitate the poetry, the richness and beauty of na-
ture, [and] to reproduce those works of art which human genius has
scattered all over the world. He is usually a painter: he is always a
man of intelligence and talent.[35]

In the face of accusations that photographers were shiftless, coarse
opportunists, Lacan maintained that the art photographer was a per-
son of "good breeding" and education. Similarly, in his treatise on pho-
tography, Le Gray contended that it was "truly the artist or man of
taste who was sure to obtain perfect results." "He alone," Le Gray con-
tinued, "has the intuition of the effects that are best suited to the sub-
ject he reproduces."[36] Lacan and Le Gray revived the aspects of Ro-
mantic genius theory that arose with photographic discourse at
photography's advent. Against the consensus, as expressed by
Baudelaire, that photography contributed to the anti-intellectualism
of the masses, Le Gray wrote that photography "refined the public
taste," because it allowed the public to see nature being tastefully and
sensitively reproduced.[37] In an important sense, Lacan and Le Gray
compounded technological genesis and natural genesis, creating an
imaginative photographer who was at once artistically adept, tech-
nologically proficient, and actively engaged in public betterment.

For those to whom photography suggested vacant-eyed automa-
tism, the issues of training and work were pivotal. The anonymous au-
thor of "Art and Photography," published in the Ruskinian journal *The*

FIGURE 43

Carleton E. Watkins, *First View of the Valley,* 1865–1866. Collection of the J. Paul Getty Museum, Malibu, California.

*New Path,* expressed the conviction that the work involved in hand copying was the genuine way to learn the language of art. Photography's apparent automatism simultaneously cheapened the photographer's relationship to nature and to the traditions of fine art.[38] A variant of that view was articulated by W. D. Clark, who held that excellence in any field resulted from studious mental effort over time. The ease of photography took away its character-building challenge. "There is no great difficulty in producing a first-rate photograph," Clark claimed.[39] In the artistic calculations of the time, some evidence of work and effort had to be evinced by a work of art. In a few short years, however, the Ruskin–Whistler trial would challenge that notion, at least for painting.

As long as photography was considered to be "Nature herself reflecting her own face,"[40] photographic practice could be scolded for an indiscriminate optical realism that was little more than an indulgence in surface attraction. Whereas that criticism held sway in the middle years of the nineteenth century, a nascent theory of photographic realism arose through the consideration of landscape photography. Though he could not bring himself to acknowledge photography as a true kin of painting, the critic H. J. Morton did concede that there were such things as "good photographs," that is, photographs that were "not merely mechanically good but artistically excellent."[41] Like Newton, Morton insisted that good photographs could be made only by those with a strong

FIGURE 44

Carleton E. Watkins,
*Dam and Lake,*
*Nevada County, Near*
*View,* c. 1871. Col-
lection of the J. Paul
Getty Museum, Mal-
ibu, California.

background in the visual arts. In a related comment, Clark, who dispar-
aged photography as an inexpressive mirror, declared that "there cer-
tainly is such a thing as *photographic art.*" Operating within narrow
bounds, photographic landscape could be beautiful.[42]

Curiously, the photography of the American West, a landscape
practice relatively free of European concerns with art theory, circum-
vented these issues. Amid the extraordinary vistas of the West, com-
mercial photographers in the 1860s began to construct a coherent,
though formally untheorized, aesthetic initiated by expansion and the
development of resources. In the work of Timothy O'Sullivan, William
Henry Jackson, and, particularly, Carleton E. Watkins, the West's vast
open spaces and dramatic high country became a naturally occurring
metaphor and endorsement for the course of history. From this per-
spective, photography's neutral vision was not a liability but an asset
that clearly rendered nature's naturally occurring symbols. Eastern
transcendentalism – the stuff of blithe air and floating eyeballs – took
the road west.

Where English and European amateurs might craft an antimodern,
picturesque photograph that lamented the decline of an agricultural-
ly based society,[43] Watkins synthesized a soaring sublime based on
wilderness. His startling views of Yosemite enlisted the tumultuous
geological events of the area as palpable emblems of the vastness and
inevitability of American enterprise. The viewer of his photographs is
often flung out over and above dizzying, deep chasms. The immediate

sensation is one of transcendence and invincibility, a feeling profoundly different from the quiet reflection and nostalgic passivity evoked by much European amateur landscape photography. Indeed, a sense of the sublime, vested in natural wonders like Niagara Falls and Yosemite but transferable to human works like the railroad, is characteristic of nineteenth-century American cultural life.[44]

In their less theatrical views – of agricultural development, expansion of the railroads, the treks of survey teams, and lumbering and mining operations – the Western photographers also created an aesthetics of development. They reconciled nature and culture in formal pictorial elements. Nature's lineaments became fused with those devised by human enterprise on the land. Railroad and river conformed; dams became decorative. An Edenic calm issues from the ordered simplicity of horizontal lines. In the absence of evidence that the Western photographers had prolonged contact with academic principles, one is compelled to conclude that the extraordinary aesthetic these photographers developed sprang from years of routine studio and documentary work.

## The Photograph as Painting

There is little doubt where David Octavius Hill and Robert Adamson found a suitable aesthetic for their photographs. The prompt public acceptance and continuing approval of their calotype work, produced during the 1840s in Scotland, bears out the hold of art terminology on photography. The look of the calotype, a paper process, impressed observers as being like painting. The calotype's sepia tones, with the slight suggestion of violet, were sunk deep into the paper on which they were printed. Not quite an ink-and-wash drawing, not quite a watercolor, the calotype looked handworked. Occasionally, the grain of the paper, which showed through the image, was raised and roughened in the washing segment of the calotype process. As a result, the calotype did not have the metallic, machine-made look of the daguerreotype. John Harden, an amateur painter whom Hill and Adamson photographed, described the duo's images as "pictures produced as Rembrandt's but improved so like his style & the oldest & finest masters that doubtless a great progress in Portrait painting & effect must be the consequence."[45]

It has been suggested that the success of Hill and Adamson's work was due to their lack of originality: "The calotypes of Hill and Adamson, considered strictly on an iconographical basis, transferred . . . to the new mechanical medium of the camera the visual repertory of almost any exhibition of the Royal Scottish Academy during the

1840's."[46] That assessment seems reasonably true, especially for the male portraits. Men's faces and hands are lit theatrically in the manner of academic painting familiar to Hill, who established the Scottish Academy. Sitters often posed with accessories, such as the implements they used in their work or avocation. These accessories had the double function of steadying the sitter for the long minute or two required for the camera exposure and emblematically alluding to the sitter's occupation or intellectual pursuits.

In 1848, the year in which Adamson's premature death marked the end of their collaboration, Hill spelled out his attitude toward photography in a letter to a friend: "The rough surface, and unequal texture throughout of the paper is the main cause of the Calotype failing in details, before the process of Daguerreotypy – and this is the very life of it. They look like the imperfect work of man – and not the much diminished perfect work of God."[47] Whereas the calotype process's uneven appearance implicitly negated the complaint that photography was a mechanical art, it also, in Hill's phrasing, suggested that photography was inherently a lesser art.

When the photographic practice of Hill and Adamson was wistfully recalled by Lady Eastlake in her 1857 *Quarterly Review* article, the author praised the photographs as "Rembrandt-like studies" whose very lack of sharp light and exact detail was analogous to painting. She maintained that "if the photograph in its early and imperfect scientific state was more consonant to our feeling for art, it is because . . . it was more true to our experience of nature."[48] For many Victorian commentators, as well as for viewers in the twentieth century, Hill and Adamson photographs possess the charm of naive art. Their "Rembrantishness" was not so much a comment on subject matter or artistic prowess, but an affirmation of the venerable antique look of the photographs. Despite the charm of Lady Eastlake's ideas, there is hardly any way that early photographers could be innocent of the medium's science and its art aspirations.[49] That Lady Eastlake knew a good deal about the technical procedures of photography and the history of early photography did not deter her from constructing the notion of naiveté around the photography of Hill and Adamson. Her thesis on photography is modestly apocalyptic, threaded through with a theory of social decline. Her writing makes it appear as though Hill and Adamson lived in the golden age of photography, before the medium was cursed with scientific knowledge and a mediocre mass audience.

It is important to note what Eastlake does not: that inexperience in photography would appear to be different from inexperience in painting. The flat, undifferentiated tonal areas, hard lines, and nonnaturalistic light in naive painting have long connoted innocence of craft. But in photography, even in early photography, the production of any image requires some illusionism. Moreover, the first photographic writings, scaled to the interests of wealthy and literate amateurs as well

FIGURE 45

David Octavius Hill
and Robert Adam-
son, *Mrs. Anne Rigby
and Miss Elizabeth
Rigby (later Lady
Eastlake),*
1843–1847. National
Gallery of Canada,
Ottawa, Canada.

as to the humble traveling daguerreotypist, were filled with techno-
logical information that Hill and Adamson could have used had they
found the blurriness of their images intolerable.

It seems likely that Hill and Adamson deliberately chose a signature
style. In some twentieth-century thought, nineteenth-century blurri-
ness became the visible marker of photographic naiveté. Inevitably,
the viewer's perception of innocence was transferred from the print
to the photographer, capitalizing on the sense of photography's orig-
inality. In the modern imagination, what makes early photographs
naive is the photographer who works "unconsciously," "innocently
or naively," with the medium. Early photographers could be com-
pared favorably with vatic poets: "They were entranced by and gave
all their attention to the photography and knew little or nothing of the
medium."[50]

The extent to which blur was taken as an emblem of artistic con-
sciousness is evidenced in the variety of reactions to the famous va-
pory portraits and *tableaux* of Julia Margaret Cameron. Cameron left
a record of what she wanted to do in photography. To get her effects,
she consciously worked against the deranging minutiae of the photo-
graph. She reveals in her autobiographical fragment, *Annals of my
Glass House* (1874), that she accidentally discovered her style but
then pursued it consciously, even defensively: "My first successes in
my out-of-focus pictures were a fluke. That is to say, that when fo-

cussing and coming to something which, to my eye, was very beautiful, I stopped there instead of screwing on the lens to the more definite focus which all other photographers insist upon."[51]

Cameron clearly was not trying to paint with photography or to exercise a specific art theory. Her testimony indicates that she achieved her results through the daily experience of making photographs. She tried "to ennoble photography and to secure for it the character and uses of High Art by combining the real and ideal and sacrificing nothing of Truth by all possible devotion to Poetry and beauty."[52] Cameron may also have been attempting to elevate photography by promoting the medium's use of Christian iconography.[53]

Many in the photographic press expressed regret over Cameron's style, which they pronounced was due to her inexperience with the technical end of the medium. In 1869, following two one-person shows by Cameron (1866 and 1868), the photographer and teacher Henry

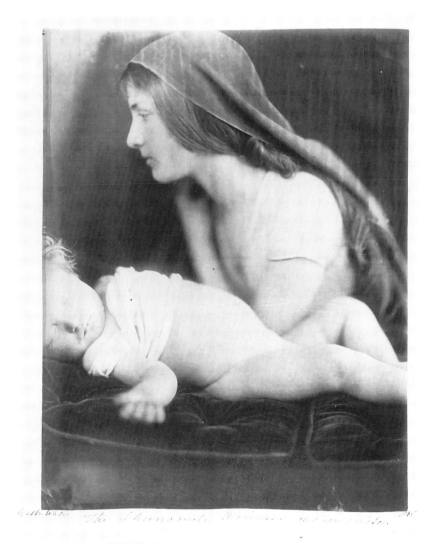

FIGURE 46

Julia Margaret Cameron, *The Shunamite Woman and Her Dead Son,* 1865. Collection of the J. Paul Getty Museum, Malibu, California.

Peach Robinson decried her smudgy images and growled that "if studies in light and shade only are required, let these be done in pigment or charcoal, with a mop if necessary, but photography is pre-eminently the art of definition."[54] It is significant to note, however, that the art press, as opposed to the photographic press, was disposed to accept Cameron's work. Thus in 1864, the year that she perfected her style but as yet had shown her work only to her friends, the *Art-Journal* praised any technique that would "assist the chiar-oscuro of photographs, . . . by the judicious application of chemistry, be made to give to photography much of artistic effect."[55] The "low tone" and "bold chiaroscuro" of Cameron's portraits gave them Old Master qualities in the eyes of her contemporaries. "It is difficult," pronounced a reviewer of her 1868 London show, "to determine what they [Cameron's portraits] could gain by being painted."[56]

Reviews of Cameron's shows demonstrate the extent to which a favorable appraisal of photography by art critics depended upon the photographer's ability to control light and dark surface patterns and to minimize detail. "If a few years ago, we have been asked the question, 'has Photography produced anything worthy of being called a work of Art?' we should have hesitated to give an answer in the affirmative," the *Art-Journal* mused. In the writer's opinion, it had taken about twenty-five years for photography to convince the art establishment that these images were "not merely imitations and copies from . . . nature, but productions of mind and thoughtful study, . . . which when gazed on, raise emotions and feeling similar to those awakened at the sight of some noble sepia sketch." In part, Cameron's photographs brought about that change of opinion. Reviewing a photography show, the writer for the *Art-Journal* concluded that "some of these photographs have been taken slightly out of focus and in the *vaporoso* manner which Mrs. Cameron has of late brought to a high state of perfection; and we are sometimes *astonished* to find ourselves contemplating what at first sight would seem to be copies taken from masters of the Venetian and other early schools."[57] *MacMillian's Magazine* was equally approving: "Mrs. Cameron was the first person who had the wit to see that her mistakes were her success and henceforward to make portraits systematically out of focus." The writer goes on to praise the beauty of Cameron's portraits: "The beauty of the heads in these photographs is the beauty of the highest art." "We seem," the writer concludes, "to be gazing upon so many Luinis, Leonardos and Vandycks."[58]

One can speculate as to why the photographic establishment was harsher in its judgment of Mrs. Cameron than was either the art press or the general public. Certainly, it was not possible to spin the web of naive artistry around Cameron as it had been with Hill and Adamson. Cameron was educated, was influential in art circles, and was capable of plainly stating her aims.[59] She considered the use of focus in photography, asking "What is focus – and who has a right to say what fo-

cus is the legitimate focus?"[60] Mrs. Cameron taught herself photography, after having reared her children. Other photographers may have questioned the seriousness of her art, because she came to it later in life. Then, too, the persistent financial difficulties of Mr. Cameron seem to have persuaded Mrs. Cameron to try to make money with her work.[61] She was sedulous in her attempts to publish, though understandably discreet on the matter. Her efforts coincided with the vehement rejection by professional photographers of lewd and shoddy commercially produced photographs and were thus understood as especially unseemly for a woman.[62]

Cameron's images may have been irritatingly out-of-focus to some, but the piety of their religious and cultural subjects was so comfortably within a woman's prescribed moral precincts that one has to wonder why the photographic press did not overlook the blurriness or even applaud it as a symbol of spiritual refinement. Perhaps it was Cameron's attempts to commercialize her work, not the look of the work itself, that led to adverse criticism. As the scholar Mike Weaver has put it, the "professionals turn nasty when they see she's serious."[63] In any case, many in the photographic establishment publicly chastised Cameron, peddling derogatory anecdotes about her poor housekeeping.

## In Relation to the Arts

During the nineteenth century, photography was judged against painting, printmaking, and, more subtly, literature and moral philosophy. Photographs were reckoned to be inferior to or better than engraved views of nature or of works of art. A photographer's work was said to emulate that of a certain painter, or to parody academic precepts. Scenes from novels or from narratives produced solely for the camera were compared with the literary originals or the theater's ability to convey ideas and emotions. The persistent application of art criteria to photography polarized ideas about what a photographer could be. Increasingly, the critical literature spoke of artist-photographers as either geniuses or imposters. By the 1860s, some critics were calling photographers "illiterate and undisciplined" and "dullards," whereas others were anointing them as persons of great faculty and accomplishment.

The expansiveness of Marcus Aurelius Root's encyclopedic *The Camera & the Pencil, or the Heliographic Art, Its Theory and Practice in All Its various Branches; e.g. Daguerreotype Photography, Together with Its History in the United States and Europe, Being at Once a Theoretical and a Practical Treatise, & designed alike as a Text-Book and a Hand-*

*Book* (1864) indicates the growing self-assurance among practitioners. Root began his tome with a grandiloquent statement of the genuine photographer's elevated status:

> I have spoken in considerable detail . . . of the high attributes, both intellectual and moral, essential to a first-class heliographer. To represent . . . the beautiful and sublime in natural scenery; to reproduce in like manner the creations of inspired human genius; and especially to delineate the human face and figure pervaded by an *expression,* that bids the soul shine glowingly through the same; are to transcribe the matchless pencilings of the Divine Proto-Artist. To do this, how imperfectly soever, demands qualities, alike of head and heart, in rapt accordance with the Infinite Creative Spirit.
>
> . . . the true heliographer, like the true artist in whatever sphere, should be an intermedium, through which the light of the Divine should pass unmodified and pure.[64]

Root wrote of his personal horror at those "inferior" photographers whose "*purely mercenary*" motives degraded the "genius" of learned, perceptive heliographers.[65] He quoted Disdéri, acknowledged proliferator of cheap carte de visite photographs, as an authority on artful photography. Disdéri's *L'art de la photographie* (1862), though not as wide-ranging as Root's effort, insisted that the proper photographer was not only a full-fledged artist like any other in the visual arts but also a person of cultural achievement and special sensibility. Presumably seeking to demonstrate their own cultural attainments, Root and Disdéri sowed the names of great painters, philosophers, and writers throughout their texts.

Increasingly, the notion of the photographer became mixed with society's construction of photographic meaning. Both photography and the photographer were concurrently regarded as attractive and dangerous. The photographer could be either a person of genius or a charlatan. The photograph could be educational, or it could belittle painting. The intellectual noise generated by photography's advocates and detractors kept photography in the public eye, making the medium an appealing subject for literature. Hawthorne's enigmatic daguerreotypist in *The House of the Seven Gables* is typical of fictional characterizations of photographers.[66]

As the concept of the artist-photographer became more common, and as more artists turned to photography for their livelihoods, knowledge of other art media came to be seen as requisite for would-be photographers. Photographic careers were thought best begun with art training, either formal or informal. Henry Peach Robinson, whose writings were much reprinted, underscored the pedagogical relation of the arts to photography in the preface of his most popular book, *Pictorial Effect in Photography* (1869). He wrote that "nine out of ten photographers are, unfortunately, quite ignorant of art. . . . Wrongheadedly, [they] think manipulation all sufficient."[67] Robinson believed that an ineffable aesthetic quality informed good art: "Without this indefinite, intangible, hidden, unknown soul, a picture is but a sci-

entific performance."[68] Like many photographers, he admitted that the medium's technical side could be bewitching, and he recommended the study of art as an antidote. Moreover, Robinson considered the study of paintings to be a better foundation for photography than even the study of nature. His success as a teacher and a writer was due in significant measure to his wholehearted endorsement of conventional art training.

Robinson's faith in his vision of an artful photography produced by cultivated photographers never wavered. In *Picture-Makaing by Photography* (1884), Robinson maintained "that photography should be not only the recorder of bald, prosaic fact, but also the means by which something akin to imagination or fancy – real live art – may be worthily embodied."[69] Photography's potential was to display "artistic thoughts in the grammar of art."[70]

Robinson's many books offered a straightforward course in composition. He translated lessons traditionally given to the neophyte painter into terms that could be readily grasped by beginning photographers. His books read like the popular self-help volumes of the time, complete with quotes from such luminaries as Ruskin, Shakespeare, Milton, and the omnipresent Robert Browning. With Ruskin and Carlyle, but lacking their originality, Robinson viewed himself as a broker between high culture and the new achievers.

Robinson did not invent the idea that photography was a secondary art, a notion that can be found in the early photographic literature.[71] He did, however, help to popularize the understanding of photography as a limited imaging method. As he reflected on his long career in *Picture-Making by Photography,* he concluded that "there are . . . subjects sometimes attempted that seem unsuitable to the art" of photography:

> We are bound to recognize ordinary facts, and should keep within the possible. An anachronism should never be allowed. A photographer should accept the limitations to which his art confines him, and only represent those scenes and subjects which could exist in the nature of his own day. To dress a figure in the costume of past times, and to call the photography of it by the name of some historical person, is to commit an anachronism.[72]

Referring to his own anachronistic art photography of the late 1850s and early 1860s, Robinson acknowledged that he "was as much a sinner in this way as anybody":

> I didn't know better. I did not hesitate to call my little efforts by the names of people who had died a thousand years before photography was thought of, or who had never had any existence at all. Ophelia, Elaine, Mariana, the Lady of Shallott – these were some of the names I profaned.[73]

Robinson's rejection of anachronism in photography was an attempt to clarify the bounds of photography in relation to painting. "In painting, it is different," Robinson wrote. The artist does not give "an exact

portrait of his model," meaning that the finished painting operates at some remove from reality. A photograph, conversely, "is the absolute reproduction of some scene or person that has appeared before the camera."[74] For all of his enthusiasm for photography's artistic possibilities, Robinson also seems to have condoned the notion of photography as an inherently compromised instrument.

In his last book, *The Elements of a Pictorial Photograph* (1896), Robinson's efforts to posit an art photography became especially strained. He tried, as many since have done, to collapse painting and photography into the idea of the picture. Works of art "should be true to nature, . . . [and] must not represent nature as faithfully as seen in a mirror."[75] The artist in both media should exercise taste and judgment and should seek to create pleasure in the beholder. Robinson never altered his partiality for the studio setup that allowed him to blend the real and the artificial:

> A great deal can be done, and very beautiful pictures made, by the mixture of the real and artificial in a picture. Although, for choice, I should prefer everything in a photograph being from nature, I admit a picture to be right when the "effect" is natural, however obtained. . . . Art is not the science of deception, but that of giving pleasure. . . . For this purpose – that is, the mixture of the real with the artificial – the accessories of the studio should receive the addition of picturesque or ivy-covered logs of wood, ferns, tufts of grass, & c., either growing in low pots, or gathered fresh. . . . If the background be well painted, it will be found to unite very naturally with the foreground.[76]

Robinson blessed the use of sodded platforms, gotten up with ferns and sprinkled with pebbles and twigs, which were wheeled into place before painted scenery. Yet he disparaged the use of Greco-Roman paraphernalia. These objects, Robinson counseled, were anachronistic and should be destroyed lest they fall into the hands (and before the lenses) of vulgar photographers. In Robinson's sense of photographic realism, the photographer could make pictures of scenes that could conceivably appear before the lens. But the camera was not permitted to picture classical antiquity.

In Robinson's theory of representation "it was the effectiveness of a picture that mattered – the degree to which it was *convincing* rather than *true*."[77] In contemporary terms, he could be said to have recognized the degree to which photographic meaning is constructed. But in the Victorian era, Robinson's hopeful coupling of appearance and reality was hazardous. The unintentional consequence of Robinson's approach, and of his considerable influence, was the amplification of the reasons photography could be reproached as the product of middlebrow, consensual reality. Complaints about the medium's socially detrimental effects relied more on the hypothesis that photography deadened the imagination than on any specific fraud in actual photographic practice.

The practice of illustrating fiction or depicting original stories in art

photography tended to vex commentators who already disliked realism and sentimentality in other media. Photographic narrative was censored by critics who had nurtured a mistrust of realist paintings, plays, and novels long before the disclosure of photography in 1839. For example, one element that critics faulted in Honoré de Balzac's novels of the 1830s was the detail with which he rendered contemporary life. Sentimentality, too, was chastised in the visual narratives of art photography just as it had been denounced in novels published before 1839. Charles Dickens's *Oliver Twist* and *Nicholas Nickleby* contained scenes as melodramatic as those that would later be concocted by art photographers, and which, like the photographs, were called vulgar.

Throughout the nineteenth century, painters and engravers frequently chronicled emotion-laden scenes, like the last moments of Lady Jane Grey, of Mary, Queen of Scots, of Charles I, and of other heroic Anglo-Saxons. The painter David Wilkie's saccharine homilies and genre scenes were engraved into the popular heart early in the century. In a sense, art photography was only playing catch-up.

Ironically, the photographic realism found in works by the painter Paul Delaroche was admired, rather than condemned. Though chill is palpable in his painting of the Tower where the condemned princes await their fate, and one could count the hairs on the ermine-strewn deathbed of his Queen Elizabeth, Delaroche's devotion to detail, sentiment, and illusion were not held against him.[78] The pleasing political symbols incorporated in his work offset the offense of faithful rendering.

Story making was at its peak by midcentury. Hence, it is no surprise that photographers made narrative images. Victorian theater, literature, and popular painting led straight to the conception of the consumptive girl depicted in Henry Peach Robinson's *Fading Away* (1858). The image is no more emotion laden, however, than is the fading away of little Paul Dombey in Dickens's *Dombey and Son* (1846–1848). Robinson's tableau also seems restrained compared to the trials and pathetic death of Nell in Dickens's *Old Curiosity Shop*. Popular Victorian painting and sales of subsequent engravings thrived on partings: Sons emigrated and husbands went off to war, while ragged children clung to their mothers' skirts. To page through popular Victorian engravings is to encounter melodramatic facial expressions readable in the back rows and to appreciate the extent to which visualizations were aided by multitudinous symbolic accoutrements, such as tattered carpetbags, ticking clocks, and unfurled handkerchiefs.

Critics of culture like Sainte-Beauve and Baudelaire insisted that the vulgar commercialization and popularization of the arts were propelled by elaborately depicted, intricately plotted stories that substituted cheap sentiment for spiritual values and aesthetic nuance. In Baudelaire's case, his 1859 tirade against photography was predicated on his abhorrence of the public's pleasure in narrative art photog-

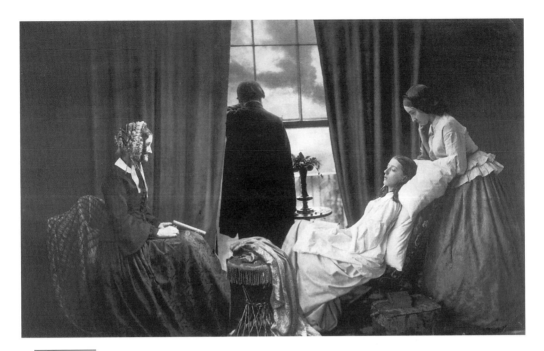

FIGURE 47

raphy. For Baudelaire, photography was one more slip in the tumble toward cultural decadence.

## POST-PHOTOGRAPHY AND THE PRE-RAPHAELITE MOVEMENT

The prevalence of Victorian narrative images and imagistic narrative helps to explain the relatively speedy acceptance and commercialization of the painting of the Pre-Raphaelite Brotherhood, the mid-nineteenth-century English art movement. The cold light and sharp detail of the paintings produced by this school were traced to the influence of photographic imagery. Moreover, some of the Pre-Raphaelites did use photography as an aide-mémoire. But photography did not give the initial impetus to the movement, which was, in many ways, against the modernization and barren material progress that were associated with photography.

Nevertheless, the hard-edged look of a Pre-Raphaelite painting – its sharp foreground and equally sharp background detail – made some critics, including some photographers, assume that there was a direct, causal link between photography and Pre-Raphaelite painting. Writing in the *Journal of the Royal Photographic Society,* W. D. Clark maintained that "Pre-Raphaelism owes much to photography, or may even spring from it, though its disciples would not willingly admit as much. Post-photography might probably more accurately describe

107

POST-
PHOTOGRAPHY AND
THE PRE-
RAPHAELITE
MOVEMENT

this style of art."[79] Henry Peach Robinson also thought that the association was partially accurate: "It may be claimed that the early photography suggested this excessive study of nature. It probably did; but it was only a suggestion."[80]

In their early years, the little band of Pre-Raphaelite painters faced two accusations: one was of archaism, meaning the deliberate adoption of nonillusionistic techniques that they associated with the period before Raphael, and the other was of photographism, using the camera to create their images and/or deliberately attempting to make their paintings look like large photographs. John Ruskin was quick to locate the contradictions in these oft-made charges. The Pre-Raphaelites, he argued, could not look backward and forward at the same time. Ruskin, who had once been an admirer of photography, contended that the medium was thoroughly inappropriate to the philosophy inculcated in the brotherhood's images. Indeed, for the Pre-Raphaelites to use photography would be to deceive. Making a picture by machine that ought to be made by hand not only offended the *Pre*-Raphaelite penchant of the movement, it also interfered with the proper physical and intellectual training necessary to becoming a painter. In sum, for Ruskin the substantial use of photographs implied the substitution of vulgar verisimilitude for higher truths. For their parts, many photographers pointed out the ways in which Pre-Raphaelite paintings distorted camera vision. By and large, amateur photographers shared the same taste for composition inspired by the precepts of Sir Joshua Reynolds. They tended to side with the academic painters against the Pre-Raphaelites.[81]

Speculation that photography influenced Pre-Raphaelite paintings involved some tricky time shifting. It suggests that the Pre-Raphaelite painting of the late 1840s and early 1850s was influenced by the look and subject matter of art photographs that were not actually produced in abundance until the late 1850s and 1860s. Neither the daguerreotype nor the early paper processes but a photographic method called collodion, invented in 1851 – three years after the founding of the brotherhood – ignited the nineteenth-century explosion of images and facilitated combination printing and the proliferation of stereoscopic photographs. For example, the physicality of John Everett Millais's Pre-Raphaelite painting *Christ in the House of His Parents* (1849), a look that revolted *The Times* of London and piqued Charles Dickens, was interpolated in the painting before such a surface appearance became prevalent in photography.[82]

Pre-Raphaelite technique has adequate precedent in art. The tropical intensity of Pre-Raphaelite colors resembles that of the colors in medieval manuscript illustration. In addition, whereas the stark, intellectual finish of Pre-Raphaelite detail ignores conventions of academic modeling and atmospheric perspective, it does occur in manuscripts and also in the work of Florentine and Flemish painters during the Renaissance. Moreover, the brotherhood's intellectual aims linked them with troupes of antiestablishment writers and

painters on the European continent, especially with the Nazarenes, a band of German painters living in Rome in the early nineteenth century. If photography had not yet been invented, Pre-Raphaelite painting would probably still appear just as it does.[83]

The success of Pre-Raphaelite painting was not significantly impeded by the charge of photographism. That critics should have singled out the Pre-Raphaelites to the obvious neglect of other influential movements and media demonstrates the extent to which photography was judged not impartially but as a surrogate for the apprehensions of many people about newness.

---

## ART, PHOTOGRAPHY, AND SOCIETY: AN UNEASY TRUCE

---

By and large what C. Jabez Hughes called mechanical photography was easily absorbed into nineteenth-century daily life, scholarship, and documentation. People generally agreed that photography's "artistic value" was "open to controversy . . . but concerning its mechanical utility there can be no dispute."[84] There were, of course, complaints that the photographic portrait was unflattering; nevertheless, daguerreotype cases cluttered drawers, and with the ascendancy of paper photography, families came to amass albums recording the lives of relatives and friends. The so-called mechanical photograph became omnipresent:

> There is scarcely a family of any class in the United Kingdom in which a likeness of well-loved features, guaranteed by the infallible sun, is not duly prized. . . . There is scarcely an educated lady, fashionable or unfashionable, whose table is not adorned with the album of cartes de visite, containing a full allowance of royalties, half-a-dozen leading statesmen, and a goodly row of particular friends – all highly useful in furnishing subjects of conversation to guests. . . . There is hardly a cottage in which a humble sixpenny "positive" does not recall, somewhat duskily perhaps, but still truthfully, the lineaments of some distant son or brother.[85]

This statement, written in 1864 by Robert Cecil, later Lord Cecil, prime minister of England, outlines the spectrum of contemporary responses to photography's art potential, designating that domain a "rather less than peaceful territory."[86] Cecil's *Quarterly Review* essay deserves to be the locus classicus of mid-nineteenth-century thought on photography and art. In the article Cecil fully discussed the dimensions of the contemporary comparison between painting and photography. He even asserted that jealousy played a part in the negative reactions of some artists and critics to photography: "It is not surprising that bad artists should have lavished upon photography a

good deal of the contempt which some thirty years ago coach pro-
prietors used to expend upon the dangerous and inconvenient system
of traveling by railways."[87]

Yet Cecil worried about the results of mass-mediated photography,
which he believed was "adapt[ing] to the million's tastes." He con-
ceded that "the enormous demand which has sprung up for pho-
tographs has produced a vast amount of detestable photography."
Still, he contended that "an art which is fortunate or unfortunate
enough to attract but a scanty circle of educated admirers, may main-
tain the loftiness of its standard unimpaired."[88] We do not condemn
all poetry because of shoddy journalism nor scorn good music and
theater because of popular fare. Photography, like other arts, must be
judged by its best examples.

Cecil maintained that a want of learning and experience led to pho-
tography's rough dismissal from the aesthetic field. Recognizing the
lack of popularly understood critical terms for photography, Cecil
suggested that, like any neglected art, photography "must educate,
not only those who are to practise it, but also those who are to enjoy
it."[89] Further, he discerned that the lack of a distinct critical language
for photography made unfair the comparison of photography to paint-
ing: "It is a curious illustration of the extent to which the art of paint-
ing had the opportunity to moulding public taste to its own necessi-
ties, that this exactness which the paintbrush and the pencil cannot
attain, has actually been made a reproach to the photographer."[90] In
Cecil's view, art photography styles had been unduly influenced by
painting theory.[91]

In his analysis, Cecil rejected realism as too vague a standard for
photography, and he renounced out-of-focus or blurred images as
well. He based his objection to the mechanical nature of photographs
primarily on the appearance and subject range of contemporary pho-
tographs rather than on the abstract ground that photography was
too literal to be art. Nor did Cecil accept the standard accusation that
photography was merely mechanical picture making. His idea of good
photography resembles Hughes's notion of art photography in that
the good photograph depends upon the personality as well as the ed-
ucation and diligence of the photographer:

> Those who talk of photography as something purely mechanical
> would be surprised to know how much the attainment of this ex-
> cellence depends upon natural gift, adroit manipulation, long expe-
> rience, and careful study of nature. . . . Such results are as much the
> work of the artist who produces them, as the results that are pro-
> duced on canvas. They depend quite as much upon individual skill
> and perception of beauty. . . . And the pleasure given is the same in
> kind. It appeals to the same sense of beauty.[92]

Throughout the essay, Cecil makes a familiar concession. His dis-
cussion is predicated on the notion that, even at its best, photogra-
phy is a compromised art medium. He could defend photography

FIGURE 48

Henry Peach Robin-
son, *When Day's
Work is Done,* 1877.
Collection of the
J. Paul Getty
Museum, Malibu,
California.

against the petty complaints of artists, however, because, by his
lights, "It is not in the least degree likely that photography will ever
dethrone painting from its present pre-eminence. The good painter's
resources are so much larger, his powers of interpretation so much
freer, that he will always command more admirers than the best pho-
tographer."[93]

"There are," Cecil remarked, "some photographers, and more pho-
tographic critics, who are of the opinion that a photograph cleanly
taken, and properly focussed is 'inartistic'; and if asked why they pass
upon it this terrible condemnation . . . that it is 'realistic.'"[94] Cecil did
not comprehend photography as a lesser kind of painting, but as a dis-
tinct, though lesser art. "Its beauties are special to itself, and hardly
come into competition with the true beauties of painting." He con-
cluded that the ground photography "occupies is limited; but on that
ground it is unapproachable."[95]

For Cecil, the limits of photography were reached in High Art Pho-
tography. He did not object to combination printing, the montagelike
technique used by Rejlander and Robinson to create their images. On
the other hand, he argued that "the great instrument by which the
painter expresses thought and feeling, and awakens human sympathy
or reverence, is not brought nearer to the photographer's grasp by
these contrivances." Ultimately, for Cecil, for many photographers,

and for critics of the medium, "From this, the loftiest region of the domain of art, the photographer is shut out."[96]

## CONCLUSION

The philosophical overtones and aesthetic debates that swelled photographic discourse in the middle years of the nineteenth century set the medium apart from the other transformational technologies affecting the Western world. Society did not judge photography to be as overtly disruptive as other technologies, notably the steam engine and the railroad, were.[97] In its later years, photography shed most of its simple associations with technological progress and, by drawing on natural genesis, enlarged its vocabulary.

The vigor with which photography was attacked and defended as a measure of truth in art may have owed less to particular aspects of photographic practice than to the fact that the medium signified a number of controversies. For better or worse, it was associated with the technological changes sustained by an urban middle-class society. As a new kind of verisimilitude, not quite a copy, not quite an actuality, photography defined modern vicarious experience. It teetered between authenticity and artificiality, knowledge and deceit. As both an idea and an imaging system, photography enhanced the tension between art conceived as the secular agency of truth and art conceived as the mirror of transient effects in nature and in society. The medium was, therefore, concurrently nostalgic and progressive. In effect, by the middle of the nineteenth century photography embodied the anxieties of modern life.

# FORCED TO BE FREE: PHOTOGRAPHY, LITERACY, AND MASS CULTURE

---

## INTRODUCTION

---

Throughout the last half of the nineteenth century, photographic practice was expanded by various techniques that produced multiple copies. The intellectual climate that configured photography as counterfeit art continued to reverberate in art theory. Ironically, the notion that the photographic image could be nothing more than a flat-footed replica helped to amplify speculation about the social prospects of photography. The medium became a touchstone within the extensive public dialogue about the benefits and consequences of mass public education. Although articulated in terms of individual betterment, at root literacy movements were motivated by a concern for social order. The ideology of improved individual free choice, facilitated by mass media, obscured a paternal attitude toward what should be learned and by whom.

The ideal of intellectual freedom permeating the middle-class outlook was tempered by an understanding of personal obligation harkening back to Jean Jacques Rousseau's formulation in *The Social Contract* (1762). Rousseau's interpretation of political freedom tacitly required that those who did not "obey the general will . . . shall be forced to be free."[1] Similarly, proponents of verbal and visual literacy supposed that the liberty to learn was counterbalanced by individual compliance with prevailing social and moral values. Nineteenth-century literacy campaigns were not revolutionary, but were infused with acquiescence to prevailing beliefs. Similarly, the fine arts, available not only through new public museums but also through reproductions of artistic works, were deemed a catalyst to the moral uplift of the populace. Indeed, the notion of a "museum without walls" is a twentieth-century phrase with an extensive Victorian past.[2] The

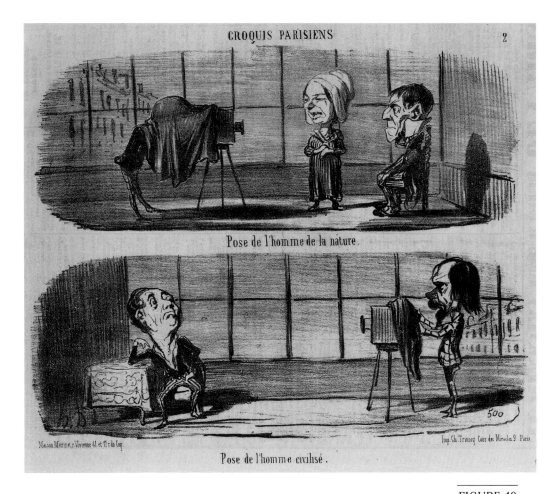

Pose de l'homme de la nature.

Pose de l'homme civilisé.

FIGURE 49

Honoré Daumier, *Pose de l'homme de la nature. Pose de l'homme civilisé,* lithograph, 1853. National Gallery of Canada, Ottawa, Canada.

dream of widespread visual literacy began before photography was disclosed to the world and continued throughout the nineteenth century. Reproductive media, such as etching, engraving, and, especially, lithography, encouraged the idea that art could be democratized. This sentiment was expressed in *The People's Journal* for December 5, 1846:

> Go forth, then, little prints! Take the place upon the walls of the artisan's dwellings of the coarse daubs which appeal only to the worst passions.... Let the spinners put them up against the beams of their looms – such pictures as these are lessons which a man cannot have too constantly before him.... How grand is the experiment we are making! Disregarding the suppressed sneers of the mere dilettante we say boldly to the working man, we trust you, we believe in you; art is for you as well as for the select circle.[3]

In France, beginning in 1834, the pedagogic value of art was formally and explicitly linked to the function of a museum in the conception of a Musée des Etudes. This became the basis for an ongoing attempt to create a Musée des Copies. The proposal attempted to yoke the advances of modern science to the best in art.

Nineteenth-century advocates of verbal literacy and visual literacy shared many suppositions. They believed that access to culture would accomplish more than providing routine familiarity with ideas, traditions, great works, and artifacts. The arts were essential in that they provided a common cultural heritage for rapidly democratizing, heterogeneous societies. Cultural literacy could be achieved through the manipulation of mass communications media like photography. Moreover, literacy was upheld as the key to upward mobility for both the working and the lower classes. In other words, mass verbal and visual literacy were thought to hasten societal progress on a broad scale.

Photography did not invent this set of assumptions, but the myth of the medium's neutral vision, coupled with its vast reproductive capacity, ministered directly to it. As public museums and galleries were opened and as the huge potential of reproductive photography became more apparent, the medium became a widely shared social metaphor for the utopian promise of egalitarian politics.[4] Writing in *The Photographic Times* in 1862, the photographer Alfred H. Wall proclaimed, "We have in photography a discovery which is to art what the printing press was to literature." Wall went on to connect the museum without walls, made possible by art reproduction, with a desirable democratization of culture. Like many other proponents of photography, he linked the free choice of educational and cultural materials to the success of an open society. Photography, he forecasted, would make works of high art widely available, "extending their influence, multiplying their admirers, and inspiring with their perfections the loftiest art-patron and the lowliest art-student." "Sooner or later," he claimed, the diffusion of art in reproduction would "exercise remarkable power in educating and refining the popular taste in art."[5] His sentiments were echoed in the photographic and non-photographic literature.

The "pictures for the poor" movement, and photography's presumptive role in it, has been largely forgotten or subsumed within the study of the "literature for the millions" campaigns.[6] This logocentric bias affected even the nineteenth-century advocates of educational photography, who found it necessary to acknowledge the power of print in their propositions. For example, when the French painter Odilon Redon mused on the educational possibilities of photography, he made reference to verbal literacy: "The mind is overwhelmed by the importance that painting could suddenly take on – thus placing it on the same terrain with the power of literature (the power [being] the power of multiplication)."[7] Similarly, the American Oliver Wendell

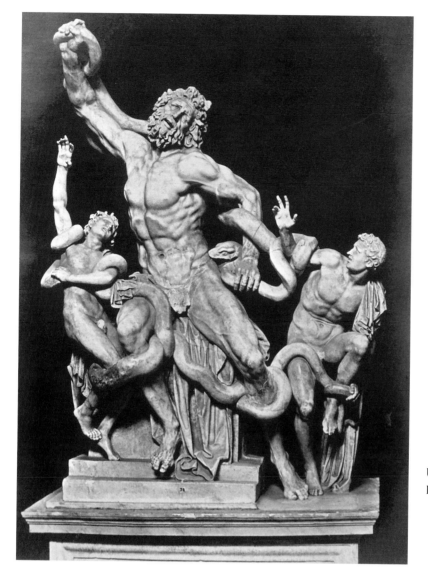

FIGURE 50

Unknown Photographer, *Laocoon,* from an unidentified series of art reproductions, c. 1860. Collection of the Author.

Holmes, in his essay on the impact of stereo photography, presented photography as challenger to the word:

> Such are the stereoscope and the photograph, by the aid of which *form* is henceforth to make itself seen through the world of intelligence, as thought has long made itself heard by means of the art of printing. The *morphotype,* or form-print, must hereafter take its place by the side of the *logotype* or word-print.[8]

Educational practice in the last half of the nineteenth century required that students acquire writing skills and numeracy along with the ability to read. Although there were some efforts to train people in draughtsmanship, appreciation of cultural artifacts did not require an ability to draw, paint, or sculpt. The emphasis on writing and computation skills made verbal literacy appear more important and pro-

ductive than visual literacy. Furthermore, the stress on verbal literacy tended to disassociate it from visual literacy.

Paradoxically, photography itself contributed to the intellectual separation of verbal literacy from visual literacy. For many, the photographic image was distinctly better than print, more objective, more truthful, and capable of giving viewers better choices. As one reviewer proclaimed: "Historical events will now be recorded with indisputable accuracy, and we shall no longer have to depend alone upon the verbal reports of ignorance and animosity."[9] In a case tried in Alabama in 1863, the court resolved that a likeness, captured by photography, was "open to the observation of the senses, and no particular skill is requisite to qualify one to testify to it."[10]

The ongoing debate about the worth of art photography has long deflected critical attention from the other, more popular uses of photography, thus increasing the difficulty of perceiving their mutual interests. Throughout the twentieth century, the academic division of verbal studies and visual studies has institutionalized the position that fundamental differences occur between representational media.[11] Until recently, both verbal studies and visual studies have stressed the hermeneutics of high culture and minimized social history, where the differentiation of the verbal from the visual has not been as pronounced.

Nineteenth-century promoters of verbal literacy and visual literacy routinely confused their own wishful rhetoric with actual social results. In the twentieth century, we have fallen into the habit of interpreting the advocates' nineteenth-century statements about the educational potential of photography as if they were nothing more than the evidence of gullible technological optimists. We have read these statements through the same screen of buoyant confidence that later writers have had for radio, for television, and for satellite and cable communication systems, and we have ignored the statements' critical subtexts, with their implications about the instrumentality of mass communications in modern society and the importance of cultural hegemony.[12] The extensive nineteenth-century discourse on photography's role in achieving mass visual literacy must be not only restored to its proper historical significance, but also analyzed in terms of the intellectual underpinnings that relate it to the concurrent campaign for verbal literacy.

## THE EDUCATIONAL REVOLUTION

Until about 1790, mass popular education in England was thought to be politically and socially dangerous.[13] The person who had been taught to read the Bible could not be prevented from reading Tom

Paine – or Fanny Hill.[14] But around the turn of the century, opinion began to change. For reasons that remain unclear, the idea arose in England and in many European countries that national literacy could be achieved without sacrificing social tranquility. The historian Lawrence Stone has concluded that "the most powerful argument behind the extension of education around 1800 was that it could be used as a means of social control."[15] Properly managed, literacy could increase morality, thereby reducing deviance and criminality.[16] This reconceptualization of literacy as a means of positive influence emphasized using the family, the school, the church, the work site, and the community as points of value transmission rather than the more overtly repressive institutions such as the law and the police. In a sense, the appeal of widespread literacy at this time may have been a practical accommodation to increased urbanization and the concomitant decline of village life.

The year of photography's disclosure, 1839, was also a peak year for Chartism in England, and education emerged as a central response to this threat of popular uprising. As recorded in *Explanations of the Intentions of Her Majesty's Government:*

> The sole effectual means of preventing the tremendous evils with which the anarchical spirit of the manufacturing population threatens the country is, by giving the working people a good secular ed-

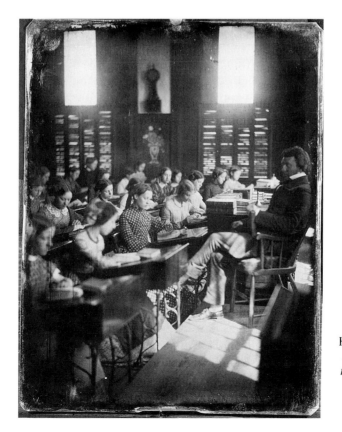

FIGURE 51

Southworth and Hawes, *Classroom in the Emerson School for Girls,* 1840–1862. The Metropolitan Museum of Art, New York.

ucation, to enable them to understand the true causes which determine their physical condition and regulate the distribution of wealth among the several classes of society. Sufficient intelligence and information to appreciate these causes might be diffused by an education which could easily be brought within the reach of the entire population.[17]

Whether literacy was seen as encouraging sedition or instilling morality, its effects were understood to be direct, determinative, and socially necessary. As a justice of the peace in Birmingham proclaimed, "I have no other conception of any other means of forcing civilization downwards in society, except by education."[18] One social theorist of the time stated that "reading will help to mend people's morals, but writing is not necessary."[19] And, in a phrase that is often repeated today, an 1839 issue of the *Edinburgh Review* declared that "we must build more schools or more prisons."[20] Moreover, in England in the 1820s, the middle-class reformers who founded both the Society for the Diffusion of Useful Knowledge (SDUK) and the Mechanics Institutes justified them as adding to the moral improvement of the working class.[21]

Businesspeople and government officials were interested in the moral reform of workers, not in their intellectual betterment. When asked for a philosophy of education, an English cotton-manufacturing firm responded: "We are of the opinion that it is more conducive to the welfare of our people to endeavour to make them enlightened Christians than wise in worldly subjects; we do not want statesmen in our factories, but orderly subjects."[22] A similar rationale informed government policy in France. In the mid-1830s, M. Guizot, minister of public instruction, stated in a letter to the nation's school teachers: "Universal elementary instruction shall henceforth be the guarantee of order and social stability."[23] This reasoning altered over the nineteenth century, as became apparent by midcentury.[24] Appeals for social control achieved through reading skills became less frequent. The concept of control was gradually replaced by the idea of transforming working-class culture.[25] This new direction emphasized the benefits of self-management and individual achievement. Shorn of coercion, the movement for literacy initiated a consensus in all social classes.[26] This new tack resounded in the rhetoric of those who pressed the educational potential of photography.

## A VAST PICTURE GALLERY

Photography was introduced to the world with a discussion of its educational advantages, albeit as benefits to practitioners of science and art rather than to the general public.[27] Within months of the Au-

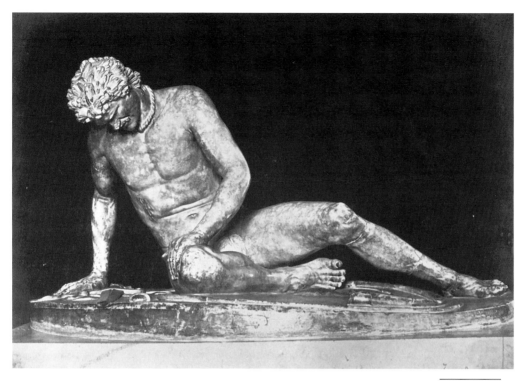

FIGURE 52

Unknown Photographer, *Dying Gaul,* from unidentified series of art reproductions, c. 1860. Collection of the Author.

gust 1839 announcement, early daguerreotypists traveled to Greece, Egypt, and the Holy Land to record ancient architecture. Amateur as well as commercial photographers issued collections of topographic views in the 1850s. The celebrated *Missions héliographiques* was organized in 1851 to record the architectural heritage of France.[28] In 1853, Roger Fenton, who would become most famous for his discreet photographs of the Crimean War, produced, as the official photographer to the British Museum, images of the museum's sculpture, carved reliefs, prints, and drawings for the use of scientists, artists, and the public. The scheme to sell the reproductions at the museum and through the print dealer P. and D. Colnaghi did not work out, however, and was abandoned in 1858.[29] In 1856 *Photographic Art Treasures* appeared, a diverse assortment of picturesque views, High Art photographs, and art reproductions aimed at collectors of engravings.[30] This collection reflected the interests and photographic pursuits of English amateur photographers rather than of those interested in public education.

During the 1830s, *The Penny Magazine* introduced reproductions of famous art works, such as *The Dying Gaul,* that aligned patriotism and moral messages with ancient art.[31] It was not until the late 1850s and the 1860s, however, after the wide dissemination of paper photography and the stereograph, that photography began to figure routinely in discussions of mass public art education.[32] By 1864, the photographer Marcus Aurelius Root could write:

> What this new art is doing, and is still more largely to do . . . [is to increase] the knowledge and happiness of the masses. What,

heretofore, the traveller alone could witness . . . , even the humblest may now behold, substantially, without crossing his own threshold . . . whatever else of interest the world may present to the sight, caught, as they may be, with absolute exactitude, by the infallible pencil of the sun, are now brought within reach of all, even the lowliest of the community.[33]

Root's understanding depends upon the belief that the photograph simulates experience in a way that images presented in other media do not. The sense of the photograph as facsimile permits the medium to substitute as a reasonable alternative to experience and to evade the charge of being counterfeit or deceptive. Root proposed that the photograph is a witness to both nature and culture. It images "natural scenery" and "noblest edifices." The photograph records "the finest existing specimens of art, ancient and modern, of foreign countries or your own."

Root repeatedly emphasized the medium's benefit to "the lowliest of the community" and to those who dwell across the humblest threshold. For Root, the photograph could bring to "the masses . . . abundant and infinitely various stores of knowledge and entertainment" and, in the course of time, "no small measure of artistic training."[34] What sets Root and the 1860s apart from photography's original proponents and earliest era is this emphasis on the mass educational function of photography. By the 1860s, photography had acquired an association with popular instruction that it had been missing in its first decade.[35] In 1866, reviewing a series of photographs taken in Berlin of Old Masters and contemporary paintings, the critic W. L. R. Cates declared that "one great practical difficulty stands in the way of a sound Art-education for the million: the impossibility, for all but a few, of direct and intimate acquaintance with the master-pieces of Art."[36] Like other critics, Cates linked art education with the general process of cultivating taste and temperament in the poor. It is important to note that both before and after photography, the art chosen for reproduction reflected the long-established didactic emphasis in art theory. Sir Joshua Reynolds's *Discourses on Art* was frequently cited.

The general press was also enthusiastic about the educational potential of photography. The press underscored the speed with which photography made possible self-improvement. In contrast to those persons educated by tutors and the Grand Tour, the properly motivated could get an education at home or through a public library. "With a pile of pictures by their side, which cost almost nothing, they can make the European tour of celebrated places, and not leave the warm precincts of their own firesides."[37] Photography's proponents viewed the impending democratization of education as a challenge to the established order. In 1858 *The Athenaeum* announced:

What an educational revolution is here, my countrymen. Why, our Tommys and Harrys will know the world's surface as well as a cir-

cumnavigator. . . . What a stock of knowledge our Tommys and Harrys will begin life with! Perhaps in ten years or so the question will be seriously discussed . . . whether it will be any use to travel now that you can send out your artist to bring home Egypt in his carpet-bag to amuse the drawing-room with.[38]

A year earlier, a critic for the same journal had declared:

The old selfish aristocratic days of hoarding are gone for ever. Rare Titians, kept in cases to be gloated over at miserly moments, will be seized and photographed. . . . Great and true Art is republican, and is for all men, needing no education to appreciate it, – no more than we need education before we fall in love.[39]

In the United States, Oliver Wendell Holmes, writing in *The Atlantic Monthly,* foresaw "the time . . . when a man who wishes to see any object, natural or artificial, will go to the Imperial, National, or City Stereographic Library and call for its skin or form, as he would for a book at any common library."[40] In the minds of many, photography was poised to sunder the traditional structure of knowledge acquisition whose exclusivity sustained economic and political power. Because travel and art acquisition were so thoroughly associated with the gentry, it is little wonder that photography's potential to enlarge their audiences made travel and art the keystones in a larger educational debate.

Interestingly, whereas plaster casts of sculpture and engravings of paintings were part of the popular education movement, criticism of their infidelity to the original never reached the level that denunciations of photography did. This is because castmaking and engraving were not associated with modernism. But chromolithography was produced by a new reproductive technique that was suffused with democratic rhetoric. For example, in his 1869 *Atlantic Monthly* essay "Popularizing Art," James Parton extolled chromolithography because it harmonized with what he deemed "the special work of America at the present moment, which is not to create, but to diffuse; . . . not to add to the world's treasures of art, but to educate the mass of mankind to an intelligent enjoyment of those which we already possess."[41] As a democratic contender, chromolithography garnered some of the same vituperation that photography endured.

Photography's proponents considered the medium's existence to be clear evidence of general social and material improvement. In "Photography: Considered in Relation to Its Educational and Practical Value," Robert Hunt argued that "no new fact can be born into this world . . . without its becoming . . . of the greatest use to the arts of industry, and to the purposes of advancing the human mind."[42]

The high-minded rhetoric surrounding educational photography tended to obscure the fact that photographic reproductions of art were themselves products in a rapidly commodifying society. In the 1860s, several entrepreneurs saw photography, despite its technical difficulties, as a way to acquire part of the growing market for art re

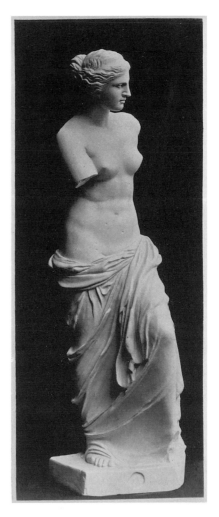

FIGURE 53

Unknown Photographer, *Venus de Milo,* from an unidentified series of art reproductions, c. 1860. Collection of the Author.

productions. The Alsatian photographer Adolphe Braun started producing art reproductions in 1866, and his business quickly became international in scope. The company copied drawings, paintings, and sculpture in Italy, Germany, and Austria and compiled a file of five hundred thousand paintings.[43] Writing in the preface to the 1887 Braun catalogue, J. C. Robinson expressed the reigning maxim: Through photography, art had "been brought to the very doors of even the humblest art lover."[44] Throughout the late 1860s and 1870s, publishers in Italy, Germany, and France produced cartes de visite illustrating art objects.[45] Fratelli Alinari Fotografi Editori, a firm that still produces art reproductions, was founded in 1854. Because there were so few art galleries in North America, publishers tended to import European art illustrations. Bierstadt Brothers in New Bedford, Massachusetts, and Bufford's Publishing House in Boston both catalogued card photographs of art separately.[46] American publishers typically offered more landscapes and city views.[47] "Art photography," a broad term, could refer to masterwork reproductions as well as to sentimental fa-

vorites like "She is Not Here," from Bierstadt's list, and Bufford's "Blowing Soap Bubbles."

Especially in the 1860s, during the heyday of stereographic photographs, Americans interpreted the popularity of photographic art reproduction as an integer in the enhancement of national taste. "The warm reception given them shows the existence of an innate sense of the beautiful in the minds of our citizens, which needs but the time and the occasion to develop itself into a true artistic judgment," pointed out one writer for *Scientific American* in 1860. Against "the imputation that Americans are a people entirely devoted to providing for the practical necessities of life," this writer saw the cultural life of Americans budding, "when their means afford them the time necessary to devote to such studies."[48] In the United States, art education had to

FIGURE 54

John Adams Whipple, *Crystalotype of an exhibit at the 1853 Crystal Palace exhibition in New York.* Published in *The Crystalotype World of Art,* 1854. Courtesy of the American Antiquarian Society, Worcester, Massachusetts.

be separated from the tinge of continental decadence against which the purity of nature and the sublimity of the American landscape were set. Attempts at art education were often phrased in religious terms. The Society for the Advancement of Truth in Art, founded in the 1860s upon John Ruskin's principles, united love of nature with love of art and thus sanctioned art education.[49] Root endorsed photographic art reproduction to augment the moral sentiments that were first stimulated by beauty in nature.[50] For the middle class, nature and art were not rigidly separate categories, but were aspects of personal improvement and taste. Likely enough, for the lower classes, who were thought to be too close to the natural state, it was art and not nature that was seen to be elevating.

Such statements by the proponents of photography as "rich men will always desire to monopolize original paintings" might seem to be part of a general critique of power relations in society.[51] Yet pronouncements about photography's ability to democratize art should not be interpreted as socially radical. They resound with the rhetoric of bourgeois freedom and individualism. The antagonism they express is that of an urban, self-educated, commercially based middle class against the interests of a landed aristocracy. The idea that photography replicates art more accurately than do other reproductive media arose in the conservative belief that the medium was not an art in itself, but an impartial mirror of whatever is set before it.[52] The photographic reproduction of art treasures promised to transmit aristocratic high culture to the lesser classes. The nineteenth century's media of mass communication symbolically endorsed the idea that the middle class could circumvent the established cultural elites, while it broadcast a message of emphatic individualism to a wider audience.

Just as most art photography in the 1850s expressed the nostalgic world view of the upper classes, reproduction of artworks was grounded in the argument that art was not endlessly progressive like science. "The lesser arts progress, but the greater art does not share in the advancement," an anonymous essayist for *Blackwood's Magazine* wrote in 1858.[53] Western art, it was believed, had reached its peak either in classical Greece or during the Italian Renaissance.[54] Photographic reproduction did not either prefigure or augment the emergence of a new culture for the new industrial age. On the contrary, arguments for the transmission of high culture often turned on a cultural version of Gresham's law. Proponents sensed that bad art, that is, popular culture, would drive out the taste for good art and, consequently, good art itself. As early as 1840, Sir Francis Palgrave had written that through mechanical means, "A permanent flood of pseudo-art is created; the multitudes are over-fed with a superabundance of trashy food, and their appetite will never desire any better nutriment."[55] Flooding the market with inexpensive, salutary images might forestall cultural crisis. In one of his articles on mass culture, "The Unknown Public," Wilkie Collins opined that "the future of English fiction may rest with this Unknown Public, which is now waiting

to be taught the difference between a good book and a bad." As a modern, Collins believed that "the largest audience for periodical literature, in this age of periodicals, must obey the universal law of progress, and must, sooner or later, learn to discriminate."[56]

## "People Will Form Collections of All Kinds"

When Daguerre published his broadsheet advertising the invention of photography, he underscored that "people will form collections of all kinds."[57] Given the tone of the broadsheet, however, it is evident that he did not mean the daguerreotype to be used by the general populace. Two decades later, both the proponents of educational photography and the advocates of verbal literacy approvingly envisioned that mass media would make possible "a grand intellectual factory."[58] The intellectual factory could process knowledge into nuggets of consumable information. The anonymous writer for *The Athenaeum* who had looked to the civilizing of "our Tommys and Harrys" saw photography as helping to create a large, flawless, efficient, speedy, data-gathering apparatus.

The way in which the advocates of educational art reproduction proposed to systemize the production and distribution of images accorded with the massive reorganization of production and consumption in the larger society. As the critic Allan Sekula has observed, photography was not so much the harbinger of modernity as it was the emblem of "modernity run riot."[59] It simultaneously symbolized abundance and chaos. While the urban-industrial world became less familiar, indeed unknowable, photography attested to an underlying rational and socially beneficial order. As social metaphor, photography reassuringly suggested that the state of things could be understood. Conceptualizing the visible world as a series of potential collections, to be gathered and tabulated through photography, connoted that the threat of intellectual, moral, and social disorder brought on by socioeconomic change could be mitigated or averted.

The structuring of art reproductions as integers in a larger system corresponds to the concurrent indexing of scientific collections, accumulation and arrangement of anthropological photographs, and inception of criminal, medical, and charity photographs.[60] This aggregation and organization of images licensed "looking" while it defined the normal and the abnormal. Novels like *The House of the Seven Gables* as well as pulp tales frequently used photographs or the idea of photography to denote the frisson of forbidden looking.[61] Indeed, as Georges Canguilheim recognized in his landmark study of the normal and the pathological, throughout the nineteenth century "the identity of the normal and the pathological . . . [was] asserted as a

FIGURE 55

gain in knowledge of the normal."[62] The obvious emphasis on the abnormal and the normal in anthropometric and criminal photography has a soft parallel in the importance given to Old Master paintings in photographic reproduction.[63] That which constitutes "the normal" in painting – masterworks and paintings that imitated their illusionism or subject matter – were photographically reproduced much more often than were the paintings associated with the avant-garde, or "the abnormal," art movements of the middle and late nineteenth century.

An anonymous critic for the *Journal of the Photographic Society* compared Dr. Hugh Welch Diamond's mid-1850s photographs of people with mental illness to art images. The idea of collecting information via the art-science of photography tended to level and homogenize the particular subject matter of the collection, creating a kind of universal intellectual currency. Chauncy Hare Townsend, an early English collector of photographs, gathered and displayed war, documentary, and landscape photographs, as well as many stereographs, mostly from the late 1850s. In his collection, and in many that would be amassed throughout the nineteenth century, the photograph became a unit of collection, somewhat divorced from the subject matter it represented.[64]

In this light, Baudelaire's assertion that the decline of imagination was abetted by photography takes on added significance.[65] Baude-

FIGURE 56

Alphonse Bertillon, *Vue générale de l'exposition du Service d'identification de la Préfecture de police à Chicago,* c. 1893. National Gallery of Canada, Ottawa, Canada.

FIGURE 57

J. Valette, *Manie.* Plate I from his *Nouveau traité élémentaire et pratique des maladies mentales,* 1876. The Harrison D. Horblit Collection of Early Photography. The Houghton Library, Harvard University, Cambridge, Massachusetts.

laire identified bureaucratic organization with the encyclopedic im-
pulse, which, he argued, obstructed creative contemplation and im-
peded thinking beyond the norm in life as well as in art. Organization
signaled the neglect of imagination and nuance. To him, the system-
atizers seemed to be setting up what H. G. Wells would later call a
World Brain. Baudelaire worried that the Brain lacked the capacity for
true, human inquiry and was, therefore, little more than a factory for
the production and distribution of convention. Ultimately, this sys-
tematizing universalist would be satirized in Gustave Flaubert's 1881
novel *Bouvard and Péchuchet,* which depicts two clerks who attempt
to create a total assemblage of the world's knowledge.

The specific literature of photography and the general interest jour-
nals that carried articles on photography tended to conflate the idea
of an intellectual factory with the idea of the library. Oliver Wendell
Holmes's forecast of a great public library filled with photographs was
far from unique. In his *Photographic Sketches* of 1856, Ernest Lacan
also thought in terms of collecting all the world's knowledge in pho-
tographs. He proposed a "gigantic project" that "little by little" would
be complete, especially when photographers realized the necessity to
expand their purview to the ends of the earth.[66] Edward Hitchcock,
geologist, theologian, and president of Amherst College, stressed the
natural origins of the photographic process and the telegraph. He in-
terpreted them as revelations of the means by which nature records
every human act and thought "Into a vast sounding gallery; / Into a
vast picture gallery; / And into a universal telegraph." The universe,
to Hitchcock, was a limitless exhibition of naturally created da-
guerreotypes – God's museum.[67] Humans would do well to emulate
the divine in nature.

Likewise, "the near perfect state of photographic technology" con-
vinced Lacan that a near perfect rendition of the world could be made.
"It is necessary," he wrote, "that photographic albums become
books."[68] A credulous fervor for photographic fact-gathering abound-
ed. It coursed through A. A. E. Disdéri's hymn to photography's pres-
ent and future, which made up a large portion of his short book,
amusingly titled *Indispensable Photographic Information for All (Ren-
seignements photographiques indispensables à tous)* (1855).[69] In 1862,
Disdéri still envisioned the encyclopedic potential of photography. He
suggested that a compendium of collections be published, containing
not only contemporary art but also Old Masters and works of archi-
tecture. The benefit of this publication would be not simply educa-
tional, but intellectual. Disdéri believed that the project would have
the clarity that comes from the rational classification and interrela-
tionship of objects.[70] Disdéri thought that eventually this compendi-
um would become a vast gallery, intended to introduce not only art,
but the organization of art.[71] This attitude persisted for decades.
Thus, in 1889, the *British Journal of Photography* urged "the formation
of a vast archive of photographs . . . containing a record as complete
as it can be made . . . of the present state of the world."[72]

Toward the end of the nineteenth century, the idea of a vast picture gallery was appended to the architecture and the cultural significance of the large department store. Both the gallery and the department store expressed the idea that individual freedom proceeds from bounteous choice. In the era's wishful thinking, the picture gallery, whether photographic or not, was thought to disseminate art by convening disparate elements in a rational order accessible to the public. The department store offered democratized and ordered choice, bringing together traditionally separate boutiques, for which limited entry and small selection had been the rule.[73] Both of these cultural spaces suggested an "aesthetics of abundance," the idea that "there was *more than* enough, indeed, *so much* that it must be very natural, very easy, and almost a God-given right, to own things."[74]

## Fact, Fact, Fact

Borrowing a page from Dickens's *Hard Times* (1854), the promoters of visual literacy and verbal literacy might have said, "Fact, fact, fact, everywhere in the material aspect . . . fact, fact, fact, everywhere in the immaterial."[75] Both campaigns tacitly advanced the principle that Michel Foucault later identified as "compulsory visibility" (*visibilité obligatoire*).[76] Individual and social progress came to be seen as dependent on the increased visibility of data in all fields of government and intellectual inquiry. The world was called to order, not just because mass communications techniques made ordering possible, but because the ordering was seen as socially fruitful. More than simple repositories of appearances and facts, the proposed vast photographic collections and libraries were compendia thought capable of affecting attitudinal change in an expanded group of users.

Crucial to the concept of the intellectual factory was the belief that mass communications techniques could catalyze a transformation in the lower and working classes. An 1868 article in *Lippincott's Magazine* typically connected free access to verbal and visual information with the achievement of democracy in the United States:

> Two things strike us in comparing American culture with that of the Old World. First, of course, is the greater diffusion of cultivation – in a wide sense, popular education. Everyone here may learn to read and everyone may obtain access to literature. Not only so, but by the marvelous art of photography, the lights and shadows of the most beautiful paintings, statues and scenes of nature, from all quarters of the world, are scattered almost on the winds, shown in shop windows, laid upon tables, or hung on the walls of even the poor. This is, in its degree, a culture of the many.[77]

In the same book in which he outlined the present and future appli-

cations of photography, Disdéri gave an account of the Universal Exposition held in Paris in 1855. He suggested that the exposition exercised a moral action on the working class that gladdened the heart and that ultimately made the workers love their work. The effect was so salubrious that Disdéri regretted that the exposition was not a permanent feature of modern urban life.[78]

Of course, the great Victorian sages like Matthew Arnold and John Ruskin preached the value of cultural attainment for persons of all classes. But only occasionally was the photographic reproduction of art objects put forward as a means to expand middle-class taste or as an economy that might relieve one of the necessity to send sons and daughters abroad.[79] For the most part, the promoters of literacy and photography spoke of civilizing a new clientele of urban workers and their children.[80] Their outlook accorded with the conclusion of the 1841 *Minutes of the Committee of Council on Education,* penned by the English educationist James Kay-Shuttleworth:

> By increasing and elevating their domestic affections it may invest their homes with an undecaying charm; by inspiring them with a thirst for knowledge it may provide rational and ennobling amusement for the hours of leisure; and by both these additions to their spiritual existence may rescue some from spending their evenings idly by their chimney corner in mere vacuity of thought; and others, from resorting to the public-house for the pleasure of talking obscenity and scandal, if not sedition amidst the fumes of gin and the roar of drunken associates.[81]

Repeatedly, the barbarism and primitivism of the lower orders was conceived as a lack of culture.[82] In its ardent plea for a comprehensive American museum that would present great works from the Old World, *Appleton's Journal* argued that

> next to mitigating the poverty of helpless and infirm persons . . . we should rank an effort to make all classes acquainted with the beautiful and curious manifestations of the human mind, and the lovely and interesting works of men's hand. . . . Life is sweeter, even to the poor, under a civilization which is favorable to the growth and cultivation of the artistic perceptions.[83]

Early American settlers were apprehensive about the arts bringing with them the decadence and materialism of Europe, but those living in the latter half of the nineteenth century legitimized on moral grounds the viewing and collecting of art. Moreover, as Alan Trachtenberg has observed, "By offering a middle ground presumably secure from aggression of the market place, culture would offer an alternative to class hostility."[84] In 1875, an American commentator, Louisa Cragin, maintained that if trade unions were transformed into choral societies and good music were brought to workers and their children, in a generation "there would be fewer strikes, the grimy faces would be less haggard; under the unconscious influence of beauty, harmony, and rhythm, labor will be more cheerfully, more faithfully performed."[85]

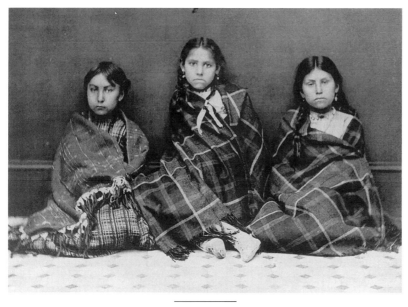

FIGURE 58

Unknown Photographer, *"On Arrival at Hampton, Va.: Carrie Anderson – 12 yrs., Annie Dawson – 10 yrs., and Sarah Walker – 13 yrs.,"* c. 1880. Peabody Museum, Harvard University, Courtesy of the President & Fellows of Harvard College.

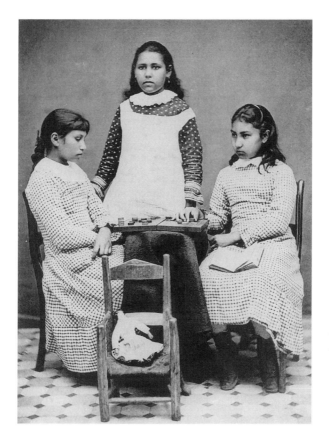

FIGURE 59

Unknown Photographer, *"Fourteen months after,"* Hampton, Virginia, c. 1880. Peabody Museum, Harvard University, Courtesy of the President & Fellows of Harvard College.

The photographer and historian M. A. Root defended even technically poor specimens of photography because these served to expose people to the world's art and to make new city dwellers sensible to beauty.[86] He believed that photography was increasing both "the knowledge and the happiness of the masses."[87] "Civilizing," with its double meaning of pacifying and educating, often appeared in the photographic literature.[88] As André Rouillé has shown, French photographic journals in the 1860s praised the civilizing mission of photography, which would "spread light to the masses, to elevate them and make them better."[89] Invoking religious missionary terms, the promoters of the civilizing effects of photography used light and dark, photography's graphic properties, to allude to knowledge and ignorance.[90] The use of darkness to connote poor persons' furtive recreations and remove from the reproving light of civilization is a prominent feature of nineteenth-century fiction and social science.

## The Intellectual Meritocracy

Photography's perceived ability to granulate knowledge while recording it installed an atmosphere of pluralistic choice around the medium. "Each student or lover of Art is at liberty to make his own selection, arranging them according to his taste, and forming a 'Gallery' of choice pictures in which he may loiter and delight at home."[91] *The Athenaeum,* a publication whose editorial stance doubted the high art potential of photography, lauded the democratic education made possible by photography: "Art can no longer be the rich man's luxury when the merest chemist's lad, with his glass and bottle, hood and bath, can carry off the very image and radiance of Alp or lake, cataract or mountain, and there proudly gaze daily upon his gem of Art as happy as my Lord with his fleshy Rubens."[92]

Photography aided, but it did not create, the equation of information access with upward social mobility. The concept was clearly articulated before 1839. The first volume of *The Penny Magazine,* begun in 1832 by the Society for the Diffusion of Useful Knowledge in Britain, asserted: "Cheap communication breaks down the obstacles of time and space – and thus bringing all ends of a great kingdom as it were together, greatly reduces the inequalities of fortune and situation, by equalizing the price of commodities, and to that extent making them accessible to all."[93] Before photography, the idea of photography, or "a medium of complacent communication" as one commentator called it, was associated with scientific objectivity as it portended emergent harmony between the upper and lower classes. A member of the Glasgow Mechanics' Institute praised the organization in these terms: "Meeting, as both classes do, on the fair field of science, where

all are as brothers, and pursuing, it may be, the same glorious objects, the wall of separation is removed for ever, and the best possible guarantee given for the inviolable maintenance of the rights of property on the one hand, and the peace and security of society on the other."[94]

The consumer of mass media was seen as making free choices among grains of cultural information equitably distributed or at least potentially so. In an 1861 issue, *The Photographic News* boasted that the medium "has swept away many of the illiberal distinctions of rank and wealth, so that the poor man who possesses but a few shillings can command as perfect a lifelike portrait of his wife or child as Sir Thomas Lawrence painted for the most distinguished sovereign of Europe."[95] Photography's verism and its reproductive capacity deepened the belief in the efficacy of education to improve the lower classes. Simultaneously, photography helped further to commodify culture. Once an airy upper-class abstraction, culture came down to earth as cultural property, which could be acquired through the marketplace like other kinds of property. As Charles Dickens has a character explain in *Hard Times*, "what is called Taste, is only another name for Fact."[96]

The perception of the social options made available by photography supported an ideology of freedom. It incorporated an important theme in middle-class economic and political theory, namely that the individual makes self-determined, rational, informed choices or purchases in an atmosphere of healthy diversity.[97] Likewise, photography supported the fervent nineteenth-century philosophy of voluntarism – the notion that social change directly stems from individual action and the concomitant principle that the individual has a social responsibility for self-improvement. Simply put, if the Tommys and Harrys did not choose to avail themselves of the new opportunities to learn, it was nobody's fault but their own.

Voluntarism was essential to the emergent middle-class intellectual meritocracy. Knowledge was power to an increasing number of legal, medical, scientific, administrative, and educational professionals and experts. The systematic methods of observation and analysis employed by these new professionals generated intellectual capital while they substantiated the value of a class system based on ability.[98] The ethos of self-improvement enveloped middle-class life and lent legitimacy to the moral engineering of the working class. Reflecting on his efforts, Victorian reformer John Arthur Roebuck concluded: "My object has been . . . to make the working man as exalted and civilized a creature as I could make him. I wanted to place before his mind a picture of civilized life such as I see in my own life . . . *I wanted to make the working man like me*."[99]

The myth of photography's transparency – its uncomplicated relationship to the world of observable reality – made the medium appear to be an essential tool for documentation and organization of professional knowledge. At the same time, like science and the idea of scientific objectivity, photographic neutral vision became a widely avail-

able social symbol for meritocratic advancement. The ideology of progress operated on many levels and in many arenas. Empiricism was social democracy writ in scientific terms.

The rhetoric of educational photography, like that of verbal literacy, became entwined with liberal social theory. "This is the *social* idea," wrote Matthew Arnold, "the men of culture are the true apostles of equality." Culture, Arnold asserted, "seeks to do away with classes."[100] The concept of culture as a societal yeast permeated conjectures on democratic pluralism and individualism. In this way, the concept of culture occluded factors of race, tradition, national origin, age, gender, the division of labor, and class as they related to personal and societal betterment. By seeming to increase the individual's access to knowledge, and appearing to make more things more visible, promoters of literacy and photography made the root causes of inequality less visible.

## "In Severe Characters of Black and White"

It is all too easy to let the image of the intellectual factory slip into the shadows of a dark parody, like Dickens's *Hard Times.* The urban landscape of Coketown, where the jail, hospital, town hall, and Mr. M'Choakumchild's school are equally regimented, offers a picture of utilitarianism and coercion that belies the way in which people voluntarily internalized the notion that literacy acquisition was key to personal success.[101]

One finds among the writings of working-class people a hopeful acceptance of individual and social improvement made possible by democratic access to the intellectual factory. Writing at midcentury, a Leeds Chartist, Joseph Baker, aspired to see people put in possession of the world's information, so that they could create "an intellectual and literary brotherhood" of industrial workers.[102] Though critical of capitalism, Owenite socialists held with the power of mass public education to make social changes. Even Charles Dickens, quick to point out the abuses in urban industrial society, made free access to the Coketown library a major source of potential opposition to the regimentation and oppression of the place.[103] At the same time, it is crucial to note that the ideology of personal and social advance could be and was critiqued by its putative beneficiaries. The English Victorian observer Thomas Wright argued that "in regard to this especial theory of the educated working man necessarily rising above the uneducated one, the working classes see that this is practically false."[104]

Did verbal literacy and educational photography accelerate the

FIGURE 60

Unknown Photographer, *Interior of the Schoolhouse of District No. 1, LaFayette, New York,* c. 1902. Courtesy of the J. Roy Dodge Collection, Syracuse, New York.

rate of industrialization or assist upward social mobility? While there is little scholarly research on the visual literacy campaigns to query, the emergent view among historians of verbal literacy is that literacy acquisition in the nineteenth century cannot be sequentially and causally connected to the success of the Industrial Revolution. Faith in the efficacy of literacy, together with the discipline learned along with reading and writing, may have made the process of rapid industrialization smoother, but literacy itself was not a requisite for the new workers.

During the last two centuries, literacy has become a worldwide outward symbol of modernization, despite there being no convincing, documented studies that show the interdependence of literacy and the characteristics of capital formation and social organization that we call modernization – at least until the turn of the century, and then not in all places.[105] This unexamined trust in the personal and societal benefits that follow from the achievement of literacy has been called the literacy myth.[106]

It is one thing to observe that world literacy increased in the last three centuries, and quite another to relate literacy deterministically to industrialization and modernization. Sweden produced the highest literacy rates – that is, reading, not writing, rates – in the West during the eighteenth century.[107] But it was in England that the Industrial Revolution occurred. When it occurred, English literacy rates may have actually declined, owing to the social disruptions and decreased opportunities for schooling that industrialization brought with it.[108]

Despite promoters' declamations, neither verbal nor visual litera-
cy was able to contribute directly to industrialization or individual up-
ward mobility. In the last century, most of the mining and industrial
jobs were manual jobs, which did not require literacy. Particularly in
the first half of the century, formal schooling did not include voca-
tional training. Generally speaking, the long-term rising rates of liter-
acy in Western countries in the last century were not due to the need
to have workers who could read or write or who had to acquire vo-
cational skills at school.[109] As Harvey J. Graff's demographic studies
in three Canadian cities have shown:

> systematic patterns of inequality and stratification – by origins,
> class, sex, race, and age – were deep and pervasive, and relatively
> unaltered by the influence of literacy. The social hierarchy . . . even
> by mid-century in modernizing urban areas, was ordered more by
> the dominance of social ascription than by the acquisition of new,
> achieved characteristics.[110]

In the narrow sense, then, literacy was not strictly necessary for the
new workers of the nineteenth century. Still, verbal and visual litera-
cy acquisition emerged as a major terrain of contested meaning.

## The Mind World

Literacy came to be understood as integral to societal progress for a
number of interrelated reasons. Then as now, it was common to con-
fuse rhetoric with results. The belief in mass media as efficient and ef-
fective agents of uniform acculturation augmented the literacy myth.
Typically, it has been thought that literacy, whether verbal or visual,
operates more or less the same way and produces more or less the
same results regardless of the cultural setting. Readers and viewers
have been assumed to be passive recipients of education.

In this mental model, the points of contact between readers, view-
ers, text, and image have been collapsed, ignored, or erased. Cultural
hegemony is understood to result from domination and repression,
reinforcing the notion of power as linear and static: a one-way street.
During this century and the last, the literacy paradigm has been so re-
ductive that it explains persistent illiteracy as reading lessons not ap-
plied often or hard enough.[111]

Recent scholarship has rejected the residue of determinism. Espe-
cially in theorizing the changes from orality to literacy, a new dynam-
ic model has emerged that portrays the process as fluid, polymor-
phous, and active.[112] Literacy acquisition is now seen to be teasingly
complex: a mixture of consent, invention, self-regulation, and resis-
tance. Although this paradigm has been advanced as a way to under-

stand the reception of verbal literacy, it suggests ways to look at the reception of educational photography as well.

Anyone who would study the reception of print or educational photography should take to heart the remark made by François Furet and Jacques Ozouf that "nobody really knows all that much . . . about the psychological, cultural and social price that has to be paid when written culture encroaches upon traditional, or oral civilizations."[113] The impact of photography and literacy should be painted as conjectural. Moreover, the term "oral culture" is an unfortunate shorthand with which to describe those persons who could neither read nor write or who were functionally illiterate. The concept of oral culture overlooks the fact that illiterate persons have had access to verbal culture through designated readers for many hundreds of years. It is safe to assume that the same sort of informal system existed for the interpretation of visual materials.

Bearing those caveats in mind, it appears that when literacy is introduced to oral cultures, even forcefully introduced, the oral culture is not immediately devastated or fundamentally altered. If literacy can be perceived symbolically by its proponents, it can be perceived as equally symbolic by those tasked with achieving it. In the nineteenth century, those who accepted the government of France, also accepted French language and culture. Conversely, those who saw literacy as a symbol of French centralization, industrialization, and homogeneity, initially adapted on a superficial level to the new demand.[114]

Still, the intellectual capital of oral cultures must be transmitted orally and through actions.[115] The cultural processes of remembering and forgetting go on in the present. Oral cultures require face-to-face contact for communication. Every encounter reinforces and enlarges the social network. One has few choices: solitude or society.[116]

The record building and externalization of thought that photography and literacy support create a seemingly more objective sense of time and space. They create a sharper recognition of pastness and otherness than oral cultures do, while minimizing the individual and group value of memory.[117] The shift from an oral culture to a literate one involves changing "from formulaic to verbatim memorization, which alters both the process of storing information and the criteria for measuring the accuracy of reproduction."[118] As the historian of literacy Jack Goody has observed, "As long as the legendary and doctrinal aspects of the cultural tradition are mediated orally, they are kept in relative harmony with each other and with the present needs of society."[119]

The threat for oral or protoliterate subcultures in Western Europe during the nineteenth century was not so much that they would embrace the facts dispensed through literacy and photography, but that the time and space scales that literacy and photography made available would create a critical, comparative awareness that could, in time, erode confidence in the oral culture from within. A telling late

nineteenth-century experience of reading designated classics was recorded by a composer named Thomas Jackson:

> Insensibly, pre-occupation with these "classics" treated as a single category – the Best – caused a student to slip into regarding Culture as a fixed Mind-world in which one either ascended with the geniuses to supreme heights or sank with the dullards and the dunces to the uncultured slime. Insensibly, in this way, one acquired a complete detachment from – if not a downright contempt for – the uncultured vulgarity and sordidness of everyday life and actuality.[120]

Internalized judgments like this are ineluctably more convincing than coercion, which is perceived as a force outside the self. Verbal and visual literacy challenged the authority of cultures, not with facts, but with an interruption and depersonalization of the customary flow of information among individuals.[121]

The compartmentalization that literacy and photography foster – the picking apart of the threads of culture – may have originated in an impulse to create an orderly and systemic intellectual factory. But this intellectual diversity could lead to relativism, both within the dominant culture and, eventually, within more traditional cultures as well. Print and photography were able to alter the mode of cultural transmission within oral cultures, allowing individuals greater solitude – and anomie.

Yet self-questioning and cultural deterioration were not inevitable outcomes. Adaptation and resistance did occur. Nineteenth-century union organizing, for example, was aided by the very literacy it was hoped would quell working-class turmoil. The critical awareness of historicity that photography may have instilled could also have created a backlash in traditional cultures, resulting in a re-valuing of cultural practices that lay below the threshold of awareness. What historian Michel de Certeau has called "consumer production," that is, "the secondary production hidden in the process of . . . utilization," has to be factored in the equation. Consumption is not passive, but active. The users of culture deflect the power of dominant classes; they escape "it without leaving it." De Certeau has written:

> the presence and circulation of a reproduction (taught by preachers, educators, and popularizers as the key to socioeconomic advancement) tells us nothing about what it is for its users. We must first analyze its manipulations by users who are not its makers. Only then can we gauge the difference or similarity between the production of images and the secondary production hidden in the process of unitization.[122]

It has been speculated that the long-term effect of photography (and related media) on Native Americans was not the total cultural capitulation of those cultures, but a revaluing of Native American cultural practices as of equal importance to the dominant culture.[123]

To more fully understand the impact of verbal and visual literacy, one must accept that "many forms of resistance were not self-

consciously oppositional or only partially political."[124] As cultural historian Stuart Hall has suggested, "People make history but in conditions not of their own making."[125] For example, sitters in early vernacular daguerreotypes insisted on including in the photograph articles of clothing and other tokens of persons not able to be present. The practice may have been more than a charming, irrelevant folk custom.[126] It may have been a challenge to photography's insistent presentism. Throughout the photographic and nonphotographic literature of the nineteenth century there is an uneasy, yet resigned, awareness of photographic time and factuality. Oliver Wendell Holmes observed: "The whole class of facts . . . is forcing itself into notice, with new strength of evidence, through the galleries of photographic family-portraits."[127] The complementary aspects of modern collecting, "desire and nostalgia, saving and loss," infused everyday life.[128]

## CONCLUSION

"Books for the millions" and "pictures for the poor" were both elements in a profound and lasting rearticulation of the role of the arts in a society that was experiencing mass culture as a central feature of modernity. Once conceived as a matter of inclination and choice, cultural acumen came to be understood "as a condition on which society as a whole depends."[129] While promulgating verbal and visual literacy, reformers concomitantly defined working- and lower-class persons as the masses in need of civilizing. Indeed, reading too much of the wrong material could be worse than no reading at all.[130] In this configuration of social duty, the obligation to civilize fell on the smooth shoulders of the person of taste, who disdained what is popular and polished a sensibility for difficult and exclusionary culture.[131]

During the last decade of the nineteenth century, many companies like Langenheim Brothers of Philadelphia produced art and architecture slides for education and entertainment.[132] Yet despite growing commercial availability of photographically produced art reproduction, the democratic and educational emphases given photographic collections in the photographic literature waned. The totalizing impulse lingered longer, but photographic collections were increasingly comprehended as properties either produced and consumed by elites or stored for some evocatively vague future. In a telling 1889 article titled "The Whole Duty of the Photographer," Cosmo Burton pronounced that the photographer's highest duty was to generate "things fair to see." He laments that photography must also serve the intellect, which he considers a "lower and less vital sphere of labor." Yet however wistful he may be for an unencumbered photographic art,

Burton accepts the modern duty to document human and natural history for the sake of posterity. He writes:

> Naturally, it is not possible for any individual or small group to make and keep records for generation after generation; this is the proper function of large organizations or societies which are immortal. . . . Such a Society should keep a library of great albums containing a record as complete as it can be made, and in *permanent photographs only* of the present state of the world.

Burton determines that "these will be most valuable documents a century hence," but to whom? He does not thrill to the thought of the Tommys and Harrys who will enlarge their world through caches of pictures. Instead, he depicts an enigmatically sinister prospect. "Nothing is surer than that the social relations of classes . . . will change profoundly in the not distant future," he writes. "Let it be remembered," Burton concludes, "that though the poor are the majority, they are naturally inarticulate and die unrecorded."[133]

# THE LURE OF MODERNITY

## INTRODUCTION

By 1870, photography was no longer a novelty. Consequently, its earlier associations with new and sudden social shifts dissolved. Late-nineteenth-century writers of futuristic fiction fastened onto electricity as a metaphor for rapid and powerful change.[1] Yet, as witnessed in photography's relationship with literacy campaigns, the medium continued to embody apprehensions about the long-term disruptiveness of modernity.

Throughout the century, the ordinary uses of the ordinary photograph had been silently absorbed into the textures of everyday life. The swiftness of that assimilation reinforced ongoing debate about the harmful impact of mass taste and the ameliorative function of the fine arts. Likewise, photography's enlarged presence in everyday life portended an intensifying image world in which representation threatened to supplant the real thing.[2] Experiments in photomechanical processes led to the development of half-tone plates in the 1880s. By the 1890s, photographs could be cheaply reproduced in magazines and newspapers. The Kodak camera, introduced in 1888, marked the debut of photographs produced directly by the middle-class consumer rather than by professional photographers. "You Press the Button, We Do the Rest," Kodak's popular slogan, expressed the innovative procedure whereby purchasers sent the camera and spent film back to Kodak for development. Advertisements in mass-market magazines like *Lippincott's Monthly* were calculated to show first-time users not only how to use the camera but where to use it: at home and on vacation.[3] For the general public, technological advances in photography were more compelling than intellectual uneasiness about imitation and authenticity.

During the medium's initial decades, the fine arts had been the ma-

jor reference point for its proponents. In the words of the photographer John Moran, writing in *The Philadelphia Photographer* in 1865, photography's "aim and end" were the same as art's. The medium "speaks the same language and addresses itself to the same sentiments," Moran proclaimed. The goal of art and of photography was "contemplation of nature" and the beautiful. Scientific objectivity and utility were, to Moran, the very opposite of art. What distinguished photography from science was "the art of seeing": a perception of nonutilitarian beauty akin to a purely aesthetic response to nature. The medium had "nothing in common with the aims of science."[4] Simply stated, art photography was produced by a person of artistic temperament working in what today would be called a nontraditional medium.

Assertions of this sort continued throughout the later part of the nineteenth century and contributed to the theoretical underpinnings of the art photography movement called Pictorialism. In striving for decorative, nonutilitarian images, the late-nineteenth-century photographers known as the Pictorialists seemed to be reacting negatively to the influence and prevalence of scientific and technological thought. With its passionate protestations of unalloyed beauty, Pictorialism has long been a favorite subject of photographic history. In contrast, the influence of scientific ideas in art photography of the late nineteenth century has not received adequate attention. Although art photographers and theorists repudiated what they thought commerce and mass culture deemed advances, theories of evolution and progress were too widespread not to have penetrated the art-for-art's-sake interval of photography. The influence of these theories was limited to proponents of change. Even aesthetic conservatives like the painter John Brett could sincerely suggest that the social role of photography was to awaken in the progeny of the masses "an interest in the visible world." Brett's conjecture that "there is an off-chance of this coming to pass by heredity" was an allusion to the inheritance of acquired characteristics, a proposition, introduced by the French naturalist J.-B. de Lamarck, which was debated afresh with the publication of Charles Darwin's books.[5]

Photographic realism, so extensively employed as an indicator of cultural decline during photography's early decades, was redrafted in the 1880s in scientific, not artistic, terms. At the end of the century, it seemed logical that a truly modern art – and modern photography – ought to parallel the achievements of modern civilization. Insofar as modernity was considered a desirable condition in which a society fully utilizes up-to-date scientific truths, art could be expected to cast off principles that were timeworn and untested and adopt demonstrable tenets.[6]

In this view, science, objectivity, realism, and modernity were all interdependent. Art – and art photography – that deliberately borrowed devices like pyramidal construction or themes from Greek mythology

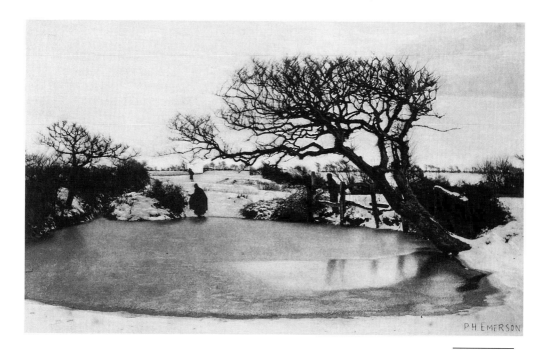

FIGURE 61

P. H. Emerson,
*A Winter's Morning,*
1887. Collection of
the J. Paul Getty
Museum, Malibu,
California.

could be reproached as intellectually retrograde and untruthful. At least in principle, the very realism previously judged hideously exact and inferior could now be cited as scientifically correct and the basis of a more progressive art practice. An even more tangled rationale was advanced by the French social critic and activist Pierre-Joseph Proudhon when he defended the realism of the painter Gustave Courbet. The actual rendition of optical reality did not interest Proudhon as much as social progress did. For Proudhon realism was at once rational, antiaesthetic, and allied "with the movement of civilization."[7] By adding social advancement as a necessary corollary to the idea of scientific development, Proudhon gave voice to the suspicion that progress must happen concurrently in all aspects of society.

The idea that realism was significant on a wide social scale raised the stakes involved in art theory. Had art, like medicine, been understood as prone to incremental improvement, the notion that art must change in response to the momentous advances of the nineteenth-century would have been easy to take. But, with increasing ardor, critics argued that art made manifest timeless truths and moral values that transcended scientific truth. This belief in art's timelessness was challenged by modernism's implicit premise that past art cannot be as good as the art of the present or future. The problem was especially acute for photography, which, from the first, was linked to scientific progress. Nevertheless, in the same period in which a unilateral cultural advance was frequently discussed, the dominant art photography defined itself in relation to established values and past masterworks, not scientific progress.[8]

143

Notwithstanding the prevalence of Pictorial photography and theory, the concepts and terms necessary to sanction scientific realism in art photography emerged during the 1880s.[9] But a full-blown practice like that later called straight photography was delayed, as practitioners and theorists struggled to find a compromise between the hold of the past and the lure of modernity. The tension from dual allegiance to culture and science is evident in the work and the influential writings of the English photographer Peter Henry Emerson. Though he did so in an unsystematic and contradictory way, Emerson fashioned an acceptance of the modern that necessitated a complicated concession to past cultural achievement.

## EMERSON: AN OVERVIEW

In photography's early days, Peter Henry Emerson would probably have been one of those privileged amateurs who likened photography to the fine arts and imaged the English countryside in the visual language of the pastoral. Born in Cuba on his American father's sugar plantation, Emerson lived briefly in Delaware but moved permanently to England, his mother's native country, after his father's death. In college he was able to combine his interest in science with the more practical pursuit of medicine. He acquired his first camera during the period of his advanced medical training. By 1885, helped by a private income, he chose photography rather than medicine as a career. Emerson's major photographic subject was rural life in East Anglia, at a time when the area was becoming a summer destination for the urban middle classes, whom Emerson, like the early amateurs, saw as harmful to traditional culture.[10] In his photographs' forceful, antiurban representations, Emerson preserved the values of the English amateurs.

Emerson also wrote extensively about photography and the theory of photography. Reading his work, one understands the appeal of this legendary eccentric, who could be dubbed both a socialist and a conservative in his lifetime. His writing style is spare, yet equivocal. Its pragmatic clarity gradually erodes, so that although each passage holds a bright area of meaning, the direction of Emerson's thought – indeed, its ultimate end – is often ambiguous.

Emerson's critics have interpreted his desultory writing as an expression of his flamboyant character. They usually cite as confirmation of his willfulness his December 1890 pamphlet titled *The Death of Naturalistic Photography*. He issued this "obituary" less than two years after proclaiming naturalistic photography – his intellectual invention – to be the fruit of the human art production over long cen-

turies. Briefly, Emerson has been viewed as a person whose mind was at once too patrician and too animated for him to bother with bourgeois orderliness. He rattled his way through contemporary photography, rattling it a great deal, but that was to be expected of an intense, impatient personality. Yet to see Emerson's eccentricity as reflecting no more than a privileged individualism is to grant him too great a measure of originality. Emerson's photographic theory was openly and deliberately derivative. He proposed altering the tacit theoretical assumptions of photography precisely because the science of his time suggested to him that the only authentic basis for both art and photography had recently been revealed.

Like many other writers of the period – Emile Zola, the Goncourt brothers, Hippolyte Taine, G. H. Lewes – Emerson tried to apply the procedures of positivism – its reliance on method, demonstration, and objective notation – to an understanding of individual psychology and creativity.[11] Like his contemporaries, Emerson was forever putting things together and trying out ideas. Unlike them, he was under no compulsion to organize his thinking for a popular audience.

To understand Emerson and what influenced him, one must tidy up his thinking and be clearer than he was in his own writing. Although science was the major source of his ideas, Emerson also absorbed and reacted to contemporary thought and practice in the arts. He critiqued the writing of John Ruskin and the photographic theory of Henry Peach Robinson. He was stimulated to think through his positions again by the paintings and aphorisms of James McNeill Whistler, and he appears to have been an avid fan of the poet and editor William Ernest Henley.[12] In his prolonged reliance on science, not art theory, as a justification for his work, Emerson not only devised an early theory of modern art photography, he also situated photography in the strong cross-currents of the modern period.

## SCIENCE AND ART

Peter Henry Emerson began in medicine but practiced only briefly. His life-long reliance on his private income – a resource allowing, even encouraging, his pettishness – has been emphasized in the studies of his ideas and photography to the point that we seldom think to ask why he even became a doctor. Nancy Newhall has suggested that Emerson wanted to be an explorer and that his training as a doctor would be welcome on any expedition.[13] His biography, likely written under his direction, records that he intended to be a scientific traveler.[14] Both notions may be partially true. But the same assertiveness and interest in frontiers would have attracted this distant cousin of the Amer-

ican philosopher Ralph Waldo Emerson straightaway to the study if not the practice of medicine.

In the nineteenth century, medicine was transformed into a profession requiring extensive university training and supervised internships. It began to attract students from good families. Interdependent advances in anesthesia and antisepsis were a particular boon to the work of surgeons. Although the blood-soaked operating theater still held its terrors, the success rate of the cutters increased, and the mortality rate decreased. The social status of the surgeons rose with their successes. Surgeons were explorers, too, with just as much swagger as the trekkers. Surgery's elitism, a characteristic of rising professions, may have encouraged Emerson to study medicine.[15]

There are numerous instances in the late eighteenth and early nineteenth centuries of persons in medicine who also experimented in and wrote about sciences other than medicine. The scientist Hermann von Helmholtz, whom Emerson admired, started his career as a physician. So did Thomas Young, the British pioneer in physics. The biologist Thomas Henry Huxley was a doctor *and* an explorer. Charles Darwin was a medical school drop-out. The author Arthur Conan Doyle practiced medicine until 1891. Emerson, like his contemporary the American painter and photographer Thomas Eakins, was intrigued by both science and art, and he explored how discoveries in each realm might affect the other.

Even though he practiced medicine for only a short time, Emerson was never far from the literature of physiology. Since the early nineteenth century, physiology was studied for what it could explain about the activities of the human mind and body and what it could reveal, by analogy, about the body politic. The body's mental and physical relationships were understood as corresponding to society's functions. In other words, intellectuals read physiology for its implications about an underlying order in the universe. Physiology was replete with first principles by which it was isomorphically related to other realms of inquiry. It meant more than it said. Like geology and biology, physiology was loosely associated with progressive reform.[16] The public associated those who read and practiced these sciences with the various movements for social change.

Just as Zola embraced the scientific method of the doctor Claude Bernard, Emerson embraced the teachings of Helmholtz.[17] Emerson and Zola found a fresh and urgent direction for art, an aesthetic theory, in the cutting edge science of their mentors. Because it was scientific, this aesthetic indicated the route by which to make art in and of the modern world. Indeed, a scientific aesthetic indicated how science and art were connected in an authentically new potential for art. In the second half of the nineteenth century, American artists, such as Winslow Homer and Thomas Eakins, and French artists, such as Georges Seurat and Paul Signac, also explored contemporary science for its aesthetic implications.

Emerson and Zola considered the artist to be a person of inherent-

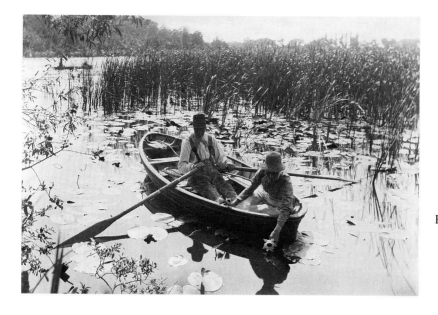

FIGURE 62

P. H. Emerson, *Gathering Water Lilies,* 1886. Collection of the J. Paul Getty Museum, Malibu, California.

ly special character and ability, a person who sees things more clearly than others.[18] But they did not understand art as merely an expression of personality. They repudiated radical subjectivity and were also impatient with idealism, which they cited as a hindrance to art. Each looked to the objective study of nature, including human nature, for the measure of quality in art.[19] Emerson considered idealism to be especially misleading for artists: "Works of the imagination" he called "untruths."[20] Truth was objective, not subjective. Although he admired Courbet and thought the realist painter to be a master among poor imitators,[21] Emerson constructed his idea of naturalism on his comprehension of contemporary physiology, not art theory.

For Emerson, modern physiology disclosed the fundamentals of aesthetics, revealing the scientific basis for which the art of the past had intuitively groped. Emerson believed that "the best artists have always tried to interpret nature, and express by their art an impression of nature as nearly as possible similar to that made on the retina of the human eye."[22] But until the modern era, the work of the best artists was subjected to an art criticism produced by "lay-men." The writing of these critics was "not based on any logical first principles," but rather was drawn from "the inner consciousness of the writers." In his own time, Emerson reasoned, art was as caught up as biology in the scientific revolution, and photography could situate itself at the cutting edge of human knowledge.

Paraphrasing Herbert Spencer, who popularized evolutionary theory, Emerson wrote that "the modern school of painting and photography are at one; their aims are similar, their principles are rational, and they link one into the other; and [they] will in time . . . walk hand in hand, the two survivals of the fittest."[23] Whereas earlier supporters of photography like John Moran had constructed their arguments

for the medium on the basis of its differences from science and similarities to art, Emerson was persuaded that modern science revealed the foundation of art, including art photography:

> Thus we see that Art has at last found a scientific basis, and can be rationally discussed, and that the modern school is the school which has adopted this rational view; and I think I am right in saying that I was the first to base the claims of photography as a fine Art on these grounds, and I venture to predict that the day will come when photographs will be admitted to hang on the walls of the Royal Academy.[24]

## PHOTOGRAPHY AFTER METAPHYSICS

In 1880, Zola pronounced that "metaphysical man is dead; with physiological man our position changes."[25] The repositioning seen by Zola called upon the artist to be an observer and analyzer of this world, not a fabricator of other worlds. Zola moved artistic truth from subjective concern to objective inquiry. For Zola, art's adoption of the method of science was a progressive step: "The experimental method, in letters as well as in the sciences, is in the process of determining the natural phenomena, both individual and social, whose metaphysical interpretation had hitherto produced only irrational and supernatural explanations."[26] The impact of evolutionary theory was as correct as it was inevitable: It "gradually drives all the manifestations of human intelligence into the same scientific path."[27]

Speaking before the Camera Club of London in March, 1886, Emerson did not cite Zola nor any of the other French writers, like Balzac, Stendahl, or Taine, who attempted to explicate human behavior in sociological terms. Nevertheless, the resemblance of his remarks to French theory, and especially to Zola's pronouncement, is startling: "Anyone who has read the history of Art . . . will look with pity on the unthinking millions who have been swayed by opinions based on no reason. The days of metaphysics are over, and with them, we hope, has died all that class of pernicious illogical literature."[28] Emerson's modernity is crystallized in this statement. Pictorial photography represents a turning point, where the past can be dismissed and the present reckoned as a genuine inauguration of the future.

Just as Zola insisted that the experimental method applied to the novel was more than a way to rescue the novel from purely subjective standards, Emerson hoped to abet a new photography that would not only loosen the conventions of the past but also bring photographic imagery in line with scientific findings. Zola wrote that through the experimental method, the sciences would "free themselves from the ir-

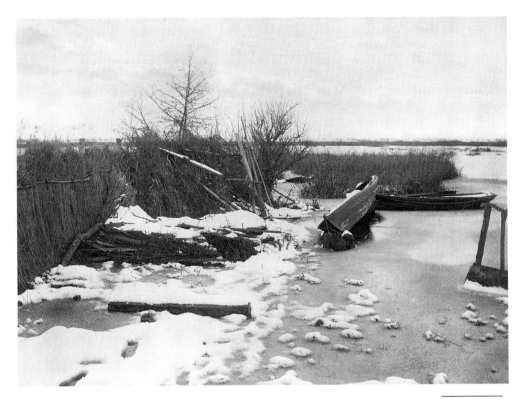

FIGURE 63

rational and the supernatural."[29] For Zola, the application of the experimental method to art was "the outcome of scientific evolution."[30]

Similarly, Emerson observed that art had been enslaved by "religion, morals, courts, kings, [and] the literati," until painters like Constable had oriented art toward nature.[31] Furthermore, Emerson concluded, "Art has at last found a scientific basis, and can be rationally discussed."[32] He argued that it was only on scientific grounds that a modern school of photography could be based. In principle, Emerson was poised to articulate a realist hypothesis, such as that of Courbet or Proudhon, but he took another heading.

Just as Zola derived some of his pivotal ideas from Dr. Bernard, Emerson enlisted Helmholtz's contention that "'Perfect artistic painting is only reached when we have succeeded in imitating the action of light upon the eye, and not merely the pigments.'"[33] Emerson reasoned that the best artists had always been naturalists in the physiological sense, and he encouraged contemporary artists "to inquire on scientific grounds what the normal human eye really does see."[34] It was from Helmholtz – not art theory – that Emerson derived one of his definitions of impressionism. He relied on Helmholtz's understanding of an impression as the image that forms on the eye. How the eye sees – its range of darks and lights, its physiologically produced distortions and peculiarities – was put forward by Emerson as the underlying principle of art and art photography.[35]

Relying on Helmholtz, Emerson attempted to disprove the idea that art was simply a transcription of physical reality in the way that cam-

P. H. Emerson, *The First Frost,* 1886. Collection of the J. Paul Getty Museum, Malibu, California.

149

era vision was thought to be.[36] The work of art should aspire to be a translation of optical impressions. In a remarkably postmodern passage, Emerson concluded that "the human eye does not see nature exactly as she is, but sees instead a number of signs which represent nature, signs which the eye grows accustomed to, and which from habit we call nature herself."[37] The idea probably owes something to his reading of Helmholtz, who remarked in his *Popular Lectures* that "our sensations are, as regards their quality, only *signs* of external objects, and in no sense *images* of any degree of resemblance."[38]

Emerson acknowledged that artistic vision was more subtle than that of the "commonplace or uneducated eye."[39] He rooted his theory in the combined outcome of the physical, physiological, and psychological properties of the normal human eye.[40] Sight may be educated – Emerson devoted a chapter of each edition of *Naturalistic Photography* to the subject – but it may not be perfected beyond the physiological limits with which we are born: "Hard work will not necessarily make an artist."[41] The incongruity of Emerson's theory is manifest in this compound of ideas. On the one hand, art is made fully democratic. On the other, it requires special sensibilities.

Emerson's inconsistencies are enlarged by his insistence that "Pictorial Art is man's expression by means of pictures of that which he considers beautiful in nature," an idea implying the operation of an innate selective faculty.[42] A seemingly simple statement, it relies on Emerson's understanding of sight. Often Emerson employs the word in the sense of impersonal observation. Seeing clearly is like thinking clearly. The beautiful is made akin to retinal images, that is, sight independent of culture and personality. Yet somehow, in its translation to art, pure sight is adjudicated by taste. Put differently, despite Emerson's insistence on the cold truth of physiologically based vision, the metaphor he built on the biological model mixes the exactness and purity of retinal vision with an older, more Romantic notion of artistic temperament. "All men see nature differently," he wrote. "But the artist sees deeper, penetrates more in the beauty and mystery of nature than the commonplace man . . . through quicker sympathies and training the good artist sees the deeper more fundamental beauties."[43] Indeed, on the title page of *Naturalistic Photography* Emerson quotes John Keats's "Ode on a Grecian Urn": "Beauty is truth, truth beauty, – that is all / Ye know on earth, and all ye need to know." Emerson was not alone in his mixed appeal to both contemporary thought and Romanticism. Hardly an artist in the last part of the century escaped the influence of Romantic theory. Nor was Emerson unique in fastening the Romantic notion of genius to an anticommercial thrashing of mass culture. Baudelaire before him and Whistler after took similar positions. What distinguishes Emerson from Whistler, for example, is the mock evolutionary stance that the painter took in his "Ten O'Clock Lecture." When Emerson alluded to contemporary science or evolutionary theory, his references were adulatory, not humorous or sarcastic.

As his use of physiology and Zola's theories shows, Emerson was an intellectual grazer. He sought information and cognitive stimulation from a host of sources. Like many Victorians, he was not a systematic thinker, but a sequential borrower, which allowed him to entertain contradictory notions. In postmodern terms, Emerson practiced appropriation, or bricolage. The aggregative, rather than integrative, approach Emerson favored permitted him to enjoy the buoyant confidence of the scientific method without having to come to terms with the dynamic mutability of scientific knowledge. Like many others throughout the nineteenth century, Emerson treated the scientific findings of the era as if they were classical verities, true for all time. In other words, Emerson's approach to scientific knowledge reverberated with the very attitude toward received ideas that he disparaged.[44] He saw change happening in all fields, yet believed himself to be beyond its reach.

When Emerson encountered the writings of George Henry Lewes, the English writer who adapted positivism to problems in philosophy and psychology, he inserted some of Lewes's major points into the formula for naturalistic photography. He remained steadfastly indifferent to whether or not these ideas harmonized with his other borrowings. As Emerson wrote in *Naturalistic Photography:* "G. H. Lewes says, 'Nothing exists but what is perceived;' we would say, nothing exists *for us* but what is perceived, and this we would make a first principle of art. A work of pictorial art is no abstract thing, but a physical fact, and must be judged by physical laws."[45] Emerson's reference to Lewes indicates his familiarity with Lewes's premise that science and its method had superseded philosophical speculation. Lewes insisted: "Psychology has taught us one lesson at least, namely that we cannot know causes and essences, because our experience is limited to sequences and phenomena. Nothing is gained by despising Experience and seeking refuge in Intuition." History, Lewes argued, gives "emphatic sanction . . . to the growing neglect of Philosophy, [and] the growing preference for Science."[46]

Lewes drew many of his ideas from Auguste Comte. Lewes published *Comte's Philosophy of Science* in 1853, the same year that Harriet Martineau's *The Positive Philosophy of Auguste Comte, Freely Translated and Condensed* appeared in England. Lewes's vast timescape was generated by his appreciation of long-term progressive development, as described by Comte's law of evolution. In Comte's societal-stage theory, all humanity passes through a theological stage, to a metaphysical stage, to the highest human condition, the positive stage.[47] For Comte and Lewes, as well as for Zola and Emerson, theirs was a time in which the metaphysical stage was breaking down, field

by field, unevenly yet inexorably.[48] Together they stood at the brink of the future, a prospect that had been made possible by science and its methods, not by art. In an important sense, they melded the older avant-gardism of art into a scientific vanguardism.

The trail of his reading of Lewes leads to Emerson's *Pictures of East Anglian Life,* published in 1888, a year before the first edition of *Naturalistic Photography.* In this text Emerson wrote of "herculean but useless labor, the works of the metaphysicians from Thales to Comte . . . [who] tried to evolve the laws of nature from their own consciousness, and failed." The extensive historical period referred to by Emerson is the same as that covered in Lewes's very popular *The Biographical History of Philosophy: From Its Origin in Greece Down to the Present Day* (1845–1846), which was produced and sold in many editions into the twentieth century.[49] Convinced that positivism was the coming worldview, Lewes and Emerson assured themselves that physiological psychology was pivotal for an understanding of epistemological questions.[50] Just as Lewes hoped to put perennial metaphysical questions on a scientific footing, Emerson hoped to establish modern photography on a foundation of scientific truths.

Emerson also involved photography in other Victorian arguments stemming from emergent physiological findings. In "Naturalistic Photography and Art," a paper that he delivered in March 1893, Emerson laid out a set of psychological propositions, which he contended bore directly on contemporary photographic practice. The first proposition – "That the material universe may be regarded . . . as eternal . . . and the fountain-head of all our *sensuous* impressions" – demonstrates Emerson's awareness of the Victorian debate over the relationship of the brain to the mind.[51]

In addition, Emerson was intellectually attracted to positivism's first cousin, evolutionary theory. It figured in his university life, if not in his formal scientific instruction. He predicated his division of photography into art, science, and industrial components in response to a popular and popularized tenet of evolutionary theory.[52] "That this division is now possible and necessary is, from the evolutionary standpoint, the greatest sign of development," Emerson asserted.[53] His formulation rested on Herbert Spencer's maxim that all authentic evolutionary development is from homogeneity to heterogeneity, which was popularly understood to mean that greater structural complexity or elaboration was a sure sign of biological and social advancement.[54] In *First Principles* (1862), Spencer applied the evolutionary law of development from homogeneity to heterogeneity to all of nature and culture, including language, painting, architecture, sculpture, poetry, music, and dance.[55]

Emerson leaned more openly on Spencer in his paper "Science and Art," which he delivered at the Camera Club Conference on March 26, 1889, just days after the publication of the first edition of *Naturalistic Photography.* He opened his address by stating, "Since all mental progress consists, as Mr. Herbert Spencer has shown, for the most

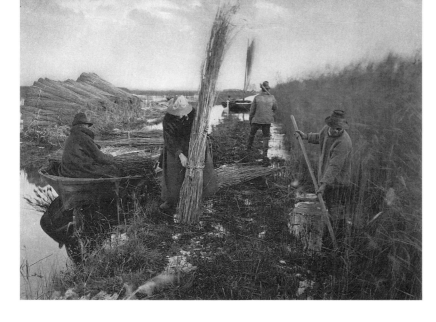

FIGURE 64

P. H. Emerson,
*During the Reed
Harvest,* 1886. Col-
lection of the J. Paul
Getty Museum, Mal-
ibu, California.

part in differentiation – that is in the analysis of an unknown complex
into known components – surely it were a folly to confuse any longer
the aims of Science and Art."[56]

Emerson saw photography and his role in it as assisting "mental
progress,"[57] thereby abetting evolution along the path of improve-
ment. He was persuaded that enlightened humans, armed with the
method of science, must and would be able to direct their own ad-
vance. "It is obvious," he wrote, ". . .according to the teachings of evo-
lution, that, if we are to make progress, this differentiation [between
the aims of scientific and artistic photography] must be made, thor-
oughly understood, and rigidly adhered to by every practitioner of
photography."[58]

Emerson read Darwin's *Descent of Man,* or he read about it, because
he refers to Darwin's fanciful idea that perception of the beautiful be-
gan in birds.[59] He was familiar too with Darwin's "On the Expression
of Emotions in Man and Animals," which included photographs by Os-
car Rejlander, and with Darwin's experiments in the expression of
emotion that had preceded the paper.[60] Whether from Darwin, or
Spencer, or even popular Darwinism, Emerson seems to have thought
that aesthetic appreciation is evolutionary and progressive.[61]

As always, it is impossible to judge how much of an idea Emerson
understood and how much of the contemporary debate he consid-
ered. For instance, when he momentarily plunged photographic the-
ory into late-nineteenth-century international issues about the varia-
tions of talent and ability in the human population, his language and
approach show that he was acquainted with the notion of the inheri-
tance of acquired characteristics, an idea that he could have drawn
from Spencer or from any number of other scientific or popular writ-

ers.[62] Indeed, Emerson seemed willing to direct his attention only to those ideas whose importance had been confirmed by various authorities.[63]

Typical of Emerson, but hardly unique in any time of burgeoning information, was that Emerson used buzzwords without fully grasping their meaning. In one instance, he told his "Science and Art" audience that photographers "should have made use of our *constructive imagination* – the highest *intellectual* power, according to recent psychologists."[64] The term "constructive imagination" figured in the work of the influential physiologist and naturalist W. B. Carpenter, and Emerson knew Carpenter's *Mental Physiology,* which appeared in many editions.[65] But Carpenter did not identify the constructive imagination as the highest human faculty. For Carpenter, it was only one kind of aggregating intelligence and was surpassed by what he called the creative imagination. What Emerson may have meant by constructive imagination is closer to the notion of productive imagination proposed by Henry Maudsley, an influential physician and a professor at University College, London.[66] One could even argue that Emerson collapsed a bit of Spencer's thought into his understanding of Carpenter and Maudsley, because Spencer had argued that the constructive imagination is more evolved and more complex.[67]

The varieties of evolutionary theory carried with them the question of whether the accumulated knowledge of a period should be seen as primarily accountable for individual achievement. In *The Study of Sociology* (1873), Herbert Spencer articulated an alternative to the notion of the genius.[68] He attacked as reactionary hokum Thomas Carlyle's assertion that "the history of what man has accomplished in this world, is at bottom the history of the great men who have worked here." Spencer did not deny the existence of great men, only their causal role in progressive social change. "If it be a fact," he wrote, "that the great man may modify his nation in its structure and actions, it is also a fact that there must have been those antecedent modifications constituting national progress before he could be evolved. Before he can remake his society, his society must make him." To Spencer, great men are "proximate initiators" of change.[69]

How to configure art and photography within the terms of this argument puzzled Emerson. He insisted that progress in art was not directly cumulative, but subject to its own barometric oscillations.[70] He was attracted to the accepted expression of art cycles in a human cadence: childhood, adulthood, old age.[71] Still, his presentation of the relationship between art and society shows an ambivalent reluctance to endorse periodicity. Declaring that art is the product of its time, he nevertheless insisted that it was valued for its transcendence of time.[72]

Emerson persistently expressed his hope that the intellectual forces and the attitudes toward knowledge that were transforming the sciences could be made to control and inform other areas of human

endeavor, such as art and photography. In this he resembled Lewes and others who had succumbed to popularization of the doctrine of uniformitarianism, the idea, originating in geology, that the forces of nature worked the same way in all times and places.[73] With many Victorian thinkers, Emerson looked forward to the unity of scientific explanation and to the ordering of all facts in some sort of comprehensive and comprehensible macrosystem. Like Spencer, he held that increased conscious control of progress in all fields was mandated by the newly discovered law of nature that revealed the vast evolutionary development from simplicity to complexity.[74]

Emerson's thoughts, especially those he incorporated into his paper "Science and Art," made him focus on the Victorian debate about the relevance of traditional humanistic learning to science and technology. As is often true in his writing, Emerson responded obliquely to contemporary ideas, but it is conceivable that he intended "Science and Art" to be his contribution to the public discussion of modern and ancient learning made prominent by Thomas Henry Huxley and Matthew Arnold.

Huxley's ideas on science and education were widely discussed. His talk "Science and Culture," which he delivered at the October 1880 opening of Sir Josiah Mason's Science College in Birmingham, England, was published in *Science and Culture and Other Essays* the following year. In his forceful, plainspoken way, Huxley confronted the claims of humanistic education. "I hold very strongly by two convictions," he wrote: "The first is, that neither the discipline nor the subject-matter of classical education is of such direct value to the student of physical science as to justify the expenditure of valuable time upon either; and the second is, that for the purpose of attaining real culture, an exclusively scientific education is at least as effectual as an exclusively literary education."[75] Huxley enlisted Matthew Arnold's famous definition of criticism from "The Function of Criticism at the Present Time," slightly misquoting Arnold's advice to "*learn and propagate the best that is known and thought in the world.*"[76] Huxley's point was that by omitting and often deriding the natural science of the past as well as of the present, humanists were not telling the full story. Huxley argued that science was as capable of producing culture, understood to be a detached critical attitude, as were the humanistic disciplines.

Arnold responded in "Literature and Science," published in 1882. He enlarged the definition of literature to include not only belles lettres but also the writing of scientists like Galileo and Darwin. He quarreled with Huxley about the substitution of scientific information for humanistic study. Arnold contended that the need to interrelate knowledge and the desire for beauty – both basic to human nature – cannot be served by science. If anything, increased scientific knowledge, which dissolves superstition, would increase the desire for humane letters.

Emerson's "Science and Art" quoted both Arnold and Huxley but concurred with the fundamental arguments of neither writer.[77] (Typical of the intellectual grazer, Emerson did not quote Huxley's address, but chose to lift Huxley's ideas from an obscure science primer.) Emerson conceded that the issue was one born of modern times, but he did not assert the civilizing merits of either art or science. Toward the end of the first edition of *Naturalistic Photography* Emerson did tentatively pick up on the dynamics of the debate, offering a weak maxim: "The artistic faculty develops only with culture. A man may be a Newton and at the same time never get beyond the chromographic stage in art."[78]

For Emerson the crux of the problem lay in recognizing the different aims of two cultures. "I do not imply any comparison between Science and Art to the advantage of either one," he wrote. "They are both of the highest worth, and I admire all sincere, honest, and capable workers in either branch with impartiality." But the time had come for practitioners of photography to clarify their position: "We in the photographic world should be either scientists or pictorial photographers; we should be aiming either to increase knowledge – that is, science – or to produce works whose aim and end is to give aesthetic pleasure."[79] Unlike Arnold or Huxley, Emerson viewed science and art as existing in some sort of logical and benign equilibrium. He chose to present himself as pluralistic and reasonable, willing to accept the claims of science and art. But his interest in degeneration theories, which became increasingly prominent after publication of the first edition of *Naturalistic Photography* in 1889, challenged his passive trust in the bearings of naturalism. In his usual glancing and synoptic way, he began to give further definition to good and bad art.

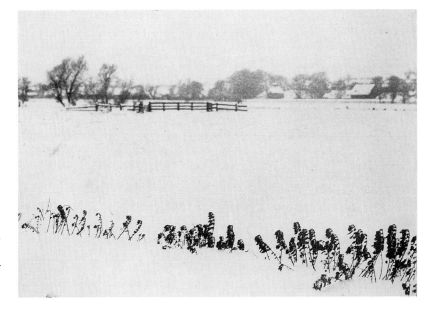

FIGURE 65

P. H. Emerson,
*Marsh Weeds,* 1895.
Collection of the
J. Paul Getty Museum, Malibu,
California.

The concept of degeneration was an exceedingly popular subject in the late nineteenth century. Like the physiology from which it partially derived, degeneration theory utilized biologically derived models of decline and created correspondences between individual and societal decadence. Until recently, it was dismissed as an intellectually vacant pseudoscience, ignoring the extent to which the subject was discussed in serious scientific circles as well as in the press.[80]

Because the idea rested on there being an unambiguous exponential relationship between outward behavior and inner mental states, degeneration was a topic with special interest for medicine and physiology. Normative behavior in middle- and upper-middle class society became the standard against which individuals and races were measured. Degenerationists thought that deviations from the norm, especially madness and genius, were the product of physiological dysfunction. They emphasized that artists were particularly susceptible to the nervous disorders that signaled degeneration; the energy and vision that produced art was diagnosed as abnormal. From his first encounters with physiology, Emerson was attracted to biologically derived models of cultural progress. Likely enough, his references to ideas and phrases found in the degeneration literature increased throughout the 1890s as the literature itself proliferated in England.

"Naturalistic Photography and Art" is peppered with ideas and phrases from degeneration books. Zola is called a "morbid impressionist"; Whistler a "sane impressionist."[81] Richard Jeffries and John Ruskin are labeled "mattoid impressionists."[82] Emerson observed that photography, "when not scientific or topographical, is a *pastime, dangerous in many respects, as apt to foster morbid vanity in the degenerate.*"[83] He suggested that the flood of would-be amateur artist photographers displayed conduct that is "the hall-mark of the degenerate mattoid."[84] "Mattoid," from the Italian, means slightly mad or on the margin of madness. The term was invented by the doctor and psychologist Cesare Lombroso, whose work culminated in the 750-page *Men of Genius* in 1889. By 1899, the publication date of the third edition of Emerson's *Naturalistic Photography,* the term was widely used in the popular press. The greater presence of degenerationist jargon in the third edition may owe to the influence of Max Nordau's *Degeneration,* which was issued in English translation in 1895. Of interest, two prominent English studies of genius and mental illness, J. F. Nisbet's *The Insanity of Genius* (1891) and Francis Galton's *Heredity Genius* (1869), appear not to have influenced Emerson as much as did the more sensational continental literature that emphasized cultural morbidity.

Emerson's later work and, one may speculate, his eventual renunciation of naturalistic photography share a root assumption with de-

generation literature. The degenerationist transmogrified Romantic inspiration, once the voucher of authentic creativity, into the unrelenting condition of mental disease. Ironically, in order to make their diagnoses, the writers of the degeneration literature became inadvertent Romantic individualists, placing extraordinary emphasis on the personal nature of art. For them, art became the infallible mirror of inner mental states. In *Degeneration* Nordau observed that "if any human activity is individualistic, it is that of the artist. True talent is always personal. In its creations it reproduces itself, its own views and feelings."[85] Hypertrophied individualism was further attenuated by the degenerationists' sweeping rejection of the preponderant style of various "isms" or schools of art. In addition, they debunked the notion of art as imitation, which fixed the source of art in objective reality, not subjective states. Nordau insisted that "imitation is not the source of the arts, but one of the media of art; the real source of art is emotion."[86]

Emerson's early writing on photography discloses degenerationist leanings, perhaps because his photographic theory was so closely derived from physiology. For instance, in the first edition of *Naturalistic Photography,* Emerson cautioned would-be photographers "that your photography is as true an index of your mind, as if you had written out a confession of faith on paper." He urged photographers to work from their individuality: "Let the student avoid imitation."[87]

In his later writing, Emerson's assertions about photography became even more dogmatic. He was carried along on the tide of a popular and scientific theory that could not have accorded with his own experience of making photographs. In "Naturalistic Photography and Art" he stubbornly insisted on an extreme personalism similar to that of the degeneration literature: "Place the camera under certain physical conditions and the same results will always follow, which is *not* the case with art, which is *personal;* indeed, the personal element in real art is paramount and all-pervading."[88] Emerson forced a distinction between photography, which he labeled impersonal, "a cross between *Nature* and a *machine,*" and art, which he designated personal, a "cross between Man and Nature – no machine intervening."[89] Emerson held that "it is plain how delicate a thing is a work of art, how thoroughly *personal* in every touch in a work worthy the name of art – what a perfect index of its creator's mind."[90] But he was not interested in the movement's attack on degenerate genius. His argument stops short at the insistence that art makes manifest the individual and never goes beyond some elementary name-calling.

Emerson's employment of degeneration lingo is as superficial, fragmented, laconic, and contradictory as his references to evolutionary theory. These instances illustrate Emerson's penchant to trust the latest scientifically derived notions, as well as his reluctance to interrelate his concepts. One finds in his writing the tacit belief that all new ideas conflict more with those passed on from a scientifically

unenlightened past than with each other. It is as if he were awaiting a grand integration of knowledge.

It is tempting to conclude that Emerson's rejection of naturalistic photography, coming as it did at the same time as his increased reference to degeneration hypotheses, was implicitly caused by his conversion to the degenerationists' point of view. But Emerson cannot be said to have fully embraced the degenerationist position. For example, he understood genius to be neither thoroughly mad nor malevolent. His views on this central concept of degeneration were close to those of Maudsley, who held that genius was strong, not weakly neurotic, and that the appearance of genius "was the highest display of organic evolution."[91] Emerson's genius was a similar figure to Whistler's dandy, a person of taste, not unlike Emerson himself. Before and after his renunciation of naturalistic photography, Emerson extolled the delicate, more evolved sensibilities of the artist and contrasted these with the sensibility of that ever-available Victorian lunk, the Philistine.[92]

## ENGLISH IMPRESSIONS
## OF IMPRESSIONISM

Not all of Emerson's ideas of impressionism had their origins in his scientific readings. He believed himself sufficiently aware of French impressionism to dismiss it as a "passing craze," a vogue so full of "eccentricities" and based on such radical subjectivity that nature, which ought to be the standard of art, could not be used to evaluate the worth of pictures. He approved of the painting of Edouard Manet but thought that the painter's followers were weak and mannered.[93] When Emerson used the terms "impressionism" or "impress" he meant the way in which an artist translates, rather than imitates, physiological perception.

Emerson favored a naturalism that was not so much a Ruskininan truth to nature as it was an attachment to things rural and a predilection for the overall or general effect of a picture. He rejected realism, including Pre-Raphaelite painting, because he believed that realists stressed details and did not paint things "as *they look* as a whole."[94] Before Whistler gave voice to the idea in his "Ten O'Clock" lecture, Emerson had concluded that naturalism was a timeless and persistent attitude toward art.[95] By and large, Emerson used contemporary art as a springboard for defining his own ideas. Thus he used his reading of Alfred Woltmann and Karl Woemann's *History of Art* (1880) to show the extent to which the field was not scientific, and he cited Philip Hamberton's 1871 essay "The Relation Between Photography and Painting" as a symptom of antiquated thinking.[96]

Emerson did enjoy a steady acquaintance with various members of

the New English Art Club, an exhibiting society for painters founded in 1886, whose founding members included Walter Sickert and Philip Wilson Steer.[97] Like Emerson, the group embraced a jumble of ideas about impressionism. Emerson and the New English Art Club members influenced each other in theory, in subject matter, and, most importantly, in the attitude that tacitly conjoined the artistic avant-garde to the ambience of the cosmopolitan gentleman's club. Like Emerson, the club reconstructed John Constable as a proto-impressionist. Whereas they were disposed to paraphrase the rustic imagery of Jules Bastien-Lepage, Emerson preferred the peasant imagery of Jean-François Millet.[98] From Emerson, members such as Henry Herbert La Thangue adapted images of the noble rural poor.[99] Early in his pursuit of naturalistic photography, Emerson envisioned "An Ideal Photographic Exhibition." He asked that members of "the Impressionist School," whom he named, be judges because they were artists who went "directly to Nature" and painted "Nature as she is."[100] Reading Steer's address to the Art-Workers' Guild in 1891, one is reminded of Emerson's position that impressionism, understood as an impression of nature, has been a constant in Western art for centuries.[101]

English impressionist painting held no clear definition of impressionism, but wavered between a rustic, plein-air naturalism, modeled on the paintings of Bastien-Lepage and the nuanced observations of light and color that owed equally to Claude Monet and Whistler. In the Bastien-Lepage emulation, peasant life and its merits were primary subjects. In the second type of impressionism, tenuous tones of natural light became paramount, slighting narrative subject matter.

The paintings of George Clausen exemplify a kind of English compromise between these two positions. They combine pastoral subject matter with fresh observations of light and atmosphere. Emerson corresponded with Clausen, who critiqued *Naturalistic Photography* from the view that photography had "*a will of its own*" that worked against an artist's ideas. Indeed, Clausen may have been the "great artist" Emerson acknowledged as convincing him that photography could not be an art.[102] In a letter to Emerson dated April 19, 1889, Clausen offered yet a third possible definition of impressionism: "My inclination now . . . is to trust more and more to pure impression. The first unconscious impression – It is very difficult to do this and to be able to get behind yourself so to speak and find out *why* it is that things impress us in a certain way."[103]

The impressionism described in Clausen's correspondence is more English than French, recalling the notion of general effect propounded by Sir Joshua Reynolds. But it is not the only definition of impressionism that was available within the New English Art Club. When the London impressionists, a subgroup within the New English Art Club, had their only exhibition late in 1889, Sickert wrote an introduction to the catalogue that stated just how "elastic" and imprecise the term "impressionism" was, especially in the English understanding. "Essentially and firstly it is not realism," Sickert wrote,

It has no wish to record anything merely because it exists. It is not occupied in a struggle to make intensely real and solid the sordid or superficial details of the subject it selects. It accepts, as the aim of the picture, what Edgar Allen Poe asserts to be the sole legitimate province of the poem, beauty. It is . . . strong in the belief that for those who live in the most wonderful and complex city in the world, the most fruitful course of study lies in a persistent effort to render the magic and poetry which they daily see around them.[104]

In other words, Sickert relied on French notions of impressionism that combined urban imagery with Baudelairian magic.

The trail of potential sources for Emerson's ideas about impressionism is further complicated by a statement he made after his boisterous recantation of naturalistic photography. Emerson wrote to his friend James Harvard Thomas, a sculptor and member of the New English Art Club, that he would give up photography and "turn Naturalist or rather I shall resume Naturalist for such I have ever been." Naturalist in this sense is neither realist nor impressionist, but student of natural history.[105] A great deal of painting was summarized as impressionist in England during the last decades of the nineteenth century. In the end, the spectrum of English impressionism with which Emerson was acquainted is less important in its particulars than in its antiacademic, antiestablishment thrust, which attracted the iconoclastic Emerson.

## "AND WE ARE THE NEW MEN"

Writing to Alfred Stieglitz in 1924, Emerson reflected, "I have studied psychology – *scientifically* – I am a productive photographer. . . . 'and we are the new men.'"[106] In the last century, the expression "new men" was sometimes used to denigrate urban middle-class goals. Notwithstanding, it also referred to individuals who gave their full allegiance to science and who cultivated a world view that questioned the truth of received ideas. The notion was embodied in lines by the English poet John Davidson, whose "To the New Men" (1894) directed these inquisitive individuals to "heat the furnace hot; . . . / Mold the world anew." "Let the whole past go," Davidson urged.

The positivist faith that Davidson and Emerson embraced was as fragile a thing as the hothouse aestheticism of the poets of the 1890s. Davidson grew to be more messianic and despairing. He drowned himself in 1909. Emerson was cushioned by his wealth, and in some sense, he was satisfied by the continuing attention paid to naturalistic photography, despite his renunciation of it. In 1893, his tone and statements about naturalistic photography were more conciliatory. Looking back, in a paper before the Photographic Society of Great Britain, he stated, "I was right from the physiological and psychological standpoints, and so it was evident there were two truths to nature – the per-

spective or mathematical truth and the psychological or visual truth."[107] By 1895 Emerson was again stumping for naturalistic photography in the *American Annual of Photography*.[108] He continued to make photographs, and he issued *Naturalistic Photography* in a revised third edition that praised with faint damn his earlier work.

Emerson's rejection of naturalistic photography can be situated in fin-de-siècle disillusionment with positivism and science. As the historians Willson H. Coates and Hayden V. White have observed, "Developments in the realm of pure science . . . led to the overthrow of simple materialism, rigid mechanism, and naive empiricism."[109] Science, which promised intellectual clarification and human betterment, began to locate complicated systems that did not seem altogether cogent. By the end of the nineteenth century, science had proven to be no substitute for metaphysics. Indeed, it began to look as illogical as metaphysics had once seemed.

In his writing Emerson indirectly foreshadowed concepts developed in twentieth-century European photographic modernism. Emerson's late emphasis on the irreducible qualities of the photographic medium – its nonsubjective qualities – was examined afresh and formed the basis of much early-twentieth-century experimental photography, such as that produced and inspired by the Bauhaus. When in 1927 László Moholy-Nagy insisted on photography's centrality within a larger "new vision" of an advanced, technologically based society, or when he announced, "Until now, all the essays and commentaries about the paths and aims of photography have been following a false trail," he was unknowingly restating Emerson's 1886 battle cry in "Photography, A Pictorial Art."[110] The spunky positivism of Emerson's early writings, which promised an integration of art and science and expressed a hope to mobilize a social vanguard within scientific culture, resounded in the photographic theory between the twentieth-century's world wars. The ideas that the photograph was a visual fact, that it could approach painting as an art, that it had the potential to document life – were concepts promoted by Russian theorists, such as Ossip Brik, Gustav Klucis, and Alexander Rodchenko, throughout the 1920s.[111] The crucial difference, of course, between Emerson's modernism and the modernism of the European theorists and practitioners of the 1920s and 1930s, is that Emerson abominated mass culture and was unwilling to consider uses of photography that would exploit its capacity to produce mass imagery.

Although they were conceptually similar to each other and sprang from the same high regard for science, Emerson's ideas probably did not have any bearing on twentieth-century photographic theory. His circuitous and contradictory style, to say nothing of his pastoral subject matter, would have repelled many twentieth-century writers who encountered it. It is not as a forebear of an important strand of twentieth-century photographic theory and practice that Emerson's work is best configured. In Emerson's work we glimpse photography's di-

rect participation in the nineteenth-century experience of societal modernity.

History, culture, and custom are weightless in Emerson's early writing. What matters is the potential of science to sweep away the pernicious residue of the past and usher in a new age of reason. The urgency with which Emerson wrote and with which he promoted the application of scientific principles to photography gauges his understanding of rapid social transformation. In the work of Peter Henry Emerson, the idea of photography embraced one of the last century's most profoundly influential concepts: to order and direct all human activities along scientific lines.

Naturalistic photography was formulated as an anti-Romantic, objective, secular, materialistic, and modern art, the outcome of centuries of struggle with the irrational.[112] It was not so much an art theory as it was a theory of knowledge with direct ramifications for art. That it eventuated in the Romantic, subjective, spiritualistic, and antimodern art movement we call Pictorialism was more than a personal irony for Emerson. Naturalistic photography remains a reflection of the degree to which, in the waning years of the last century, science itself disclosed the weak points of rationalism.

## AN ELEGIAC MODERNISM:
## SOME CONCLUSIONS

Emerson's "rational view" of a progressive photographic practice resting on a "scientific basis" could not be maintained in the fin-de-siècle world.[113] During the last decade of the nineteenth century, science destabilized itself by demonstrating sleek, balanced models of meaning to be more mental constructs than trustworthy approximations of the universe. As science gradually forfeited a measure of its mid-Victorian credibility, art theory based on science, like naturalistic photography, seemed both implausible and dated. Consequently, Emerson's photographs of rural life in England could be detached from his theory and regarded as conservative exempla of the intensifying antimodernist ruralism promoted by English elites across a broad political spectrum.[114] At about the same moment, the initial wave of cultural relativism washed over the arts and scholarship, undermining the positivist consensus on the ultimate rightness of Western cultural values. The reaction against positivism that coalesced in the 1890s involved "a rediscovery of the non-logical, the uncivilized, [and] the inexplicable."[115]

In the larger frame of nineteenth-century cultural history, Emerson's insistence on a scientific foundation for art came late, arriving when major intellectual figures were already exploring "irrational mo-

tivation in human conduct."[116] Thinkers like Henri Bergson and Ernst Mach elevated intuition as the superior human faculty, while exposing the limitations of human thought processes.[117] In this regard, it is useful to remember that Peter Henry Emerson was almost an exact contemporary of Sigmund Freud.

Emerson's scientific art theory was superseded by that of the photographer Alfred Stieglitz. Through family experience, temperament, and schooling, the American Stieglitz was exceptionally familiar with the science of his time. His father was an eager technocrat and successful entrepreneur, who designed the family home with all the latest improvements. He propelled the mathematically gifted Alfred into choosing a career in mechanical engineering and sent him to school in Germany, where engineering education was particularly advanced. In Germany, Alfred Stieglitz bought his first camera – the subject of much photo lore. Equally significant was Stieglitz's exposure to revolutionary scientific ideas. When he made the transition from engineering to photography, he wrote articles not only on art theory but also on technical subjects such as photochemistry.[118]

Despite his familiarity with the latest science, Stieglitz did not establish his photographic theory on a few specific scientific tenets, as Emerson had done. Instead, he yoked a scientistic attitude to a philosophy that cultivated intuitive or mystical insights.[119] Released from adherence to narrow principle or specific scientific law, Stieglitz was free to trust his own experience and fuse subjectivity to the use of the camera. Recollecting in 1940 the way in which his photographs taken in the late 1880s were lauded by artists in Berlin, Stieglitz declared that "something fundamental . . . was in the machine . . . the machine had come to stay. My camera and lens in a way could be looked upon as a machine, but without the machine and myself being one, that which these artists so admired would not exist."[120]

The "machine and myself" formed the crux of Stieglitz's early theory. Emerson had been at pains to justify taste and personal expression in scientific terms. But Stieglitz, bolstered by theories of intuitive knowledge endorsed by science, psychology, and symbolist art, easily exalted the exceptional individual or creative genius, whose production of artifacts helps to shape culture for the betterment of humankind. His confident neo-Romantic view was evident in his 1903 rationale for the Photo-Secession:

> In all phases of human activity the tendency of the masses has been toward ultra conservatism. Progress has been accomplished only by reason of the fanatical enthusiasm of the revolutionist, whose extreme teaching has saved the mass from utter inertia. What is to-day accepted as conservative was yesterday denounced as revolutionary. It follows, then, that it is to the extremist that mankind largely owes its progression. In this country photography also has followed this law. . . . those most deeply interested in the advancement of photography along the lines of art have been compelled to register their protest against the reactionary spirits of the masses.[121]

FIGURE 66

Alfred Stieglitz, *The Terminal,* 1893. Collection of the J. Paul Getty Museum, Malibu, California.

Alfred Stieglitz proved to be a newer man than Peter Henry Emerson because Stieglitz was able to overcome the contradictory ideas that hampered Emerson and join photography to a modernism that was detached from either a specific scientific theory or an obsolete philosophy of science. Stieglitz managed to jettison science and the philosophy of science as bases for art photography, while reinstating some of science's midcentury optimism. For Stieglitz, science was art's assistant, not its sole pathfinder. Unlike Emerson, Stieglitz represented photographic technology as fully yielding to human expression:

> The modern photographer, through the introduction of a great number of improved printing methods, has in his power to direct and mold as he will virtually every stage of making his picture. . . . there are virtually no limitations to the individuality that can be conveyed in the photographic print. . . . each individual print has a distinct identity of its own that reflects the mood and feeling of its maker.[122]

Still, Stieglitz's debt to Emerson and to the notion of naturalistic photography is significant. From Emerson he may have learned to employ the more colloquial vocabulary of science, eventually calling his gallery a laboratory, or "experiment station."[123] Certainly, Stieglitz amplified Emerson's anti-Philistinism, his distress over mass culture, and his reliance on innate taste.[124]

165

Emerson savored contemporary scientific insights, but he did not like modern life, especially what he viewed as its intrusion into the unspoiled countryside, his favorite photographic subject. Like others in the professional elite, he adopted the values of the English aristocracy, celebrating the notion of culture and excoriating Philistine money grubbing.[125] In Emerson's ominous vision the "old world" of East Anglia would be tricked up with a "modern hotel, with electric bells, elevators, hot-air pipes, dynamo-machines, telephones, ammonia-phones, electric fishing and shooting à la Jules Verne, water tricycles, and the devil knows what."[126] He may have enjoyed urban scenes rendered by Manet, but he generally regarded the city to be a place of "cheap civilisation," where "degeneration awaits the race, where all is vanity and artifice."[127] In the third, that is, the postrenunciation, edition of *Naturalistic Photography* (1899), Emerson hammered upon a class-ridden concept of corrupting, urban-based, machine culture. "Art is personal," he declared; "photographs are machine-made goods, useful, as is machine-made furniture, machine-made fabrics, and perhaps – for the slums – machine-made music."[128]

Stieglitz, however, as Lewis Mumford has observed, elevated photography as "a major element in modern experience: it meant actuality."[129] For Stieglitz, the camera represented humankind's ability to coerce science and technology to serve nonutilitarian ends. Stieglitz imaged the absorption of the new into the dynamic stream of civilization by photographing the city, with its influx of immigrants and its innovative skyscrapers. The very urban life despised by Emerson became for Stieglitz the ostensible subject for personal expression and evocation. In the same article in which Stieglitz commended photographs of "metropolitan scenes" that managed to "impart . . . the poetic conception of the subject," he exalted pictorial photography as "the real photography, the photography of to-day."[130] Through Stieglitz's pictorial photography, the city – one of the most visible signs of modernism – is elevated beyond simple description. Emerson, on the other hand, never got beyond associating photographic realism with the decline of culture.

Stieglitz widened the chasm between what Emerson had called the two truths to nature: the one mathematical, the other perceptual or psychological. As the historian Alan Trachtenberg has observed, Stieglitz's language is polarized and polarizing. Stieglitz contrasted factual images to expressive photographs. He endorsed art photographs made solely for gallery display.[131] By severing the world of action from the realm of thought and spirit, that is, by updating Emerson's insistence on the split between documentary and artistic photography, Stieglitz revivified photography as a suitable project for the serious amateur rather than the weekend hobbyist. At the same time, the dissolution of the apparent subject in photography in favor of the imaginative subject prepared the way for an avant-garde photography that would be nonreferential, such as Malcolm Arbuthnot's abstractions or Alvin Langdon Coburn's vortographs.[132] In an era when a

taste for nuance, suggestiveness, and the enigmatic in art were considered to nourish one's class standing as well as one's imagination, Stieglitz convincingly argued that the camera was an instrument of personal expression through which one could locate and discover the beautiful.

Stieglitz maintained that the photograph, despite its camera origins, bore no resemblance to the mass-produced print. He affirmed that culture could reinvent itself using technology and not be dominated by the machine in the process. Experimentation could play a role in art without changing art's mission, and photography could be progressive, yet not ravage the permanent social value of art. In sum, regardless of its mechanical means, photography could achieve the status of a fine art.[133]

Stieglitz spoke of art, and art photography, as if they were components of a vaguely delineated social revolution. Unlike most nineteenth-century revolutionary rhetoric, his did not call for direct, political group action. Instead, he counseled that profound social change would spring from individual effort and shifts in perception. By yoking what was essentially the well-established Romantic emphasis on individual response to the demands of late-nineteenth-century life, Stieglitz evinced a pattern of thought called reluctant modernism, that is, a tendency to find a prominent place for received ideas in the midst of social change.[134] He was not alone in trying to harmonize traditional values with urban, industrial, mass culture. He took a stance against both the academic art world and commercial culture. In a 1912 interview in which he recalled his early years, Stieglitz explained that his idea of photography was "against all authority in everything, for art is the only expression of life."[135] Essentially, Stieglitz was no more consistent in his thinking than Emerson was. Stieglitz's contradictions, however, drew together the modernist values of his time.

The modernism with which Stieglitz made his peace had greatly changed since the emergence of positivism and the disclosure of photography in 1839. At the end of the nineteenth century, modernism had become less dependent on the philosophy of science and was more directly tied to technological utopianism and an intuitive sense of progress. Essential to Alfred Stieglitz's achievement was his ability to manipulate the idea of photography as a cultural metaphor for the modern, while understanding that the machine itself was an ambivalent symbol for human advancement. Stieglitz pronounced the artist capable of mastering the camera and producing individuated art pictures rather than mass-intoxicated images. In so saying, Stieglitz affirmed that humankind would prevail in the coming Machine Age. In a sense, Stieglitz cultivated the idea that the future condition of society would depend less on particular human actions and more on the effects of mechanization. Yet all the while, he enshrined introspective sensibility and vouchsafed individual perception.

Stieglitz's concession came at a time that, because of increased lit-

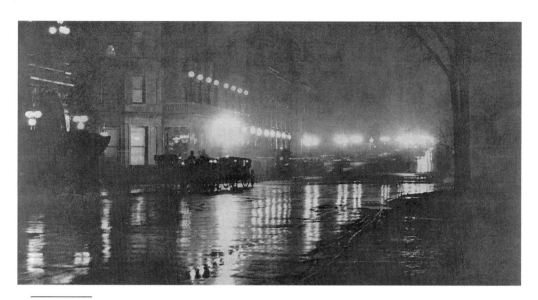

FIGURE 67

Alfred Stieglitz,
*The Glow of Night –
New York,* 1896. Col-
lection of the J. Paul
Getty Museum, Mal-
ibu, California.

eracy, high-speed presses, and international communications net-
works, factual photography was newly empowered to disseminate in-
formation. But according to Stieglitz, purely factual photography de-
picted a lesser reality and one largely unrelated to the project of art:
"It has been argued that the productions of the modern photograph-
er are in the main not photography. While, strictly speaking, this may
be true from the scientist's point of view, it is a matter with which the
artist does not concern himself, his aim being to produce . . . that
which seems to him beautiful."[136]

Stieglitz was a forceful personality, but he did not single-handedly
alter the culturally defined idea of photography. Like the Victorian
"proximate initiator of change," he articulated a shift that was taking
place.[137] About 1900, avant-garde art and photography were divorc-
ing themselves from subject matter and beginning to court beauty.
Just as the symbolist painter and writer Maurice Denis asserted that
"a picture before it is a war horse, a naked woman, or some anecdote,
is essentially a flat surface covered with colors arranged in a certain
order,"[138] Stieglitz suggested that photography could oust publicly
readable subject matter in favor of form and private expression. By
1900, art photography endorsed the neo-Kantian concept of disinter-
ested art. Photography revealed a way to maintain the artist as cul-
tural hero, while denying the worst of the modern world. Art photog-
raphy developed as a recognizable symbol in the campaign against
nightmarish standardization, mechanization, and cultural democrati-
zation. The nostalgia with which the medium had been imbued from
the first was enhanced and expanded. The idea of photography be-
came saturated with early modernism's melancholy and disillusion-
ment with the course of science. Concurrently, photography em-
braced the concepts of manageable social progress and the viability
of human innovation. At century's end, photography was both elegiac
and progressive – a Janus figure, gazing forward and backward.

# Epilogue: Ghosts – Photography and the Modern

Initial impressions of photography were guided by contradictory views about the role of images and the social consequences of artistic originality. If the medium hinted at a democratization of knowledge, it also augured the dominion of the masses. To think of photography as art meant contemplating it as social leveler. This friction between benefits and perils infiltrated nineteenth-century literature.

Photography's first fictions were full of ghosts. Whereas the railroad and telegraph entered the nineteenth century's complex symbolism of modernity, neither was as encumbered with phantasms and specters as was photography. Of course, it was common to insist, as does one character in *The House of the Seven Gables,* that new methods of transportation and communication would produce socially detrimental consequences. But the association of photography with disorder and decline, as well as with individual and social advancement, was regularly expressed in supernatural terms. Photography was the only one of the early-nineteenth-century transformational technologies that forcefully connoted the lack of control by human beings.[1]

Two of early photography's characteristics offered the ingredients for powerful social metaphors. By itself, the simple "ghosting" of nineteenth-century photographs, that is, the appearance of incomplete, blurred images, does not sufficiently explain why stories involving photography are so often haunted. But the idea of "ghosting" – the perception of a defective reality – became central to photographic fiction. Similarly, photography's basic technical property, the latent image, communicated the concept of latency, which is to say, the condition of being suspended between states of existence.

Throughout an extensive social dialogue, the heavily freighted idea of photography served as surrogate for the nineteenth century's negotiations with modernity and gave expression to the suspicion that nature had been trespassed upon by a technology and a social order that were developing beyond the scope of human management. Per-

haps this is why both overt and tacit discussions of photography's effects so often redounded to the notion of progress. In photographic discourse, modernity appeared as a portentous world-historical enterprise.

Almost one hundred and fifty years after the disclosure of photography to the world, critics were still enumerating the medium's ghosts. In his influential article "The Traffic in Photographs," Allan Sekula asserted that "photography is haunted by two chattering ghosts: that of bourgeois science and that of bourgeois art."[2] From its beginnings to the late twentieth century, photography has been laden with many givens – a passel of contradictory metaphors, half-realized associations, and unexamined received ideas. Small wonder that originality has been central to its discussion. Whether chattering about art, science, or society, photography's ghosts have been talking about the modern world's prospects for authentic improvement.

In contemporary writing, photography continues to be a lively metaphor for the sundry aspects of a now-tattered modernity. Even today, when the video camera and television have largely replaced photography as a vehicle of rapid, credible news and information, the experience of mass media, coupled with the recognition of mediated reality, are expressed through the tenacious language of photographic discourse. Thus in his seminal 1981 essay "Last Exit: Painting," the artist and critic Thomas Lawson could claim that "The camera, in all its manifestations, is our god, dispensing what we mistakenly take to be truth. The photograph *is* the modern world."[3] In our time, the photograph, which once equated seeing and knowing, now symbolizes endangered vision, obsessive self-regard, and the collapse of moral authority. In the extremes of postmodern sadness, photography distills apocalyptic loss.

It would be foolhardy to predict a speedy demise to such a powerful and adaptable social metaphor. Still, the computer has recently been symbolically tasked with many of the hopes and fears surrounding the modern that had been articulated through photographic discourse. With the increasing use of and social dialogue about computer networking and virtual reality, the relationship of humans to nature, to society, to culture, and to each other may become reconfigured in terms of the defining metaphor of the computer.

It is meaningful to note that some theoretical treatments of computer imagery speak of post-photography.[4] Photographic discourse has been structured around the way the medium produces a trace of optical reality through the use of a camera. With the advent of self-generating computer imagery, the indexical connection between optical reality and image has been severed. The camera is not essential to the process, nor does the computer image replicate the material world. Some observers allege that the extensive use of computers is exhausting the fundamentals of Western visuality. "Postphotography is no longer modeled on an optical consciousness operating inde-

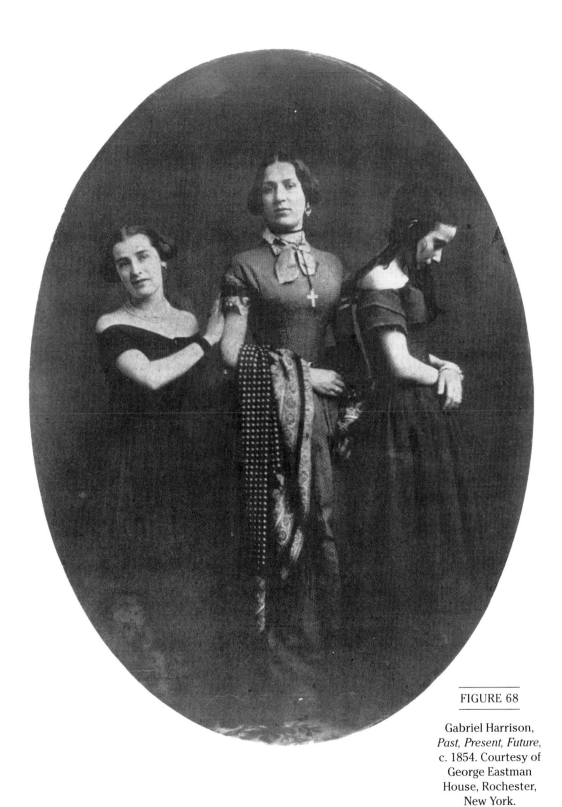

FIGURE 68

Gabriel Harrison,
*Past, Present, Future,*
c. 1854. Courtesy of
George Eastman
House, Rochester,
New York.

pendently of its material and symbolic contexts," insists the critic David Tomas.[5]

On the other hand, photographic discourse has proven itself sufficiently nimble to encompass the central concerns of representation and mass media, regardless of technological source. It is plausible that computer symbolism will not so much dislodge the idea of photography as be absorbed by and adapted to the continuing problems of vision. In that sense, photography may continue to be the modern world.

# NOTES

## PREFACE

1. Thomas Lawson, "Last Exit: Painting," *Artforum* (October 1981): 45.
2. Roger Chartier's articles have been collected in *Cultural History: Between Practices and Representations,* trans. Lydia G. Cochrane (Ithaca, NY: Cornell University Press, 1988). Also see Roger Chartier, *The Cultural Uses of Print in Early Modern France,* trans. Lydia G. Cochrane (Princeton, NJ: Princeton University Press, 1987) and Roger Chartier, *The Culture of Print,* trans. Lydia G. Cochrane (Cambridge: Polity Press, 1989).
3. Erwin Panofsky, "An Introduction to the Study of Renaissance Art," in his *Meaning in the Visual Arts* (Garden City, NY: Doubleday Anchor Books, 1955), p. 41.
4. Nathaniel Hawthorne, *The House of the Seven Gables* [Centenary Edition], vol. 2 (Columbus: Ohio State University Press, 1965), p. 180. See the discussion in Chapter 1.

## 1: ORIGINS OF PHOTOGRAPHIC DISCOURSE

1. Paul Valéry, "The Centenary of Photography," in *The Collected Works in English of Paul Valéry,* vol. 2, *Occasions,* ed. Roger Shattuck and Frederick Brown (Princeton, NJ: Princeton University Press, 1970), p. 159.
2. For example, Alexander Pope articulated the difference between inherent genius and acquired genius in his essay on Shakespeare: "The poetry of Shakespear [*sic*] was inspiration indeed: he is not so much an Imitator, as an Instrument of Nature; and 'tis not so just to say he speaks from her, as that she speaks through him." Alexander Pope, "Preface to the *Works of Shakespeare,*" in *Literary Criticism of Alexander Pope,* ed. Bertrand A. Goldgar (Lincoln: University of Nebraska Press, 1965), p. 161.
3. W. H. F. Talbot, *The Pencil of Nature* (1844–1846; facsimile rpt., New York: DeCapo Press, 1969, unpaginated). See "Introductory Remarks."
4. From Daguerre's broadsheet, reproduced in "An Announcement by Daguerre," *Image* 8 (March 1959): 34. Translation mine.
5. Joseph Nicéphore Niépce, "*Notice sur l'héliographie,*" trans. in J. M. Eder, *History of Photography* (New York: Columbia University Press, 1945), p. 218. The original French is available in Victor Fouque, *La vérité sur l'invention de la photographie. Nicéphore Niépce, sa vie, ses essais, ses travaux, d'après sa correspondance et autres documents inédits, par Victor*

*Fouque* (Paris: Librairie des auteurs et de l'Académie des bibliophiles, 1867), p. 162. [*The Truth Concerning the Invention of Photography: Nicéphore Niépce, His Life, Letters and Works,* trans. Edward Epstean (1935; rpt., New York: Arno Press, 1973), p. 90.]

6. Eder, p. 215.

7. The extent and persistence of this idea is illustrated in Michel F. Braive's *The Photograph: A Social History,* trans. David Britt (New York: McGraw-Hill Book Co., 1966), p. 52, by a late-nineteenth-century French parlor game, which places Daguerre between Edison and Sauvage. Yet Daguerre is associated not with the idea of invention, but with perfecting photography, presumably from nature.

8. Quoted in Edward Lind Morse, *Samuel F. B. Morse: His Letters and Journals,* vol. 2 (New York: Houghton Mifflin Co., 1914), pp. 143–144.

9. Journal entry for October 28, 1841, in Edward Waldo Emerson and Waldo Emerson Forbes, eds., *Journals of Ralph Waldo Emerson, 1820–1872,* vol. 6 (Boston and New York: Houghton, Mifflin Co., 1889), pp. 110–111. Not all versions of Emerson's journal are as exact as to the date.

10. Gail Buckland gathered contemporary newspaper and journal accounts along with William Henry Fox Talbot's letters in her *Fox Talbot and the Invention of Photography* (Boston: David R. Godine, 1980), pp. 39–59. The words "invention" and "discovery" are used extensively throughout. Larry J. Schaaf has shown the extent to which Talbot's photography was the result of an extended series of experiments. Nevertheless, photography was spoken of as discovered rather than invented. See Larry J. Schaaf, *Out of the Shadows: Herschel, Talbot and the Invention of Photography* (New Haven, CT: Yale University Press, 1992).

11. Clement Greenberg, "The Camera's Glass Eye: Review of an Exhibition of Edward Weston," in *Clement Greenberg: The Collected Essays and Criticism,* vol. 2, ed. John O'Brian (Chicago: University of Chicago Press, 1986), p. 60. (Emphasis mine.)

12. See, for example, *Photography: Discovery and Invention: Papers Delivered at a Symposium Celebrating the Invention of Photography* (Malibu, CA: J. Paul Getty Museum, 1990).

13. Jean-Jacques Rousseau, "The Letter to M. D'Alembert on the Theatre," in *Jean-Jacques Rousseau and the Arts,* trans. Allan Bloom (Ithaca, NY: Cornell University Press, 1960), sect. 11, pp. 123–137. Also see the discussion in Jean Starobinski, *The Invention of Liberty, 1700–1789* (Geneva: Skira, 1964), pp. 100–104.

14. Ralph Waldo Emerson, "Nature," in *Ralph Waldo Emerson: Essays and Lectures* (New York: Library of America, 1983), p. 10. This is not to imply that Rousseau and Emerson used the idea of photography for similar ends. Rousseau imagined heart speaking to heart – a community of individuals. Emerson found the self dissolving in Nature. One sought to integrate the individual with culture, and the other saw improvement through melding with nature.

15. Emerson's passage about becoming a transparent eyeball is often quoted in the photographic literature as if photography were its main object. It should be remembered that the fact, metaphor, and instruments of vision played important roles in Emerson's philosophy. Not only did he praise daguerreotypes, but before the invention of photography he pronounced the age an ocular one and suggested that there be telescopes on every street corner to aid the shortsighted! (See Paul, p. 82, cited next.) The fullness of Emerson's "angle of vision" is discussed in Sherman Paul's enduring book of the same name (Cambridge, MA: Harvard University Press, 1982). On the other hand, it is intriguing to consider the extent to which

Emerson's contemporaries thought of the transparent eyeball as a camera obscura. The poet Christopher Pearse Cranch (1813–1892) caricatured Emerson as an eyeball (with hat!) striding into nature on spindly legs that look like those used with a tripod. The illustration is found opposite page 5 in Paul's study.

The idea of passive sight strongly influenced nineteenth-century naturalism. The English sage and critic John Ruskin proposed going to nature "rejecting nothing, selecting nothing, and scorning nothing." See *The Works of John Ruskin*, ed. E. T. Cook and A. Wedderburn, 39 vols. (London: G. Allen, 1903–1912), vol. 3, p. 624 (hereafter, Ruskin, *Works*).

16. Henry David Thoreau, *Walden* (New York: New American Library, 1960), p. 79. Rousseau's communitarian festival is similarly disposed to the values of unimpeded sight and the "abolition of representations." See Starobinski, p. 101.

17. Edgar Allen Poe, "The Daguerreotype," *Alexander's Weekly Messenger* (January 15, 1840), 38. Panopticism, a late-eighteenth-century inversion of the communitarian spirit emanating from the idea of photography, has been charted by Michel Foucault. See the section on literacy and cultural hegemony, Chapter 4.

18. The connection between concepts of mind and ocular imagery is discussed in Richard Rorty's *Philosophy and the Mirror of Nature* (Princeton, NJ: Princeton University Press, 1979). See also Rorty's section on the Cartesian mind and the idea of a neutral mirror. These issues also loomed over the naming of photography. See Geoffrey Batchen, "The Naming of Photography," *History of Photography* 17 (Spring 1993): 22–32.

19. Fouque, pp. 62 and 64. Letter to Claude Niépce, May 5, 1816. [English, p. 30. N.B.: Translation shifts sections of text.]

20. *Comptes Rendus Hebdomadaires des Séances de l'Académie des Science*, vol. 8 (Paris: Bachelier, 1839), p. 270. Arago's contribution to French optical theory is discussed in Jed Z. Buchward, *The Rise of the Wave Theory of Light* (Chicago: University of Chicago Press, 1989).

21. Daguerre [Louis Jacques Mande], *Historique et Description des Procédés du Daguerréotype et du Diorama* (Paris: Moleni et Fils Aîné, 1839), p. 27, unnumbered note.

22. Peter J. Mustardo, "Early Impressions of the Daguerreotype from the Notebook of an Anonymous Frenchman: A Translation," *History of Photography* 9, no. 1 (January–March 1985): 56. For the identification of the notebook's writer, see *History of Photography* 9, no. 3 (July–September 1985): 260. For Biot's idea of an artificial retina, see *Comptes Rendus*, vol. 9, p. 7. Arago also used the term "artificial retina." Terry Castle has noted an 1878 analogy between the photographic plate and the retina used to explain away apparitions. See Terry Castle, *The Female Thermometer: 18th Century Culture and the Invention of the Uncanny* (New York: Oxford University Press, 1995), pp. 179 and 244 n. 22.

23. See, for example, Man Ray, *Photographs* (Paris, 1934), n.p., and László Moholy-Nagy, "Unprecedented Photography," in *Photography in the Modern Era: European Documents and Critical Writings, 1913–1940*, ed. Christopher Phillips (New York: Metropolitan Museum of Art/Aperture, 1989), pp. 83–85.

24. Greenberg, p. 60.

25. Lewis Mumford, *Technics and Civilization* (New York: Harcourt, Brace and Co., 1934), p. 338.

26. Mumford, p. 338.

27. Mumford, p. 340. Mumford's biographers, Thomas P. Hughes and Agatha C. Hughes, comment that in Mumford's thought "the medium of photogra-

phy was the harbinger of a new social psychology, in which individuals viewed themselves from all three dimensions." See *Lewis Mumford: Public Intellectual* (New York: Oxford University Press, 1990), p. 295.

28. André Bazin, *What is Cinema?,* trans. Hugh Gray (Berkeley: University of California Press, 1967), p. 13.

29. Bazin, p. 13.

30. See Allan Sekula, "On the Invention of Photographic Meaning," in *Thinking Photography,* ed. Victor Burgin (London: Macmillan, 1982).

31. John Tagg, *The Burden of Representation: Essays on Photographies and Histories* (Amherst: University of Massachusetts Press, 1988), p. 63. The issue of photographic transparency has been of interest to aestheticians. See Roger Scruton, "Photography and Representation," *Critical Inquiry* 7 (Spring 1981): 577–603, and Kendall L. Walton, "Transparent Pictures: On the Nature of Photographic Realism," *Critical Inquiry* 11 (December 1984), 246–277.

32. Helmut and Alison Gernsheim, *L. J. M. Daguerre: The History of the Diorama and the Daguerreotype,* 2nd ed. (New York: Dover Publications, 1968), pp. 43, 53, and 71–72. In her account of the phantasmagoria, a magic lantern show perfected by Etienne-Gaspard Robertson in Paris during the early 1800s, Terry Castle describes the Gothic effects created in this form of entertainment, which resemble the kinds of tableaux created later by Daguerre in the diorama. Perhaps the association of photography with magic, the occult, and spectral imagery was enhanced by the phantasmagoria, as well as by the diorama. See Castle, pp. 140–167. In this regard, it is interesting to note that the discovery of photography was explained with reference to the rapidity and variety of "the phantasmagoria of inventions." See "New Discovery in the Fine Arts," *The New Yorker* 7 (April 12, 1839): 49. The same article, taken from an unspecified issue of *Blackwood's Magazine,* comfortably puns on the graphic properties of photography, referring to it as "the real black art of true magic." In a related story, Wolfgang Schivelbusch tells of the diorama within the larger context of the development of artificial lighting. See Wolfgang Schivelbusch, *Disenchanted Night: The Industrialization of Light in the Nineteenth Century* (Berkeley: University of California Press, 1995), esp. pp. 213–221.

33. "Self-operating Processes of Fine Art. The Daguerotype [*sic*]," *The Museum of Foreign Literature, Science and Art* 35, n.s. 7 (January–April, 1839): 341. Also see Alan Trachtenberg, "Photography: The Emergence of a Key Word," pp. 16–47, in *Photography in Nineteenth-Century America,* ed. Martha S. Sandweiss (Fort Worth: Amon Carter Museum of Western Art and New York: Harry N. Abrams, 1991).

34. Buckland, p. 53. The statement occurs in a letter to William Henry Fox Talbot. Herschel is generally credited with proposing the word "photography" for the process as well as with suggesting the terms "positive" and "negative."

35. *Comptes Rendus,* vol. 9, p. 252. Also reprinted in Helmut and Alison Gernsheim, *Daguerre.* Writing on Professor Jacques Charles, the French physician who is said to have demonstrated a technique for making profiles photogenically, Francis Wey wrote: "Charles mourut, sans laisser le secret de son procédé. Mais il avail démontré que la lumière peut dessiner toute seule; les idées furent lancées sur ce problème; l'utopie avait désormais sa raison d'être." Francis Wey, "Comment le soleil est devenu peintre: histoire du daguerréotype et de la photographie," *Musée des Familles* (June 1853): 259.

36. Mayer and Pierson, *La Photographie* (Paris: Librairie L. Hachette, 1862; rpt., New York: Arno Press, 1979), pp. 8–11.

37. In his book *The History of the Discovery of Photography,* trans. Edward Epstean (Paris, 1925; New York: Tennant and Ward, 1936), George Potonniée carefully set out his objection to the use of *Giphantie* as a precursor to photography. He noted that Tiphaigne de la Roche's image was a moving image, not a static one, and that it worked allegorically in the novel. Further, Potonniée remarked that de la Roche was writing not anticipatory or science fiction, but a satire on the morals of his time. He added that the *Giphantie* excerpt, taken out of context, was copied from one text to another without consideration for its role in the original, larger, story. See Chapter VIII, "Tiphaigne de la Roche," pp. 42–46.

38. [Tiphaigne de la Roche, Charles Francois], *Giphantie* (London: Printed for R. Horsfield, 1761; Woodbridge, CT: History of Photography Microfilm, 1982). The important passage from *Giphantie* is translated and reproduced in the Gernsheims' *History,* p. 35.

39. Eder, who was not impressed with the forecasting in the *Giphantie* story, preferred to find anticipations of photography in ancient mythology and in Greek and Roman writing. He did not deride those who have enshrined the *Giphantie* story, but, like many historians of the period, he invoked the cultural authority of writers from the classical past.

40. William Henry Fox Talbot, *Some Account of the Art of Photogenic Drawing* (London: R. & J. S. Taylor, 1839), p. 201. In *The Art of Photography: 1839–1989,* ed. Mike Weaver (New Haven, CT: Yale University Press, 1989), published for the sesquicentennial of the disclosure of photography, the editor chose to include an excerpt from Talbot's *Legendary Tales in Verse and Prose,* published in London in 1830. The extract, titled "The Magic Mirror," is a simple tale about a Wizard, a Spell, a veiled Mirror, and an inquisitive teenager, and it has nothing at all to do with the invention of photography other than that it was written by one of the medium's pioneers. Yet it was included, presumably because it alludes precursively to the magical properties of photography.

41. Poe, p. 27. In a letter dated September 1824, Niépce also remarked on the magical quality of an early attempt to produce a camera image on a lithographic stone. He noted that the "effect is truly something magical." The letter, currently in a Russian collection, is quoted in Joel Snyder, "Inventing Photography, 1839–1879" in *The Art of Fixing a Shadow: One Hundred and Fifty Years of Photography,* ed. Sarah Greenough, Joel Snyder, David Travis, and Colin Westerbeck (Boston: Bulfinch Press, 1989), p. 10. The notion of the photograph as magical persists despite our knowing the process by which a photograph is made. This was noted by Roland Barthes in *Camera Lucida: Reflections on Photography,* trans. Richard Howard (New York: Hill and Wang, 1981), where he writes that, as a realist, he considered the photograph "an emanation of *past reality,* a *magic,* not an art" (p. 88).

42. Reprinted in *Elizabeth Barrett to Miss Mitford,* ed. B. Miller (New Haven, CT: Yale University Press, 1954), pp. 208–209. Mesmerism, a kind of hypnosis popular in the late eighteenth and nineteenth centuries, was invented by Franz Mesmer.

43. See, for example, two anonymously written stories: "The Magnetic Daguerreotype," *Photographic Art Journal* 4 (June 1852): 353–359, and "My Lost Art," *The Atlantic Monthly* 10 (August 1862): 228–235. Christian Metz has argued that photography is inherently related to totemism. See his "Photography and Fetish," *October,* no. 34 (Fall 1985): 81–90. David Freedberg has also written on the subject of fetishism in art. See his *The Power of Images: Studies in the History and Theory of Response* (Chicago: University of Chicago Press, 1989).

44. Nathaniel Hawthorne, *The House of the Seven Gables* [Centenary Edition], vol. 2 (Columbus: Ohio State University Press, 1965), p. 176. On Hawthorne and photography, also see Richard Rudisill, *Mirror Image: The Influence of the Daguerreotype in America* (Albuquerque: University of New Mexico Press, 1971), p. 233.

45. Hawthorne, p. 180.

46. Holgrave's character was likely drawn from contemporary views of the photographer. In *The Photographic Art-Journal* for August 1851, the editor announced that despite the multiple benefits to society produced by photography, some daguerreotypists "pander" to "vitiated and gross appetite[s]." "So many have taken [daguerreotypy] up as a mere means of obtaining an easy livelihood, who are totally unfitted either by taste, education or inclination to pursue it with the least degree of ability or success, that considerable disrepute has stained its former fair fame" (p. 100).

47. The continuing application of the apparatus of magic found in American diaries, newspapers, and novels, as well as the association of photography with death, is discussed in Alan Trachtenberg's "Mirror in the Marketplace: American Responses to the Daguerreotype, 1839–1851," in *The Daguerreotype: A Sesquicentennial Celebration,* ed. John Wood (Iowa City: University of Iowa Press, 1989), pp. 60–73. Of interest, Stephen Soderbergh's 1989 film *sex, lies, and videotape* extended the language of magical insight to video. The reception of photography in Europe and the United States is given a fuller discussion in Chapter 2.

48. For predictions of the future impact of mass media, see *Imagining Tomorrow: History, Technology, and the American Future,* ed. Joseph J. Corn (Cambridge, MA: MIT Press, 1986), especially Susan J. Douglas, "Amateur Operators and American Broadcasting: Shaping the Future of Radio," pp. 35–57.

49. Walter Benjamin, "The Work of Art in the Age of Mechanical Reproduction," *Illuminations,* ed. Hannah Arendt, trans. Harry Zohn (New York: Schocken Books, 1969), pp. 224–226. Benjamin's understanding of photography is extensively discussed by Eduardo Cadava in "Words of Light: Theses on the Photography of History," *Diacritics* 22 (Fall–Winter 1992): 84–114.

   Likely enough, the ability of reproductions to stimulate interest in originals was anticipated in the nineteenth century by proponents of art reproduction by chromolithography. In his article "Popularizing Art," for *The Atlantic Monthly* in March 1869, James Parton observed that "chromos will enhance, rather than diminish the value of originals; because the possession of an original will confer more distinction when every one has copies; and it is *distinction* which the foolish part of our race desires" (p. 355).

50. [Augustine Joseph Hickey Duganne], *The Daguerreotype Miniature: Or, Life in the Empire City* (Philadelphia: G. B. Zieber & Co., 1846), p. 30.

51. "My Lost Art," p. 229.

52. *French Primitive Photography,* introduction by Minor White, commentaries by André Jammes and Robert Sobieszek (New York: Aperture, 1970), unpaginated.

53. Minor White in *French Primitive Photography,* unpaginated.

54. Photographer Nicholas Nixon expressed similar sentiments about the photograph:

   While describing something that matters with clarity, economy, and force seems to be photography's perennial esthetic, how this comes about remains for most a private and, for the most part, intuitive matter. The best photographs are transparent, sensual, intelligent, fulfilled, freshly arrived, enduring and, in the deepest sense, are of the world.

Letter of June 3, 1975, quoted in William Jenkins, "Introduction to the New Topographics," in *Reading into Photography: Selected Essays, 1959–1980,* ed. Thomas F. Barrow, Shelley Armitage, and William E. Tydeman, eds., (Albuquerque: University of New Mexico Press, 1982), p. 53.

The imputed innocence of photography has not been associated constantly with intuition. During the 1930s, for instance, avant-garde theorists such as the Czech artist Karel Teige underscored the revolutionary potential of photography by emphasizing the medium's capacity to undermine class prerogatives. Tiege wrote: "daguerreotypes were not polluted by 'art,' they owed absolutely nothing to painting and the graphic arts. They were a clean piece of work." See Karel Tiege, "The Tasks of Modern Photography," trans. Jitka M. Salaquarda, in *Photography in the Modern Era,* ed. Christopher Phillips (New York: Metropolitan Museum of Art, 1989), p. 315.

55. This idea is discussed in Robert Scott Root-Bernstein, *Discovering: Inventing and Solving Problems at the Frontiers of Scientific Knowledge* (Cambridge, MA: Harvard University Press, 1989), p. 17.

56. Helmut and Alison Gernsheim, *Daguerre,* p. 78.

57. Daguerre, pp. 3–4.

58. *Comptes Rendus,* vol. 13, p. 172.

59. In the original French manual edition of Arago's report, the word "genius" is used to describe Daguerre and his invention. Moreover, this inventor and his invention are favorably contrasted with the claims of prior invention made by so-called ambitious mediocrities. See Daguerre, p. 10. In the English translation, "ambitious mediocrities" is replaced by "petty geniuses." In Eder's translation, p. 233, the sense that Daguerre is being called a genius among pretenders almost disappears.

60. Daguerre, p. 16.

61. Reproduced and translated in Daguerre, pp. 1–5.

62. It is always possible that some archival sources will turn up. But at present it is impossible to thoroughly reconstruct the sequences and circumstances of Daguerre's invention. Most of our current information is secondhand and anecdotal.

63. H. Gaucheraud, in the *Gazette de France,* August 18, 1839, quoted in Helmut and Alison Gernsheim, *Daguerre,* p. 84.

64. John Szarkowski, "American Photography and the Frontier Spirit," *Symposion über Fotographie* (Graz, 1979): 99.

65. Helmut and Alison Gernsheim, *Daguerre,* pp. 78–79. In *The Magician and the Camera* (New York: Oxford University Press, 1981), Erik Barnouw notes that the intersection of early cinema and magic has received little attention. A similar observation can be made for the still camera and magic.

66. Talbot, *Pencil,* "Introductory Remarks," unpaginated.

67. Talbot, *Pencil,* title page.

68. See Carl Woodring, *Nature into Art: Cultural Transformations in Nineteenth-Century Britain* (Cambridge, MA: Harvard University Press, 1989), p. 75.

69. Quoted in Morse, p. 142.

70. Martin Kemp, *The Science of Art: Optical Themes in Western Art from Bruneleschi to Seurat* (New Haven, CT: Yale University Press, 1990), p. 199. Some seventeenth-century Dutch painters used the camera obscura because they preferred the intensification of colors that it could produce.

71. For an introduction to the relation of these devices to photography, see Heinrich Schwarz, "Art and Photography: Forerunners and Influences," *Magazine of Art* 42, no. 11 (November 1949): 232–257. This essay is included in *Art and Photography: Forerunners and Influences. Selected Essays by Heinrich Schwarz,* ed. William E. Parker (Layton, UT: Gibbs M. Smith and Peregrine Smith Books, 1985).

72. See Jonathan Crary, *Techniques of the Observer: On Vision and Modernity in the Nineteenth Century* (Cambridge, MA: MIT Press, 1990), esp. p. 23. In her essay "Were They Having Fun Yet? Victorian Optical Gadgetry, Modernist Selves," Susan R. Horton discusses the popularity of optical illusions as cultural accommodation to the competing appeals of Romanticism and empiricism. See *Victorian Literature and Victorian Visual Imagination,* ed. Carol T. Christ and John O. Jordan (Berkeley: University of California Press, 1995), pp. 1–26.

73. Helmut and Alison Gernsheim, *Daguerre,* p. 79.

74. The bill is reproduced in Daguerre, pp. 7–9. Samuel F. B. Morse may have been the only person to actually experiment with fixing the images of the camera obscura with no immediate, practical, applications in mind. See the letter to his brother, dated March 9, 1839, Morse, p. 129.

75. Reprinted in Daguerre, pp. 11–28. See Arago's list, p. 12.

76. Kemp, p. 191.

77. Daguerre, p. 18.

78. Crary, p. 33.

79. Daguerre, p. 15.

80. *The Literary Gazette,* Saturday, February 2, 1839, quoted in Buckland, p. 39. An extensive discussion of the link between science and industry by Alexander von Humboldt is found in *Cosmos,* trans. E. C. Otté (London: Henry G. Bohn, 1849), p. 34:

> Those states which take no active part in the general industrial movement, in the choice and preparation of natural substances, or in the application of mechanics and chemistry, and among whom this activity is not appreciated by all classes of society, will infallibly see their prosperity diminish in proportion as neighboring countries become strengthened and invigorated under the genial influence of arts and sciences.

81. Poe, p. 37.

82. Crary, p. 53. The complexities of technological determinism are discussed in *Does Technology Drive History? The Dilemma of Technological Determinism,* ed. Merritt Roe Smith and Leo Marx (Cambridge, MA: MIT Press, 1994).

83. Walter Benjamin, "A Small History of Photography," in *One-Way Street and Other Writings,* trans. Edmund Jephcott and Kingsley Shorter (London: New Left Books, 1979), p. 240. For one of the earliest examples, see Arago's speech to the French Chamber of Deputies, *Comptes Rendus,* vol. 9, p. 252.

84. Samuel F. B. Morse may be an exception.

85. Talbot, *Pencil,* Part I, and H. J. P. Arnold, *William Henry Fox Talbot: Pioneer of Photography and Man of Science* (London: Hutchison Genham, 1977), pp. 106–107. Talbot did write about fixing the images of the camera obscura in his letter to the French Academy, but he was paraphrasing Arago's language. See *Comptes Rendus,* vol. 8, p. 171. Both Gail Buckland and Larry Schaaf write extensively about Talbot's chemistry.

86. Excerpted in Buckland, p. 39.

87. See, for example, various documents, such as the agreement between Niépce and Daguerre, dated June 13, 1837; Arago's report; and Talbot's writing in *The Pencil of Nature.*

88. F. D. Klingender, *Art and the Industrial Revolution,* ed. Arthur Elton (New York: Schocken Books, 1970), p. 35. For science in the period, see Charles Coulston Gillispie, *The Edge of Objectivity: An Essay in the History of Scientific Ideas* (Princeton, NJ: Princeton University Press, 1970); J. D. Bernal, *Science and Industry in the Nineteenth Century* (Bloomington: Indiana University Press, 1970); and J. T. Merz, *History of European Thought in the Nineteenth Century* (Edinburgh: William Blackwood and Sons, 1907).

89. Thomas Wedgwood and Sir Humphry Davy, "An Account of a Method of

Copying Paintings Upon Glass, and Making Profiles, by the Agency of Light Upon Nitrate of Silver," *Journal of the Royal Institution of Great Britain* 1 (1802): 170–174. Reprinted in Beaumont Newhall, *Photography: Essay and Images* (New York: Museum of Modern Art, 1980), pp. 15–16. The quotation appears on p. 174 of the original and p. 16 in the Newhall collection.

90. See Eder, pp. 139–140, and Helmut and Alison Gernsheim, *History*, pp. 40–41. Davy cites Scheele in a footnote to his article on Wedgwood's experiments.
91. Helmut and Alison Gernsheim, *History*, pp. 40–41.
92. William Henry Fox Talbot, *Some Account of the Art of Photogenic Drawing*, p. 198.
93. Hubert Damisch, "Five Notes for a Phenomenology of the Photographic Image," *October* 5 (Summer 1978): 71. For a critique of this position, see Allan Sekula, "The Traffic in Photographs," *Art Journal* 41 (Spring 1981), esp. p. 15.
94. Bernal, p. 135, has written: "What is most apparent . . . are the contradictions – the easy and rapid realizations in practice of some ideas at some times, the many false starts and halting progress of others." The narrative or myth-building character of science writing is outlined in Roger Lewin, *Bones of Contention: Controversies in the Search for Human Origins* (New York: Simon and Schuster, 1987), pp. 30–46.
95. *Edinburgh Review* 154 (January 1943): 161–162.
96. Mayer and Pierson, pp. 12–13.
97. Louis Figuier, "La photographie" (1868), in *La photographie au Salon de 1859* and *La photographie et Le stéréoscope* (rpt., New York: Arno Press, 1979), pp. 3–5, and Root, p. 396.
98. Unsigned [Lady Elizabeth Eastlake], "Photography," *Quarterly Review* (London) 101 (April 1857): 446.
99. See my "A Very Merry (Un)Birthday," *The Center Quarterly* 11 (Winter 1990): 9–11, and "Curiouser and Curiouser: Through the Looking Glass for the Sesquicentennial of Photography," *Afterimage* 17 (January 1990): 5–7.
100. Thomas S. Kuhn, *The Structure of Scientific Revolutions*, 2nd ed. (Chicago: University of Chicago Press, 1970), p. 2.
101. See Fouque, Part II, pp. 44–185.
102. See, for example, T. H. James, "Why Photography Wasn't Invented Earlier," in *Pioneers of Photography, 1790–1925: Their Achievements in Science and Technology*, ed. Eugene Ostroff (Springfield, VA: Society for Imaging Science and Technology, 1987), p. 14. Of equal interest is the minor theme in photographic studies that the daguerreotype, because it could not produce multiples, should be considered a false start. See, for example, Gene Thornton, "The Place of Photography in the Western Pictorial Tradition: Heinrich Schwarz, Peter Galassi and John Szarkowski," *History of Photography* 10 (April–June 1986): 91–92.
103. For science sources, see n. 88. For information on procedures to accredit new inventions in England, see Buckland, pp. 35–36.
104. Helmut and Alison Gernsheim, *Daguerre,* and Elizabeth Anne McCauley, "François Arago and the Politics of the French Invention of Photography," *Views: The Journal of Photography in New England* 11-4/12-1 (Fall 1990/Winter 1991): 8–11, 19–22.
105. See the section of this chapter on nature, originality, and photography.
106. Schaaf recounts Niépce's activities while he was in England to promote photography. Rather than focusing on Niépce's secretiveness, Schaaf sees the Frenchman as having been extraordinarily unlucky because

he approached the English scientific establishment at a time of discord and disorder. See Schaaf, pp. 30–32.

107. For a discussion of the individuals who came forward in 1839 to claim the invention of photography, see Pierre Harmant's three-part "Anno Lucis," *Camera,* no. 5 (May 1977): 39–43; no. 8 (August 1977): 37–41; and no. 10 (October 1977): 40–44. Also of interest is Mrs. Fulhame's 1794 treatise *View to a New Art of Dying and Painting,* which is discussed in Schaaf, pp. 23–24.

108. *Comptes Rendus,* vol. 9, p. 259.

109. Daguerre, p. 37. Civilization and the concept of civilizing also relate to literacy campaigns in the nineteenth century and to cultural hegemony. See Chapter 4 on photography and literacy.

110. *Comptes Rendus,* vol. 9, pp. 266–267. The point was not lost on the English, who noted that Arago was being "even more French than usual" (*Literary Gazette* [July 20, 1839]: 459; quoted in Arnold, p. 122). Also see Talbot's response on the same page.

111. Joseph Louis Gay-Lussac in his presentation to the Chamber of Peers. Excerpted and translated in Eder, p. 241.

112. The full title of Werge's text is *The Evolution of Photography with a Chronological Record of Discoveries, Inventions, Etc., Contributions to Photographic Literature, and Personal Reminiscences extending over Forty Years* (1890; rpt., New York: Arno Press, 1973).

113. George Iles, *Flame, Electricity and the Camera* (New York: Doubleday & McClure Co., 1901), p. 267.

114. Erich Stenger, *The History of Photography: Its Relation to Civilization and Practice,* trans. Edward Epstean (Easton, PA: Mack Printing Co., 1939), p. 3.

115. Like Iles, Lewis Mumford did not relate photography to the development of printing. In Mumford's tripartite scheme for the evolution of communications, printing is an eotechnic invention; photography belongs to the more modern, or so-called neotechnic, era.

116. *North American Review* (July 1854): 20–21, quoted in Rudisill, pp. 30–31.

117. Mumford, p. 5.

118. Mumford, p. 49.

119. Mumford, p. 242–245. Mumford included, along with the still camera, the phonograph and the motion picture camera in his roundup of machines whose principal aim and aesthetic mandate was veristic reproduction and a functionalist aesthetic. Also see the discussion in Thomas P. Hughes and Agatha C. Hughes, *Lewis Mumford: Public Intellectual* (New York: Oxford University Press, 1990), pp. 294–296.

120. Mumford, p. 340.

121. Heinrich Schwarz, "Before 1839: Symptoms and Trends," in Parker, p. 98. It is interesting that this idea has been taken up in relation to the foundations of seventeenth-century Dutch painting. Svetlana Alpers discusses the idea of photography before the fact of photography and even comes close to using that particular phrase in *The Art of Describing: Dutch Art in the Seventeenth Century* (Chicago: University of Chicago Press, 1983). See, especially, the chapter, "'Ut pictura, ita visio.' Kepler's Model of the Eye and the Nature of Picturing in the North."

122. Schwarz, "On Photography, Part II," p. 91, and Schwarz, "Before 1839," in Parker, p. 101.

123. For a discussion of the implications of this shift, see Susan Sontag, *On Photography* (New York: Delta Books, 1977).

124. Schwarz, "Before 1839," in Parker, p. 98.

125. Peter Galassi, *Before Photography: Painting and the Invention of Photography* (New York: Museum of Modern Art, 1981), p. 18. Gene Thorn-

ton has written on the intellectual relationship between Schwarz and Galassi (pp. 85–98). Crary has also criticized this position in his *Techniques of the Observer*, p. 17.

126. In their review of the show and its catalogue, Henri Zerner and Charles Rosen pointed out that there was nothing new in an art historian's posing a formal analysis of visual similarities. See *New York Review of Books,* 28 (December 3, 1981): 31.

127. Sontag, p. 153.

128. Sekula, p. 94.

129. In the now classic essay "The Work of Art in the Age of Mechanical Reproduction," Walter Benjamin hypothesized that the aura of an object, which sprang from its uniqueness, was diminished or destroyed in the era of multiple, photographic reproduction. If anything, multiple imagery has placed increased emphasis on contact with the original. Hence increased travel to art sites and increased attendance at musical events.

130. Daguerre, p. 2. One of the few to acknowledge the centrality of reproduction to photography's societal impact was Francis Frith. In the *Art Journal* 5 (1859): 72, Frith noted that the "*non-reproductive*" characteristic of the daguerreotype "excluded the idea of its application to the various commercial and valuable purposes for which the great principle of photographic representation was seen to be so strikingly available."

131. From a speech to the National Academy of Design, April 24, 1840, excerpted in M. A. Root, *The Camera and the Pencil* (1864; rpt., Pawlet, VT: Helios Press, 1971), p. 391. Around the same time, Elizabeth Barrett Browning used the word "facsimile" to express the new status of the photographic copy. See the section on magic and illusionism in this chapter. The idea of photography as mass communication and education is discussed in Chapter 4.

    The word was not used exclusively in connection with photography. It was also applied to the panorama – huge, scroll-like paintings popular in the nineteenth-century. Panoramas, like photographs, were thought to be vicarious experiences of travel. See Miles Orvell, *The Real Thing: Imitation and Authenticity in American Culture, 1880–1940* (Chapel Hill: University of North Carolina Press, 1989).

132. Daguerre, p. 53. Also see the discussion of magic in this chapter.

133. Rosalind Krauss, "Photography in the Service of Surrealism," in Rosalind Krauss and Jane Livingston, *L'Amour Fou* (New York: Abbeville Press, 1985), p. 31.

134. Jean Baudrillard, *Simulations,* trans. Paul Foss, Paul Patton, and Philip Beitchman (New York: Semiotext(e), 1983), p. 2.

135. See "An Announcement by Daguerre," p. 34.

136. This is not to imply that the subject never came up. For example, Oliver Wendell Holmes's essays "The Stereoscope and the Stereograph," *The Atlantic Monthly* 3 (June 1859): 738–748, and "Doings of the Sunbeam," *The Atlantic Monthly* 12 (July 1863): 1–15, deal with the personal and societal implications of photographically derived multiple images. Nevertheless, the preoccupation with the subject is more characteristic of this century. Holmes is discussed in Chapter 2.

137. William Ivins, *Prints and Visual Communication* (Cambridge, MA: Harvard University Press, 1953), p. 1.

138. Ivins, p. 2.

139. See, for example, Klingender, pp. 75–77.

140. Several photographic historians have attempted to generalize the social and cultural prehistory and early history of photography. See Gi-

sele Freund, *Photography and Society* (Boston: David R. Godine, 1980). Also see Alan Thomas, *Time in a Frame: Photography and the Nineteenth-Century Mind* (New York: Schocken Books, 1977).

141. For miniature painters and their reaction to the introduction of photography, see John Murdoch, Jim Murrell, Patrick Noon, and Roy Strong, *The English Miniature* (New Haven, CT: Yale University Press, 1981), pp. 207–209. Paul Delaroche's alleged remark that painting died on the advent of photography is one of the most overblown tales in photo-folklore. In fact, Delaroche supported the daguerreotype as an aid to preliminary drawing. See *Comptes Rendus,* vol. 9, p. 260.

142. Freund, p. 18. Of course, handdrawn silhouettes could be multiplied but not to the extent of the physionotrace engravings.

143. Robert Rosenblum discusses the outlined shadow and the legend of the Corinthian Maid in his "The Origin of Painting: A Problem in the Iconography of Romantic Classicism," *Art Bulletin* 39 (1957): 279–290. It is interesting to keep in mind that this legend about tracing also acquired connotations of magic.

144. Roland Barthes, p. 3.

145. Szarkowski, p. 103.

146. The concept of a defining technology is found in David J. Bolter, *Turing's Man: Western Culture in the Computer Age* (Chapel Hill: University of North Carolina Press, 1984), p. 11.

## 2: PHOTOGRAPHY AND THE MODERN

1. Thomas Carlyle, "Characteristics," from *Critical and Miscellaneous Essays,* 3, in *Works,* ed. H. D. Traill (London: Chapman and Hall, 1896–1899), p. 32.

2. Claude Lévi-Strauss compares the operation of mythmaking to the work of the *bricoleur,* that is, the handyman. Like the magpie, the *bricoleur* is restricted to the materials at hand. The *bricoleur* is daring and assertive. The point of Lévi-Strauss's extended analogy is to contrast Western, scientific knowledge with mythmaking. See Claude Lévi-Strauss, *The Savage Mind* (Chicago: University of Chicago Press, 1966), pp. 16–22. Also see discussions of myth in Lévi-Strauss, *Structural Anthropology,* trans. Claire Jacobson and Brooke Grundfest Schoepf (New York: Basic Books, 1963), and in Lévi-Strauss, *The Way of Masks* (Seattle: University of Washington Press, 1982). For other critical interpretations of myth and mythmaking, see Roland Barthes, *Mythologies* (New York: Hill and Wang, 1983); Leszek Kolakowski, *The Presence of Myth,* trans. Adam Czerniawski (Chicago: University of Chicago Press, 1989); and Vladimir Propp and Anatoly Liberman, eds., *Theory and History of Folklore* (Minneapolis: University of Minnesota Press, 1984). The essays edited by Eric Hobsbawm and Terence Ranger in *The Invention of Tradition* (New York: Cambridge University Press, 1983) take up a comparable set of incidents in which histories were invented for the purposes of continuity and social symbolism.

3. The fictive growth of the Charles story did not go unnoticed. Writing in 1925, George Potonniée, a French photographic historian, attempted to unravel the aggrandizement of Charles's photography. Potonniée pointed out that Charles's major biographer did not write a word about the professor's photographic experiments. He concluded that "the writers who have known least of Charles' experiments have talked about him extensively." Further, a host of writers "have concealed the origin of their information and it is not rash to say that their stories are fables" (1925; Eng. trans 1936; rpt., New York: Arno Press, 1973), pp. 54 and 57.

4. Arago's presentation is in Daguerre, *Historique.*

5. [Book Review], *The Edinburgh Review* 76 (January 1843): 161, note.

6. Wey, "Comment le soleil," 259.

7. Mayer and Pierson, p. 12.

8. Figuier, *La photographie,* pp. 3–4 and 26–27. In their seminal text on the French calotype, André Jammes and Eugenia Parry Janis date the first edition of *Les Merveilles de la science* to include Figuier's *La photographie,* of which the Arno reprint is conspicuously a copy, to 1867. See *The Art of French Calotype* (Princeton, NJ: Princeton University Press, 1983), p. 111, n. 45.

   It is important to underscore that Figuier did not include the putative encounter of Daguerre with Professor Charles in his earlier and much shorter history of the discovery of photography. See L. Figuier, *"Histoire et Progrés de la photographie,"* in *Revue des Deux Mondes* 24 (1848): 114–138. The legend grew in the 1850s and 1860s.

   In their book on Daguerre, the Gernsheims relate this tale and also the fable about the fortuitous accident in Daguerre's chemical cupboard said to have inspired his concept of the latent image. The Gernsheims consider these stories to be insubstantial, and they do not pursue the implications of mythmaking contained in them. See Helmut and Alison Gernsheim, *Daguerre,* p. 50.

9. The Gernsheims think that The Stranger might have been Hippolyte Bayard or M. Hubert. See their *Daguerre,* pp. 50–51. Chevalier's own account of the incident is more matter-of-fact than the putative verbatim interviews with him by Wey and Figuier. See Charles Chevalier, *Guide de Photographie* (Paris: Charles Chevalier, 1854), pp. 20–23.

10. For a discussion and inventory of the individuals who came forward to claim title to the invention of photography, see Harmant, "Anno Lucis."

11. Wey, "Comment de soleil," 263–264.

12. Mayer and Pierson, pp. 20–24. Gaston Tissandier, *Les merveilles de la photographie* (Paris: Hachette et Ce., 1874) carries a similar account. But in Tissandier's version, the Pantheon has been replaced by the Invalides, and the year has become 1825.

13. A source for the Turner remark is A. M. W. Stirling, *The Richmond Papers* (London: William Heinemann, 1926), p. 163.

14. See the account by Beaumont Newhall and Robert Doty, "The Value of Photography to the Artist, 1839," in *Image* 11 (1962): 25–28.

15. Mayall's account of Turner is found in a long letter he wrote to Walter Thornbury. See Thornbury's *The Life of J. M. W. Turner, R. A.* (1862, 1877; rpt., London: Ward Lock Reprints, 1970), pp. 349 and 350–352.

16. Newhall and Doty, p. 25.

17. "Fine Arts," unsigned review of the Society of British Artists, *The Athenaeum* (April 17, 1847): 416.

18. "Self-Operating Processes of Fine Art," p. 341.

19. *Journal of the Photographic Society,* no. 51 (February 21, 1857): 217. Attributed to Joseph Durham, ARA, a member of the photographic society.

20. Alophe, *Le passé, le présent, et l'avenir de la photographie* (Paris: E. Dentu et chez auteur, n.d. [1861]), pp. 3 and 39.

21. "Photography," *Blackwood's Edinburgh Magazine* 51 (April 1842): 547.

22. Benjamin, "The Work of Art in the Age of Mechanical Reproduction," p. 226.

23. "Photogenic Drawing, or Drawing by the Agency of Light," *The Edinburgh Review,* 154 (January 1843): 160–161, and 169.

24. These observations are found in a substantial note in Ruskin, *Works,* vol. 3, p. 210.

25. Ruskin, *Works,* vol. 33, p. 304.

26. Ruskin, *Works,* vol. 11, pp. 201–202.

27. Ruskin, *Works,* vol. 11, p. 212.

28. See, for example, Ruskin, *Works,* vol. 33, p. 304.

29. Ruskin, *Works,* vol. 20, p. 165.

30. Ruskin, *Works,* vol. 22, p. 510, n. 8.

31. "Art and Photography," *The New Path* 2 (December 1865): 198. For a history of Ruskin's involvement with *The New Path,* see Linda S. Ferber and William H. Gerdts, *The New Path: Ruskin and the American Pre-Raphaelites* (New York: The Brooklyn Museum/Schocken Books, 1985).

32. Ruskin, *Works,* vol. 18, p. 434.

33. Ruskin, *Works,* vol. 20, pp. 96–97. The importance of vision in Ruskin's aesthetic theory and the extent to which it was inflected by photography is discussed in Lindsay Smith, *Victorian Photography, Painting and Poetry: The Enigma of Visibility in Ruskin, Morris and the Pre-Raphaelites* (New York: Cambridge University Press, 1995).

34. John Henry Newman, *The Idea of a University; Defined and Illustrated* (1852: Oxford: Clarendon Press, 1976), pp. 135–136.

35. Thomas Henry Huxley, *Science and Culture,* in *Thomas Henry Huxley, Collected Essays,* vol. 3 (1893–1894) (Hildesheim: George Olms Verlag, 1970), p. 156.

36. "Photography and Chromo-Lithography: Their Influence on Art and Art Culture," *The Philadelphia Photographer* 5 (April 1868): 116.

37. Robert Hunt, "The Science of the Exhibition," in *The Crystal Palace Exhibition: Illustrated Catalogue* [Special Issue of *The Art-Journal*] (London, 1851; rpt., New York: Dover Publications, 1970), p. xi.

38. Hunt, p. xi.

39. "The Great Industrial Exhibition," *Athenaeum,* no. 1241 (August 9, 1851): 854.

40. "The Great Industrial Exhibition," *Athenaeum,* no. 1227 (May 3, 1851): 477.

41. See, for example, Root, pp. 411–412; Figuier, "*Histoire and progrès de la photographie,*" p. 138; and Holmes, "The Stereo and the Stereograph," p. 739. Also see previous chapter. In his unsigned essay on photography, discussed below, Robert Cecil disagreed with the analogy. See [Robert Cecil], "Photography," *Quarterly Review* 116 (July and October 1864): 482. Cecil, Lord Salisbury, is identified as such in Walter E. Houghton, ed., *The Wellesley Index to Victorian Periodicals,* vol. 1 (London: Routledge & Kegan Paul, 1966). Cecil is discussed in Chapter 3.

42. Root, p. 28.

43. Baudelaire, "The Exposition Universelle, 1855," in *Art in Paris,* pp. 125–126.

44. Baudelaire, "The Exposition Universelle, 1855," pp. 126–127.

45. Baudelaire, "Salon of 1859," in *Art in Paris,* p. 152.

46. Baudelaire, "Salon of 1859," p. 152.

47. Baudelaire, "Salon of 1859," p. 154.

48. Baudelaire, "Salon of 1859," p. 153.

49. Baudelaire makes this association in "The Exposition Universelle, 1855," p. 162.

50. Baudelaire, "Salon of 1859," p. 154.

51. Baudelaire, "Salon of 1859," p. 153.

52. "Tout paraît usé: art, littérature, moeurs, passions: tout se détruire," Chateaubriand, *De la nouvelle proposition relative au bannisement de Charles et de sa famille* (Paris, 1831), p. 42.

53. C.-A. Sainte-Beuve, "De la littérature industrielle," *Portraits Contemporains,* vol. 2 (Paris: Michel Lévy Frère, 1889), p. 434. The comments appeared in September 1839.

54. Sir Francis Palgrave, "The Fine Arts in Florence," *Quarterly Review* 66 (1840): 326.

55. Gustave Flaubert, *Correspondance* (1850–1854) (Paris: Louis Conard, 1910), p. 427.

56. James Abbott McNeill Whistler, *The Gentle Art of Making Enemies* (1892; rpt., Dover Publications, 1967), p. 142.

57. Wey, "Comment le soleil," pp. 299–300. This opinion was widely shared by French amateur photographers at the time. See Eugenia Parry Janis, *The Photography of Gustave Le Gray* (Chicago: Art Institute of Chicago and University of Chicago Press, 1987), p. 27. In British photographic history, the most famous advocate of paper photography was, of course, David Octavius Hill. See his ideas in Chapter 3.

   For Wey's understanding of photography's ability to interpret as opposed to copy, see his "De l'influence de l'héliographie sur les Beaux-Arts," in *Panorama, Diorama, Photographie,* ed. Heinz Buddemeier (Munich: Wilhelm Fink Verlag, 1970), pp. 258–266. Understandably, Wey's statements in favor of photography were more approving in his *La Lumière* articles.

58. Writing in *The Philadelphia Photographer* (1864), H. J. Morton approvingly remarked that the camera's confident objectivity was like the eye of God. See the discussion in Trachtenberg, "Photography: The Emergence of a Keyword."

59. See Jammes and Janis, p. 32, and Figuier, *La photographie,* pp. 178–188.

60. Claudet, "La photographie dans ses relations avec Beaux-Arts," *Gazette des Beaux-Arts,* series 1, 9 (January 15, 1861): 107 and 103.

61. Ph. Burty, "Exposition de la société francaise de photographie," *Gazette des Beaux-Arts,* series 1, 2 (May 15, 1859): 211.

62. Rembrandt Peale, "Portraiture," *The Crayon,* 4, Part II (February 1857): 44.

63. Eugène Delacroix, "Le dessin sans maître, par Mme. Elisabeth Cavé," *Revue des Deux Mondes* 3 (September 15, 1850): 1144–1145.

64. Gustave Le Gray, *Photographie: traité nouveau théorique et pratique des procédés et manipulations sur papier . . . et sur verre* (Paris: Lerebours et Secretan, [1852]), p. 1. Also see p. 3.

65. Robert Hunt, *A Popular Treatise on the Art of Photography* (Glasgow: R. Griffin and Co., 1841), p. 92. Wey, "De l'influence de l'héliographie sur les Beaux Arts," *La Lumière* (1851), reprinted in Buddemeier, p. 262.

66. R.[obert] H.[unt], "Photographic Exhibitions," *The Art-Journal,* n.s. 2 (1856): 49.

67. Robert Hunt, "Photography: Considered in Relation to Its Educational and Practical Value," *The Art-Journal,* n.s. 4 (1858): 261.

68. John Leighton, "On Photography" [Abstract], *Journal of the Photographic Society* 1 (June 21, 1853): 74.

69. W. D. Clark, "On Photography as a Fine Art," *The Photographic Journal* 10 (May 15, 1863): 286.

70. Henri Delaborde, "L'art français au Salon de 1856," *Revue des Deux Mondes* 21 (June 1, 1859): 530.

71. Enne. Jn. Delécluze, "Exposition de 1850," *Journal des Débats* (March 21, 1851), n.p. Francis Wey responded to him in "Du naturalisme dans l'art de son principe et de ses conséquences," which was published in *La Lumière* (1851), and reprinted in Buddemeier, pp. 267–273.

72. For Reynolds's influence on art photography and the daguerreotype see John Wood's "Silence and Slow Time: An Introduction to the Daguerreotype," in *The Daguerreotype: A Sesquicentennial Celebration,* ed. John Wood (Iowa City: University of Iowa Press, 1989), p. 12, and John Wood, "The Secret Revealed: Literature of the Daguerreotype," in *Secrets of the Dark Chamber: The Art of the American Daguerreotype,* ed. Merry A. Foresta and John Wood (Washington, DC: National Museum of American Art/ Smithsonian Institution Press, 1995).

73. Ronald Campbell, "Photography for Portraits: A Dialogue held in an Artist's Studio," *The Art-Journal,* n.s. 4 (1858): 273.

74. Campbell, p. 274.

75. Eastlake, p. 460.

76. Eastlake creatively misquotes William Newton's address to the Photographic Society of London, printed in the *Journal of the Photographic Society* 1 (March 3, 1853): 6–7. Newton wrote that "in the illustrations which are set forth to the world to be placed in similar positions as pictures and engravings, their appearance ought not to be so *chemically* as *artistically* beautiful." Like Eastlake, he saw a place for highly detailed documentary photographs.

77. Eastlake, p. 465.

78. Eastlake, p. 467.

79. Eastlake, p. 468.

80. Eastlake, p. 460.

81. "Photographic Society," *The Athenaeum* (January 5, 1859): 86.

82. See, for example, Léon Rosenthal, *Du romantisme au réalisme: essai sur l'évolution de la peinture en France de 1830 à 1848* (Paris: Librarie Renouard, 1914), p. 42, or César Graña, *Modernity and Its Discontents: French Society and the French Man of Letters in the Nineteenth Century* (New York: Harper Torchbooks, 1967), p. 11. On the matter of mass society and cultural decadence, see Patrick Brantlinger, *Bread and Circuses: Theories of Mass Culture as Social Decay* (Ithaca, NY: Cornell University Press, 1983). Many contemporary critics have not drawn attention to photography's prominence in this nineteenth-century debate. An exception is Christian A. Peterson's article, "American Arts and Crafts: The Photograph Beautiful, 1895–1915," *History of Photography* 16 (Autumn 1992): 189–232.

83. For Gautier's aestheticism, see his review of the Salon of 1837, and the preface to his novel, *Mademoiselle de Maupin* (1835).

84. "Photographic Exhibition," *The Art-Journal,* n.s. 2 (1857): 40.

85. For a detailed account of scientific illustration and its effect on art, see Barbara Maria Stafford, *Voyage into Substance: Art, Nature, and the Illustrated Travel Account, 1760–1840* (Cambridge, MA: MIT Press, 1984).

86. Francis Frith, "The Art of Photography," *The Art-Journal* 5 (1859): 72.

87. J. David Bolter discusses this phenomenon throughout *Turing's Man: Western Culture in the Computer Age.*

88. M. de Saint-Santin, "De quelques arts qui s'en vont," *Gazette des Beaux-Arts,* series 1, 19 (October 1, 1865): 304.

89. Saint-Santin, p. 316.

90. Saint-Santin, p. 304.

91. Phillipe Burty, "La photographie en 1861," *Gazette des Beaux-Arts,* series 1, 11 (September 1, 1861): 243, and "La gravure et la photographie en 1867," *Gazette des Beaux-Arts,* series 1, 23 (September 1, 1867): 271.

92. Philippe Burty, "La gravure au Salon de 1864," *Gazette des Beaux-Arts* 16 (June 1, 1864): 554–565, and Saint-Santin, p. 304.

93. Wey, "Comment le soleil," p. 299.

94. "Photographic Society," *The Athenaeum* (February 20, 1858): 246.

95. "Photographic Society," *The Athenaeum* (January 15, 1859): 186.

96. "The Photographic Society," *The Athenaeum* (January 10, 1857): 54.

97. S. F. B. Morse to Washington Allston, undated (probably fall 1839) in Edward Lind Morse, pp. 143–144.

98. Edward Waldo Emerson and Waldo Emerson Forbes, pp. 110–111.

99. [William] Lake Price, *A Manual of Photographic Manipulation,* 2nd ed. (1868; rpt., New York: Arno Press, 1973), p. 1.

100. Charles Blanc, "L'oeuvre de Marc-Antoine: réproduction par la photographie," *Gazette des Beaux-Arts,* series 1, 15 (September 1, 1863): 275. Richard Shiff discusses the implicit debt that Charles Blanc and

Henri Delaborde owed to Quatremère de Quincy for their ontological understanding of photography. See Richard Shiff, "Phototropism (Figuring the Proper)," *Studies in the History of Art* 20 (1989): 167.

101. Blanc, p. 269.
102. Henri Delaborde, *Mélange sur l'art contemporain* (Paris: Jules Renouard, 1866), pp. 375–377.
103. Delaborde, *Mélange,* p. 384. Figuier wrote that photography "is inexorable and nearly brutal in its truthfulness." See his *La photographie,* p. 179.
104. Eastlake, p. 465.
105. In *Secure the Shadow: Death and Photography in America* (Cambridge, MA: MIT Press, 1995), p. 66, Jay Ruby contends that postmortem photographic practice did not wither in the 1880s, but continued in the form of memorial photography and other techniques.
106. See Elizabeth Ann McCauley, *Likenesses: Portrait Photography in Europe, 1850–1870* (Albuquerque: Art Museum/University of New Mexico, 1981), for a discussion of the term "likeness."
107. Castle, p. 137.
108. Oliver Wendell Holmes, "The Stereoscope and the Stereograph," *The Atlantic Monthly* 3 (June 1859): 739.
109. Oliver Wendell Holmes, "Sun-Painting and Sun-Sculpture," *The Atlantic Monthly* 8 (July 1861): 14.
110. Holmes, "Sun-Painting," p. 14.
111. Holmes, "Sun-Painting," p. 14.
112. Holmes, "Doings," p. 15. See also Edward Hitchcock, *The Religion of Geology and Its Connected Sciences* (Boston: Phillips, Sampson, and Co., 1859), p. 426, where Hitchcock suggests that photography "can bring out and fix those portraits, so that acuter senses than ours shall see them, as on a great canvas, spread over the material universe."
113. Holmes, "Stereoscope," p. 748.
114. Holmes, "Stereoscope," p. 748.
115. Holmes, "Stereoscope," p. 747.
116. This aspect of modernity is discussed in Chapter 4.
117. For a discussion of the stereotyping process, see Mary Cowling, *The Artist as Anthropologist: The Representation of Type and Character in Victorian Art* (New York: Cambridge University Press, 1989).
118. Barthes, p. 93. In his 1927 essay "Photography," the film historian Siegfried Kracauer also noted a resemblance between history and photography: "*Historicist* thinking . . . emerged at about the same time as modern photographic technology." The theme of the essay is the contrast between human memory and photographic imagery, which, Kracauer argued, launches a fragmentation of memory and diminution of nature familiar in postmodern theory. See Siegfried Kracauer, "Photography," in his *The Mass Ornament: Weimar Essays,* ed. and trans. Thomas Y. Levin (Cambridge, MA: Harvard University Press, 1995), p. 49.
119. Barthes, pp. 93–94.

### 3: ART, PHOTOGRAPHY, AND SOCIETY

1. *Journal of the Photographic Society,* no. 51 (February 21, 1857): 217. Attributed to Joseph Durham, ARA, a member of the Photographic Society.
2. Mayer and Pierson, p. 196.
3. Mayer and Pierson, p. 213.
4. Philip H. Delamotte, *The Practice of Photography: A Manual for Students and Amateurs* (1855; rpt., Arno Press, 1973), p. 2.

5. A. A. E. Disdéri, *L'Art de la photographie* (Paris: L'auteur: 1862), p. 249.

6. Eastlake, p. 465.

7. Phillip Hamberton, "The Relation between Photography and Painting," *Thoughts About Art* (Boston: Roberts Brothers, 1871), p. 143.

8. See, for example, David Shi, *Facing Facts: Realism in American Thought and Culture, 1850–1920* (New York: Oxford University Press, 1995).

9. C. Jabez Hughes, "On Art Photography," *American Journal of Photography* 3 (1861): 261.

10. Hughes, pp. 261–262.

11. Hughes, p. 262.

12. For a history of amateur photography, see Grace Seiberling, *Amateurs, Photography, and the Mid-Victorian Imagination* (Chicago: University of Chicago Press, 1986).

13. See Aaron Scharf, *Art and Photography* (London: Penguin Books, 1968), p. 109.

14. *Atheneaum,* no. 1539 (April 25, 1857): 538–539.

15. "Exhibition at Photographic Society," *The Art-Journal,* n.s. 4 (1858): 121.

16. R[obert] H[unt], "Photographic Exhibitions," *The Art-Journal,* n.s. 2 (1856): 49.

17. H[unt], "Photographic Exhibitions," pp. 49–50.

18. The argument continues in twentieth-century thought. For example, Rudolf Arnheim articulated limits to photography and then suggested that they be put in positive terms. See "On the Nature of Photography," *Critical Inquiry* 1 (September 1974): 149–161.

19. Baudelaire, "Salon of 1859," p. 153.

20. This debate is discussed more fully in Chapter 4.

21. Elizabeth Ann McCauley has written that "the quality of criticism as a whole is rather low" in the period from 1850 to 1870. See her *Likenesses: Portrait Photography in Europe, 1850–1870* (Albuquerque: The Art Museum, 1980), p. 13.

22. See W. L. Burn, *The Age of Equipoise* (New York: W. W. Norton & Co., 1964), p. 25. Also see Hobsbawm and Ranger, *The Invention of Tradition.*

23. See Dawn Ades, *Photomontage* (London: Thames and Hudson, 1986), esp. pp. 7–17. Shunning the insistent moral emphasis of High Art Photography, subsequent art movements adapted the technique of collage. Eventually, critics related combination printing to constructivism, dada, and surrealism.

24. Henri de La (*sic*) Blanchère, *L'Art du photographe* (Paris: Amyot Editeur, 1859), p. 3.

25. Newton, p. 6.

26. See, for example, de La Blanchère, p. 9.

27. The phrase "theory of sacrifice" was used by Francis Wey in his essay on the relationship of photography to the fine arts. See Buddemeier, p. 60. De La Blanchère also wrote about it. See his *L'Art du photographe,* p. 9, for example. The idea is discussed in Jammes and Janis, *The Art of the French Calotype,* pp. 96–101. Also see the manuscript fragment of Charles Négre that they reproduce in their appendix, p. 262.

28. H. J. Morton, "The Sister Arts," *The Philadelphia Photographer* 3 (March 1866): 72.

29. W. D. Clark, "On Photography as a Fine Art," *The Photographic Journal* (May 15, 1863): 286–287.

30. Newton, p. 6.

31. See his statements as recorded in the *Journal of the Photographic Society* 1 (1853): 6–7.

32. R. W. Buss, "On the Use of Photography to Artists," *Journal of the Photographic Society* 1 (June 21, 1854): 75–76. Charles Vignoles, an engineer and amateur photographer, also noted the resemblance between Newton's

ideas and those advanced by Reynolds. Newton subsequently expanded his remarks, noting a debt to Reynolds. George Shadbolt, another amateur, also joined the discussion, disagreeing with Newton's notion that photography was limited because it could not replicate natural light. See pp. 76–78, immediately following the Buss article.

33. Newton, p. 6.

34. Newton, p. 6.

35. Ernest Lacan, "A Physiological Sketch of the Artist-Photographer, "*La Lumiére* (January 15, 1853): 11. Translated and reproduced in Janis and Jammes, "Appendix," p. 263.

36. Gustave Le Gray, *Photographie: traité nouveau: théorique et pratique des procédés et manipulations sur papier . . . et sur verre* (Paris: Lerebours et Secretan, 1852), p. 2. My translation. The accentuation of the taste and education of the photographer was also expressed as a desired professional standard against which charlatans and cut-rate daguerreotypists could be measured. See *The Photographic Art-Journal* (August 1851): 99–101. It is interesting to note that the poet and essayist Alphonse Marie Louis de Lamartine's change of opinion about photography occurred when he realized that "la photographie, c'est le photographe." In other words, the photograph is the product of the photographer's sensitivities, not of the mechanical instrument employed. M. A. de Lamartine, "La littérature des sens: La peinture, Léopold Robert," *Cours Familier de Littérature* (Paris: Chez l'auteur, 1859), vol. 7, chap. 37, sect. 25, p. 43, n. 1.

37. Le Gray, p. 1.

38. "Art and Photography," *The New Path* 2 (December 1865): 198.

39. Clark, p. 286.

40. "Self-operating Processes of Fine Art. The Daguerotype (*sic*)," p. 341.

41. Morton, p. 72.

42. Clark, p. 287.

43. See Seiberling, "The Viewer and the Viewed: Imagery of the Amateurs," in her *Amateur Photography and the Mid-Victorian Imagination.*

44. This idea is discussed at length in David E. Nye's *American Technological Sublime* (Cambridge, MA: MIT Press, 1994).

45. John Harden, letter to his married daughter, Mrs. James Baker, dated November 23, 1843, quoted in Colin Ford and Roy Strong, eds., *An Early Victorian Album: The Photographic Masterpieces (1843–1847) of David Octavius Hill and Robert Adamson* (New York: Alfred A. Knopf, 1976), p. 321.

46. Roy Strong, "D. O. Hill and the Academic Tradition," in Ford and Strong, p. 50.

47. Letter from Hill to Mr. Bicknell, dated January 17, 1848, quoted in Strong and Ford, p. 50.

48. Eastlake, p. 459.

49. In 1857, a decade after the partnership of Hill and Adamson was dissolved by Adamson's death, *The Edinburgh News* for December 27 acclaimed their work as preferable to the "stereoscopic sugar dolls or the agonising attitudes of recent and more 'perfect' photographs." Quoted in Sara Stevenson, "David Octavius Hill and Robert Adamson," in Mike Weaver, *British Photography in the Nineteenth Century: The Fine Arts Tradition* (New York: Cambridge University Press, 1989), p. 41, n. 16.

50. Minor White, *French Primitive Photography* (New York: Aperture, 1970), unpaginated.

51. Julia Margaret Cameron, "The Annals of My Glass House" (1874), reproduced in Beaumont Newhall, *Photography: Essays and Images* (New York: Museum of Modern Art, 1980), p. 136.

52. Julia Margaret Cameron's letter to Sir John Herschel is reproduced in Helmut Gernsheim, *Julia Margaret Cameron: Her Life and Photographic Work* (Millerton, NY: Aperture, 1975), p. 14.

53. See Mike Weaver, *Julia Margaret Cameron: 1815–1879* (Boston: Little, Brown and Co., 1984), and his "Julia Margaret Cameron: The Stamp of Divinity," in *British Photography*, pp. 151–161.

54. Henry Peach Robinson, *Pictorial Effect in Photography* (1869; rpt., Pawlet, VT: Helios Press 1971), p. 145.

55. [Unsigned review], *The Art-Journal*, n.s., 3 (1864): 27.

56. [Unsigned review], *The Art-Journal*, n.s., 7 (1868): 58.

57. [Unsigned review], *The Art-Journal*, n.s., 7 (1868): 15.

58. [Unsigned review], "Mrs. Cameron's Photographs," *Macmillan's Magazine* 8 (November 1865–April 1866): 230–231.

59. Cameron's photographic education is described by April Watson in "A History from the Heart," in *For my best beloved Sister Mia: An Album of Photographs by Julia Margaret Cameron*, ed. Therese Mulligan, Eugenia Parry Janis, Joanne Lukitsh, and April Watson (Albuquerque: University of New Mexico Press, 1995), pp. 14–25.

60. Quoted in Helmut Gernsheim, *Julia Margaret Cameron*, n.p, 61.

61. See Weaver, "Julia Margaret Cameron: The Stamp of Divinity," pp. 154–155, and his *Overstone Album and Other Photographs by Julia Margaret Cameron* (Malibu, CA: The J. Paul Getty Museum, 1986), pp. 18–19.

62. Michael Bartram, *The Pre-Raphaelite Camera: Aspects of Victorian Photography* (New York: Little, Brown and Co., 1985), p. 124.

63. Mike Weaver correspondence with the author, dated July 21, 1992.

64. Root, p. xvi.

65. Root, p. 40.

66. Discussed briefly in Chapter 1. The relationship between photography and literature throughout the nineteenth and twentieth centuries has not been systematically explored. Carol Shloss has looked at photographs in relation to fiction in her *In Visible Light: Photography and the American Writer, 1840–1940* (New York: Oxford University Press, 1987). Jefferson Hunter explored the relationship of twentieth-century photographs and texts in *Image and Word* (Cambridge, MA: Harvard University Press, 1987). Also see Trachtenberg, "Photography: The Emergence of a Keyword," for some nineteenth-century examples of popular fiction that use the photograph and the photographer. Jean Rabb has produced a critical anthology of major works titled *Literature and Photography: Interactions, 1840–1990* (Albuquerque: University of New Mexico Press, 1995).

67. Henry Peach Robinson, *Pictorial Effect in Photography*, Preface, unpaginated.

68. Robinson, *Pictorial Effect*, p. 187.

69. Henry Peach Robinson, *Picture-Making by Photography* (1884; rpt., New York: Arno Press, 1973), p. iii.

70. Robinson, *Picture-Making*, p. iv.

71. See, for example, the paper given by Frank Howard to the Liverpool Photographic Society in 1853, in which Howard compares the camera's capabilities to those of an astute artist, like Sir Thomas Lawrence. The conciliatory tone is evident in the proposition "if photography cannot hope to compete with human skill in the representation of the operations of human intellect, there are many occasions on which it may very materially assist the fine arts." See [Frank Howard], "Photography Applied to Fine Art," *Journal of the Photographic Society*, no. 3 (January 21, 1854): 155.

72. Robinson, *Picture-Making*, p. 116. Robinson's interpretation of photography's limits persisted for many years. It probably underlies the painter John Brett's assessment of photography, "The Relation of Photography to the Pictorial Art," *The Journal of the Camera Club*, vol. 3, no. 31, Conference Number (April 1889): 89, and may inform the conven-

tional ideas voiced by the Rev. T. Perkins, M.A., in "Limitations in Art, Especially Photography," *The Journal of the Camera Club* 3 (September 1889): 166–168, and 3 (October 1889): 171–172. A response by the Pictorialist photographer George Davison immediately follows the October article.

73. Robinson, *Picture-Making*, p. 117.

74. Robinson, *Picture-Making*, p. 116.

75. Robinson, *The Elements of a Pictorial Photograph* (1896; rpt., New York: Arno Press, 1973), p. 17.

76. Robinson, *Pictorial Effect*, p. 109.

77. Miles Orvell, *The Real Thing: Imitation and Authenticity in American Culture, 1880–1940* (Chapel Hill: University of North Carolina Press, 1989), p. 86.

78. Delaroche's *The Princes in the Tower* and *The Death of Elizabeth I* are now in the Louvre in Paris.

79. Clark, p. 288.

80. Robinson, *Elements,* p. 20.

81. For a discussion of the response of photographers to Pre-Raphaelite painting, see Bartram, pp. 26–27. Lindsay Smith has suggested that the resemblance of Pre-Raphaelite painting to photography was not so much a matter of copying the look of photographs, but denotes the conceptual crises brought on by the medium. See "'The seed of the Flower': Photography and Pre-Raphaelitism," in Smith, *Victorian Photography, Painting and Poetry,* pp. 93–112.

82. See Leslie Parris, ed., *Pre-Raphaelite Papers* (London: The Tate Gallery, 1984), pp. 19–20.

83. Not all Pre-Raphaelite painting was highly detailed and illusionistic. Dante Gabriel Rossetti's work was neither. In his study of the presumed influence of photography on impressionist painting, Kirk Varnedoe insisted that "the stiff delineation and airless stage-set spaces of Leys and the Pre-Raphaelites . . . can all be shown, whatever their seeming consonance with photography, to owe directly to sources in older art." See "The Artifice of Candor: Impressionism and Photography Reconsidered," *Art in America* 68 (January 1980): 70.

84. Cecil, p. 496.

85. Cecil, p. 483.

86. Cecil, p. 503.

87. Cecil, p. 504.

88. Cecil, p. 506.

89. Cecil, p. 507.

90. Cecil, p. 507.

91. Cecil, p. 507.

92. Cecil, pp. 506–507.

93. Cecil, p. 505.

94. Cecil, p. 507.

95. Cecil, p. 505. The formal uniqueness of photography became a major component of twentieth-century photographic modernism.

96. Cecil, p. 510.

97. For a discussion of the impact of these technologies, see Leo Marx, *The Machine in the Garden: Technology and the Pastoral Ideal in America* (New York: Oxford University Press, 1964) and more recently, Julie Wosk, *Breaking Frame: Technology and the Visual Arts in the Nineteenth Century* (New Brunswick, NJ: Rutgers University Press, 1992). Ralph Waldo Emerson did call the daguerreotype a "great engine," but not in the sense of its being an engine of destruction. See Trachtenberg, "Photography: The Emergence of a Keyword," pp. 20–21.

1. Jean Jacques Rousseau, *The Social Contract and Discourses,* trans. G. D. H. Cole (London: J. M. Dent & Sons, 1947), Bk I, Chap. VI, p. 14. The "swelling stream of pedagogy, adult education, and the recuperation of childhood" that was "created during the Enlightenment" is discussed in Barbara Maria Stafford's *Artful Science: Enlightenment Entertainment and the Eclipse of Visual Education* (Cambridge: MA: MIT Press, 1994), p. 20. Stafford makes it clear that the Enlightenment mix of education and entertainment was oriented toward the middle- and upper-middle classes. It was deemed progressive, but seems to have lacked the overt interest in social control that characterized nineteenth-century literacy movements, which were oriented toward the working and lower classes.

2. The phrase "museum without walls" is that of André Malraux, from the book of the same title, trans. Stuart Gilbert and Francis Price (Garden City, NY: Doubleday, 1967), but the concept, and even the suggestion of the phrasing, occur in the nineteenth century. For example, Philippe Burty, a critic who had mixed feelings about the impact of photography on art, described a photographic album of coins and gems as "the most curious and least expensive museum the author has visited." See his "Collections des Medailles Artistiques et de Pierres," *Gazette des Beaux Arts* 4 (December 15, 1859): 364.

3. *The People's Journal* 2 (December 5, 1846): 311. Quoted in Frances Borzello, *Civilising Caliban: The Misuses of Art, 1875–1980* (London: Routledge and Kegan Paul, 1987), pp. 40–41.

4. See Elizabeth Anne McCauley's discussion of "Art Reproductions for the Masses," in her *Industrial Madness: Commercial Photography in Paris, 1848–1871* (New Haven, CT: Yale University Press, 1994). For English efforts, see Anthony Hamber, "The Photography of the Visual Arts," Part I in *Visual Resources* 5 (1989): 289–310; Part II in *Visual Resources* 6 (1989): 19–41; Part III in *Visual Resources* 6 (1989): 165–179; Part IV in *Visual Resources* 6 (1989): 219–241.

5. Alfred H. Wall, "Photographic Reproductions," *The Photographic Times* 1 (May 1, 1862): 114.

6. Frances Borzello, cited in note 3 above, has written about the campaign for visual literacy using this nineteenth-century phrase. See her discussion of the Barnetts' philanthropic gallery called Toynbee Hall. Also see her "Pictures for the People," in *Victorian Artists and the City,* ed. Ira Bruce Nadel and F. S. Schwarzbach (New York: Pergamon Press, 1980), pp. 30–40. "Literature for the millions" was also a common slogan in the last half of the nineteenth century.

   For a general history of art reproduction, see Susan Lambert, *The Image Multiplied* (London: Trefoil Publications, 1987). Giles Waterfield has carefully studied the late-nineteenth-century emergence of the South London Gallery, an art exhibition hall specifically placed in a working-class neighborhood with the intention of exposing the locals to the pleasures and educational benefits of art. See *Art for the People,* ed. Giles Waterfield (London: Dulwich Picture Gallery, 1994), especially Waterfield's essay, "Art for the People," pp. 31–63.

7. Odilon Redon, *A Soi-Même* (Paris: H. Floury, 1922), p. 54. Translation mine.

8. Oliver Wendell Holmes, "The Stereoscope and the Stereograph," p. 744.

9. "The Photographic Society," *The Athenaeum* (January 20, 1855): 86.

10. *Barnes v. Ingals* 39 Alabama 193 (1863), pp. 78–79. Quoted in Richard Rudisill, *Mirror Image: The Influence of the Daguerreotype on American Society* (Albuquerque: University of New Mexico Press, 1971), p. 213.

11. Even Ivins, who scorned the high-culture bias evident in studies of the

graphic arts, did not pursue the popular uses of photography or the calls for visual literacy achieved through mass media that occurred in the nineteenth century.

12. See the forecasts for various twentieth-century technologies collected in Joseph J. Corn, ed., *Imagining Tomorrow: History, Technology, and the American Future* (Cambridge, MA: MIT Press, 1986).

13. See Carl F. Kaestle, "'Between the Scylla of Brutal Ignorance and the Charybdis of a Literary Education': Elite Attitudes toward Mass Schooling in Early Industrial England and America," in *Schooling and Society: Studies in the History of Education,* ed. Lawrence W. Stone (Baltimore: Johns Hopkins University Press, 1976), and Richard Johnson, "Educational Policy and Social Control in Early Victorian England," *Past and Present,* no. 49 (November 1970): 96–119.

14. Paraphrasing Lawrence W. Stone in his "Literacy and Education in England," *Past and Present,* no. 42 (1969): 86.

15. Stone, "Literacy and Education," p. 91.

16. Stone, "Literacy and Education," pp. 85–86. Of course, control of the working class is a major theme throughout E. P. Thompson's *The Making of the English Working Class* (New York: Vintage Books, 1963).

17. Quoted in David Vincent, *Literacy and Popular Culture: England, 1750–1914* (Cambridge: Cambridge University Press, 1989), p. 83. See also Johnson, "Educational Policy and Social Control," p. 97. For a fuller explanation of educational experts' responses to Chartism, see Richard Johnson, "Educating the Educators: 'Experts' and the State 1833–39," in *Social Control in Nineteenth-Century Britain,* ed. A. P. Donajgrodzki (London: Croom Helm, 1977), p. 91.

18. Quoted in Johnson, "Educational Policy and Social Control," p. 97.

19. Stone, "Literacy and Education," p. 89.

20. Quoted in Stone, "Literacy and Education," p. 90.

21. See Steven Shapin and Barry Barnes, "Science, Nature and Control: Interpreting Mechanics' Institutes," in *Schooling and Capitalism: A Sociological Reader,* ed. Roger Dale, Geoff Esland, and Madeleine MacDonald (London: Routledge and Kegan Paul, 1976), pp. 55–65. Also see R. K. Webb, *The English Working Class Reader, 1790–1848* (London: George Allen and Unwin, 1955), pp. 60–82. Despite the rhetoric, the results achieved were spotty. The working classes did not want their craft skills and secrets disclosed and communicated in print. See Vincent, pp. 110–119.

An early effort in art education took place in 1858 at the Mechanics Institution in Manchester, England, where Francis Frith's slides of ancient Egyptian architecture and sculpture were shown. See Howard B. Leighton, "The Lantern Slide and Art History," *History of Photography* 8 (April–June 1984): 107–117.

22. Quoted in Harold L. Silver, "Ideology and the Factory Child: Attitudes to Half-time Education," in *Popular Education and Socialization in the Nineteenth Century,* ed. Phillip McCann (London: Methuen and Co., 1977), p. 145.

23. Quoted in François Furet and Jacques Ozouf, *Reading and Writing: Literacy in France from Calvin to Jules Ferry* (Cambridge: Cambridge University Press, 1982), p. 121.

24. Richard Johnson gives an account of the transformation and the lack of any clear explanations in his "Notes on the Schooling of the English Working Class, 1780–1850," in *Schooling and Capitalism: A Sociological Reader,* ed. Roger Dale, Geoff Esland, and Madeleine MacDonald (London: Routledge and Kegan Paul, 1976).

25. See Johnson, "Notes," pp. 49–50, and Johnson, "Educating the Educators," p. 89.

26. Furet and Ozouf suggest that some of the reasons may be increased be-

lief in the notion of individual progress, shame among the new urban poor that they were unable to read, and imitation of the accomplishments of the upper classes. See pp. 125–130. R. K. Webb, in his classic, *The British Working Class Reader, 1790–1848* (London: George Allen and Unwin, 1955), argued for a more resilient working class, at least within the time frame of his study. Also see Furet and Ozouf, pp. 125 ff. and 149 ff.

27. See the discussion in Chapter 1.

28. See the discussion in Chapter 1.

29. See the essay by Valerie Lloyd in the catalogue *Roger Fenton: Photographer of the 1850s* (London: South Bank Board, 1988), pp. 10–13. Also, Christopher Date and Anthony Hamber suggest that Fenton unofficially began working in the British Museum in 1852. See their "The Origins of Photography at the British Museum, 1839–1860," *History of Photography* 14 (October–December 1990): 309–325. Seiberling discusses art reproduction, pp. 83–89.

30. See Seiberling, p. 80.

31. See Patricia Anderson, *The Printed Image and the Transformation of Popular Culture, 1760–1860* (Oxford: Clarendon Press, 1991), pp. 58–71.

32. In France, enthusiasm for educational imagery dates from the Revolution, when civic education was stressed. Jean Adhémar focuses on the French use of images in childhood education in his "L'Enseignement par L'Image," *Gazette des Beaux-Arts* 98 (September 1981): 49–57.

33. Root, p. 28. Also see pp. 413–415. The connection of Root's thought to the concept of progress is discussed in Chapter 2.

34. Root, p. 28.

35. Prior to 1860 there were several calls to use photography in an art education effort. But the attitude is more frequently encountered in the 1860s.

36. W. L. R. Cates, "The Berlin Photographs of Great Pictures," *Fine Arts Quarterly Review,* n.s. 1 (1866): 216.

37. "Stereoscopes for Amateurs – Process of Producing Stereoscopic Photographs," *Scientific American* 2 (June 2, 1860): 361.

38. "Stereoscope: or, Travel Made Easy," *The Athenaeum,* no. 1586 (March 20, 1858): 371.

39. "Fine Arts. New Publications" [review of *Gems of the Art-Treasures Exhibition*] *The Athenaeum,* no. 1549 (July 4, 1857): 856.

40. Holmes, "The Stereoscope and the Stereograph," p. 748. In his essay "Wealth," published in *The Conduct of Life* (1860), Ralph Waldo Emerson conjoined the study of nature to the study of art. Though he did not mention the potential role of photography, he did suggest that "how to give all access to the masterpieces of art and nature is the problem of civilization." He continued: "The socialism of our day has done good service in setting men on thinking how certain civilizing benefits, now only enjoyed by the opulent, can be enjoyed by all." See "Wealth," in *The Conduct of Life,* in *Ralph Waldo Emerson: Essays and Lectures,* p. 995.

41. Parton, p. 354. For a brief history of nineteenth-century educational plaster-cast efforts, see Betsy Fahlman, "A Plaster of Paris Antiquity: Nineteenth-Century Cast Collections," *Southeastern College Art Conference Review* 12 (1991): 1–9. The history of art reproduction by engraving and photography in the period is the subject of Trevor Fawcett's "Graphic Versus Photographic in the Nineteenth-Century Reproduction," *Art History* 9 (June 1986): 185–218. Realizing that the complaints against chromolithography were similar to those made against photography, the anonymous writer of "Photography and Chromo-lithography: Their Influence on Art and Art Culture," which appeared in *The Philadelphia Photographer* 5 (April 1868): 115–117, defended the educational value of both media. It is interesting to note that Bernard Berenson applauded reproductions of art via

photography as an unprecedented basis for connoisseurship. Unlike those interested in mass public education, Berenson promoted photography as an essential aid to the study of art attributions. See "From 'Isochromatic Photography and Venetian Pictures,'" in *The Bernard Berenson Treasury,* ed. Hanna Kiel (New York: Simon and Schuster, 1962), pp. 69–70. The article originally appeared in *The Nation,* 57 (November 9, 1893): 346–347.

42. Hunt, "Photography Considered in Relation to Its Educational and Practical Value," p. 262.

43. See Naomi Rosenblum, "Adolphe Braun: A 19th Century Career in Photography," *History of Photography* 3 (October 1979): 357–372, and Naomi Rosenblum, "Adolphe Braun: Art in the Age of Mechanical Reproduction," in *Shadow and Substance: Essays on the History of Photography,* ed. Kathleen Collins (Bloomfield Hills, MI: Amorphous Institute Press, 1990), pp. 191–196. Also see William C. Darrah, *Cartes de Visite in Nineteenth Century Photography* (Gettysburg, PA: W. C. Darrah, 1981), p. 109.

44. J. C. Robinson, "Preface," *Catalogue général des photographies inaltérables au charbon et héliogravure* (Paris: Braun et compagnie, 1887), p. xxxii.

45. Darrah, p. 109. Because it usually did not involve the reproduction of color, the reproduction of sculpture was easier than for painting. For early examples, see *The Kiss of Apollo: Photography and Sculpture, 1845 to the Present,* ed. Jeffrey Fraenkel (San Francisco: Fraenkel Gallery, n.d.).

46. Bierstadt Brothers, *Catalogue of Photographs* (New Bedford, MA, 1860), and [John H.] Bufford & Sons, *Photograph List: Embracing American and Foreign Photographs of Every Description . . .* (Boston: Bufford, 1864).

47. Generally speaking, Americans tended to vest nature with morally instructive qualities. See Thomas Bender, *Toward an Urban Vision: Ideas and Institutions in Nineteenth-Century America* (Lexington: University Press of Kentucky, 1975).

48. "Stereoscopes for Amateurs," p. 361.

49. For art education in the United States, see Roger B. Stein, *John Ruskin and Aesthetic Thought in America, 1840–1900* (Cambridge, MA: Harvard University Press, 1967). Large photographic establishments, most notably the English company founded by Francis Frith, catered to the Victorian taste for educational views of nature and world architecture. See Elizabeth Lindquist-Cock, "Francis Frith: The Enterprising Cameraman," in *Shadow and Substance,* pp. 165–173.

50. Root, p. 415.

51. "Photography and Chromo-Lithography," p. 116.

52. Perhaps the ultimate expression of this attitude is found in H. D. Gower, L. Stanley Jast, and W. W. Topley, *The Camera as Historian* (London: Sampson Low, Marston and Co., 1916), in which the thesis of photography's absolute fidelity underlies the justification for recordkeeping in art, history, science, and politics. The book attempts to expand the scheme of Sir Benjamin Stone, whose National Photographic Record, begun in 1897, proposed recording all the views and architecture of Britain and storing the images in the British Museum. Gower, Jast, and Topley created an elaborate scheme based on the Dewey Decimal System, with which to classify visual imagery.

53. "The Byways of Literature: Reading for the Millions," *Blackwood's Magazine* 86 (August 1858): 202, encapsulates and critiques many of the ideas that propelled the "literature for the millions" campaigns. It addresses "the masses" as primitives or children, with reprehensible "natural" tastes in art, who need instruction and cultivating by their betters. *The Wellesley Index* 1 attributes the article to Margaret Oliphant, the British essayist and novelist. The idea of photography as a lesser art is discussed in Chapters 2 and 3.

54. See, for example, Boime, pp. 243–245. Peter Henry Emerson confronted this opinion directly. See Chapter 5.

55. Palgrave, p. 324.

56. Wilkie Collins, "The Unknown Public," reproduced in *My Miscellanies,* in *The Works of Wilkie Collins,* vol. 20 (New York: Peter Fenelon Collier, n.d.).

57. The broadsheet is reproduced in Gernsheim, *Daguerre,* pp. 79–81. The original French, and a literal translation by Beaumont Newhall are available in *Image* 8 (March 1959): 32–36.

58. Quoted in Johnson, "Notes," p. 47.

59. Allan Sekula, "The Body and the Archive" (revised version), in *The Contest of Meaning: Critical Histories of Photography,* ed. Richard Bolton (Cambridge, MA: MIT Press, 1989), p. 343.

60. In addition to Sekula's work on police photography, see John Tagg, *The Burden of Representation: Essays on Photographies and Histories* (Amherst: University of Massachusetts Press, 1988). Various essays in Elizabeth Edwards, ed., *Anthropology and Photography, 1860–1920* (New Haven, CT: Yale University Press, 1992) address this subject.

61. The theme of looking at that which had been hidden, was forbidden, or both, runs through the literature of the nineteenth century. See, for example, Shloss's discussion in *In Visible Light,* p. 41, and Trachtenberg, "Photography." In "Photography and Fetish," Christian Metz explores the relationship of photography to death and the making of fetishes, which was an allied subject in the nineteenth century. Also see David Freedberg, *The Power of Images: Studies in the History and Theory of Response* (Chicago: University of Chicago Press, 1989). The notion of the photograph as never quite detached from its referent is the primary theme of Roland Barthes's *Camera Lucida.*

62. Georges Canguilheim, *The Normal and the Pathological,* trans. Carolyn R. Fawcett (Cambridge, MA: MIT Press, 1991), p. 43.

63. The notion of a "universal" art collection was not limited to photographic reproduction of art. It also informed the plans for a Musée des Copies. See Boime, p. 240. Also see John Elsner and Roger Cardinal, *The Cultures of Collecting* (Cambridge, MA: Harvard University Press, 1994), and Werner Muensterberger, *Collecting* (Princeton, NJ: Princeton University Press, 1994). In their introduction, Elser and Cardinal discuss how collecting borders on the pathological.

64. Collecting necessitates purging the object's original context. The activity of collecting is discussed in Elsner and Cardinal, see n. 63 above.

65. See Chapter 3.

66. Ernest Lacan, *Esquisses photographique, à propos de l'exposition universelle, et de la guerre d'Orient; historique de la photographie, développements, applications, biographies et portraits* (Paris: Grassart, 1856), pp. 210–211. Translation mine.

67. Hitchcock, p. 410.

68. Lacan, p. 210.

69. [A. A. E.] Disdéri, *Renseignements photographique indispensables à tous* (Indispensable Photographic Information for All) (Paris: L'auteur, 1855), pp. 30–39.

70. See Elsner and Cardinal, p. 1, and Jean Baudrillard, "The System of Collecting," originally "Le système marginal" in his *Le Système des objects* (1968) in Elsner and Cardinal, pp. 7–24.

71. [A. A. E.] Disdéri, *L'Art de la photographie* (Paris: L'auteur, 1862), pp. 313–325.

72. *British Journal of Photography* 36 (1889): 688.

73. For a discussion of the department store in relation to the museum, see Rémy G. Saisselin, *The Bourgeois and the Bibelot* (New Brunswick, NJ: Rut-

gers University Press, 1984), pp. 31–49. Also see Thomas J. Schlereth, *Victorian America: Transformations in Everyday Life, 1876–1915* (New York: HarperCollins, 1991), pp. 146–151, and Anne C. Rose, *Voices of the Marketplace: American Thought and Culture, 1830–1860* (New York: Twayne Publishers, 1995).

74. Miles Orvell, *The Real Thing: Imitation and Authenticity in American Culture, 1880–1940* (Chapel Hill: University of North Carolina Press, 1989), p. 42.

75. Charles Dickens, *Hard Times* (1854; Harmondsworth, England: Penguin Books, 1969), p. 66.

76. Michel Foucault, *Discipline and Punishment: The Birth of the Prison,* trans. Alan Sheridan (New York: Vintage Books, 1979), p. 187. The French phrase "visibilité obligatoire" is found on page 189 of the original French publication, *Surveiller et punir* (Paris: Éditions Gallimard, 1975). Foucault's chapter on "Panopticism" encompasses many ideas that find parallels in nineteenth-century photographic theory. Panopticism is, as Foucault points out, not merely an architectural idea, but "the principle of a system" of thought. Michel Foucault, *Power/Knowledge: Selected Interviews and Other Writings, 1972–1977,* ed. Colin Gordon and trans. Colin Gordon, Leo Marshall, John Mepham, and Kate Soper (New York: Pantheon Books, 1972), p. 148.

The word "panopticism" is a likely and easily constructed neologism to suit Foucault's ideas. Similar terms with these Greek roots were used for nineteenth-century photographic equipment and projects. See Richard Rudisill, *Mirror Image: The Influence of the Daguerreotype on American Society* (Albuquerque: University of New Mexico Press, 1971), pp. 142–143 and 229.

77. "American Culture," *Lippincott's Magazine* 1 (Philadelphia) (June 1868): 645.

78. Disdéri, p. 4.

79. See Johnson, "Notes," p. 47, and Johnson, "Educational Policy," p. 101. Weber also alludes to the uses of "civilizing." See p. 314. The concept is discussed throughout Shapin and Barnes, "Science, Nature and Control," cited in note 21 above.

80. Vincent, pp. 86–87, succinctly presents the ways in which schooling, articulated as an effort to rescue children from barbarism, disrupted patterns of familial authority. Also see Johnson, "Notes," p. 89, and Johnson, "Educational Policy," p. 113. Teachers became self-proclaimed agents of civilization against the culture of parents.

81. Quoted in Vincent, p. 189.

82. See, for example, Vincent, p. 87; Shapin and Barnes, p. 61; or Johnson, "Educational Policy," pp. 101 and 111.

83. "Museums of Art as a Means of Instruction," *Appletons' Journal of Popular Literature, Science, and Art* 15 (January 1870): 80. In her book on the founding and philosophy of *Picturesque America,* an illustrated magazine begun by *Appletons' Journal,* Sue Rainey devotes the first chapter to "*Appletons' Journal* and the Mission to Civilize." See Sue Rainey, *Creating Picturesque America: Monument to the Natural and Cultural Landscape* (Nashville, TN: Vanderbilt University Press, 1995), pp. 3–18.

84. Alan Trachtenberg, *The Incorporation of America* (New York: Hill and Wang, 1982), p. 147. Neil Harris discusses the evolution of America's attitude toward European art in his *The Artist in American Society: The Formative Years, 1790–1860* (New York: George Braziller, 1966). Harris concludes that travelers on European tours routinely observed how European governments used art and museums as social control. See Chap. 6.

85. For a discussion of civilizing efforts in the United States, see Lawrence W. Levine, *Highbrow/Lowbrow: The Emergence of Cultural Hierarchy in America* (Cambridge, MA: Harvard University Press, 1988), and "The Politics of Culture," in Trachtenberg, *Incorporation of America,* pp. 140–181.

86. For the suggestion that the middle class might use the reproduction of art works for their own enrichment, and for their own economies, see A. H. Wall on photographic reproduction, cited in note 5 above.

87. Root, p. 28.

88. Root, p. xv, or Louis Figuier, *La photographie* (1869) (rpt., Arno Press, 1979), p. 187. Root also embraced the encyclopedic potential of photography, linking it with the civilizing of the masses as well as with the related development of national feeling. See pp. 26–29. Root's enthusiasm for the unique relationship of the photograph to its object should not be judged as antique. In "The Ontology of the Photographic Image," *What is Cinema?,* trans. Hugh Gray (Berkeley: University of California Press, 1967), vol. 1, p. 14, André Bazin insisted that "no matter how fuzzy, distorted, or discolored, no matter how lacking in documentary value the image may be, by virtue of the very process of its becoming, the being of the model of which it is the reproduction; it is the model."

89. André Rouillé, *L'empire de la photographie, 1839–1870* (Paris: Le Sycomore, 1982), p. 147. The concept of civilization has been part of the discourse legitimizing photography from 1839, beginning with the arguments for Daguerre's pension formulated by Dominique-François Arago and Joseph Gay-Lussac. Also see Gareth Stedman Jones, *Languages of Class: Studies in English Working Class History, 1832–1982* (New York: Cambridge University Press, 1983), pp. 191–194.

90. For example, Rouillé, p. 147. In *Culture and Anarchy* (1869), Matthew Arnold considered that the pursuit of the perfect was the pursuit of sweetness and light. This analogy held sway through the late nineteenth and early twentieth centuries in the work and writing of social reform photographers like Jacob Riis.

    Whereas it may have claimed the greatest potential impact, photography was not the only visual mass medium to be discussed in terms of its ability to elevate morality and taste. Chromolithography, a process that could reproduce paintings, was hailed as a democratic means to bring culture to all classes. See Peter C. Marzio, *The Democratic Art: Chromolithography, 1840–1900, Pictures for a Nineteenth-Century America* (Boston: David R. Godine, 1979). Music was similarly applauded as a "civilizing agent." For music as a democratic force, see John Sullivan Dwight, "Music as a Means of Culture," *The Atlantic Monthly* 26 (September 1870): 321–331.

91. Cates, p. 218.

92. "The Photographic Society," *The Athenaeum* (January 10, 1857): 10.

93. Quoted in Edward W. Earle, ed., *Points of View: The Stereograph in America – A Cultural History* (Rochester, NY: The Visual Studies Workshop, 1979), p. 10.

94. Quoted in Earle, *Points of View,* p. 10.

95. *Photographic News* (England) (October 18, 1861): 500. Quoted in Helmut Gernsheim, *Lewis Carroll: Photographer* (New York: Chanticleer Press, 1950), p. 6.

96. Dickens, *Hard Times,* p. 51.

97. See Leslie Good's article, "Power, Hegemony, and Communication Theory," in *Cultural Politics in Contemporary America,* ed. Ian Angus and Sut Jhally (New York: Routledge, 1989), pp. 51–64.

98. Johnson points out that "civilizing" was a typical expert word. See his "Educating the Educators," p. 89. In many ways, the eugenics movement at

the end of the century was the logical extension of these ideas. See David Green, "Veins of Resemblance: Photography and Eugenics," in *Photography/Politics: Two,* ed. Patricia Holland, Jo Spence, and Simon Watney (London: Comedia/Photography Workshop, 1986), pp. 9–21.

99. Quoted in Johnson, "Educating the Educators," p. 90. (Emphasis Roebuck.)

100. Matthew Arnold, "Culture and Anarchy," in *The Portable Matthew Arnold,* ed. Lionel Trilling (New York: Viking Press, 1949), Chap. 1, p. 499.

101. See Dickens, *Hard Times,* Chap. 2. The locus classicus of the notion that cultural hegemony is consensual rather than the product of force is Antonio Gramsci, *Selections from the Prison Notebooks,* ed. and trans. Quintin Hoare and Geoffrey Nowell Smith (New York: International Publishers, 1971), pp. 12, 242–243, and passim. Graff relates literacy to Gramsci's understanding of hegemony in Harvey J. Graff, *The Literacy Myth: Literacy and Social Structure in the Nineteenth-Century City* (New York: Academic Press, 1979), pp. 11–12. Similarly, Henry A. Giroux discusses the hegemonic potential of literacy in *Schooling and the Struggle for Public Life: Critical Pedagogy in the Modern Age* (Minneapolis: University of Minnesota Press, 1988), pp. 147–149.

102. Quoted in Simon Frith, "Socialization and Rational Schooling: Elementary Education in Leeds before 1870," in Phillip McCann, p. 84. Also see Thomas W. Laqueur, "Working-Class Demand and the Growth of English Elementary Education, 1750–1850," in Lawrence Stone, ed., *Schooling and Society: Studies in the History of Education* (Baltimore: The Johns Hopkins University Press, 1976), pp. 192–205.

103. Dickens, p. 90. The last sentence of Foucault's essay on "Panopticism" asks, "Is it surprising that prisons resemble factories, schools, barracks, hospitals, which all resemble prisons?" Foucault, *Discipline and Punishment,* p. 228.

104. Quoted in Vincent, p. 134; also see pp. 134–155.

105. Graff, *The Literacy Myth,* p. 9. Ozouf and Furet also question the assumption of a correlation between the rise of literacy and the increased number of schools. They offer an equation in which the schools contribute to literacy but are also a response to the increased demand for it. Thus: "Although the school was one sign – and sought to appear to be its symbol – it did not give the signal for access to written culture." See p. 263. Also see pp. 233–237. Relatedly, see Johnson, "Notes," and Peter N. Flora, "Historical Processes of Social Mobilization: Urbanization and Literacy, 1850–1965," in *Building States and Nations,* ed. S. N. Eisenstadt and Stein Rokkan, vol. 1 (Beverly Hills, CA: Sage Publications, 1973), p. 219.

106. Harvey J. Graff, *The Legacies of Literacy: Continuities and Contradictions in Western Culture and Society* (Bloomington: Indiana University Press, 1987), p. 3.

107. Graff, *Legacies,* p. 224.

108. Graff, *Legacies,* Chaps. 6 and 7. For a discussion of the reductionist approach to literacy and social control, see Vincent, pp. 95 ff.

109. A modification to this generalization should be made for countries like France, where a well-established bureaucracy and creeping credentialism required proportionately more literate workers than other countries. See Graff, *Legacies,* pp. 270–271.

110. Graff, *The Literacy Myth,* p. xviii.

111. In the late 1960s and early 1970s in England and the United States, the recalcitrance of illiteracy was taken by some to be a window of opportunity through which not only to resist industrialization but also to create an alternative to it. The works of Ivan Illich are associated with

this idea. See E. Verne, "Literacy and Industrialization – The Dispossession of Speech," in *A Turning Point for Literacy,* ed. Léon Bataille (New York: Pergamon Press, 1976), pp. 211–228.

112. Criticizing prevailing concepts of social control, Gareth Stedman Jones wrote: "It is as if class conflict in England has been a largely one-sided affair conducted by capitalism and its representatives; as if the rural and urban masses, like the newborn child of Locke's psychology, were simply a blank page upon which each successive stage of capitalism has successfully imposed its imprint." Gareth Stedman Jones, p. 78.

113. Furet and Ozouf, p. 3. Patricia Anderson is similarly guarded in *The Printed Image.* She emphasizes that "the emergence of a formative mass culture – at least in its visual forms – was not a process of wholesale repression or replacement" (p. 4).

114. Furet and Ozouf, p. 298.

115. E. Durkheim, *The Elementary Forms of Religious Life* (1915), utilized in Jack Goody and Ian Watt, "The Consequences of Literacy," in *Literacy in Traditional Societies,* ed. Jack Goody (Cambridge: Cambridge University Press, 1968), p. 28. My ideas in this section are based on their work, especially pp. 27–68.

116. Goody and Watt, pp. 59–60. [Paraphrased.]

117. See Walter J. Ong, *Orality and Literacy* (London: Methuen, 1982), p. 91. For a summary of the various views about the change from orality to literacy and the implications for memory, see Vincent, pp. 18–20 and 182–183.

118. Vincent, p. 182.

119. Goody and Watt, p. 44.

120. Quoted in Vincent, p. 225.

121. In Western cultures, it was the flow of information and power from parents to children that was deliberately disrupted. See Vincent, pp. 73–83.

122. *The Practice of Everyday Life,* trans. Steven Rendall (Berkeley: University of California Press, 1984), p. xiii. See his related notion of the *perruque,* pp. 24–42.

123. For a general discussion of Native American photography see Laura U. Marks, "White People in the Native Camera: Subverting Anthropology," *Afterimage* 19 (May 1992): 18–19.

124. For a discussion of contemporary re-use of images produced by the dominant culture, see Marusia Bociurkiw, "The Transgressive Camera," *Afterimage* 16 (January 1989): 18. Also see E. Ann Kaplan, "Pornography and/as Representation," *enclitic 17/18* 9: 8–19. Doug Ischar has made the related argument for gay responses in relation to physique pornography in "Parallel Oppressions: The Ideal and the Abject in Gay Representation," *Afterimage* 16 (1989): 10–11. See also Thomas Waugh, "Lesbian and Gay Documentary: Minority Self-Imaging, Oppositional Film Practice, and the Question of Image Ethics," in *Image Ethics: The Moral Rights of Subjects in Photographs, Film, and Television,* ed. Larry Gross, John Stuart Katz, and Jay Ruby (New York: Oxford University Press, 1988), pp. 248–272.

125. Stuart Hall, quoted in Lawrence Grossberg, "History, Politics and Postmodernism: Stuart Hall and Cultural Studies," *The Journal of Communications Inquiry* 10 (Summer 1986): 71.

126. In his essay "The Daguerreotype: American Icon," *American Daguerreotypes from the Matthew R. Isenburg Collection* (New Haven, CT: Yale University Art Gallery, 1989), Alan Trachtenberg speculates "that one subliminal appeal of the daguerreotype was its overt association with certain traditional crafts." He suggests that "the daguerreotype might be considered the first industrial folk art, a vernacular in the machine age" (p. 16).

127.  Holmes, "Doings of the Sunbeam," 10.

128.  Elsner and Cardinal, p. 1.

129.  Raymond Williams, p. 62. Williams draws a distinction between culture and civilization, the latter being the intellectual opposite of primitivism.

130.  See Kelly J. Mays, "The Disease of Reading and Victorian Periodicals," in *Literature in the Marketplace: Nineteenth-Century British Publishing and Reading Practices,* ed. John O. Jordan and Robert L. Patten (New York: Cambridge University Press, 1995), pp. 165–194.

131.  The classic analysis of what would be called "highbrow, lowbrow, middlebrow" was rendered by Russell Lynes in his *The Tastemakers* (New York: Harper, 1954). The conceptual history of the social dynamics that informed nineteenth-century notions of highbrow and lowbrow is Lawrence W. Levine's *Highbrow/Lowbrow,* cited in note 85 above.

132.  See Elizabeth Shepard, "The Magic Lantern Slide in Entertainment and Education, 1860–1920," *History of Photography* 11 (April–June 1987): 91–108.

133.  Cosmo I. Burton, "The Whole Duty of the Photographer," *The British Journal of Photography* 36 (October 11, 1889): 667–668. For the continuing history of photographic collections, see Peter James, "Evolution of the Photographic Record and Survey Movement, c. 1890–1910," *History of Photography* 12 (July–September 1988): 205–218.

## 5: LURE OF MODERNITY

1.  The social and cultural impact of electricity, including its characterization in science fiction and utopian literature, is discussed in David E. Nye's *Electrifying America: Social Meanings of a New Technology* (Cambridge, MA: MIT Press, 1991).

2.  For a discussion of the contrast between representation and the truth, see Miles Orvell, *The Real Thing: Imitation and Authenticity in American Culture, 1880–1940.* Henry James's 1893 short story, aptly titled "The Real Thing," gingerly narrates this dilemma.

3.  Douglas Collins, *The Story of Kodak* (New York: Harry N. Abrams, 1990), p. 57.

4.  John Moran, "The Relation of Photography to the Fine Arts," *The Philadelphia Photographer,* vol. 2, no. 15 (March 1865): 33–34.

5.  Brett, p. 86. It is interesting to note that Peter Henry Emerson's article "Science and Art" appeared in the same *Journal of the Camera Club* number.

6.  In her introductory essay to the catalogue and exhibition she edited and organized, Ellen Handy refers to Emerson as a modernist in the sense that he, like subsequent self-consciously modern artists, accented the formal properties of art. Her understanding of Emerson's relationship with the modern places him within the development of modern art, not of modern science or social modernism. This approach informs the otherwise trenchant essay by Brian Lukacher in Handy's catalogue. See Ellen Handy, "Pictorial Beauties, Natural Truths, Pictorial Practices," and Brian Lukacher, "Powers of Sight: Robinson, Emerson, and the Polemics of Pictorial Photography," in *Pictorial Effect, Naturalistic Vision: The Photographs and Theories of Henry Peach Robinson and Peter Henry Emerson,* ed. Ellen Handy (Norfolk, VA: The Chrysler Museum, 1994), pp. 1–23 and 29–53.

7.  Pierre-Joseph Proudhon, "Concerning the Principle of Art and Its Social Purpose" (1857), in *Nineteenth-Century Theories of Art,* ed. Joshua C. Taylor (Berkeley: University of California Press, 1987), p. 393. This essay, translated from Proudhon's *Du principe de l'art et de sa dest-*

*ination sociale* (1865), is comparable in its progressivist claim to Emerson's "Photography, A Pictorial Art" (1886). Equally progressivist but more reliant on science was Hippolyte Taine's "The Philosophy of Art" (1865). The idea of progress in art had sufficient currency in 1855 for Baudelaire to write his famous essay "On the Modern Idea of Progress as Applied to the Fine Arts," in which he attempted to differentiate between material advance and the timeless realm of beauty and the spirit.

8. For the conventional contemporary contrast between progress in science and progress in art, see George Moore, "Art and Science," in *Modern Painting* (London: Walter Scott Publishing Co., 1893), pp. 135–138. Moore's essay "The Camera in Art" is similarly normative. Moore may be referencing Emerson when he asserts that "the insinuating poetry of chiaroscuro the camera is powerless to reproduce." ("The Camera in Art," *Modern Painting,* p. 189.)

9. As Beaumont Newhall has pointed out, the idea of pure photography was argued in the photographic journals in the 1880s. See Beaumont Newhall, *The History of Photography* (New York: The Museum of Modern Art, 1982), pp. 147–148.

10. For a discussion of this aspect of English landscape experience, see Ann Bermingham, *Landscape and Ideology: The English Rustic Tradition, 1740–1860* (Berkeley: University of California Press, 1986). Also see John Taylor, "Aristocrats of Anthropology: A Study of P. H. Emerson and other Tourists on the Norfolk Broads," *Image,* vol. 35, nos. 1–2 (Spring/Summer 1992): 2–23.

11. The intricate and debatable genealogy of positivism is beyond the scope of this study. See W. M. Simon, *European Positivism in the Nineteenth Century: An Essay in Intellectual History* (Ithaca, NY: Cornell University Press, 1963).

12. Henley was an influential critic. He and Emerson possessed so many similar opinions on art and culture that one wonders if Henley's views, published while he was editor of the *Magazine of Art* (October 1881–August 1886), were not a major unacknowledged source for Emerson's opinions. That Emerson read the publication was recorded in his writing for the *American Amateur Photographer,* where he observed that the "*Magazine of Art* [is] our most advanced artistic periodical." See Nancy Newhall, *P. H. Emerson: The Fight for Photography as a Fine Art* (New York: Aperture, 1975), p. 75.

   Both Henley and Emerson found much to fault in Michelangelo, and much to praise in Millet. Both disliked what Ruskin had to say and how he said it. Both were attracted to Japanese painters; each praised the originality of Constable and Manet. Each admired Whistler, but were critical of his art and theory nonetheless. For Henley as for Emerson, French painting was central to modernity. Imitation, especially detailed, so-called photographic detail, in painting was false and misleading. For each, the act of art was one of selection, not imitation, and that selection was inevitably tied to the personality of the artist or writer. Henley was unarguably better acquainted with the literary realism of Balzac, Flaubert, and Zola, but he liked it no better than did Emerson. Interestingly, both Henley and Emerson have come to be viewed as less complex personalities than they were in deed. Emerson, the fusty patrician, doubted the benefits of English life to the poor in East Anglia; Henley, the supposed rigid counterdecadent, published the chapters of Hardy's *Tess* that outraged public opinion.

13. Nancy Newhall, p. 22.

14. *The English Emersons* (London: David Nutt, 1898), p. 116, hereafter E. E. The following other abbreviations are used for the works of Peter Henry Emerson:

E. A. L.    *Pictures of East Anglian Life* (London: Sampson Low, Marston, Searle and Rivington, 1888).

E. L.    *On English Lagoons* (London: David Nutt, 1893).

I. P. E.    "An Ideal Photographic Exhibition," *The Amateur Photographer*, vol. 2 (October 23, 1885).

N. P. 1    *Naturalistic Photography for Students of the Art,* 1st ed. (1889; rpt., New York: Arno Press, 1972).

N. P. 2    *Naturalistic Photography for Students of the Art,* 2nd, rev. ed. (New York: E. and F. Spon, 1890).

N. P. 3    *Naturalistic Photography for Students of the Art,* 3rd ed., rev., and *The Death of Naturalistic Photography* (1899, 1890; rpt. together, New York: Arno Press, 1973).

N. P. A.    "Naturalistic Photography and Art," a paper read to the Photographic Society, March 1893, revised and included as Chapter 4 in N. P. 3.

P. P.    "Photography, A Pictorial Art," *The Amateur Photographer* 3 (March 19, 1886). The same title with slightly different punctuation was used by Emerson as the subtitle of the "L'Envoi" of N. P. 1.

S. A.    "Science and Art," a speech delivered to the Camera Club Conference, March 26, 1889, appended to N. P. 2 and N. P. 3. Reference is to N. P. 3, where the speech is separately paginated as Appendix A.

T. A.    "Topography and Art," Appendix B of N. P. 3; an undated paper.

W. N. P.    "What is a Naturalistic Photograph?" *The American Annual of Photography* (1895): 123–125.

15. William Innes Homer discusses the status of surgeons and the attraction of artists like Thomas Eakins to science and medicine in his essay on *The Gross Clinic* in *Thomas Eakins* ed. John Wilmerding, (Washington, DC, The Smithsonian Institution Press, 1994), p. 80. The subject is also taken up by Elizabeth Johns in *Thomas Eakins: The Heroism of Modern Life* (Princeton, NJ: Princeton University Press, 1983), pp. 55–56. The rising status of physicians and other professionals such as lawyers forms part of the argument for the renewal of aristocratic values. See Martin J. Weiner in his *English Culture and the Decline of the Industrial Spirit, 1850–1980* (Cambridge: Cambridge University Press, 1981).

16. Paul Rabinow discusses this process in *French Modern: Norms and Forms of the Social Environment* (Cambridge, MA: MIT Press, 1989), pp. 10 and 24–25. Also see Adrian Desmond, *The Politics of Evolution: Morphology, Medicine, and Reform in Radical London* (Chicago: University of Chicago Press, 1990).

17. It is likely that Emerson encountered Helmholtz's ideas in his pre-med training. Still, it is important to note that the art history by Alfred Woltmann and Karl Woermann, *History of Painting* (New York: Dodd, Mead & Co., 1880), which Emerson quotes liberally, opens with an acknowledgment of Helmholtz and includes the notion that in the past painters had tried to render images as they appeared in the retina of the eye.

18. Emile Zola, "Salon de 1866," in *Salons,* ed. F. W. S. Hemings and Robert J. Niess (Paris: Librairie Minard, 1959), pp. 61 and 70. For Emerson's views, see N. P. 1, p. 97.

19. See Zola, "Salon de 1866," p. 61, and Emile Zola, *Le Roman Expérimental* (Paris: Bernouard, 1982), p. 12.

20. N. P. 1, p. 21, and P. P., p. 138.

21. N. P. 1, p. 90.

22. N. P. 1, p. 97.

23. P. P., p. 139.

24. P. P., p. 139.

25. Zola, *Le Romain Expérimental,* p. 52. I have relied on the translation of Eugen Weber in his *Paths to the Present: Aspects of European Thought from Romanticism to Existentialism* (New York: Dodd, Mead & Co., 1960), p. 177.

26. Zola, *Le Romain Expérimental,* p. 52. Weber trans., p. 177.

27. Zola, *Le Romain Expérimental,* p. 1. Weber trans., p. 164.

28. P. P., p. 138. The phraseology may be Zola's, but the thought is equally that of the antivitalist, antialchemist Hermann Helmholtz. See his lecture on "The Aims and Progress of Physical Science," note 38 below. On the other hand, Helmholtz carefully delineated a line between what he called the moral sciences and the physical sciences. Each had its own object and mode of operation. See "On the Relation of Natural Science to General Science" (November 22, 1862), in *Popular Lectures on Scientific Subjects,* cited below, note 38. Brian Lukatcher has observed a debt to Zola in Emerson's understanding of impressionism. See Lukatcher, p. 47.

29. Zola, *Le Romain Expérimental,* p. 15. Weber trans. p. 170.

30. Zola, *Le Romain Expérimental,* p. 15. Weber trans. p. 170.

31. P. P., p. 138.

32. P. P., p. 139.

33. P. P., p. 139.

34. N. P. 1, p. 97.

35. P. P., pp. 138–139.

36. The term "camera vision," as objective sight and thought was used at the end of the century. See D. S. MacColl, *Nineteenth-Century Art* (Glasgow: James MacLehose and Sons, 1902), pp. 2–3.

37. P. P., p. 139, and N. P. 1, p. 97.

38. N. P. 1, p. 114. For Helmholtz, see the discussion in Maurice Mandelbaum, *History, Man, and Reason: A Study in Nineteenth-Century Thought* (Baltimore: Johns Hopkins Press, 1971), pp. 292–298. The quotation from Helmholtz appears on page 343 of his lecture, "The Aims and Progress of Physical Science," translated by Dr. W. Flight, in H. Helmholtz, *Popular Lectures on Scientific Subjects,* 1st series, new ed., trans. E. Atkinson (London: Longmans, Green, and Co., 1884).

39. N. P. 1, p. 97.

40. N. P. 1, p. 97.

41. N. P. 1, p. 234.

42. P. P., p. 138.

43. N. P. 1, pp. 22 and 23. In "'The Right Thing in the Right Place,': P. H. Emerson and the Picturesque Photograph," in *Victorian Literature and the Victorian Visual Imagination,* Jennifer M. Green argues that traditional aesthetics overwhelmed Emerson's concern with the laboring subjects in many of his images.

44. There is a patch of humility and tentativeness in Emerson's writing. N. P. A. ends with proposals for linking the aesthetic response to evolution. Emerson states, "As for these propositions, I do not intend to fight over them, for they are *propositions,* and therefore no fighting matter, but provisional until psychology shall either prove or disprove them." See N. P. A., p. 190. However, the general tenor of Emerson's writing is more assured. He shared an outlook on psychology with Lewes, p. 789 (see note 46 below), who wrote that "psychology is not a mature science yet, but it boasts of some indisputable truths."

45. N. P. 1, p. 20, and N. P. 3, p. 27.

46. George Henry Lewes, *The Biographical History of Philosophy, From Its Origin in Greece down to the Present Day* (New York: D. Appleton and Co., 1868), p. xxix.

47. Lewes, p. 780.

48. Lewes, pp. 695–696, and 783–784. Emerson's idea that "the days of meta-physics are over," as well as his belief that French thought was vanguard thought, could have been confirmed by Lewes, who wrote that the "grand-est . . . truest . . . system that Philosophy has yet produced" was produced in France. See Lewes, p. 788.
49. E. A. L., pp. 118–119.
50. Hock Guan Tjoa, *George Henry Lewes: A Victorian Mind* (Cambridge, MA: Harvard University Press, 1977), p. 25.
51. N. P. A., pp. 179–180. Sources of the debate include Spencer, *First Principles,* pp. 66–68, cited below, note 55; Maudsley, *The Physiology of Mind,* pp. 125–135, cited below, note 66; and W. B. Carpenter, *Principles of Mental Physiology,* pp. 2–9, cited below, note 65. Emerson appears to be in agreement with Spencer's doctrine of the evolution of the mind as Spencer has laid it out in his *Principles of Psychology,* p. 559. Nevertheless, Emerson's earlier writing shows that he was no simple materialist. In N.P. 1, although he heavily quotes Woltmann and Woermann's *History of Painting*, he pointedly rejects the authors' deterministic materialism. See N. P. 1, p. 28.
52. P. P., passim, and N. P. 1, pp. 8–12. Evolutionary theory's importance to photographic history is discussed in Chapter 1.
53. N. P. 1, p. 10.
54. This notion of evolutionary development from homogeneity to hetero-geneity became such a Victorian commonplace that Emerson did not need to cite a source.
55. Herbert Spencer, *First Principles* (New York: D. Appleton and Co., 1899), p. 370.
56. S. A., p. 67.
57. S. A., p. 67.
58. S. A., p. 68.
59. Charles Darwin, *The Origin of Species and The Descent of Man* (New York: Modern Library, n.d.), p. 467. For another view of Emerson's Darwinism, see Sarah Knight, "Change and Decay: Emerson's Social Order" in *Life and Landscape: P. H. Emerson, Art and Photography in East Anglia, 1885–1900,* ed. Neil McWilliam and Veronica Sekules (Norwich: Sainsbury Centre for Visual Art, University of East Anglia, 1986), pp. 12–20.
60. N. P. 1, pp. 278–279.
61. N. P. A., p. 180. See also Darwin, *Descent,* p. 468, and Herbert Spencer, *The Principles of Psychology,* vol. 2 (New York: D. Appleton and Co., 1899), pp. 645–647.
62. Herbert Spencer, *Social Statics* (New York: D. Appleton and Co., 1865), p. 80, and Spencer, *First Principles,* pp. 429 and 458–459.
63. For example, when Emerson brings up the case of the blind American girl, Laura Bridgman, he is following Spencer, Carpenter, and Maudsley, as discussed later.
64. S. A., p. 70.
65. See, for example, "Topography and Art," N. P. 3, where Emerson relates an anecdote about Carpenter and then, without citing his source, proceeds to use Carpenter's notion of representation. See William B. Carpenter, *Principles of Mental Physiology,* 4th ed. (New York: D. Appleton and Co., 1899), pp. 431–433. Emerson also uses "constructive imagination" in N. P. 3, p. 29, but not in N. P. 1, which helps to date his acquaintance with the term. In N. P. 3, he uses it more or less correctly, to mean only one kind of aggregating intelligence.
66. Henry Maudsley, *The Physiology of Mind* (New York: Appleton and Co., 1889), p. 523.
67. Spencer, *Psychology,* vol. 2, pp. 533–537.

68. Spencer pronounced more mildly on genius in his *Psychology,* vol. 2, pp. 533–537.

69. Herbert Spencer, *The Study of Sociology,* Am. Ed. (New York: D. Appleton and Co., 1912), p. 31. Lewes disagreed with Spencer's scheme as far as it concerned the originality of Comte. See Lewes, pp. 696–697. The proximate initiator of change is discussed in Chapter 1.

70. N. P. 1, pp. 95–96. The idea that advancement in art is not tied to technological progress certainly predates Emerson's consideration of it in relation to photography. See Chapter 4 for a discussion of this idea as it inflected notions of mass production and visual literacy at midcentury.

71. See, for example, N. P. 1, pp. 38, 47, 59, and 71.

72. See, for example, N. P. 1, pp. 61–62.

73. Tjoa, p. 122.

74. Spencer, *Psychology,* vol. 2, pp. 495–503.

75. Thomas Henry Huxley, "Science and Culture," in Thomas Henry Huxley, *Science and Education: Collected Essays* (Westport, CT: Greenwood Press, 1968), p. 141.

76. Matthew Arnold, "The Function of Criticism at the Present Time," in *The Complete Prose Works of Matthew Arnold,* vol. 3, *Essays in Criticism,* ed. R. H. Super (Ann Arbor: University of Michigan Press, 1962), p. 283. Emphases Arnold.

77. See Matthew Arnold, "Literature and Science," in *The Complete Prose Works of Matthew Arnold,* vol. 10 (1974), pp. 69 and 71; and Thomas Henry Huxley, *Introductory,* Science Primers Series (New York: D. Appleton and Co., 1880), p. 16.

78. N. P. 1, p. 258.

79. S. A., p. 76.

80. There are several scholarly accounts of the growth of this idea in the Victorian period. See, for example, Jerome Hamilton Buckley, *The Triumph of Time: A Study of the Victorian Concepts of Time, History, Progress, and Decadence* (Cambridge, MA: The Belknap Press of Harvard University Press, 1966). In his book *Mental Physiology: Especially in Its Relations to Mental Disorders* (London: J. A. Churchill, 1895), Theophilius B. Hyslop added a useful historical footnote that rounds up the literature of degeneration as it was known and read in England. See unnumbered note, pp. 465–466. The list differs in several important ways from the international understanding offered in the recent study edited by J. Edward Chamberlin and Sander L. Gilman, *Degeneration: The Dark Side of Progress* (New York: Columbia University Press, 1985). Hyslop drew a genealogy of the works on degeneration that included not only the prominent writing of Lombroso, Nisbet, and Nordau, but also Spencer's *Psychology,* William James's articles in *The Atlantic Monthly,* and the work of Maudsley – all more moderate and independent than the infamous studies.

In rough outline, Emerson's attraction to Social Darwinism has been acknowledged. Bonnie Yochelson, in her doctoral dissertation, "P. H. Emerson: An Art Historical Study of a Victorian Photographer" (New York University, 1985), suggests: "The doctrine was more than a pretext for Emerson's bellicose prejudices. The image of universal struggle appealed to his artistic imagination, and by replacing an ethical or moral system with one of competing self-interests, it also fed his insecurities" (pp. 36–37).

81. N. P. A., p. 176.

82. N. P. A., p. 176.

83. N. P. A., "L'Envoi," pp. 60–61.

84. T. A., p. 85.

85. Max Nordau, *Degeneration* (New York: D. Appleton and Co., 1895), p. 29.

86. Nordau, p. 324. For Nordau on the ineffectuality of schools and isms, see pp. 29–30.

87. N. P. 1, p. 247.

88. N. P. A., p. 175.

89. N. P. A., pp. 175 and 176.

90. N. P. A., p. 182. These comments are well within an expansive Romantic tradition evidenced by both Delacroix and Ruskin in relation to photography.

91. Maudsley, *The Physiology of Mind*, p. 527. Henry Maudsley also disagreed with the prevailing idea that genius was mad, and, to some extent, he differed with the mathematical neatness of Galton's theory of genius. See Henry Maudsley, *The Pathology of Mind* (New York: D. Appleton and Co., 1880), pp. 96 and 301.

92. See N. P. 1, p. 14; N. P. A., p. 181; and W. N. P., p. 125. Brian Lukatcher suggests, too preemptively, I think, that "for all of its propounded faith in principles of scientific observation, Emerson's treatise ultimately prizes subjectivity, and therein the subjection, of the real." Lukatcher, p. 43.

93. See N. P. 1, pp. 22 and 120.

94. N. P. 1, p. 25.

95. See the discussion of his "Photography, A Pictorial Art," above. Emerson eventually quoted from Whistler's "Ten O'Clock" in N. P. 1., p. 16. The tone and direction of Emerson's introductory remarks in N. P. 1 suggest a reliance on Whistler's lecture.

96. See N. P. 1, pp. 28 and 278. Emerson shows contempt for Woltmann and Woermann's attempt to relate art styles to economic and political history. Because most of their text is unalloyed recitation of art-historical facts, the real target of this critique is probably John Ruskin and his understanding of the social context of art. Hamberton's essay is discussed in Chapter 3.

97. When Emerson recommended that artists (not photographers) be judges at Camera Club exhibitions, it was the English impressionists he specifically recommended. I. P. E., p. 462. A useful contemporary source for the various English understandings of impressionism and realism is MacColl's *Nineteenth-Century Art*. Some of MacColl's theory owes to Emerson. See p. 11, n. 1. Also see Yochelson, who discusses the New English Art Club and its relation to Emerson, esp. on pp. 84–125. Eventually Emerson criticized the painting of the New English Art Club. See Fiona Pearson, "The Correspondence Between P. H. Emerson and J. Harvard Thomas," in Weaver, *British Photography,* p. 200.

98. Emerson wrote caustically about the paintings of Bastien-Lepage. See N. P. 3, pp. 118–119, for example.

99. Discussed in Kenneth McConkey, *British Impressionism* (New York: Harry N. Abrams, 1989), p. 128.

100. I. P. E., p. 462.

101. See "Mr. P. Wilson Steer on Impressionism in Art. Art-Workers' Guild, 1891," Appendix D in D. S. MacColl, *Life, Work and Setting of Philip Wilson Steer* (London: Faber and Faber, 1945), pp. 177–178.

102. See the Emerson-Clausen correspondence reproduced in "Appendix I: The Emerson Correspondence – A Selection," in Neil McWilliam and Veronica Sekules, pp. 8–10. Nancy Newhall and Aaron Scharf suggest that Whistler may be the "great artist" in question. See Nancy Newhall, p. 90, and Aaron Scharf, "P. H. Emerson. Naturalist and Iconoclast," in McWilliam and Sekules, p. 30. It would not be unusual for Emerson to have elided Clausen's thoughts with Whistler's ideas.

103. McWilliam and Sekules, Emerson-Clausen correspondence, p. 9.

104. Walter Sickert, "Introduction to the Catalogue of the 'London Impressions' Exhibition'" (Goupil Gallery, December 1889), reproduced in MacColl, *Life, Work and Setting of Philip Wilson Steer,* p. 176.

105. The correspondence is in a private collection. See Fiona Pearson, "The Correspondence Between P. H. Emerson and J. Harvard Thomas," in Weaver, *British Photography,* pp. 200–201.

106. Quoted in Nancy Newhall, p. 125. Of course, later uses of the term "New Man" were riddled with neo-Darwinist concepts of race. See Romy Golan, *Modernity and Nostalgia: Art and Politics in France Between the Wars* (New Haven, CT: Yale University Press, 1995), p. x. Terry Smith briefly discusses industrialism's New Man in *Making the Modern: Industry, Art, and Design in America* (Chicago: University of Chicago Press, 1993).

107. N. P. A., p. 170.

108. W. N. P.

109. Willson H. Coates and Hayden V. White, *The Ordeal of Liberal Humanism: An Intellectual History of Western Europe* (New York: McGraw-Hill Book Co., 1970), vol. 2, p. 134.

110. László Moholy-Nagy, "Unprecedented Photography," in *Photography in the Modern Era: European Documents and Critical Writings, 1913–1940,* ed. Christopher Phillips (New York: Metropolitan Museum of Art, 1989), p. 83.

111. See Christopher Phillips, *Photography in the Modern Era.*

112. For a general introduction to scientism and for a review of late-nineteenth-century thought, see Franklin L. Baumer, *Modern European Thought: Continuity and Change in Ideas, 1600–1950* (New York: Macmillan Publishing Co., 1977). For an analysis of late-nineteenth- and early-twentieth-century amateur photography and cinema that attends to the social contexts of pictorialism, see Patricia R. Zimmerman, "Filming Adventures in Beauty: Pictorialism, Amateur Cinematography, and the Filmic Pleasures of the Nuclear Family from 1897 to 1923," *Afterimage,* vol. 14 (December 1986): 8–11.

113. As Ellen Handy notes, his attitude changed over time. See Handy, p. 21.

114. Discussed in Wiener, pp. 42–62.

115. H. Stuart Hughes, *Consciousness and Society: The Reorientation of European Social Thought, 1890–1930,* rev. ed. (New York: Vintage Books, 1977), p. 35.

116. Hughes, p. 35. Also see Stephen C. Brush, *The Temperature of History: Phases of Science and Culture in the Nineteenth Century* (New York: Burt Franklin & Co., 1978).

117. For an exhaustive study of Stieglitz and science, see Geraldine Wojno Kiefer, *Alfred Stieglitz: Scientist, Photographer, and Avatar of Modernism, 1880–1913* (New York: Garland Publishing, 1991). Kiefer demonstrates that Alfred Stieglitz absorbed ideas from these thinkers and that the major area of his borrowings from science was psychology. At the same time, she rejects pigeonholing Stieglitz as a turn-of-the-century vitalist. He was "committed not so much to impersonal forces as to the forcefulness of individual ideas." See Kiefer, p. 32.

118. See Kiefer, pp. 49–117.

119. Kiefer outlines Stieglitz's reliance on Ernst Mach's understanding of the use of intuition in science on pp. 99–101.

120. Quoted in Kiefer, p. 88.

121. Alfred Stieglitz, "The Photo-Secession," *The Bausch and Lomb Lens Souvenir* (Rochester, NY: Bausch & Lomb Optical Co., 1903), reprinted in Beaumont Newhall, *Essays and Images* (New York: Museum of Modern Art, 1980), p. 167.

122. Alfred Stieglitz, "Modern Pictorial Photography," *The Century Magazine,* vol. 64, no. 6 (October 1902): 824–825.

123. Kiefer discusses Stieglitz's use of "experiment station" on pp. 59–60. Also see Dorothy Norman, *Alfred Stieglitz: An American Seer* (New York: Random House, 1962), p. 115, where Stieglitz is reported to have said that his gallery was like "a laboratory in which we are testing the taste of the public."

124. P. P., p. 139. Stieglitz's dependence on Emerson for a basic framework is evident in a draft of the article he prepared for *Scribner's* in 1899. Paraphrasing Emerson's 1886 "Photography, A Pictorial Art," Stieglitz suggests that photography was once "slave, hand-maid, or helping friend" to "research, science, or art." But with the advent of pictorialism, photography had "come into her own, and in the strength of maturity taken her place among the sister arts." Inferentially, Stieglitz historicizes Emerson's contribution to his own thinking. Quoted in Alan Trachtenberg, *Reading American Photographs: Images as History* (New York: Hill and Wang, 1989), p. 172. See also Stieglitz's article "Pictorial Photography," *Scribner's Magazine* vol. 26, no. 56 (November 1899): 528–537.

125. See Weiner, pp. 14–24.

126. E. A. L., p. 81.

127. E. L., p. 26.

128. N. P. 3, "L'Envoi," p. 63.

129. Lewis Mumford, *The Brown Decades: A Study of the Arts in America, 1865–1895* (1930; New York: Dover Publications, 1971), p. 105.

130. Stieglitz, "Pictorial Photography," p. 537.

131. Trachtenberg, *Reading American Photographs,* p. 174.

132. See Melinda Boyd Parsons, "Malcolm Arbuthnot: Modernism and the End of Pictorialism," in Weaver, *British Photography,* pp. 281–296. For a history of Coburn's vortographs, see Mike Weaver, *Alvin Langdon Coburn: Symbolist Photographer, 1882–1966, Beyond the Craft* (New York: Aperture, 1986).

133. Early in his career, Stieglitz seemed to favor the more vapory kinds of pictorialism. But his own images were never as amorphous as those he selected for exhibitions. Even within The Linked Ring, the influential British association of art photographers who seceded from the Photographic Society of Great Britain in 1891–1892, the blurry and the straight, that is the purists and the impressionists, or *flouistes* in France, coexisted. Ultimately, it was not the look of the image per se, but the presence of the imagination that counted in Pictorial work. For the variations in Pictorial style, see Margaret Harker, *The Linked Ring: The Secession Movement in Photography in Britain, 1892–1910* (London: William Heinemann, 1979), pp. 92–93.

134. The term "reluctant modernism" is also the title of George Cotkin's study of American intellectual and cultural life in the last two decades of the nineteenth century. See George Cotkin, *Reluctant Modernism: American Thought and Culture, 1880–1900* (New York: Twayne Publishers, 1992). Cotkin points out that many American thinkers attempted "to synthesize the traditions and ideals of Victorianism with the challenges and possibilities of modernist streams of thought" (p. xi).

135. Norman, p. 115.

136. Stieglitz, "Modern Pictorial Photography," p. 825.

137. After all, Henry Peach Robinson was also articulating the separation of art photography from science.

138. Maurice Denis, "Definition of Neo-Traditionalism," in *From the Classicists to the Impressionists: A Documentary History of Art and Architecture*

*in the Nineteenth Century,* ed. Elizabeth Gilmore Holt (Garden City, NY: Anchor Books, 1966), p. 509.

## EPILOGUE

1. See, for example, the two anonymously written stories "The Magnetic Daguerreotype" and "My Lost Art," mentioned in Chapters 1 and 2. Contemporary fiction also invests photography, the photographer, and the idea of the photograph with incomprehensible ghostlike effects. See Ariel Dorfman's *Mascara,* Julio Cortazar's *Blow-Up,* Steve Szilagyi's *Photographing Fairies,* or Mario Vargas Llosa's *The Storyteller.*
2. Allan Sekula, "The Traffic in Photographs," p. 15.
3. Lawson, "Last Exit: Painting," p. 45.
4. The term was used in relation to the Pre-Raphaelite movement of the mid-nineteenth century, where it meant a visual style subsequent to the advent of photography, not the cessation of photography.
5. David Tomas, "From Photograph to Postphotographic Practice: Toward a Postoptical Ecology of the Eye," *Substance* 55 (1988): 64. Also see Kevin Robins, "The Virtual Unconscious in Postphotography," *Science as Culture,* no. 14 (1992).

# BIBLIOGRAPHIC SURVEY

The following is intended to assist the general reader. More specialized books and articles are located in the notes to each chapter.

Nineteenth-century photographic books and journals, plump with recipes and principles for improving the body and soul of photography, await a powerful synthesis that will make manifest the extensive range of ideas permeating their pages. The breadth of photography's primary literature can be glimpsed through the more than two thousand items that comprise the microfilm collection called *History of Photography* (Woodbridge, CT, 1982). Popular nineteenth-century journals containing articles on photography, such as *The Atlantic Monthly* and *The Athenaeum,* are often still available in the original. Microform editions of influential American, British, French, and German journals and magazines are becoming more abundant.

The temper of nineteenth-century American writing on the daguerreotype can be sampled in the selection of articles reproduced by Merry A. Foresta and John Wood in *Secrets of the Dark Chamber: The Art of the American Daguerreotype* (Washington, DC: National Museum of American Art, 1995). These and other sources have been integrated into Robert Taft's classic study, *Photography and the American Scene* (1938; rpt., New York: Dover Publications, 1964). Several early European documents are reproduced in Heinz Buddemeier's *Panorama, Diorama, Photographie* (Munich: Wilhelm Fink Verlag, 1970). Martin Gasser's "Histories of Photography 1839–1939" (*History of Photography* 16, no. 1 [1992]: 50–60) reviews and categorizes prominent nineteenth- and twentieth-century texts.

Peter Galassi's essay in the exhibition catalogue, *Before Photography: Painting and the Invention of Photography* (New York: Museum of Modern Art, 1981) reignited a stubborn conundrum in photographic studies, that is, why photography appeared in the early nineteenth century. Before Galassi, a comprehensive presentation of photogra-

phy's precursors was penned by Heinrich Schwarz in his *Art and Photography: Forerunners and Influences,* ed. William E. Parker (Layton, UT: Gibbs M. Smith and Peregrine Smith Books, 1985). Both Beaumont Newhall's *Latent Image: The Discovery of Photography* (Garden City, NY: Doubleday & Co., 1967) and Helmut Gernsheim's *The Origins of Photography* (London: Thames and Hudson, 1982) are sound introductions to the players and forces at work in photography's invention. Of equal interest is the earlier effort by George Potonniée in *The History of the Discovery of Photography,* trans. Edward Epstean (New York: Tennant and Ward, 1936). More recent scholarship includes work collected in *Photography: Discovery and Invention: Papers Delivered at a Symposium Celebrating the Invention of Photography* (Malibu, CA: J. Paul Getty Museum, 1990) and the conscientious study by Larry Schaaf, *Out of the Shadows: Herschel, Talbot and the Invention of Photography* (New Haven, CT: Yale University Press, 1992). Also relevant is Pierre Harmant's "Anno Lucis," a three-part study of photography's first year in *Camera* (no. 5 [May 1977]: 39–43; no. 8 [August 1977]: 37–41, and no. 10 [October 1977]: 40–44).

Beaumont Newhall's *The Daguerreotype in America* (New York: Duell, Sloan and Pearce, 1961; rpt., Dover, 1975) is a standard work on this photographic process, along with texts by Floyd Rinhart and Marion Rinhart, such as *The American Daguerreotype* (Athens: University of Georgia Press, 1981). In addition, *The Daguerreotype: A Sesquicentennial Celebration* (Iowa City: University of Iowa Press, 1989), edited by John Wood, gathers essays by contemporary scholars on the medium. It includes Alan Trachtenberg's informative "Mirror in the Marketplace: American Responses to the Daguerreotype, 1839–1851."

As their title states Helmut and Alison Gernsheim discuss *The History of Photography from the Camera Obscura to the Beginning of the Modern Era* (New York: McGraw-Hill Book Co., 1969). Helmut Gernsheim's *The Origins of Photography,* already cited, is a revised version of the first part of the Gernsheims' *History.* Also, the Gernsheims' book *L. J. M. Daguerre,* 2nd ed. (New York: Dover Publications, 1968), is extremely useful, as are the studies by H. J. P. Arnold, *William Henry Fox Talbot: Pioneer of Photography and Man of Science* (London: Hutchinson Benham, 1977), and Gail Buckland, *Fox Talbot and the Invention of Photography* (Boston: David R. Godine, 1980). Talbot's own *The Pencil of Nature* is available in facsimile edition (New York: Da Capo Press, 1961).

William Welling's *Photography in America: The Formative Years, 1839–1900* (New York: Thomas Y. Crowell Co., 1978) discusses the development of the daguerreotype and other photographic processes in the United States. In his *The Keepers of Light: A History and Working Guide to Early Photographic Processes* (Dobbs Ferry, NY: Morgan & Morgan, 1979), William Crawford gives general readers access to the chemistry of early photography. *Amateurs, Photography, and the Mid-Victorian Imagination* (Chicago: University of Chicago Press, 1986), by Grace Seiberling, is particularly appropriate for art theory as is *The*

*Pre-Raphaelite Camera: Aspects of Victorian Photography* by Michael Bartram (New York: New York Graphic Society, 1985). Lindsay Smith's *Victorian Photography, Painting and Poetry* (New York: Cambridge University Press, 1995) discusses the intersections of these fields.

Texts on specific periods and themes include Gail Buckland, *Reality Recorded: Early Documentary Photography* (Greenwich, CT: New York Graphic Society, 1974); Janet E. Buerger, *The Era of the French Calotype* (Rochester, NY: International Museum of Photography at George Eastman House, 1982); Richard R. Brettell, *Paper and Light: The Calotype in France and Great Britain, 1839–1870* (Boston: David R. Godine, 1984); William C. Darrah, *Cartes de Visite in Nineteenth-Century Photography* (Gettysburg, PA: W. C. Darrah, 1981); Edward W. Earle, ed., *Points of View: The Stereograph in America – A Cultural History* (Rochester, NY: Visual Studies Workshop, 1979); Mark Haworth-Booth, ed., *The Golden Age of British Photography, 1839–1900* (Millerton, NY: Aperture, 1985); André Jammes and Eugenia Parry Janis, *The Art of French Calotype* (Princeton, NJ: Princeton University Press, 1983); and André Rouillé, *L'empire de la photographie, 1839–1870* (Paris: Le Sycomore, 1982).

A number of general books take up nineteenth-century photographic practice and its social consequences. Among these are Michel F. Braive, *The Photograph: A Social History* (New York: McGraw-Hill, 1966); Gisele Freund, *Photography and Society* (Boston: David R. Godine, 1980); Peter Bacon Hales, *Silver Cities: The Photography of American Urbanization, 1839–1915* (Philadelphia: Temple University Press, 1984); Elizabeth Anne McCauley, *Likenesses: Portrait Photography in Europe, 1850–1870* (Albuquerque: Art Museum/University of New Mexico, 1981), and Elizabeth Anne McCauley, *Industrial Madness: Commercial Photography in Paris, 1848–1871* (New Haven, CT: Yale University Press, 1994); Richard Rudisill, *Mirror Image: The Influence of the Daguerreotype on American Society* (Albuquerque: University of New Mexico Press, 1971); Martha A. Sandweiss, ed., *Photography in Nineteenth-Century America* (Fort Worth, TX: Amon Carter Museum, and New York: Harry N. Abrams, 1991); Alan Thomas, *Time in a Frame: Photography and the Nineteenth-Century Mind* (New York: Schocken Books, 1977); Alan Trachtenberg, *Reading American Photographs: Images as History: Mathew Brady to Walker Evans* (New York: Hill and Wang, 1989); and Mike Weaver, ed., *British Photography in the Nineteenth Century: The Fine Arts Tradition* (New York: Cambridge University Press, 1989).

Essays and commentary on photography's cultural contexts can be found in works such as Miles Orvell, *The Real Thing: Imitation and Authenticity in American Culture, 1880–1940* (Chapel Hill: University of North Carolina Press, 1989), and David Shi, *Facing Facts: Realism in American Thought and Culture, 1850–1920* (New York: Oxford University Press, 1995). Though not specifically on photography, Lawrence Levine's *Highbrow/Lowbrow: The Emergence of Cultural Hierarchy in America* (Cambridge, MA: Harvard University Press, 1988) outlines

many of the issues involved in the medium's social and cultural history. Photographic practice is similarly discussed in Robert M. Crunden's *American Salons: Encounters with European Modernism, 1885–1917* (New York: Oxford University Press, 1993).

Several texts discuss photography's association with other arts and cultural perspectives. Jane Rabb's outstanding anthology and bibliography *Literature and Photography: Interactions 1840–1990* (Albuquerque: University of New Mexico Press, 1995) give witness to the persistence of this cultural interpenetration. Similar in scope, but with an emphasis on colonialism, are the essays brought together by Elizabeth Edwards in the text she edited called *Anthropology and Photography* (New Haven, CT: Yale University Press, 1992). For a history of the relationship between reproductive media and photography, see Estelle Jussim, *Visual Communication and the Graphic Arts: Photographic Technologies in the Nineteenth Century* (New York: R. R. Bowker, 1974). William Ivins's *Prints and Visual Communication* (Cambridge, MA: Harvard University Press, 1953) has become a touchstone in the area of visual literacy.

Few books extensively discuss the relationship of verbal and visual literacy movements in the nineteenth century. Nevertheless, both Frances Borzello's *Civilising Caliban: The Misuses of Art, 1875–1980* (New York: Routledge and Kegan Paul, 1987) and the exhibition catalogue titled *Art for the People: Culture in the Slums of Late Victorian Britain* (London: Dulwich Picture Gallery, 1994) deal with art and issues of mass communication. Harvey J. Graff's *The Literacy Myth* (New York: Academic Press, 1976) and the essays that Jack Goody edited in *Literacy in Traditional Societies* (Cambridge: Cambridge University Press, 1968) are fine starting points for understanding the complexities involved in the investigation of literacy movements.

Among the most helpful general histories of photography are J. M. Eder's enduring *History of Photography,* trans. Edward Epstean (New York: Columbia University Press, 1945); Jean-Luc Daval, *Photography: History of an Art* (New York: Rizzoli International Publications, 1982); Ian Jeffrey, *Photography: A Concise History* (New York: Oxford University Press, 1981); Beaumont Newhall, *The History of Photography: From 1839 to the Present* (New York: Museum of Modern Art, 1982); Naomi Rosenblum, *A World History of Photography* (New York: Abbeville Press, 1984); Naomi Rosenblum, *A History of Women Photographers* (New York: Abbeville Press, 1994); and Aaron Scharf, *Art and Photography* (Penguin, 1968). Also see the essays collected in *A History of Photography: Social and Cultural Perspectives,* Jean-Claude Lemagny and André Rouillé, eds., trans., Janet Lloyd (New York: Cambridge University Press, 1987); Kathleen Collins, *Shadow and Substance: Essays on the History of Photography* (Bloomfield Hills, MI: Amorphous Institute Press, 1990); and the studies compiled by Mike Weaver in *The Art of Photography, 1839–1989* (New Haven, CT: Yale University Press, 1989).

Themes and issues in contemporary photographic historiography

were announced in Allan Sekula's widely anthologized article "On the Invention of Photographic Meaning" (*Artforum* 13, no. 5 [1975]: 36–44). Sekula's essay can be found with key writings by Walter Benjamin, Roland Barthes, and Umberto Eco, among others, in *Thinking Photography,* ed. Victor Burgin (London: Macmillan Publishers, 1982). Similarly oriented toward the analysis of photographic history are the writings of Abigail Solomon-Godeau collected in *Photography at the Dock: Essays on Photographic History, Institutions, and Practices* (Minneapolis: University of Minnesota Press, 1991). In *Techniques of the Observer: On Vision and Modernity in the Nineteenth Century* (Cambridge, MA: MIT Press, 1990), Jonathan Crary combines an exploration of photography's forebears with an analysis of the Enlightenment's impact on interpretation of photographic images. In contemporary thought, photographic practice is increasingly examined in the context of photographic criticism. Although it does not deal with nineteenth-century sources, Joel Eisinger's integrative study *Trace and Transformation: American Criticism of Photography in the Modernist Period* (Albuquerque: University of New Mexico Press, 1995) heralds renewed efforts at the cross-disciplinary study of photography.

# INDEX